NANTUCKET
IMPRESSIONS

NANTUCKET
IMPRESSIONS

Robert Gambee

Edited by Elizabeth Heard

W.W. Norton & Company

New York • *London*

This book is dedicated to
Jackie Schuman
who designs all of my books

Nantucket offers us a wonderful feeling of being free. It is a freedom that comes, in part, from being separated from mainland America. Because Nantucket is an island thirty miles at sea, the boss cannot call and ask you to drive over for a morning meeting that has just been scheduled. You simply cannot do it.

It is a freedom you find sailing the sea with the wind in your face, or walking the beach with only the calls of the gulls and the ebb and flow of the surf to accompany you. It is the rush of the ocean waves up the South Shore—each one different, yet eternally the same. It is the freedom to pull up anchor and set sail. This is a well-worn image but important to remember, as the routines of our daily lives can often trap us. There are no such traps on Nantucket (unless you look for them.)

There is a special sense of freedom in the present, knowing that this is a place that has been settled for hundreds of years. Others have been here and lived different lives, all in celebration of their independence.

This is the story of Nantucket. Historically, freedom on the island once meant escape from religious persecution (one of the reasons the original settlers came here.) Nantucketers were always a bit more independent than other Americans. And when they took up their long whaling voyages, this feeling was intensified.

The freedom of letting go allows us to experience the here and now—setting forth on an adventure with only the winds and currents to guide us. But this is not the freedom to do whatever we want at the expense of others. It is not the ability to drive anywhere along the dunes or moors. Nor is it the freedom to build new structures as we please. For these activities we are indebted to the stewardship of the Nantucket Conservation Foundation, which contains growth, and to the Historic District Commission, which controls it. The latter is truly one of the most valuable commissions anywhere. It is a group of dedicated souls who face the daunting task of trying to accommodate new building activity while still preserving the look of the island. Week after week they tirelessly review applications, with little appreciation from the other side. Yet this is a fine example of how the citizens of

Nantucket are combining growth with preservation, allowing the island to expand and change.

Nantucket is a unique spot in both mind and body. In the introduction to my first book on the island (1973), Nathaniel Benchley wrote, "Nantucket is, quite literally, home to me, but it is also home to any number of people who aren't year-round residents. It is home to some who haven't been there for years; it is home to others who come and go with the seasons; and it is home to a great many more who, probably without knowing it, are groping for what Nantucket has to offer. It is, more than anything else, a state of mind, and those who achieve it never want for anything more."

I hope that everyone who reads this book will come away closer to achieving that state of mind, with a heightened sense of the special qualities of Nantucket.

—R. G.

Special Acknowledgements

Starling Lawrence	Publishing editor
Lucy Leske	Horticultural information
George Bassett	Motor yacht and Marina notes
Polly Whittell	Motor yacht information
Eric Holch	Sailing and artist information
James Lentowski	Nantucket Conservation Foundation
Niles Parker	Nantucket Historical Association
Inae Bloom	Historical research
Kathryn Bonomi	Indexing
Carol Desnoes	Electronic pagination and design
Patricia Chui	Copy editing
Susan Carlson	Production supervision
Tsuguo Tada	Printing manager
Kohei Tsumori	Printing supervision—New York
Tsuyoshi Naganuma	Printing supervision—Hong Kong

Contents

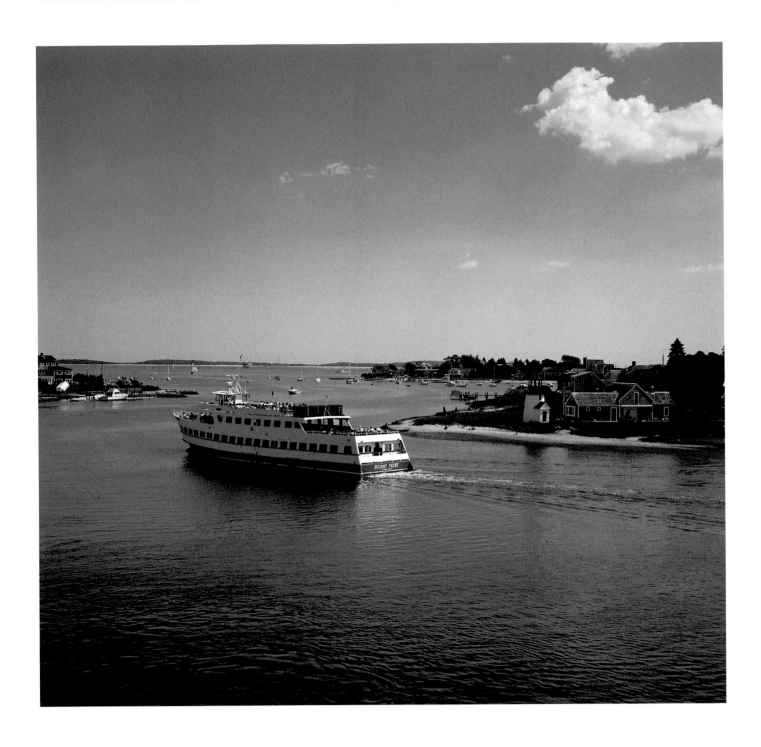

Hyannis Harbor. The best way to get to Nantucket from Hyannis is to follow the *Brant Point* to Brant Point. Or one can fly over to Nantucket Memorial Airport, whose aviation letters, ACK, derive from Ackersley Field. (NAN was not a permitted abbreviation, since the letter "N" is reserved for the U.S. Navy.)

Here is the Hy-Line's motor vessel passing Channel Point Lighthouse, part of a private residence that was built in 1979 as a two-thirds replica of Brant Point Lighthouse. Since the lighthouse is on the port, or left, side of the channel when ap-proached from seaward, Channel Point has a green light; whereas Brant Point Lighthouse, being on the starboard side, has a red light. Channel Point's light is decorative and is either on or off. Brant Point's is functional and occulating, which means it is on more than it is off during operating hours.

Opposite: The 9 x 35 Binocular Viewing Machines on board the ferry bring everything much closer, once one gets the hang of it. These are made in Norwalk.

Off to Nantucket

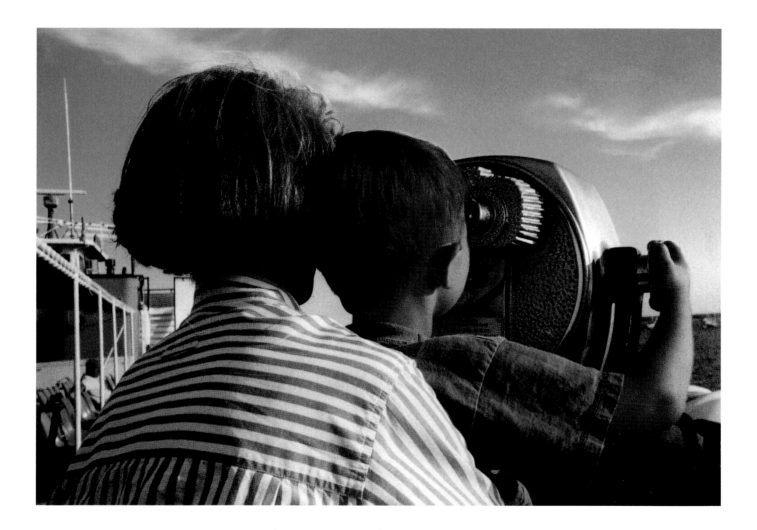

On board the ferries to Nantucket. The Woods Hole, Martha's Vineyard and Nantucket Steamship Authority, a state-run boat line, presently has a fleet of ten vessels—including its latest acquisition, the *Schamonchi*, which serves Martha's Vineyard. Other passenger vessels include the *Eagle*, the *Islander*, the *Martha's Vineyard*, and the *Nantucket*, as well as the *Flying Cloud*, a high-speed catamaran. The Steamship Authority also has four freight boats: the *Gay Head*, the *Governor*, the *Katama*, and the *Sankaty*.

Steamship Authority ferries that operate to and from Nantucket Island are the *Flying Cloud* (built in 2000), with a capacity of three hundred passengers and a top speed of 36 knots; the *Eagle* (built in 1988), with a capacity of 1,367 people and 52 vehicles; and the *Nantucket* (built in 1974), with a capacity of 1,146 passengers and 50 vehicles. The latter two ferries are always full of cars and trucks, but not, fortunately, of people.

One of the wonderful design features of these passenger vessels is the steel-mesh guard railings that encircle all decks, ensuring that no one can toddle away and fall off. The ferries offer a wonderful time to sit back, relax, and enjoy a two-hour (or more) cruise. Once the mad dash to the gangplank has been made—often following a lengthy drive accompanied by more paraphernalia, angst, and unexpected stops than originally envisioned—travelers can sit back and slip into a different pace.

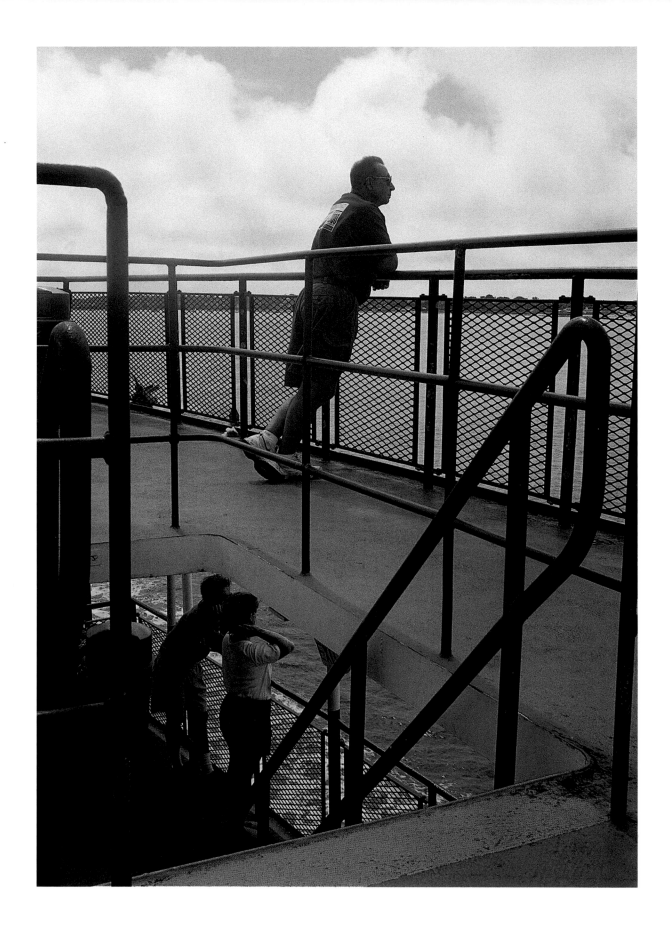

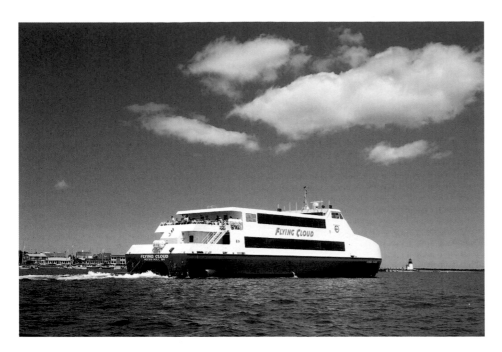

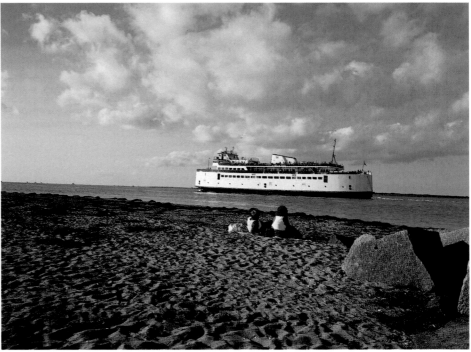

Among the ferries serving Nantucket are the *Flying Cloud* (2000) (*above, top*), the *Eagle* (1988) (*above*), the *Brant Point* (1973) (*opposite, top*), and the *Great Point* (1988) (*opposite, bottom*). The larger vessels are operated by the Woods Hole, Martha's Vineyard and Nantucket Steamship Authority; privately owned Hy-Line Cruises operates the passenger-only ferries. Formerly operating out of New Bedford and then out of Woods Hole, the Steamship Authority moved its Nantucket service to Hyannis in 1972.

Fast ferries have been added to both the Hy-Line's and Steamship Authority's fleets in recent years. The Hy-Line's *Grey Lady* (1995) is a high-speed water-jet catamaran. These fast boats out of Hyannis have proved popular because the waters of Nantucket Sound are generally calm. An earlier attempt at high-speed ferry service from Boston and around the Cape was unsuccessful because of turbulence caused during the three-hour trip.

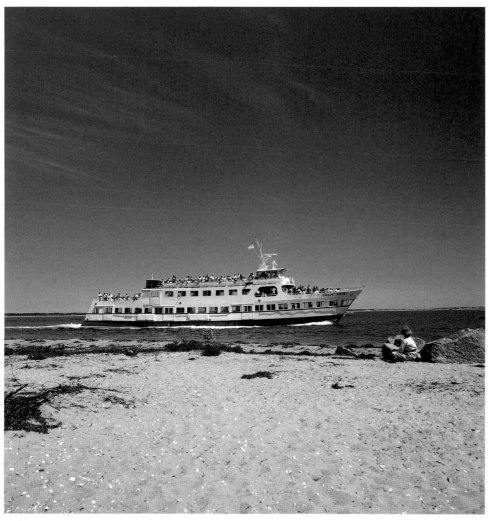

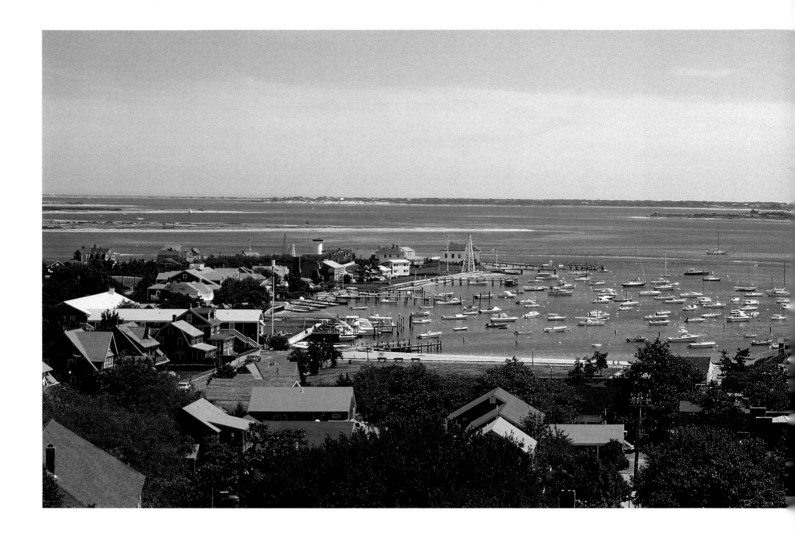

Nantucket Harbor as seen from the steeple of Old North Church. The *Nantucket* is just arriving from America. Regular steamer service began in 1818, and until the mid-1920s, the boats were graceful side-wheelers with staterooms and dining salons.

Until the early 1800s, a wide variety of sailing vessels visited Nantucket, but none on a regular schedule. Although the packets tried to maintain frequent service, the vagaries of wind and tide made their arrivals and departures diverge far from whatever date and time had been promised. Storms would often suspend sailings for weeks at a time, and the idea of regular, daily service was not even contemplated.

All of this changed on May 5, 1818, when a little paddle steamer named the *Eagle* huffed and puffed her way to the island from New Bedford. On the initial trip were sixty passengers, many of whom were Quaker Friends attending a meeting on the island. By June 25, more regular trips were scheduled; thus began the first such ferry service in New England. It did not last long, however—only a year. In 1828, another attempt at scheduled service was made, without much success. But on October 4, 1832, the little steamer *Telegraph* improved the picture, as did the creation of the Nantucket Steamboat Company the following year. The *Telegraph* provided valuable service during the winter because its hull was fortified to battle the ice.

Occasionally, on winter runs, passengers were asked to gather at the stern (or the rear) as the ship ran onto an ice floe. They then moved to the bow and added their weight to that part of the ship to break the ice. A unique feature of the dependable little *Telegraph* was her cabin boy, who would often sit at the entrance to the saloon in rough weather and play his violin to soothe afflicted passengers.

In the 1850s, the *Telegraph* had "Nebraska" painted on one side because of the island's interest in the Kansas-Nebraska Act, calling for admission of the Nebraska territory as a new state. Her official name, however, remained *Telegraph*.

The Nantucket Steamboat Company added additional, larger vessels to its fleet and even operated the Jared Coffin House for its customers. But the service was not always on schedule, and steamboats were occasionally pulled from rotation to do private work. A typical crossing was eight hours, so a few days of extra travel time was not considered serious—at least to the directors of the steamboat company.

At the left of this 1985 photograph are the red roofs of the U.S. Coast Guard Station at Brant Point. In the middle are the Nantucket Yacht Club and its Boat House. To the right are three concrete pylons and the terminal building of the Woods Hole, Martha's Vineyard and Nantucket Steamship Authority, whose

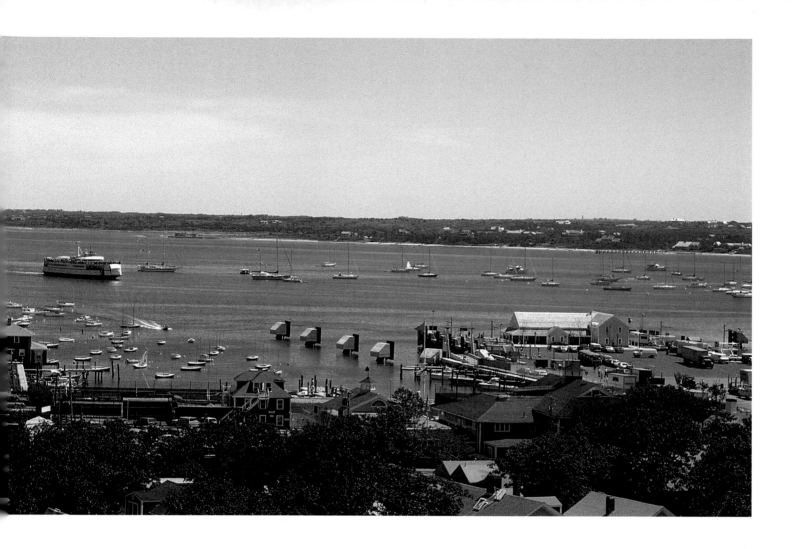

daily crossings take about two-and-a-half hours and are indeed on schedule.

Popular legend holds that the sandbar at the mouth of Nantucket harbor formed in the mid-1800s and grew to a point where whalers could no longer enter, forcing the whaling industry to relocate. The fact is the Nantucket Bar was a problem as early as 1760. A large shoal was discovered enclosing the harbor, preventing the entrance of large sloops except at high tide. Thus the bar was there all along; it was the whaleships that grew, drawing over fourteen feet. At high tide, there were only nine feet of water atop the bar. The danger lay not simply in the lack of depth, but in the violence the sandbar's presence was capable of causing. When the tide is out and the wind blows, ocean currents build on the bar. The wind pushes against the tide and large swells roll across it like cliffs of water. Ships trying to navigate can suddenly go from ten feet of water to none at all, and can run aground on the shoal. In 1803, a group of Nantucketers petitioned Congress for aid, and the U.S. Army Corps of Engineers was dispatched. They proposed a type of wooden jetty: wooden piles driven into the sand, filled in between with wooden planks. But the town, thinking this would be harmful to the ships, voted to dredge instead. Congress again reviewed the situation and dispatched the engi-

neers, who this time came back with a proposal for a breakwater at an exceptionally large sum. The islanders proceeded to dredge, but ran out of money with the next tide.

As the whaling industry prospered in the 1830s and 1840s, merchants decided to focus their efforts on asking Congress for better navigational charts and protection for the industry's far-flung fleet, especially its ships in the Pacific Ocean. They took their eyes off the immediate problem while pursuing greater riches. But the problem never went away, and a number of large whaleships founder right outside of port, causing some foresighted sailors to start migrating to New Bedford. Camels, which were devices intended to aid in moving ships across the bar, came to the rescue in 1843; by 1845 they had transported forty-five of the fifty-seven ships entering or leaving the harbor. Unfortunately, the camels were too late; while they made the transition over the bar easier, such a solution was not as easy as relocating the industry to the mainland. The decline in whaling had begun, long before the Jetties were finally built. But the Jetties do serve a valuable purpose today, enabling ferries and other large private craft to enter the harbor. Despite the delay, we are indeed grateful for their presence.

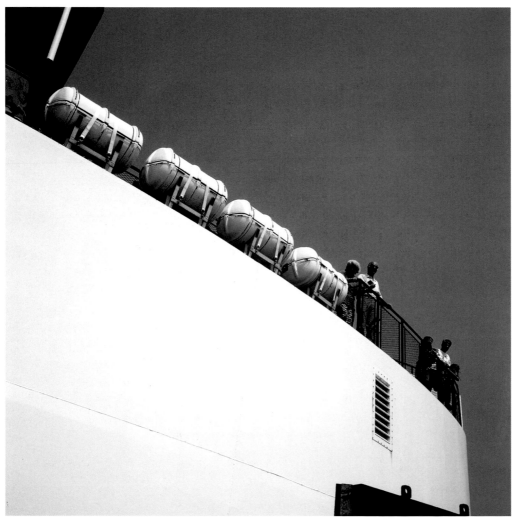

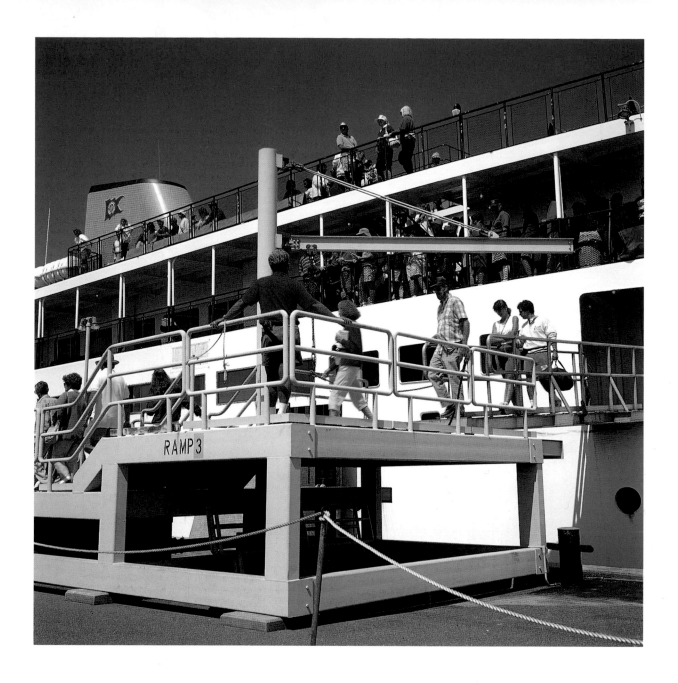

The *SS Nantucket* and the *SS Eagle*. These large passenger-and-vehicle ferries are referred to as steamships, even though the last vessel to be so powered was the *Naushon*, which was sold in 1975. The Steamship Authority runs these diesel engine-powered vessels between Nantucket and Hyannis all year long on a daily basis, weather permitting. The islanders depend on them not only for basic transportation, but also for the delivery of most of their basic necessities. The original *Nantucket* was built in 1886, equipped with watertight bulkheads and a fifteen-foot boiler. On the main deck, in addition to the freight area, were a social hall, staterooms, and a separate ladies' cabin. Cherry railings and balusters bordered the wide staircase that led up to the promenade deck and its ninety-eight-foot-long curved saloon. Covering this was a twenty-eight-foot skylight.

The first *Eagle* was built in 1818, ten years after Robert Fulton's *Clermont*. She had an inauspicious trial run: her wooden boilers exploded in the Thames River in New London. Copper boilers were subsequently installed. Her best time from New Bedford to Nantucket was eight hours, seven minutes. Winds and tides often brought these early paddle wheelers to a dead stop.

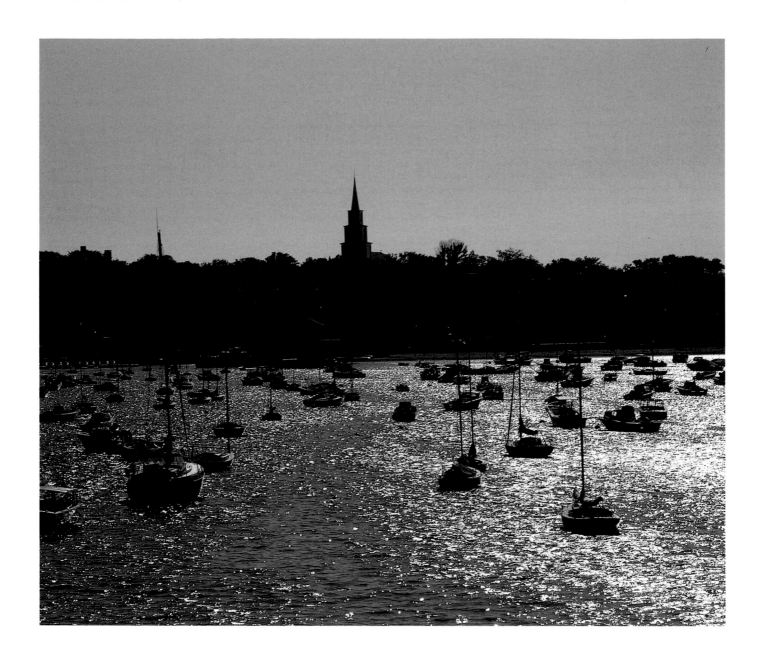

Above: The skyline of Nantucket as seen when rounding Brant Point on an early summer evening. Catboats and other craft doze in the Anchorage. Old North Church (built in 1834, with a new steeple dropped down by helicopter in 1968) is a prominent feature.

Opposite: Arriving at Brant Point is an old friend operating under her own steam. The lightship *Nantucket*, shown in this 1995 photograph, is the largest lightship ever built. Built in 1936, it was stationed for forty years at the southern end of the dangerous Nantucket shoals, serving as sentry for vessels

18

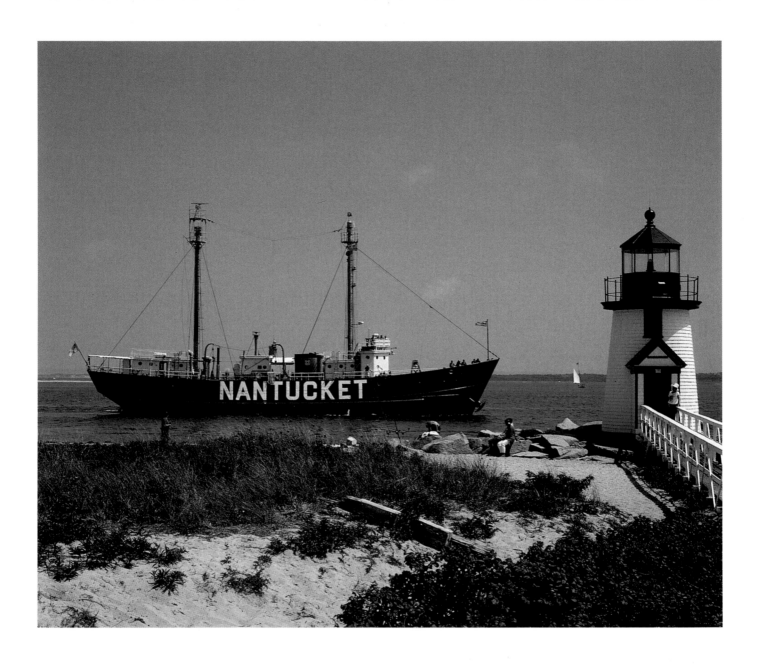

approaching New York along the crowded North Atlantic shipping lanes.

Congress put the first lightship into service at the entrance to Chesapeake Bay in 1820. Nantucketers had their first lightship in Nantucket Sound in 1828. By 1854, there were two stations: one in Nantucket Sound at Cross Rip Shoal, the other fifty miles south on the South Shoal. The *South Shoal* was a retired Nantucket whaler painted red with yellow masts. Whale lamps in the mastheads were visible for fifteen miles on a clear evening.

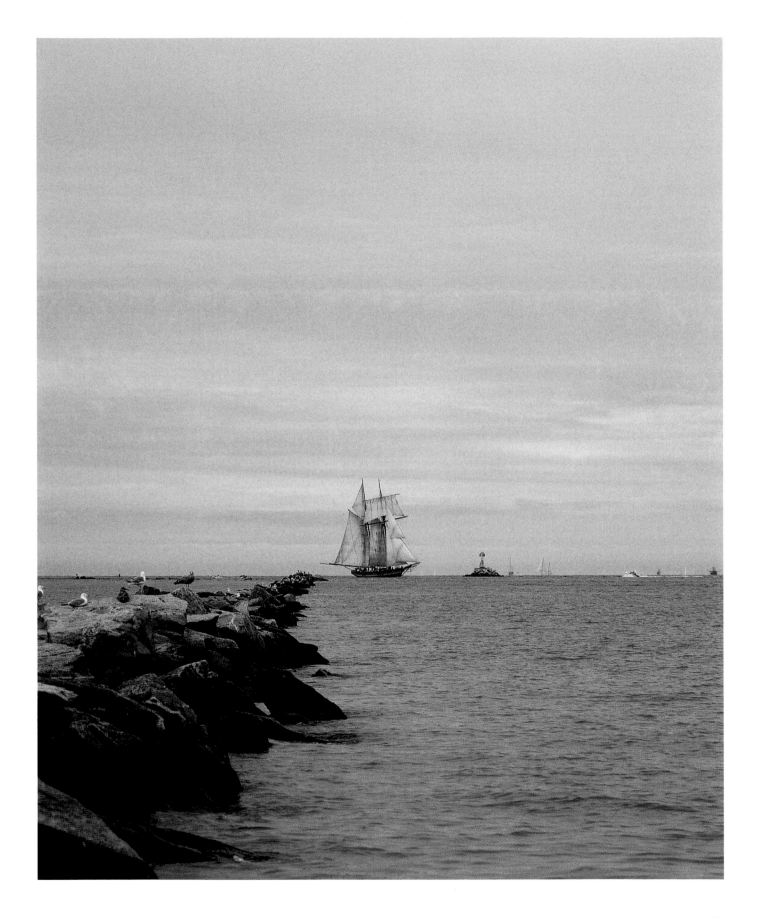

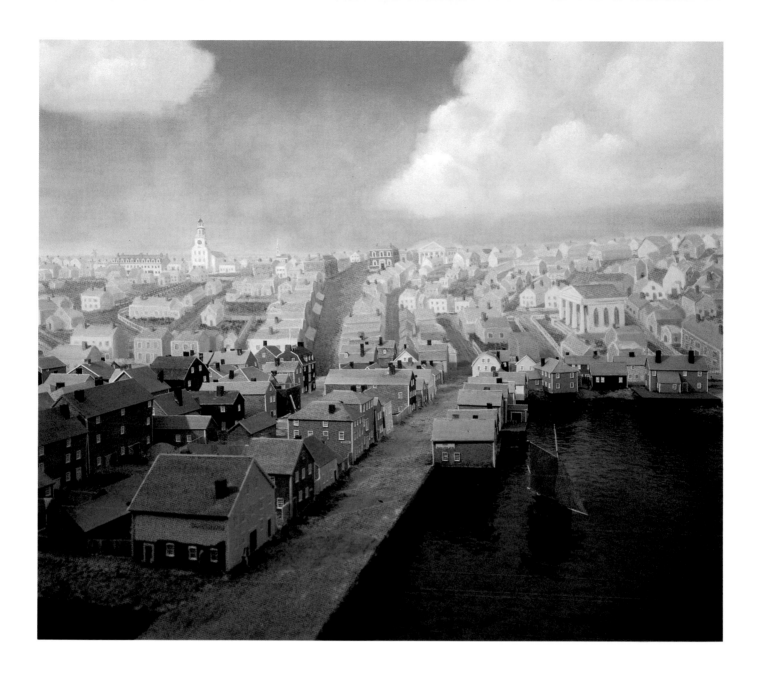

Opposite: Sailing through the Jetties is the graceful *Pride of Baltimore*, a newly created version of a topsail schooner from the 1812 era.

The vessel is based on the Baltimore clipper ship *Chasseur*, which was launched in 1814 and became known as "the Pride of Baltimore." These clipper ships were fast (capable of attaining fifteen knots) and distinguished by their raked-back rigging and arrow-sharp profile. They played an important role in the War of 1812 and were frequently featured in scrimshaw of the period, but they never became successful after the war because their narrow hulls was not capacious enough for cargo or passengers. The original *Pride of Baltimore* was built in 1977 and sailed until 1986, when she succumbed to a violent storm north of Puerto Rico. A replacement vessel was built by the State of Maryland and serves as an economic and goodwill ambassador for the state.

The massive stone jetties were first proposed in 1803 by the United States Congress to help prevent sand from accumulating across the entrance to the harbor and inhibiting the passage of whaleships. But various opinions and indecision in Congress resulted in no definitive action being taken until 1881, well after the whaling industry had collapsed. The western jetty was built in 1881, the eastern one in 1894. Barges delivered 500,000 tons of stone that year.

Above: Nantucket in the 1840s, as depicted in a diorama at the Nantucket Historical Association.

Above and opposite: Arriving at Steamboat Wharf. The Woods Hole, Martha's Vineyard and Nantucket Steamship Authority is a public organization run by the communities it serves. New Bedford service was eliminated in 1960 and Hyannis added in 1972, although Hyannis service first began in the early 1830s.

The Steamship Authority is the successor to the Nantucket Steamboat Company (founded in 1842) and the New Bedford, Vineyard and Nantucket Steamboat Company (1854). In 1886 the two rivals were consolidated into the New Bedford, Martha's Vineyard and Nantucket Steamboat Company. It

immediately ordered a new side-wheel vessel, the *Nantucket,* which was placed in service on July 31, 1886. She proved to be as successful in her operation as she was graceful in her appearance.

On May 2, 1911, the steamboat *Sankaty,* built to replace the aging side-wheeler *Martha's Vineyard,* made her maiden voyage from New Bedford to Nantucket. She was built at the Fore River Company Yard in Quincy, Massachusetts, and was propeller-driven with a steel hull. Since she was not as wide as the side-wheelers and did not have the benefit of their stabilizing

breadth, the *Sankaty* tended to roll more. But passengers adapted, accepting some discomfort in exchange for much-improved speed.

Earlier that year, the New York, New Haven and Hartford Railroad had taken control of the steamboat company and begun operating it as the New England Steamship Company. Additional vessels were added to the fleet, including the beloved *Nobska*, which was built at the Bath Iron Works in Maine in 1925. For the next fifty years, she provided dependable island service with grace. I remember seeing the *Cross Rip* light-

ship from our stateroom as we sailed from New Bedford. This was the end of our long journey, and my parents liked the chance to relax, ring the bell for the steward to bring a bucket of ice, and settle into our Nantucket vacation.

Less memorable vessels also joined the fleet: the *Nantucket* (renamed the *Naushon*), built in 1957 in Camden, New Jersey, by the J.J. Mathis Company, and the *Uncatena*, built in 1965 in Warren, Rhode Island, by the Blount Marine Works. The latter reached a new low in vehicle design, whether bus, boat or otherwise.

Straight Wharf was originally built by Richard Macy in 1723 as an extension of Main Street. The cobblestones that flow right up to the edge of the wharf enabled the heavy carts of whaling bounty to be pulled up to the tryworks, candle factories, and shops.

Ferry service to the mainland and Martha's Vineyard is provided by Hy-Line Cruises, Inc., the successor to a company that began in 1946.

The Hy-Line is a privately held corporation owned by the Scudder family of Hyannis. It was founded in 1962 as a sightseeing operator. For the next eight years it operated Hyannis Harbor Tours, but in 1971 it started ferry service from Hyannis to Oak Bluffs on the Vineyard. In 1972, the Woods Hole, Martha's Vineyard and Nantucket Steamship Authority, created by the Commonwealth of Massachusetts to continue service from the mainland to the islands, added Hyannis as a point of embarkation. As a result, the Nantucket Boat Line, which had provided service from Hyannis since 1946, decided to sell its operation to the Scudder family. Hyannis Harbor Tours purchased the company, including its three vessels, docking facilities, and the trade name Hy-Line.

Presently the company has a fleet of eleven ferries, three of which regularly ply the route between Hyannis and Nantucket. Hy-Line began high-speed catamaran service in 1995 with the *Grey Lady* (since replaced by the *Grey Lady II*), offering first-class comfort and first-class speed. She makes six round trips a day during the summer, each leg taking about an hour.

24

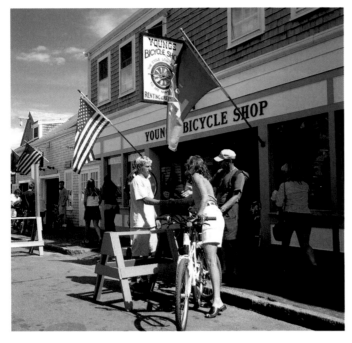

Activity on Steamboat Wharf. This is one of Nantucket's five wharves and the town pier. After North Wharf (1750) came New North Wharf, which was built by twenty-four shareholders in 1770; the name was changed to Steamboat Wharf in 1838. From the wharf's beginnings, it was the embarkation point for passengers going to the mainland. By the mid-1800s, there were daily crossings during the summer, whereas in the winter, the steamer ran only once a week. Nantucket had the first regularly scheduled steamboat transportation in New England.

In the early 1800s, over two hundred people were employed by a wool factory at the head of the wharf. The wharf officially became known as Steamboat Wharf when the Nantucket Steamboat Company was organized in 1838. In 1888 this line merged with the New Bedford and Martha's Vineyard Steamboat Company. Control of this merged entity passed in 1911 to the New York, New Haven and Hartford Railroad which was promoting Cape Cod and the islands as tourist destinations. My earliest camp memories are of boarding the *Cape Codder* at Grand Central Terminal and riding all the way to the Cape. Our trunks were forwarded via Railway Express and had their own leisurely journey.

The first bicycle on Nantucket arrived in 1886. Its owner was J. Stockton Cary, and it was a high wheeler—with a large wheel in the front and a small one in the back—called an Ordinary. Cary readily let anyone who was adventuresome try it out, but usually one trip down the cobblestones was enough for most. Shortly afterward came the more popular Safety Bicycle. Charlie Congdon frequently rode this to work at his pharmacy on Main Street. Eventually more bicycles arrived, and by the turn of the century there was a bicycle race track built by Eugene Burgess on what is now the Marine Home Center property. By a vote of the 1896 town meeting, a bicycle path was built to Siasconset.

In 1929, Harvey Young arrived in Nantucket in response to an ad for a plumber and steamfitter. As a sideline, he began to collect, repair, and rent out used bicycles from his home at 45 Pearl Street (now India Street). He worked mainly as a plumber, and he and his wife also ran a small convenience store. But as the bicycle business grew, Young looked for larger quarters, and found them at 10 Broad Street. It was a garage that was generally empty during the day but occupied by the Lindsay family's Packard at night. The owner of the garage, J. B. Ashley, agreed that Young's bicycle shop could operate there if the bikes were moved every evening to make room for the Packard.

Earl Cook established the second bicycle shop shortly afterward, originally on Charter Street, but by the end of the early 1940s on South Beach Street. Other cycle shops have opened up, and during today's summer days it appears there are more bicycles about town than automobiles.

Around the Wharves

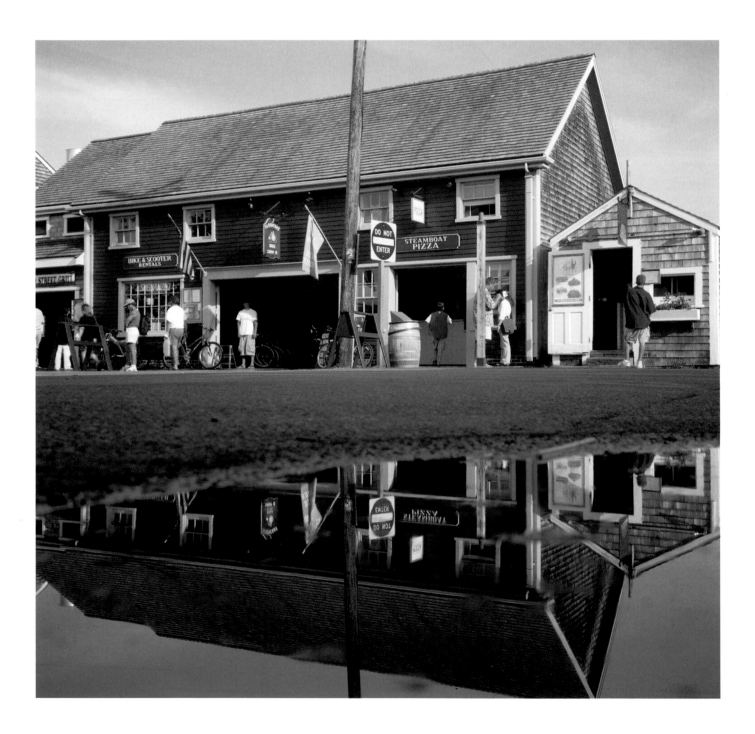

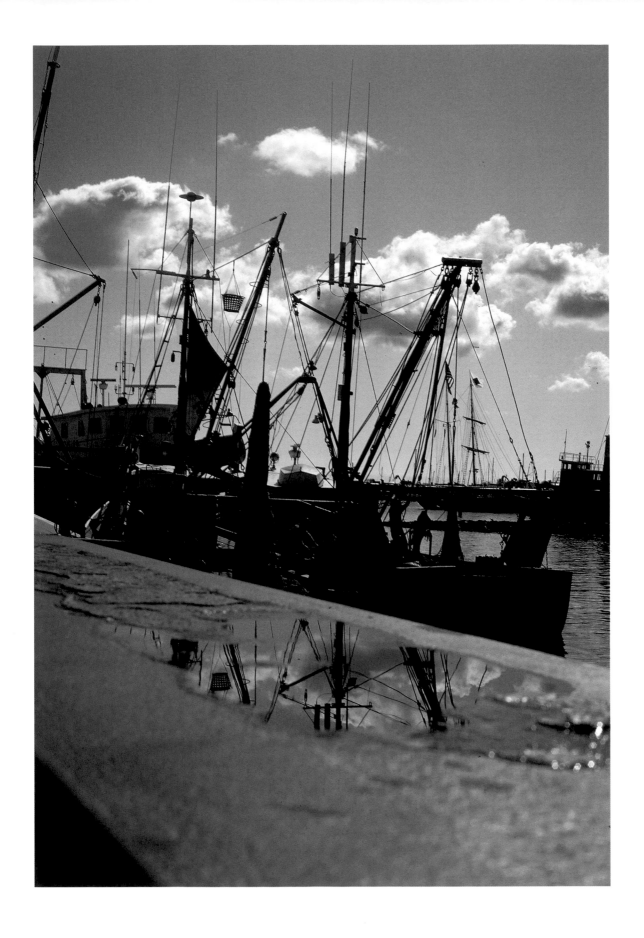

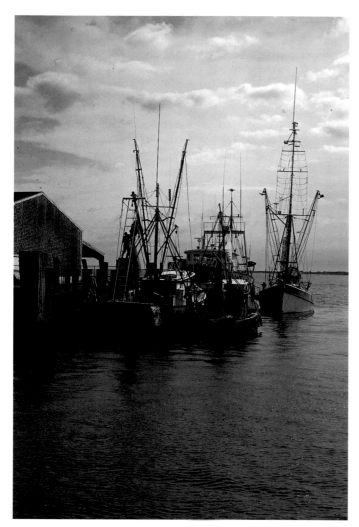

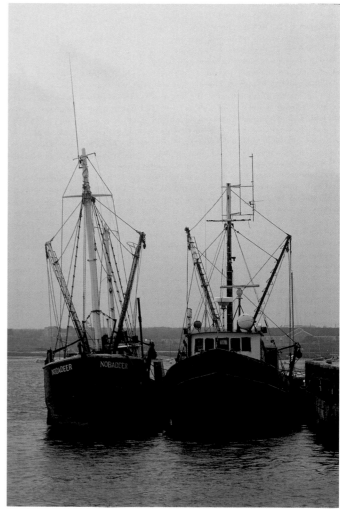

Fishing boats back from sea. These boats concentrate on catching bluefish, cod, flounder, haddock, halibut, and swordfish. Today fishing is a modest source of Nantucket's income, compared with whaling in the nineteenth century.

Nantucketers were forced into farming the seas because poor soil conditions made farming the land impractical. Whaling began by accident, when one lone whale strayed into the harbor and was captured. In 1672, the islanders hired a professional to teach them about whaling, and in 1690, the pursuit began. The quest was for whale oil, primarily intended for England, which was consuming over four thousand tons annually in houses and streetlights. Before people learned to extract oil from the ground,

they extracted it from whales. It was one of the most lucrative growth industries of the nineteenth century. Between 1815 and 1865, the value of the industry's total production rose by more than one thousand percent. But it was a risky business. Ships were rammed by whales, men were lost at sea, and those who did return came home only after very long voyages.

By 1800, Nantucket whalers were sailing around Cape Horn, often on voyages of two years or more. In 1832, over thirty whaleships set out to sea in that one year alone, and by 1834, Nantucket had over eighty-eight whalers out sailing around the world. Nantucket had indeed become the whaling capital of the world.

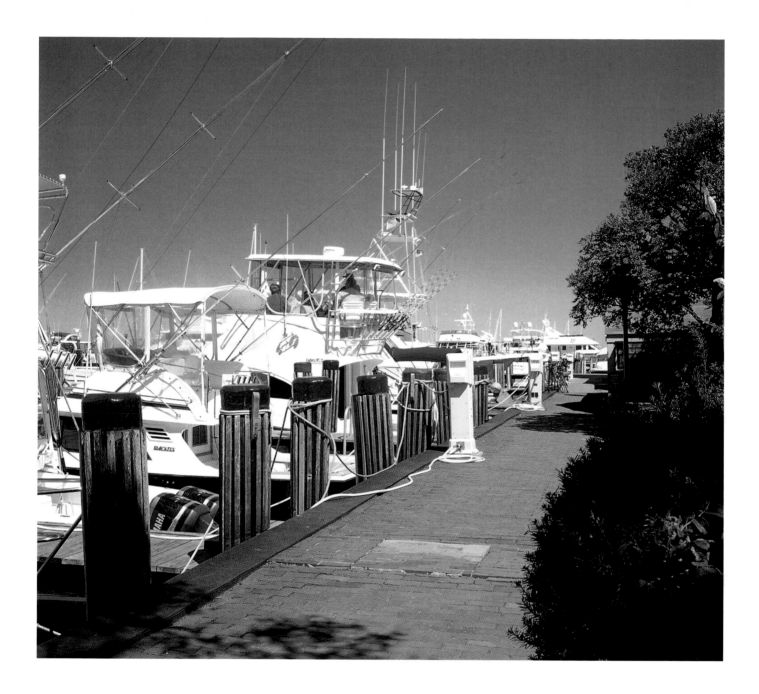

Lower Swain's Wharf, originally built in 1816 and known as Commercial Wharf. The photographs show fishing boats, sport fishermen, and motor yachts. Powerboats have become increasingly popular, even with former sailors, because they are easier to handle and require less crew than sailboats. They are also more convenient for getting there and back quickly. Sailing is slower and requires more skill. Either way, motorboating is a pleasurable activity for many people. The motor yacht is a relatively recent invention, slow to catch on with the general public. Although Ole Evinrude invented a detachable rowboat motor in 1909, the wealthy were attracted to steam yachts, some of which reached lengths of over three hundred feet by 1930. Families such as the Vanderbilts owned ships that were extraordinary showpieces of comfort and style.

After World War II, however, powerboating became a more democratic pastime. With more economical and sophisticated engines, starters, navigation equipment, and materials, the number of Americans involved in recreational boating increased from about five million in 1950 to over sixty million today. The motor yacht has come a long way from the floating salons of the 1920s with their wind-up Victrolas. Today's towering pleasure craft tackle the most challenging seas and yet, true to the yachting tradition, make the day's catch almost incidental to reaching the next night's port of call.

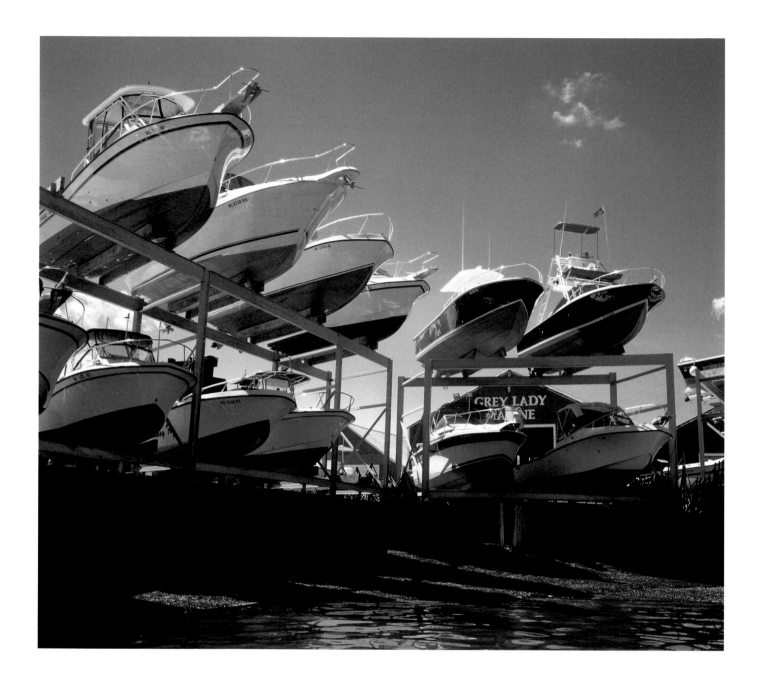

Town Pier and Grey Lady Marine. The Town Pier was built in 1976, a cooperative endeavor between the Federal Department of the Interior and the Town of Nantucket. It is designed for residential boats of up to thirty feet in length and is a reasonably priced marina for Nantucket's own residents. The length of the pier is 870 feet. This includes fifty-five slips, eight dinghy docks for visiting boaters, and seven transient slips.

New fishing boats stacked up at Grey Lady Marine are ready to leap into service. They are known for their high speeds and can often be seen cutting through the East Jetty en route to Great Point. These outboard powerboats, actually built right here at the shipyard, are appropriately called "Grey Ladies."

Grey Lady Marine was started in 1991 near the Memorial Airport and moved to its present location at 96 Washington Street in 1999. It functions as a full-service boat yard and provides valet service in and out of the dock during the summer season (May through October). The boats pictured on the racks include Grady-Whites, Sea Rays, Makos (*to the left*), Regulator 26s, and Black Fins (*to the right*). These recreational boats are between twenty-two and thirty feet long and can drive at speeds of up to twenty-five miles per hour. The area where Grey Lady Marine operates has been a boat yard since the late 1920s.

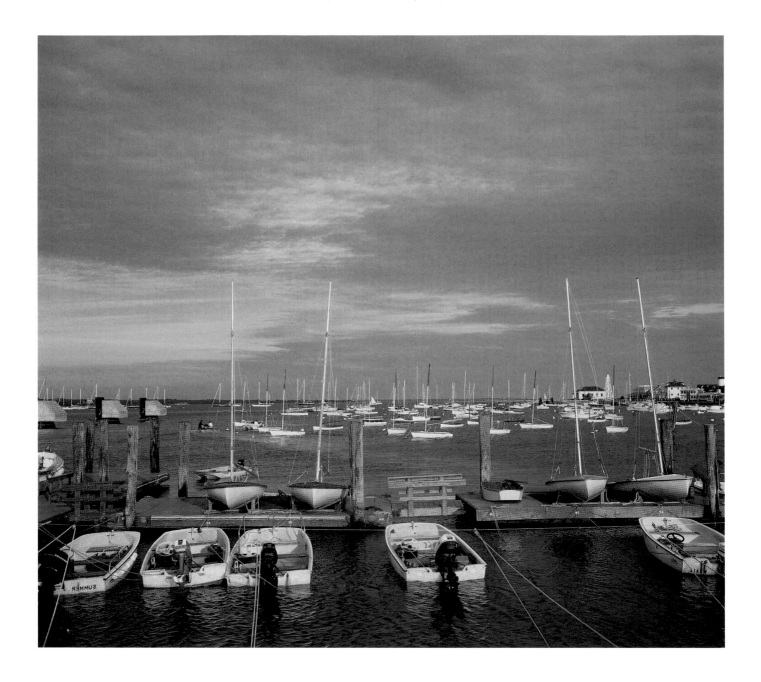

Above: A view of the harbor from the Nantucket Yacht Club. On the floating dock are "420s," which are used by young racers during the summer and by the Nantucket High School varsity sailing team in the fall. Nantucket Community Sailing works with the Yacht Club to coach the high school team, which recently won the Cape Cod Championship. In the foreground are Boston Whalers, the outboard of choice for scooting around the harbor for picnics and fishing.

Opposite: Catboats were originally designed for fishing and lobstering, being easy to sail in a light wind. The single gaff-rigged sail made for smooth operation, and the wide beam and shallow draft were ideal for Nantucket waters. So numerous were catboats that a section of Easy Street Basin was simply referred to as Catboat Basin. In 1925, the Nantucket Yacht Club selected a twelve-foot version made by John Beetle and dubbed it the Beetle Cat. With their multicolored sails, the boats became better known, collectively, as the Rainbow Fleet.

Catboat Basin, on the south side of Steamboat Wharf, harbored fishing and excursion boats. It was filled in when the wharf was widened in 1929 to provide a larger parking area for automobiles.

The catboat was developed in the New York area shortly after the Civil War. It is purely an American design, with its mast far forward in the "eyes" of the boat. Catboats are useful not only in fishing but also in Nantucket's tourism industry, ferrying vacationers to the beaches for bathing and picnicking.

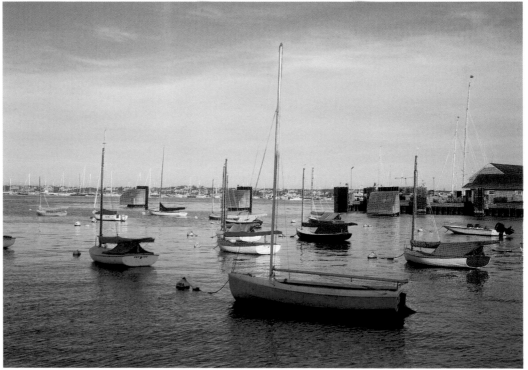

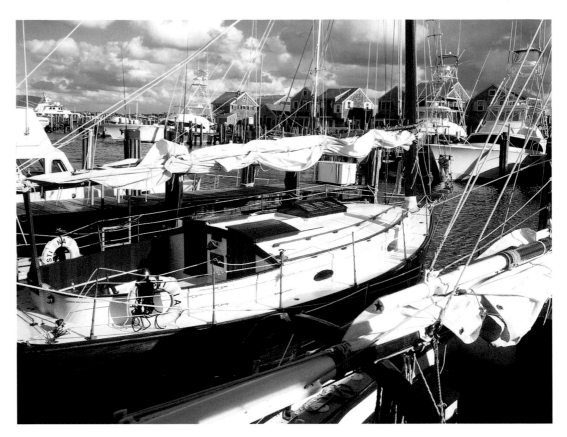

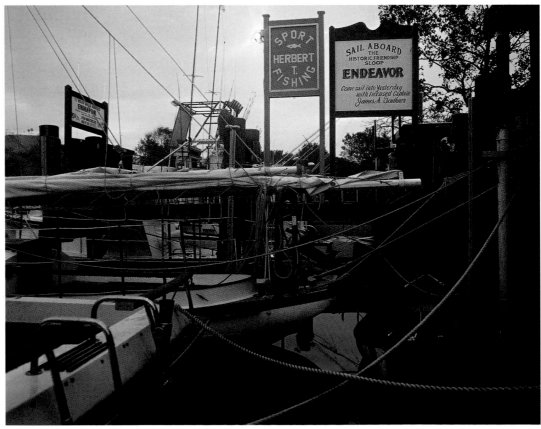

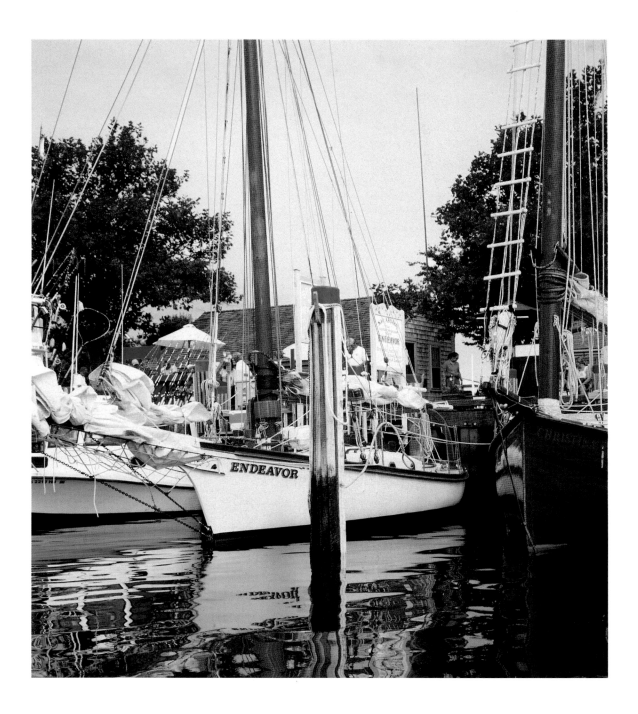

Charter sailboats and fishing boats continue to offer their services today, as they have for over a hundred years. The *Endeavor* (*above and opposite*) is a Friendship sloop, of the type originally designed and built in Friendship, Maine. They were designed as work boats, used for lobstering and long-line fishing off the coast of Maine. A typical Friendship sloop has a clipper bow capped by a long bowsprit, a bold sweeping sheer, and a big gaff-rigged mainsail, and at least two jibs.

The *Endeavor* has been used for charters on Nantucket since 1982, the longest such sailing charter operation on the island. On many occasions, her signature American flag may be seen flying from the main mast. Offering one sailing adventure after another, for families, corporate executives, "pirate parties," or wedding groups (though not at the same time), the *Endeavor* is very much a familiar part of Nantucket's harbor activities.

Also shown is the twenty-eight-foot catboat *Christiana*, which was built in 1926 by Charles Anderson. Her varnished mahogany and polished brass are reminiscent of the elegance of an earlier era of sailing. This boat sails seven times each summer day. One of its special trips is the sunset cruise, which, weather permitting, guarantees guests a memorable experience.

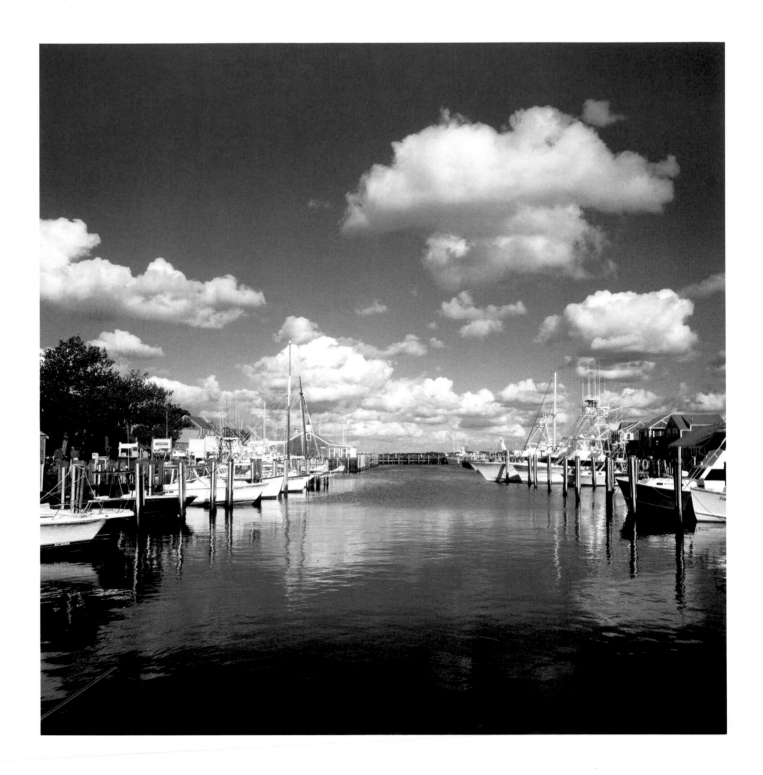

As the steamship rounds Brant Point, the broad panorama of Nantucket unfolds. Wharves, gray-shingled buildings, and the sentinel South Tower and Old North Church steeples appear all at once as a backdrop to the lively harbor. By day, the port is full of activity, with sails and flags everywhere. As darkness comes, the lights from the wharf cottages and anchored boats cast shimmering reflections in the water. The Nantucket Boat Basin has become a major port of call for the luxury yachts.

Nantucket began to lure summer visitors as America prospered toward the end of the nineteenth century. Before the Civil War, the United States had been predominantly agrarian. Farmers were essentially bound to their land, and city wage-

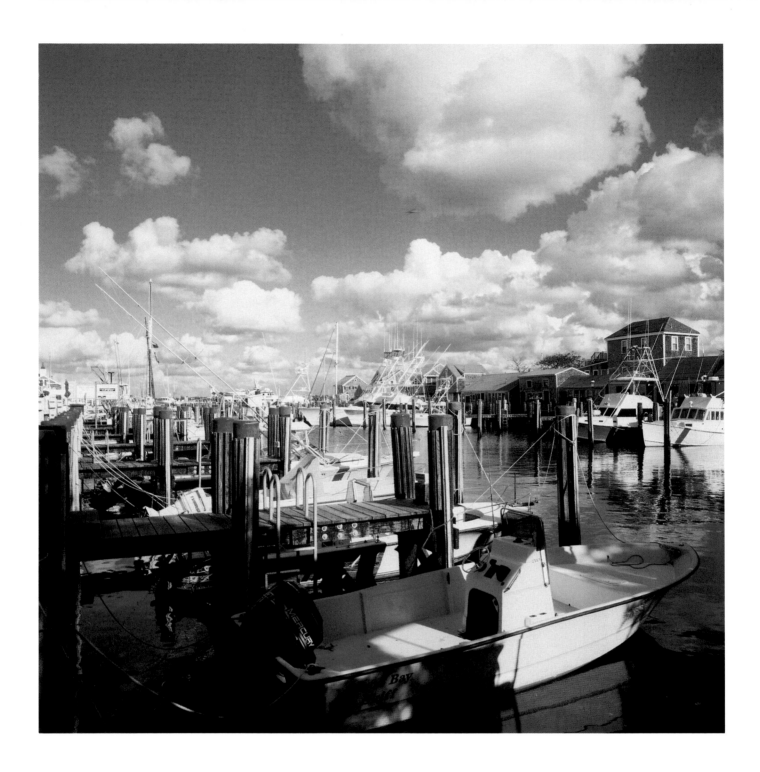

earners often worked seven-day weeks. Except for the very wealthy who owned country estates, vacations were an unimaginable luxury. By contrast, the 1870s was a period of strong economic growth, with industrial production and mechanized farming creating a new middle class that had both the time and resources to vacation.

Recognizing the potential of this trend, Nantucketers allocated substantial capital for building specially designed vacation hotels. These early resorts featured large dining rooms with a wide array of menu choices, wines, and spirits, and spacious public rooms for dances, fetes, and meetings. Tourism soon became the island's primary summer business.

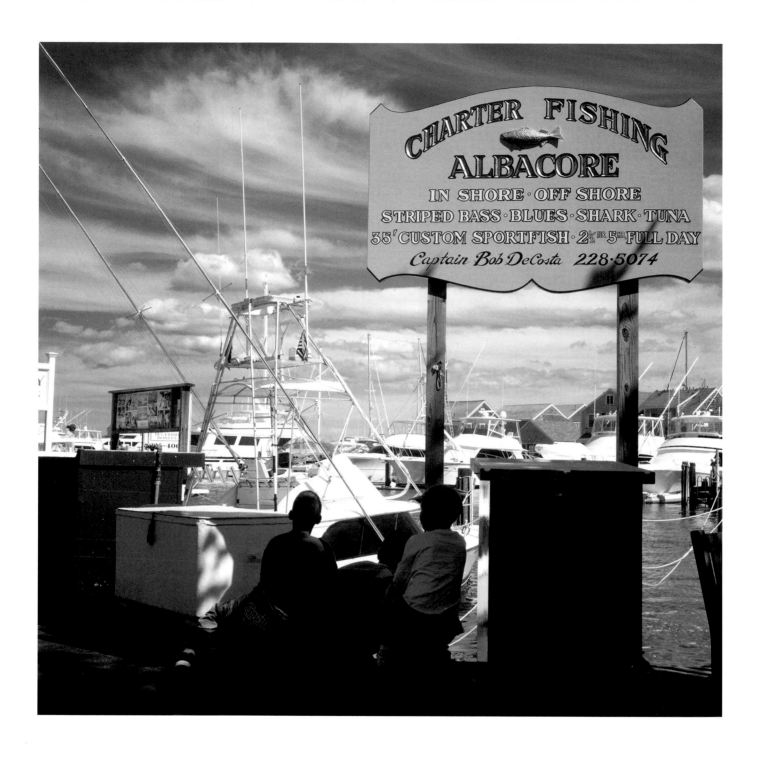

The notion of sailing for pleasure and fishing for recreation is fairly recent. In the nineteenth century, commercial fishing boats dominated the harbor. Large catboats such as the *Lilian*, which ran daily excursions to the Wauwinet house, were moored in the area called Catboat Basin. No one bathed at Children's Beach, and ironically, the Nantucket Athletic Club offered no outside activities at all. In 1920, however, the latter facility reorganized as the Nantucket Yacht Club, and the popularity of sailing, tennis, and swimming grew rapidly. Commercial fishing and agriculture—the island's former primary industries—became secondary.

Today there are eight charter fishing boats operating out of the harbor, seeking primarily bluefish and striped bass, but also tuna and sharks further offshore. The *Albacore*, a thirty-five-foot, custom-built sport fisherman, is the oldest family-run vessel in Nantucket and sails all summer long. Additional fishing charters operate during the summer months out of Madaket.

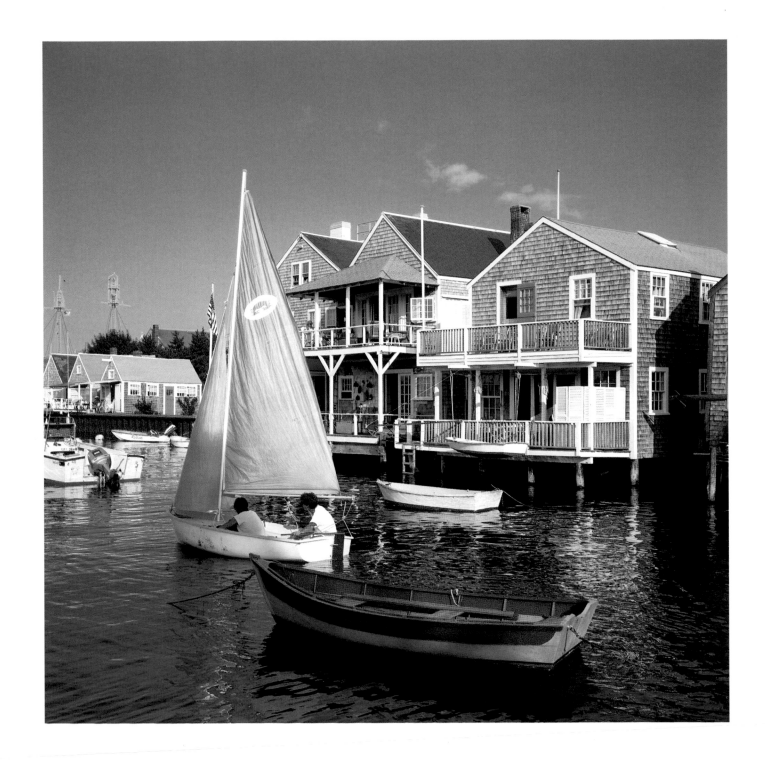

Old North Wharf, built in 1774. Of the five wharves and the town pier, Old North Wharf is the only one that is entirely residential. The section shown here was called Burdett's Wharf at the turn of the last century. Many of these lofts date from the 1850s. A twelve-foot fiberglass dinghy navigates the waters of Easy Street Basin, one of the most picturesque spots of the harbor.

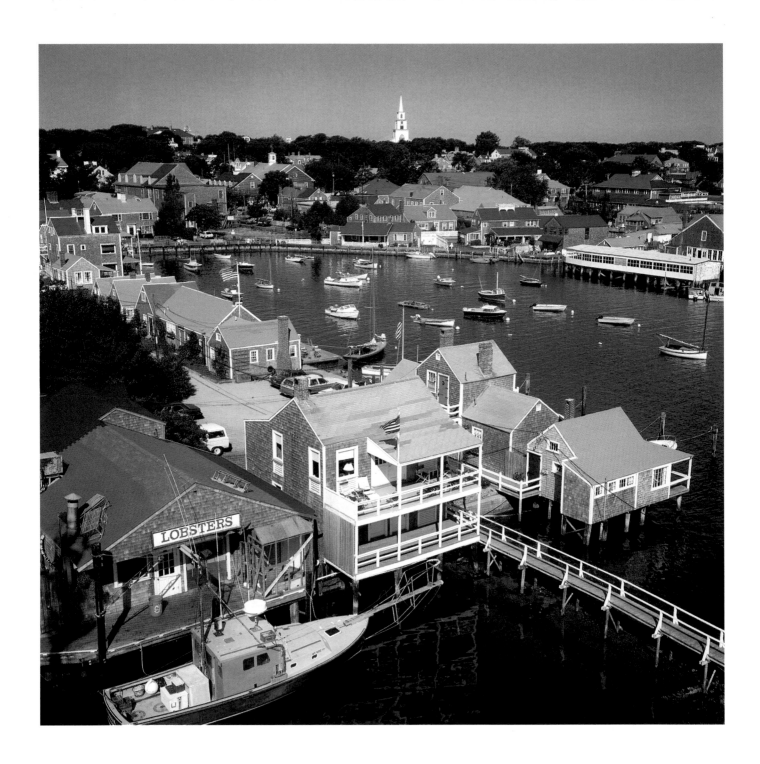

This view of North Wharf and Easy Street Basin was taken from the crow's nest of the *Nantucket* lightship when she was a fixture in the harbor. To the right is the Skipper Restaurant, which originated in 1921 when a tired schooner, the *Allen B. Gurney*, made her last trip to the island. Gladys Wood transformed the old boat into a tearoom, which prospered for over seventy years. Thrifty as always, islanders used the schooner's mast in restoring a favorite island attraction, the Old Mill. For many years, it was the mill top's tail.

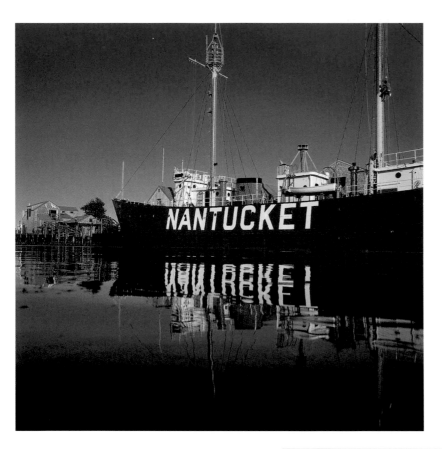

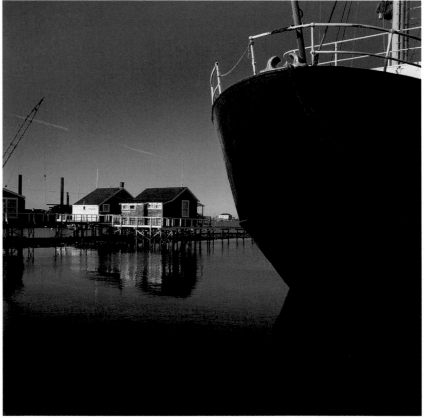

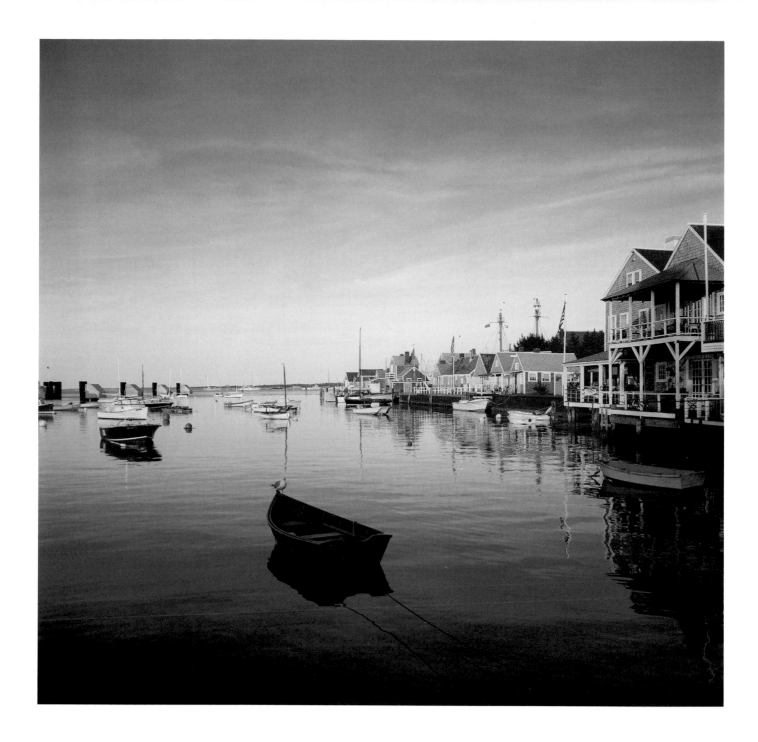

The *Nantucket* lightship, Old North Wharf cottages on stilts, and Easy Street Basin. The basin was originally called Catboat Basin after the many fishing catboats that tied up here. It was so important a fixture that when the railroad was put into service, the tracks went around the basin from Steamboat Wharf rather than cutting across it. The view of the harbor has changed little over the years, although North Wharf once extended further out and to the left. At low tide, the original foundation is still clearly visible. The tide at this location varies from that of Great Point by almost an hour, generally rising and falling twelve inches according to the lunar day (twenty-four hours and fifty minutes).

This is a gentle spot, a view framed by lofts and boathouses, with dories and sailboats bobbing in the water. The wharves reach out to embrace the scene, with the vast harbor stretching beyond. It is a place to sit and watch the sunlight's changing patterns from dawn until dusk, a place to rest one's back easily against Main Street's bustling activities.

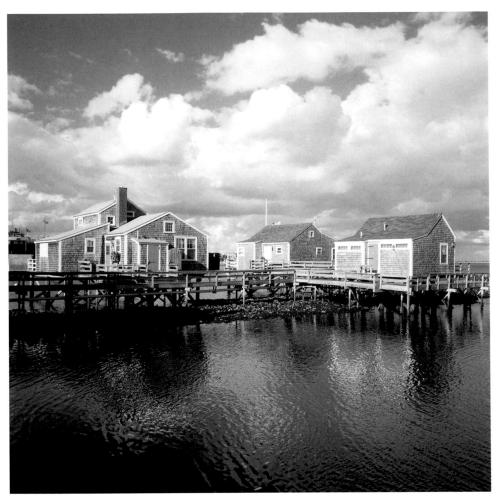

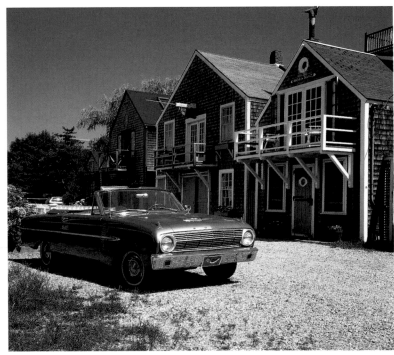

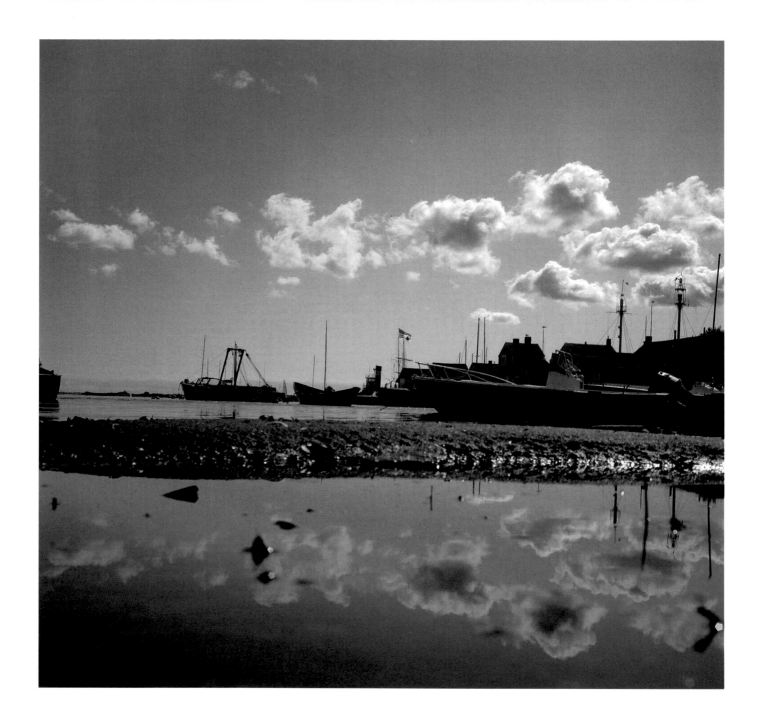

Old North Wharf. This is Nantucket's second oldest wharf and, as was the pattern, it was privately owned. It was built as an extension of Cambridge Street in 1750 by the Coffin family. As with Straight Wharf, there were over thirty shareholders who ran fishing businesses on here. It was designated a historic district in 1955.

The fire of 1846 also affected this wharf as it did Straight Wharf. It was rebuilt, but not to its original length, the old original foundation of which is clearly visible at low tide.

In 1872, the wharf was purchased by Captain Barzillai Burdett, who ran a shuttle catboat called the *Dauntless* to the Cliff Bathing Beach. This catboat was also referred to as the "Star Boat" because of the red star that appeared on its flag. In 1946, the Sanford family bought the wharf and eight cottages from Richard Everett, a descendent of the Coffin family. Many of the structures were sold to individuals for residential use, and the wharf officially entered the private way status it enjoys today. Parked in front of some of the lofts is a 1962 Ford Falcon convertible—one family's land-based sailboat.

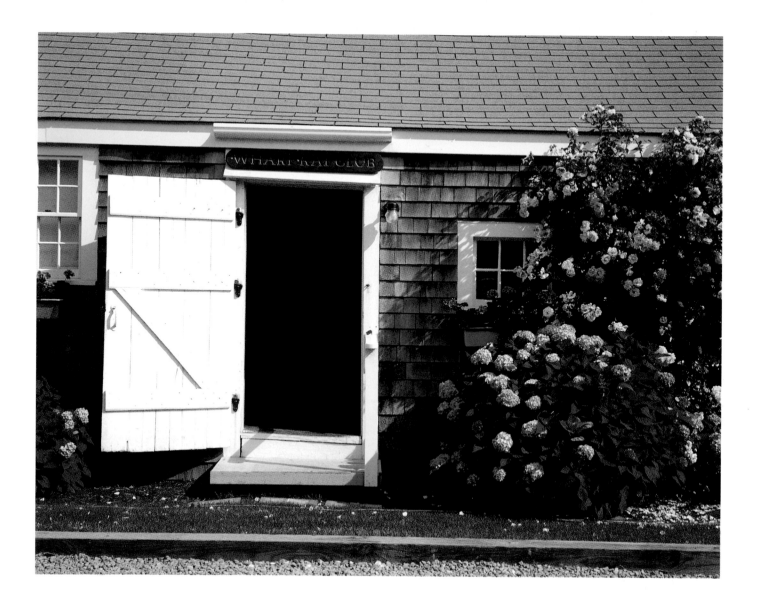

The houses and lofts on Old North Wharf are a weathered blend of the old and the very old. They have evolved from boat shops, fishing shacks, and sail lofts. Most of the structures are named after whaleships owned by Jared Coffin ("Independence," "Constitution," "Lydia," "Mary Slade," "Jared Coffin," and "Charles and Henry").

In early 1900s, North Wharf was used as a landing point for the island's thriving quahog-fishing business. Hundreds of bushels were culled and prepared each day for shipping to the mainland. Gene Perry and Herb Coffin rented a shanty for this activity, and the fishermen gathered around, swapping stories and referring to each other as wharf rats. When the quahog beds dried up, other fishing activity took over, and Perry and Coffin began selling fishermen's clothing. A bench was placed on one side of the shop, a stove provided heat on the cold, wet days, and the gams (slang for whalers' social visits) flowed. A log book began in 1927, marking the formal organization of the Wharf Rat Club.

Tony Sarg was a member in the 1930s and was responsible for designing the familiar burgee: a reclining rat smoking a pipe. He was an artist, puppeteer, and author from New York City who summered on Nantucket with his family from 1922 to 1942. He ran his own gift shop and also designed posters and fliers to help fund-raising events. In addition, Sarg is credited with creating, in 1927, the very first large-sized balloon (it was of Felix the Cat) for Macy's Thanksgiving Day Parade.

The Wharf Rat Club has no bylaws, dues, or membership hierarchy. Presently there are about 175 members, men and women. The only prerequisite for membership is the ability to tell good stories; once that has been established, an anonymous "committee" may extend an invitation to join.

Originally, the clubhouse as well as its companions, "Lydia," "Independence," and "Constitution," were all located on the south side of the wharf.

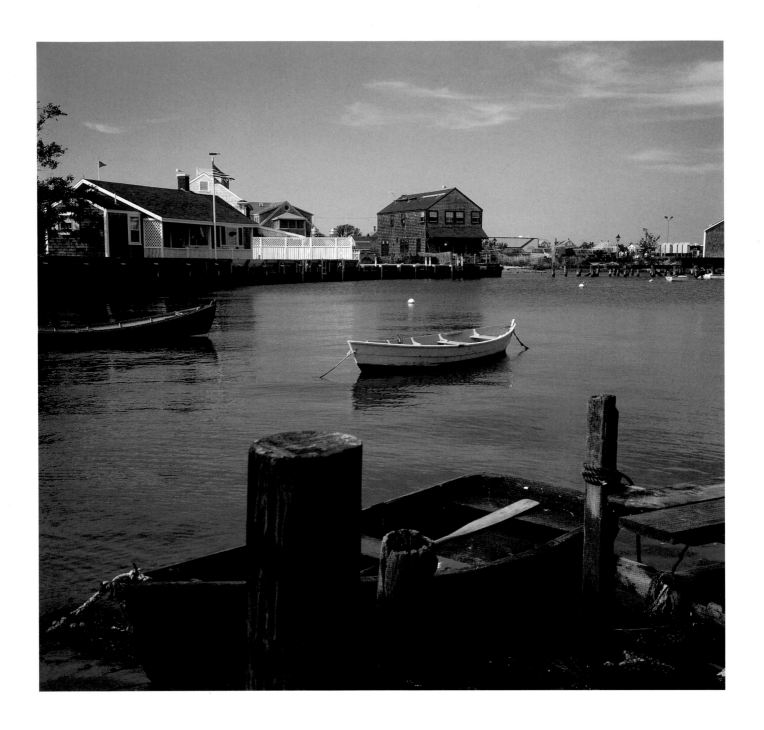

Easy Street Basin and the Wharf Rat Club. Nantucket's five wharves, all built between 1723 and 1816, were all planned as extensions of the island's main streets, integrating the shipping commerce with the town. All year long, the whaling ships were a dominant presence at the wharves, as were the blacksmith shops, warehouses, and outfitters. Those areas were busy, odorous and burly—a far cry from the tranquility of today. Even as the whaling industry ended, the commerce remained, with coal sheds, ice houses, and a granary taking the place of whaling-oriented businesses. At the turn of the last century, the wharves still bustled with steamer and train traffic (accompanied by plumes of smoke and cinders). Railroad service to Surfside began in 1881 with an engine named Dionis (after the wife of Tristram Coffin) and two open passenger cars purchased from the Danville, Olney and Ohio River Railroad in Illinois. Train service continued intermittently until 1917. Significant credit for the transformation to what we now see on the harbor front goes to the foresight of Walter Beinecke and Sherburne Associates, who dramatically changed the wharves and harbor front beginning in 1964.

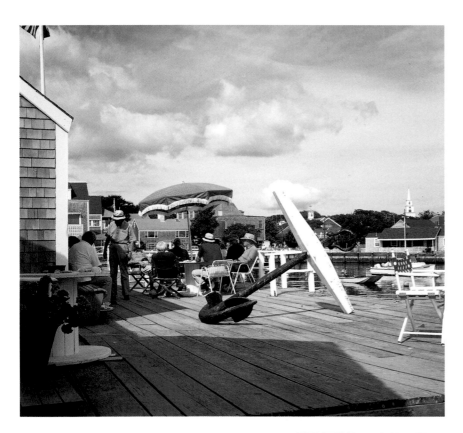

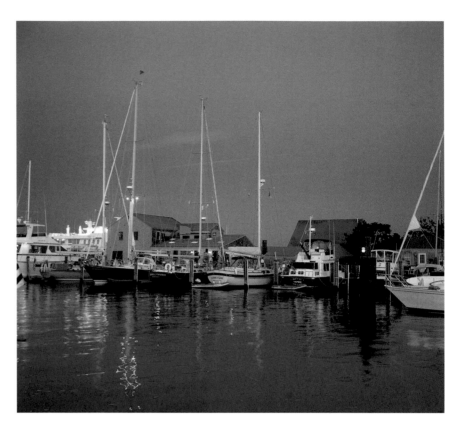

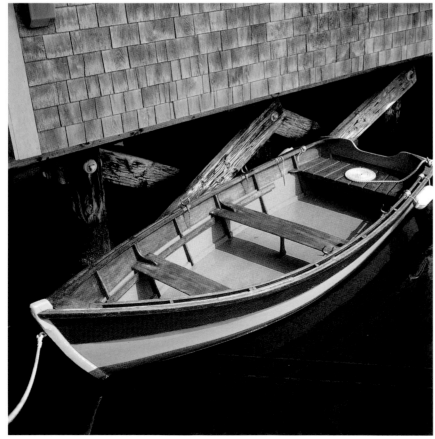

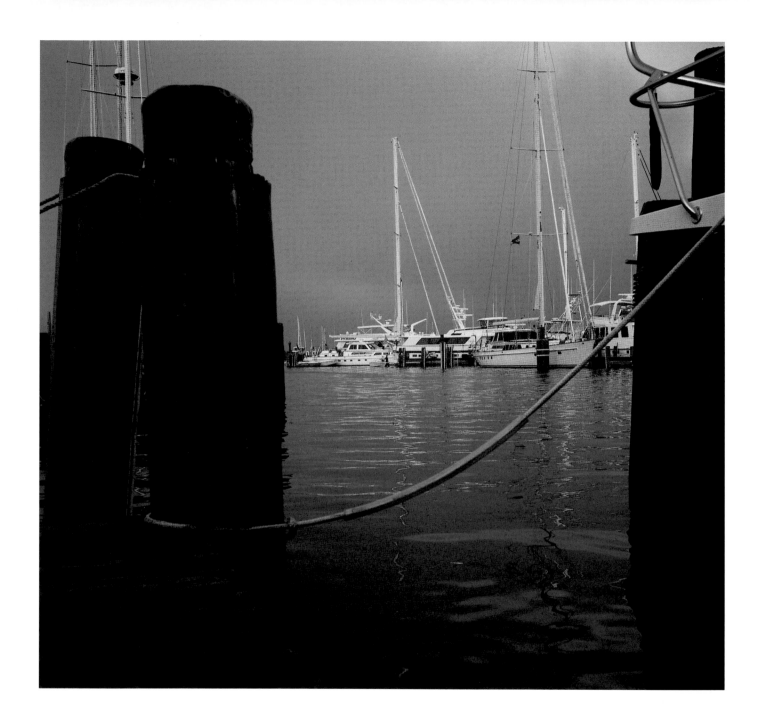

Sailboats, motor yachts, and a rowing skiff at the Boat Basin. The views are from Old South Wharf looking to inner Swain's Wharf (*opposite, top*) and outer Swain's Wharf (*above*). The large sailing vessel is fifty-eight feet long and is sloop-rigged.

The Boat Basin shelters a flock of pleasure boats. It is difficult to say when people began sailing purely for the fun of it, but Charles II played a part by introducing the Dutch *yaght* to England. It was a small, fast boat, originally designed in the Netherlands for a variety of purposes, including recreation. The first yacht club in England was established in 1775.

Adrian Block's *Onrust* may be considered the first *yaght schip* built in America (1614). It took the Dutch explorer back to his home via Block Island. America's first yacht club, the New York Yacht Club, was organized in 1844, and the Nantucket Yacht Club in 1890. Yachts as we know them today—sleek-hulled sailing craft known for both speed and grace—owe much to Commodore John Stevens of the New York Yacht Club and his brother Robert, who applied mathematical and scientific principles to yacht design.

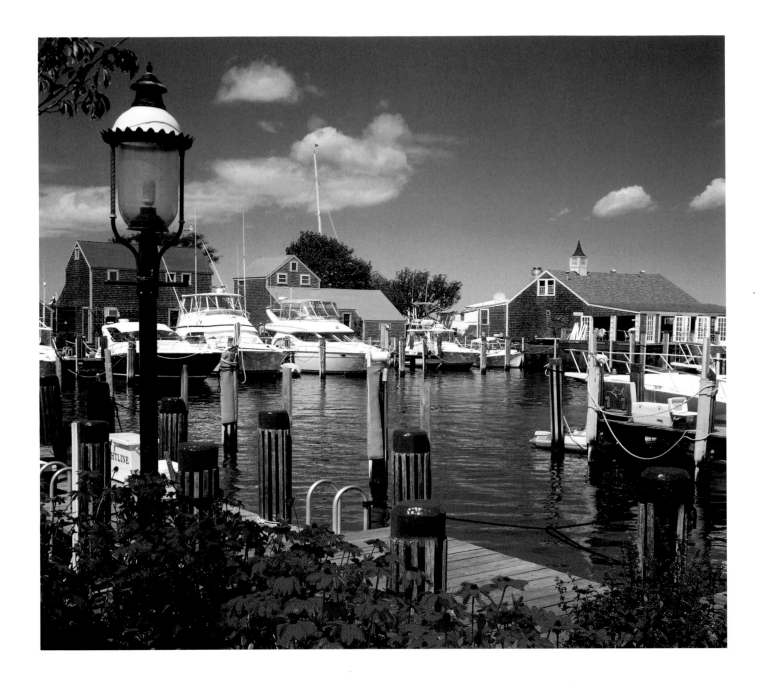

Shown in the photographs are (*above*) cruisers, sport fishermen, and motor yachts, (*opposite, top*) a large, sixty-eight-foot Burger yacht with traditional lines at the left of the photograph, and a small fishing boat with a canvas canopy followed by a row of sailboats. This view is from the head, or innermost section of Swain's Wharf, looking east to seaward. *Opposite, bottom:* Here is a collection of sport fishing and cruising yachts ranging in length from forty-six to fifty-eight feet. This is the north side of Old South Wharf looking south-southeast with the old granary building in the background. The wood-and-grain storage facility is the last remaining structure of the Island Service Company.

The Nantucket Boat Basin is among the foremost ports of call for "megayachts" on the East Coast. There are more than two dozen yachts over sixty-five feet long, and at least ten over 110 feet, anchored here on the typical summer evening. The annual Broward Rendezvous in the basin attracts boats ranging from 72 to 130 feet in length. Broward is among the most sought-after boat builders, manufacturing approximately eight yachts a year.

Most sport fishing motor yachts moored in Nantucket during the summer range from forty-eight to sixty-one feet. They are used for game fishing locally (blue marlin and swordfish, along with bluefish off Great Point). In the winter, most migrate to Florida. Whatever the venue, the pleasure of socializing with congenial neighbors at the mooring enhances the satisfaction of the sporting side of the day.

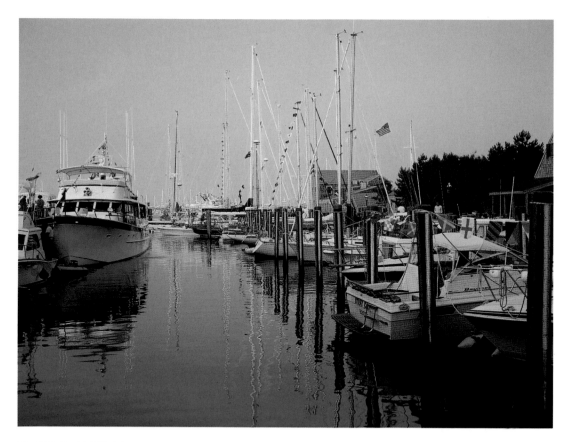

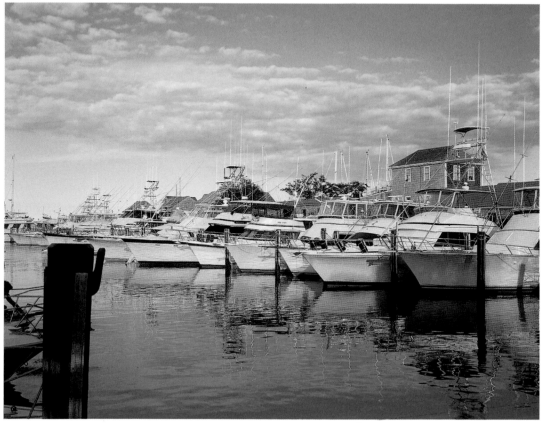

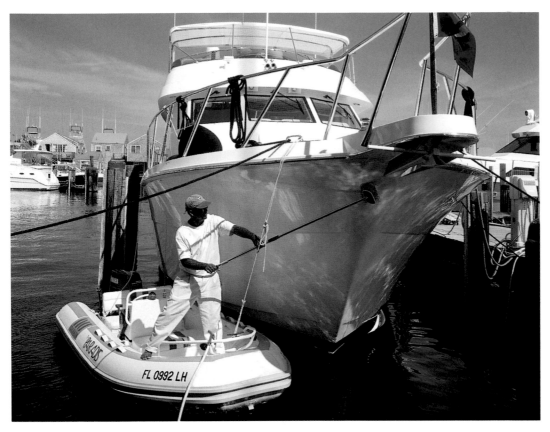

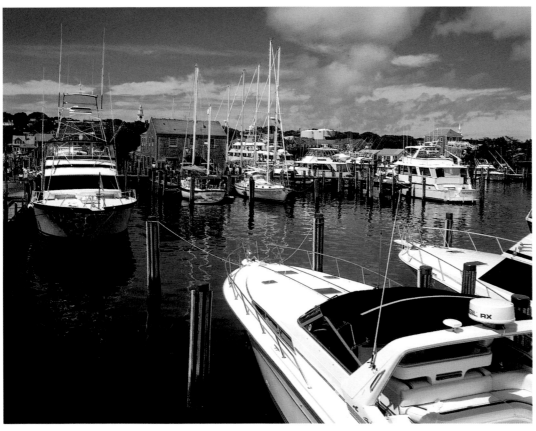

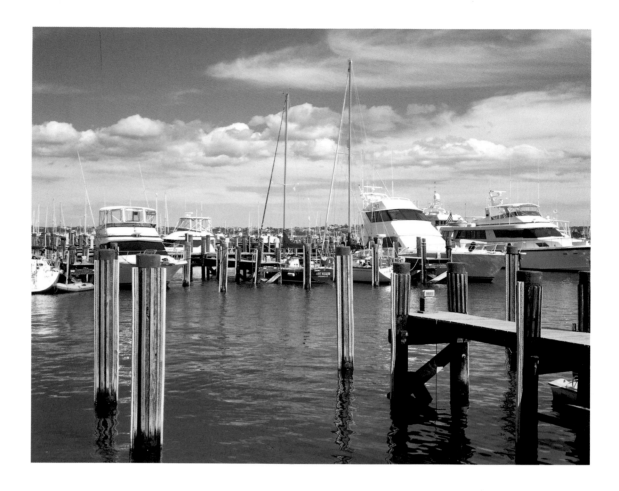

Opposite, top: A top-of-the-line seventy-five-foot Hatteras Cockpit Motor Yacht, which has a top speed of twenty-two knots and can cruise for twelve hours before refueling. Regular cleaning is required to keep the damage from salt spray to a minimum. Cleaning below the water line helps to help maintain top speed and fuel efficiency, and also keeps the crews of the compulsive owners busy. *Opposite, bottom*: An express cruiser in the foreground with, left to right, a sport fisherman, two sailboats, and a medium-sized motor yacht.

Above: Two sloop-rigged sailboats tied up at Straight Wharf, flanked by sport fishermen. A large motor yacht with a flying bridge is at the right of the photograph.

There are many types of powerboats, including fishing boats and sport fishermen. The latter have large, rear-facing swivel chairs and often "tuna towers." These towers are used for spotting the fish and even controlling the boat. Long poles such as outriggers help in the trolling process. Sport fishing has become most popular in recent years, but as American waters become increasingly fished out, many people are rejecting the sport and turning to motor yachts, which also can be more family-friendly with larger decks and living quarters.

Nantucket is one of the premier ports of call for large motor yachts (over sixty feet long) and megayachts (over one hundred feet). It is one of the few marinas that can accommodate their size and needs, also offering plenty of upscale amenities within an easy reach. The megayachts traditionally have a classic look,

somewhat boxy but nevertheless elegant. Increasing in popularity these days is the swept-back, ultra-modern "Eurostyle" design.

Large yachts—at first sailing yachts, and then steam- and diesel-powered—have been popular with the wealthy and powerful since the turn of the last century. The Vanderbilts, Morgans, Astors, and Dodges all tried to outdo each other with ever-larger, ever-grander yachts. The largest private yacht ever built was Emily Roebling Cadwallader's *Savarona III*, launched in 1930 at a length of an unbelievable 408 feet. One of history's most opulent sailing yachts is Marjorie Merriwether Post's *Sea Cloud*, which was christened in 1931 and is still sailing today.

This was an era of grand yachts appointed in a style suggestive of the Palace of Versailles. It was the age of the Baron and the Banker. Manners, breeding, taste, and money mattered, leading J. P. Morgan to observe, "You can do business with anyone, but you can only sail with a gentleman."

If World War I put a damper on the big yacht scene, the Great Depression and World War II killed it completely for three decades. The yachts gradually began to reappear in the 1970s and 1980s, with a boom in megayachts resuming in the 1990s.

The megayachts have become status symbols as well as floating entertainment centers. One of the key developments making this possible for the advent of satellite communication, allowing busy executives to conduct business wherever they may be cruising.

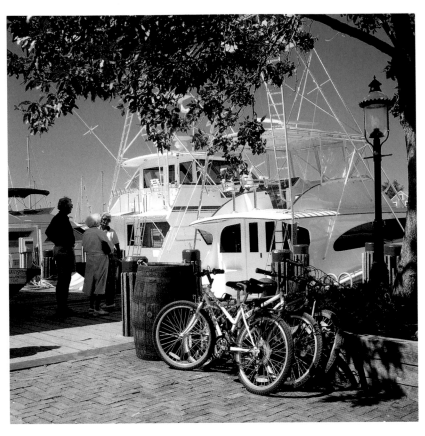

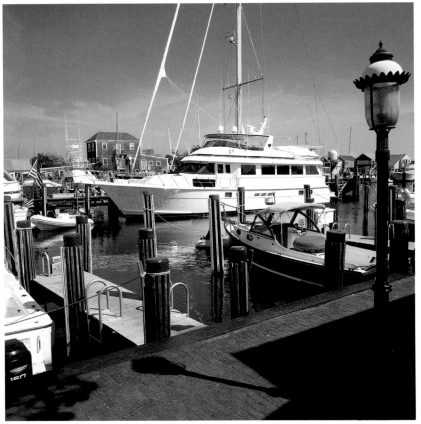

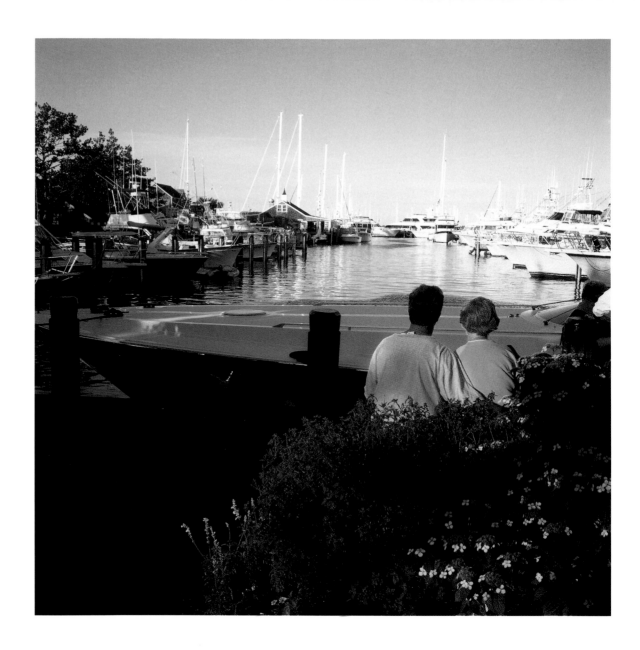

Opposite, top: A pair of sport fishing boats at Old South Wharf, back from the day's cruise with trail bikes waiting to take everyone into town. The boat on the left is a fifty-eight-foot Garlington, and the one on the right is a sixty-five-foot Hatteras.

Opposite, bottom: The large megayacht tied up in Tanker Dock is a seventy-foot Hatteras motor yacht with traditional styling. In the foreground is a twenty-four-foot Wasque, made in Martha's Vineyard and used for cruising, fishing, and as a picnic boat.

Above: Rows of power cruisers and sport fishermen line the Straight Wharf and South Wharf piers. The hull of a large express cruiser appears in the foreground. Behind the couple are the familiar lacecap hydrangeas. The crossing of Whale and Main Streets is the place where town and harbor merge—a spot where artists and others can simply sit and "watch the pass." Now as before, the Boat Basin at the edge of town is an area bustling with activity, although tourists and shoppers have replaced the deck hands and merchants of the 1800s.

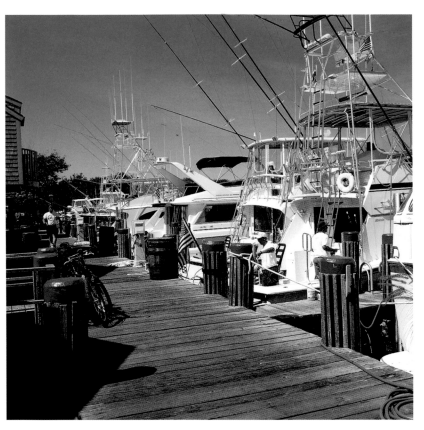

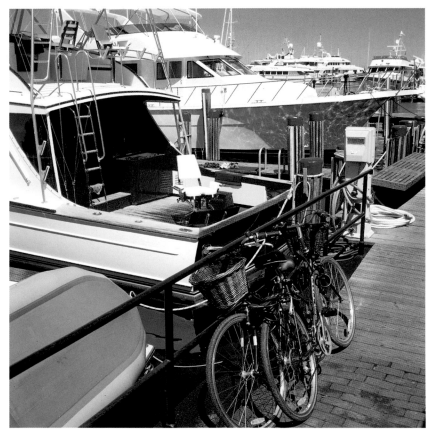

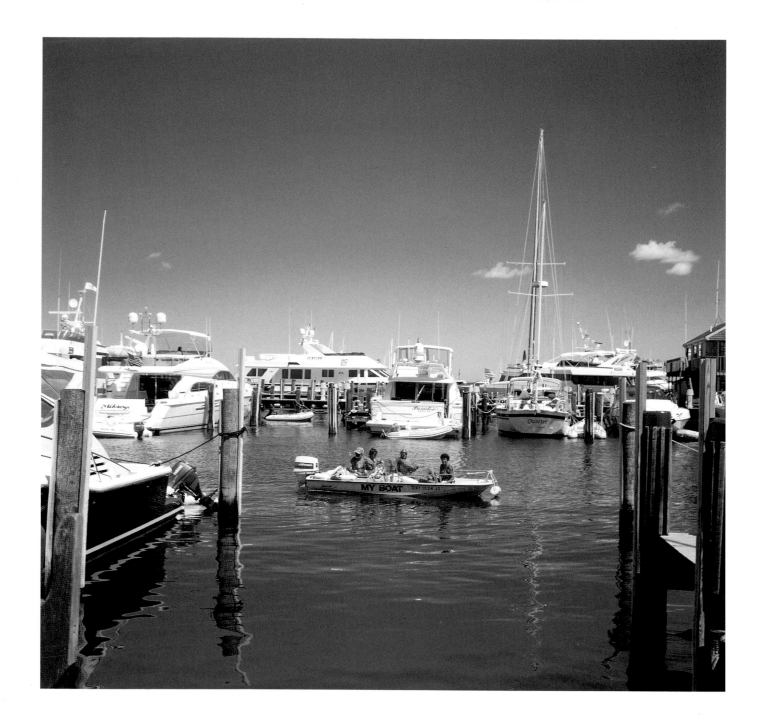

Opposite, top: A collection of cruising motor yachts with enclosed salons, and sport fisherman boats like the beautiful Hatteras, with the life ring on its starboard side. The fourth from the front has an aft-raked radar arch. Like many yachts of this class, it has a flying bridge with controls both there as well as in the pilot house. The smaller motor yachts generally have only one helm station.

Opposite, bottom: The teak-lined cockpit of a Merritt sport fisherman, with its fishing or fighting chair. Beyond it are large motor yachts with traditional styling. This view is from Swain's Wharf looking northeast.

Above: Sailors have all manner of craft with which to enjoy the day. In the background are (*left to right*) a modern, "Euro-style" motor yacht, a cockpit motor yacht, and a sailboat. In the far background is the profile of a large, traditional motor yacht.

The Nantucket Boat Basin was built between 1967 and 1969. It currently has 242 slips and accommodates yachts ranging from 19 to 285 feet, with the average craft being 42 feet long. Most visitors tie up for two to four nights. In the off-season, local fishing and scalloping boats are the Basin's occupants.

Graceful masts cast shimmering reflections in harbor waters at dawn and dusk. *Opposite*: A row of Marconi sloop-rigged sailboats. *Above*: Sailboats and a pair of motor yachts tied up at Straight Wharf.

However tranquil the scene may appear in these photographs, there is always plenty of activity in the marina. Nantucket has five long wharves, each reaching more than three hundred feet into the harbor. In earlier years, tied up to their sides or anchored further out were up to twenty whaleships either unloading or being fitted out for the next voyage. Around them scurried the many sloops and schooners that brought food, supplies, and passengers to the island or were also engaged in fishing. The wharves was full of sailors, stevedores, and artisans—not to mention the horse-drawn carts moving everything about—bustling up to the factories and shops, and back down to the ships. Nantucket's prosperity was solely tied to this industry, and the wharves served as its epicenter. During the summertime today, the harbor is just as busy, although the fitting out for the day's sail is somewhat less involved.

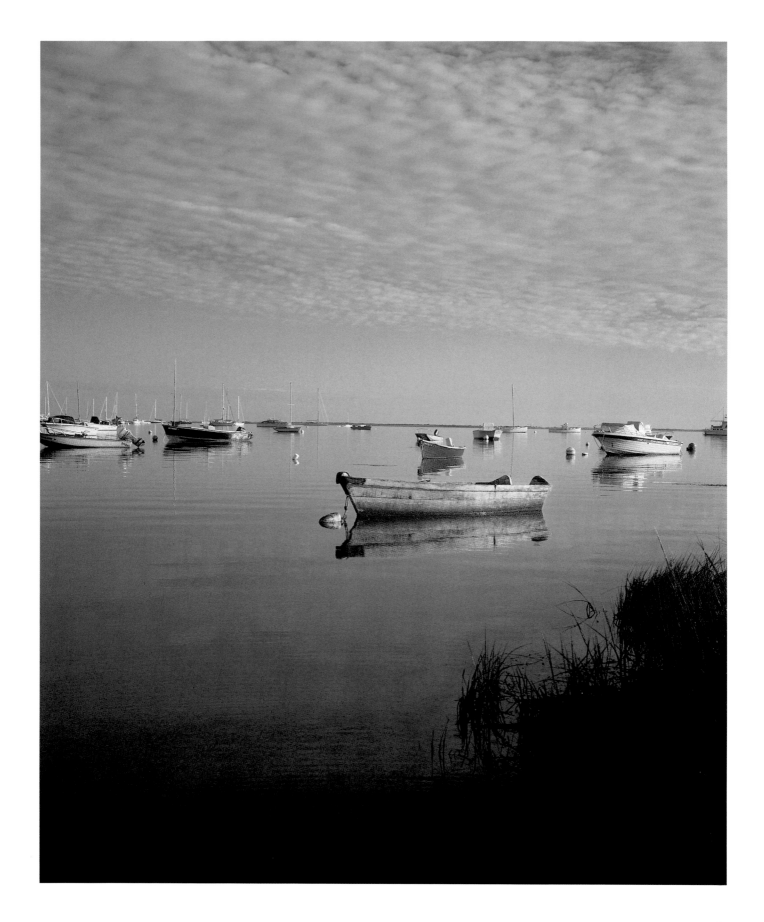

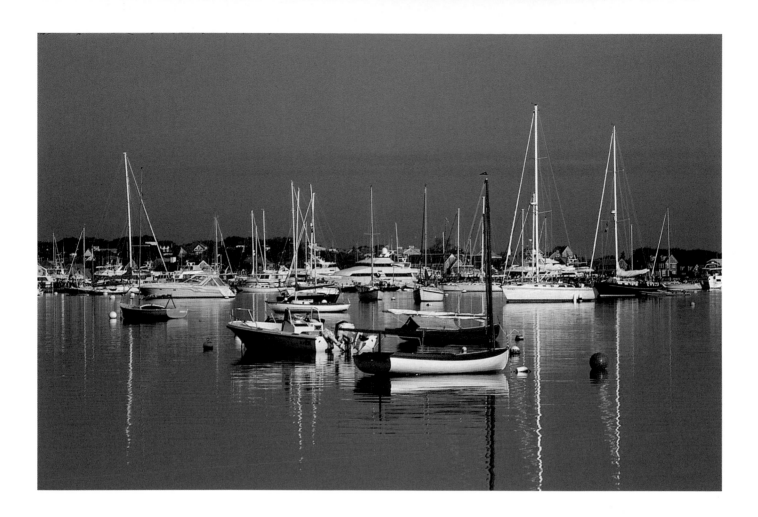

A gathering of small pleasure craft off Monomoy. Dories, whose high, flared sides and V-shaped transoms give them stability in rough seas, have long been popular in New England. The word *dori* is derived from the word for dugout used by natives of the Central American Mosquito Coast. Such craft are also known as *dinghies*, a word of Bengali origin; the little boats were popular along the coasts of India as well.

In the first part of the nineteenth century, Monomoy was far less placid. A device called a "camel" was invented to transport increasingly large whaleships (which had a deep draw) over the sandbar building up across the channel that led to the harbor. The camels were sunk low enough for the vessel to pass over the chains joining them. When the water in the camels' storage tanks was emptied by steam power, the floating system could support 800 tons and cause them to draw only seven feet. It is thought that the term *camel* derives from the Middle Eastern practice of placing a load too heavy for one camel between two animals and letting the burden be supported from their sides. Nantucket's camels were last used in 1849.

The Nantucket Yacht Club. This was organized in 1890 as the Nantucket Athletic Club. A large clubhouse was built in 1904, containing facilities for all activities popular at the time: bowling, billiards, and cards. Recreation was different then. There were no golf courses, tennis courts, or sailing clubs on Nantucket. There were not even sports clothes; everything was conducted in business suits for men, and floor-length dresses for women. Sailing was for commerce, not sport, although catboats could be hired for picnic excursions. Most vacation time was spent reading, writing letters, playing cards, or rocking on the wide verandas of the new hotels. Nantucketers had not yet really learned to play.

In 1908 the Athletic Club added a gymnasium which was occupied by the Naval Reserve during World War I. The facilities

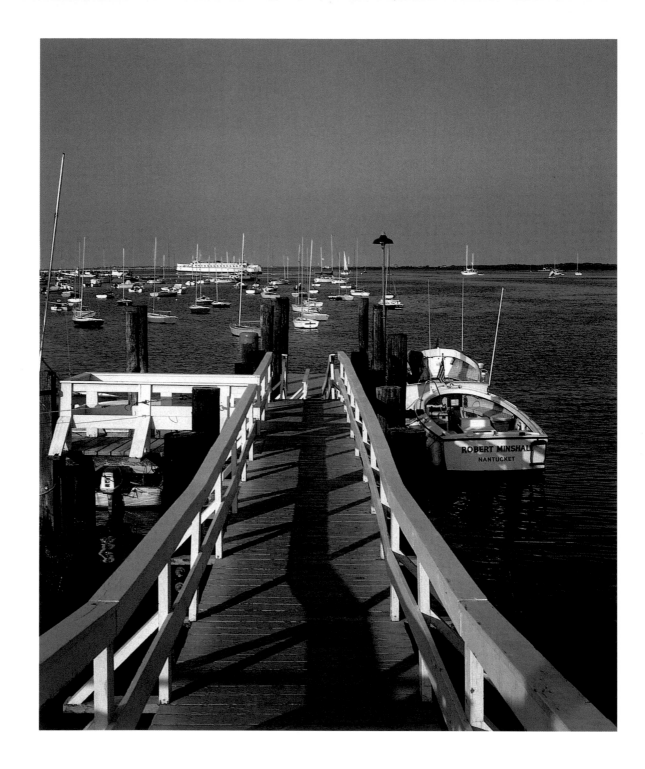

were subsequently acquired by the Nantucket Yacht Club, organized in 1920 by a group of Hulbert Avenue residents.

Above: Shown in this 1982 photograph is the club's floating dock and, in the distance, the "steamer" *SS Uncatena* passing out to sea. The *Uncatena* was one of the least admired of the recent ferries, and its retirement was a joyous occasion. The launches are the *Robert Minshal*, a twenty-five-foot Fortier, and the *Alert*, a twenty-nine-foot Dyer (in front). Both shuttle members of the Yacht Club to and from their boats in the anchorage.

The floating docks rise and fall about four feet with the tide and were underwater (as was the clubhouse) during the 1991 no-name storm, which has since become known as the "Perfect Storm."

Off for tennis practice at the Nantucket Yacht Club, while patio guests are serenaded by the piano player. We assume these two mainstays of family life, tennis and piano, have been around forever. In fact, tennis was only introduced to the U.S. in 1874 from England, and to Nantucket after World War I.

Modern tennis dates from 1874, when the first courts were built in England. A few months later, Staten Island and Newport built courts of their own. The first championship was played in 1877 at Wimbledon; Dwight Davis offered a cup for men's tennis in 1900, and the Wightman cup for women was first played in 1923.

Given the island's Quaker heritage, pianos were largely unknown here until the 1830s. The first one imported was Captain Seth Pinkham's in 1831. The William Crosbys had a Chickering

grand piano at their One Pleasant Street home in 1837. And then there was the astronomer Maria Mitchell, who, as a child, conspired with her sister to buy a piano and keep it in a neighboring building, where the sister could practice in secret. Eventually they decided to move it into their house and arranged for their parents to be out one afternoon. When the parents returned, Mrs. Mitchell, the proper Quaker, was scandalized. But the more relaxed Professor Mitchell decided to let it stay. The Overseers of the Pacific Bank, where he was its treasurer, sent a committee to investigate. He reasoned with the committee members that since the bank owned the mortgage for the Meeting House, any sanction against a piano in a Quaker home would be improper. That seemed to satisfy the committee, and the piano stayed in the Quaker household.

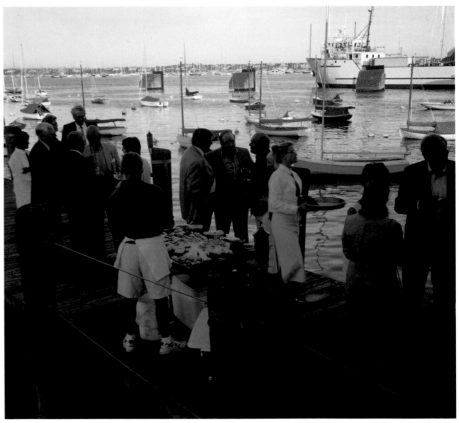

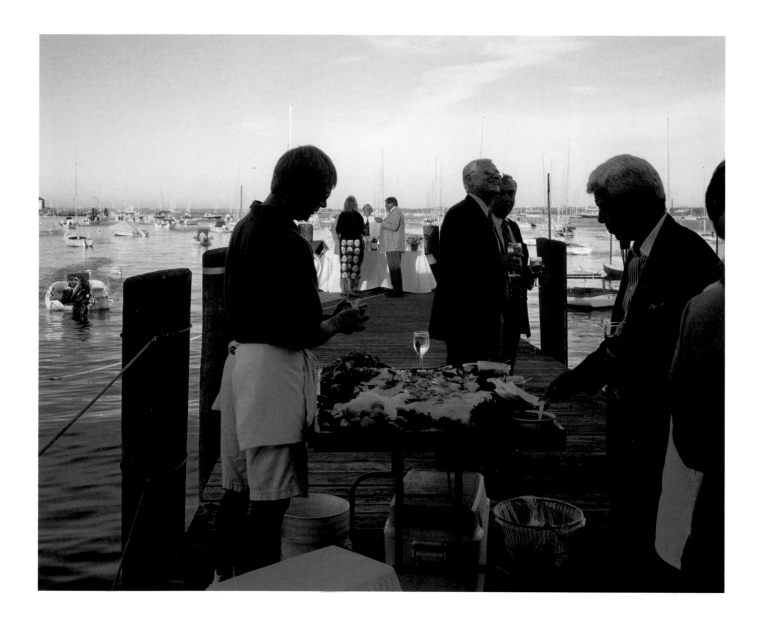

A private party at the Nantucket Yacht Club's "Boat House" with a raw bar of clams, oysters, and shrimp. The Boat House was built as a private residence by William Wallace in 1915. The Steamship Authority's freight boat, *Sankaty*, is tied up in the distance.

Shellfish are aquatic animals with protective shells. One major category of shellfish is the crustaceans (lobsters, crabs, shrimp) with segmented bodies. Mollusks, another type of shellfish, have soft, non-segmented bodies enclosed in a calcium compound shell. If the shell consists of two parts and is hinged, it is a bivalve. Popular bivalves include oysters, scallops, and clams. Quahog clams are harvested in shallow bays and classified by size. The smallest and most desirable are littlenecks—usually eaten raw or on the half-shell. Larger quahogs are cherrystones. These can be eaten raw, but are also used in chowders and stuffings. The larger the clam, the tougher it is, and the greater is the likelihood that it will be thrown into a chowder.

Longnecks are generally called steamers, after the typical method used to prepare them. They live about five inches below the surface of tidal flats and are harvested with clam rakes or hoes. Since they are often sandy when freshly dug, it is best to soak them for a few days. They can live for brief periods in fresh water.

Scallops are now the most popular bivalves for eating. Small, tasty bay scallops are at their peak in the fall and are harvested until March.

Oysters round out the list of bivalves that are widely consumed. They have an unusual quality of absorbing the flavor of their environment, and experts can generally tell where an oyster comes from by its distinctive taste. For example, Wellfleet oysters have a sharp, briny flavor owing to the high tides and rapid currents that regularly flush the harbor there and bring in fresh supplies of plankton. There is an oyster variety to please every taste.

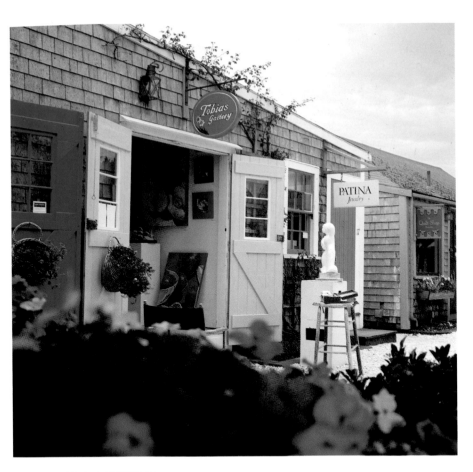

Old South Wharf is Nantucket's third oldest wharf, completed in 1760. Along with Straight Wharf, this one was always active in the loading, unloading, and fitting of whaleships. Many of the shanties on the wharf today attest to this heritage. Since it was unaffected by the Great Fire, Old South Wharf was Nantucket's principal pier for several years while Steamboat, Old North, and Straight Wharves were being rebuilt.

During the late 1800s, when whaling had ceased functioning as a viable industry, South Wharf became a general business wharf and public dock. Among the numerous shops were six blacksmith foundries, a sail loft, lumber yard, and rope walk. In 1910, Nantucket's second ice plant began operations here under the auspices of William T. Swain, whose family owned the

wharf at the time. After the First World War, Henry Lang, president of the Island Service Company, which was a general supplier of fuel, ice and lumber, purchased the wharf from the Swain family. Among several other changes was the installation of the island's largest coal pocket. The wharf became known as Island Service Wharf.

In 1964, Sherburne Associates purchased the wharf from the family and began a dramatic alteration. The existing shanties and a granary were moved to the A&P parking lot to protect them from demolition while the wharf was refurbished as part of the 1967 marina project. South Wharf then returned with a new "old" look, incorporated into what was now to be an artists' wharf. White shells and mature trees were added, giving the wharf the appearance of a country lane flanked by galleries. Structures were added at the head of the wharf, including the A&P market and the Anglers' Club

building. But for the yachts bobbing in their slips on either side, one would not think this was a wharf at all. It was a brilliant transformation by Sherburne from an industrial and commercial site to a quaint collection of galleries that invite a leisurely perambulation.

Robert Perrin opened the first gallery on Old South Wharf in 1959 and had regular Thursday evening "openings" with cocktails. This drew customers down to the wharf every time. With the refurbishment, which was completed in 1968, the wharf now has twenty shanties that are galleries, plus a few shops. The only wharf that does not allow cars, Old South offers a peaceful spot to stroll and presents a unique collection of artist-operated showrooms.

Willi Tobias does sculpture, often working right outside her gallery (*opposite, top*). She also exhibits watercolors by other artists.

Downtown

Morning on Main Street. This section is historically referred to as Main Street Square. The broad, handsome avenue, called State Street until the early 1800s, was laid out in 1697. In an unusual example of New England urban planning, Richard Macy built Straight Wharf in 1723 as an extension of Main Street, providing whaleships with direct access to shops, services, and fitters. The cobblestones, transported from the mainland as whaleship ballast, were laid beginning in 1831. The paving enabled heavy carts to move up to stores more easily. The elms on Lower Main Street are among the most spectacular in all of New England.

Side by side are two pharmacies, amiable companions for many years. Congdon's was actually established in 1860 while its neighbor, the Nantucket Pharmacy, opened in 1936 and was known as Mac's (after its owner, David McMillan). Congdon's has remained basically unchanged since 1860, with its soda fountain and free-standing stools intact—unlike Nantucket Pharmacy's 1936 stools, which revolve. Both stores have been friendly competitors over the years, with clientele loyal to each. There is a lot of back-and-forth; some customers prefer one pharmacy's lunch counter and the other's prescription counter. The lunch menus have changed very little over the years. Customers can still get a vanilla Coke or a frappe.

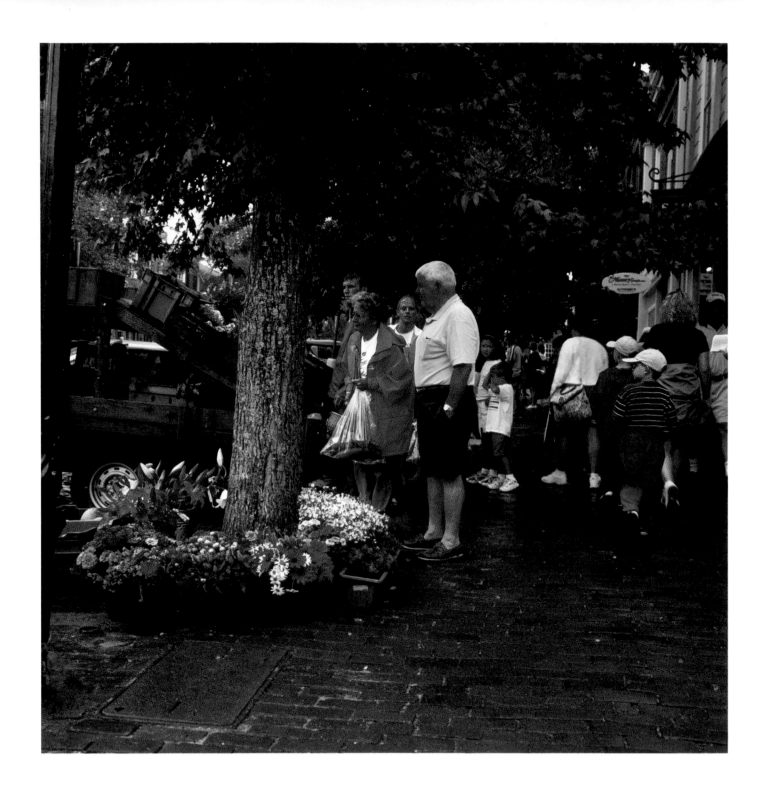

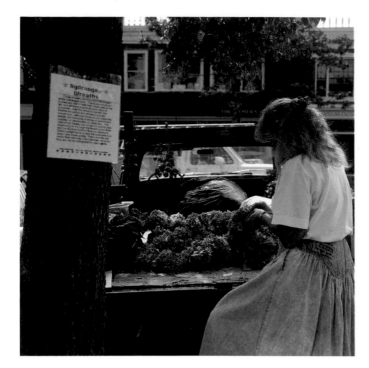

Flowers and vegetables for sale on Main Street. The Bartlett Farm, in the same family for seven generations, is the island's largest farm, with one hundred acres under cultivation. Its stand on Upper Main Street has been a treasured gathering place for over fifty years. Here residents and visitors can savor an exchange of news or gossip while selecting their favorite island-grown produce. Bartlett's was originally a dairy farm, but has since expanded into vegetables, flowers, prepared foods, and even wine. These days, its principal business is vegetable cultivation, with one of the most popular summer crops being lettuce: the farm grows some twenty varieties, harvesting approximately three thousand heads a week. Bartlett's produce is also delivered to island supermarkets, hotels, and restaurants.

Hydrangea wreaths are a familiar decoration. The shrubs flourish all over the island, showing their full blossoms of blue, pink, and lavender all summer long. At the end of the summer, just after they have lost a bit of color, they are picked, placed on wreath frames, and allowed to dry. When attached while still wet, they are more easily handled. Most gardeners use a straw wreath for the base and attach clumps of heads with pins and wire. Pins are inserted into the flower stems, which are placed at an angle around the wreath, always facing in the same direction. No spray need be applied. The flowers, dried to a soft hue, will last a year indoors. Some people paint them with white paint for a ceramic look, while others use gold for Christmas wreaths. But natural or painted, they make for easy decoration projects.

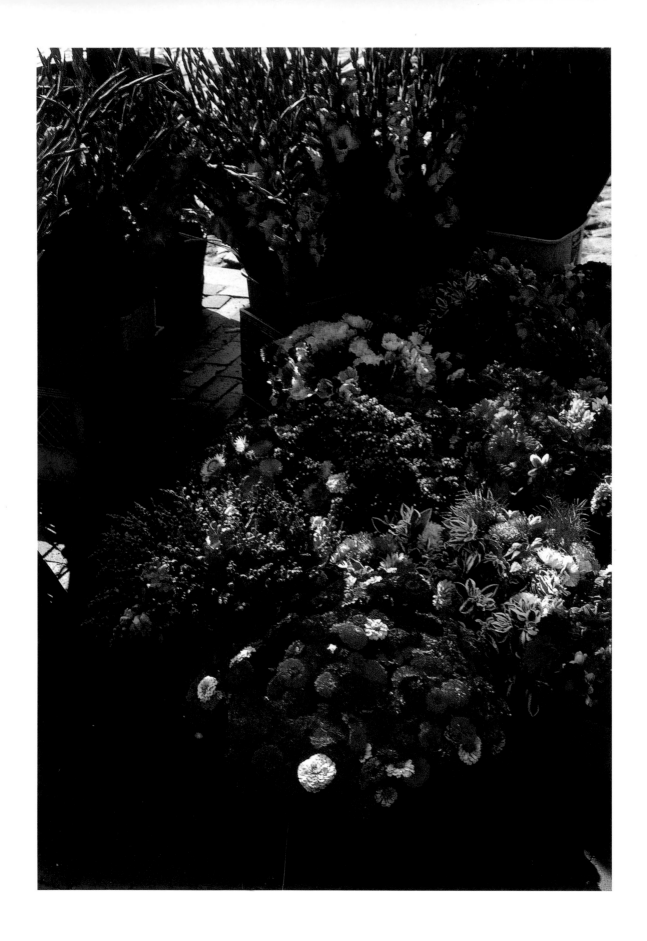

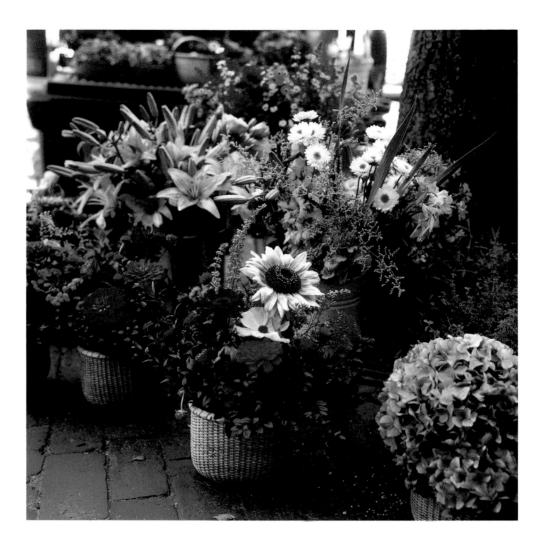

Above: Flowers on Main Street from Dukes Road. Shown are (*clockwise from center*) pink Asiatic lilies; a mixed bouquet of gladiola, sea lavender, white chrysanthemums, and sweet peas; hydrangeas; and baskets of mixed flowers including zinnias, cosmos, sunflowers, gomphrena, and buddleia.

Asiatic lilies are grown from bulbs and produce flowers year after year, usually in July, in shades of yellow, orange, white, and pink. Unlike Oriental lilies, they have very little fragrance. They love the Nantucket climate and grow very well there. Rabbits and deer are drawn to them, too, nipping off the buds just as the gardener is ready to enjoy their full blooms. Sea lavender grows wild on Coatue and other isolated beaches, where the plants can get covered with sea water for half the day. In July, their delicate flower sprays turn salt marshes a pretty shade of lavender. Chrysanthemums are widely grown on Nantucket and are semi-hardy perennials. Sunflowers, which are annuals, make wonderful cut flowers. Gomphrena is an annual usually grown for drying. Buddleia is a shrub that produces spikes of fragrant flowers in August. The shrub, highly resistant to deer and rabbits. It actually thrives in Nantucket because of its tolerance of wind and fog, drought and dry soil (and anything else the island throws in).

Opposite: Bartlett's Ocean View Farm stand on Main Street. Shown in the photograph are (*clockwise from the top*) gladiola, cosmos (*in front of the glads*), Bells of Ireland, annual dahlias, annual asters, zinnias, snapdragons, straw flowers, and statice.

Gladiola are grown from bulbs planted from April through June. They are not popular as garden flowers because they are tall, with only one flower spike, and tend to topple in the wind. Cosmos is an annual, grown widely on the island both in the garden and as a cut flower. It blooms all summer long. Bells of Ireland is an upright plant with small yellow flowers inside green cups, grown mostly as a cut flower. Annual dahlias make nice garden plants with attractive foliage and compact growth. Annual asters are native to China and are grown as both bedding plants and cut flowers. Straw flowers have been growing on the island for many years. They make terrific dried arrangements because their blossoms are already papery-dry on the plant. Snapdragons are Old World flowers native to the Mediterranean and grown here since Colonial days. They are wonderful garden plants as well as cut flowers, offering many color choices. Zinnias are another popular, old-fashioned annual, native to Central and South America. In the center of the photo is statice, which has been grown on Nantucket for years.

Mitchell's Book Corner. When he retired in 1968 from the advertising world on Madison Avenue, Henry Mitchell Havemeyer, together with his wife, Mary Allen, founded Mitchell's Book Corner. Both were descendants of early settlers of the island and had been summering here for many years in a gracious home on the crest of Orange Street.

Under Mitch's stewardship, the store expanded to be the largest bookseller on the island, and today is one of the finest independent bookstores in the region. He also began a tradition of running weekly ads in the *Inquirer and Mirror* that were both informative and humorous, bringing his advertising-honed instincts to the world of books. The advertisements were eventually collected and published at the same time that Mary Allen's own Nantucket cookbook was being published.

Their daughter, Mimi Havemeyer Beman, grandniece of the astronomer Maria Mitchell, took over the store in 1978. During the summer, Mitchell's Book Corner has become a favorite destination spot of authors and readers, the famous and the not-so-famous. Andy Rooney and I have met there, checking out each other's books and simply browsing. Customers have included Oscar de la Renta, Walter Cronkite, Princess Grace, Jacqueline Onassis, Goldie Hawn, and Mister Rogers. I did not see Peter Benchley on the day I was autographing my first color book in August 1986. He had been signing a new bestseller at the store the week before, and my goal was to sign and sell as many copies as he had. Since I got off to a good, brisk start on my autographing day, I decided to stay beyond the allotted morning shift. After lunch, I came back and saw friends who had returned for more copies. One even brought her dog so that I could autograph a book for him, since he was featured in a photograph. Along about four o'clock, I asked if we were catching up with Peter Benchley's record yet and was informed we had passed that level in the morning, but the store just wanted to keep the party going. And so we did.

Mitchell's Book Corner is operated all year long by a well-read staff made up of people who know their books and make helpful recommendations. The Nantucket Room offers every book in print on the subject of Nantucket. "Meet me at Mitchell's" is a frequently heard phrase as families embark for town. Whether after morning errands or evening ice cream or sometime in between, stopping by here is indeed an active focal point in many people's days.

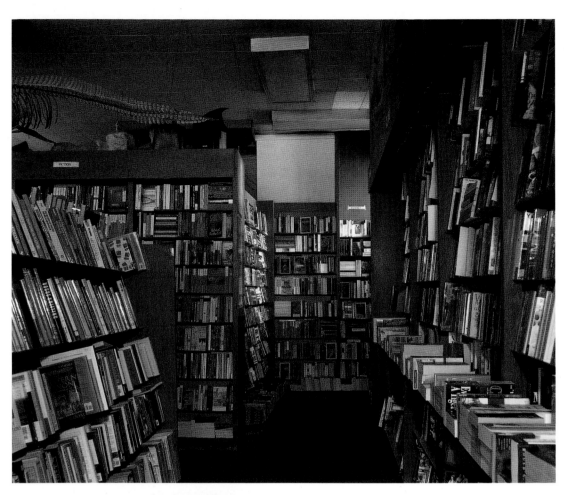

Murray's Toggery Shop. Among the Island's most distinctive features are the "Nantucket Reds," designed and marketed by Phil Murray and his family.

The idea had its genesis in the cotton pants worn by people in Brittany, and admired by the elder Phil Murray. Some of the sails on the boats in Brittany also shared the same fabric and color. In the early 1950s, the elder Murray started to sell a specially tailored version of the pants in his store at 62 Main Street, the Toggery Shop, which he had purchased in 1945.

Noting the growing popularity of the red pants, his son, also named Phil, decided to alter their design, arranging to have the fabric manufactured and dyed to his specifications and the pants made exclusively for the store. The name "Nantucket Reds" was adopted at this time. The well-known fabric is a sturdy red cotton that fades to a dusty rose after only a few washings. Initially, Nantucket Reds were only pants, but then came shorts, shirts, and eventually baseball caps and women's skirts. The most popular new item is the Nantucket Reds shirt, which regularly sells out each season.

It is believed that Rowland H. Macy once had an emporium on the original site of Murray's. His main store was in the adja-cent building, at 58 Main Street. When the Murrays purchased the Toggery Shop in 1945, the store consisted of a single building constructed after 1846, which had for many years been home to the City Clothing Company. In 1959, Phil Murray bought out his father and subsequently purchased the adjacent store, formerly Louis Coffin's Dry Goods. This new space enabled the Murrays to add a separate women's department run by Phil's daughter, Trish Bridier. Eventually, the Murrays added a second floor and excavated below ground to provide additional storage space.

Over the years, the style of the Nantucket Red pants has evolved. Originally it was a loose-fitting garment with no pleats, a watch pocket, and a button fly instead of a zipper. Now the trousers are more contemporary, and the line includes Bermuda shorts, boys' pants and shorts, and women's slacks and skirts. Shirts and caps are a more recent addition, and the Nantucket red color is also now seen on cotton pullovers and tote bags. But the traditional heavy cotton fabric remains unchanged, quickly fading to the familiar soft color and blending into the island life of casual summer days.

Shops on Main Street: The Nantucket Looms and Anderson's. This main shopping street has evolved on Nantucket as it has in downtown cities on the mainland. Gone are the hardware and food stores, which have been replaced by specialists in home furnishings, antiques, and clothing. Only Congdon's Pharmacy has remained intact—a stalwart presence since 1860. In the nineteenth century, most of the retail shops of Nantucket were on Centre Street, while Main Street catered to the island's basic industry. It was a grand but not genteel thoroughfare. Widened in 1846 and paved with cobblestones, it nevertheless was a serious, nautical commercial center.

Both the Nantucket Looms and Anderson's are located in century-old structures that have had many tenants over the years. The Looms' majestic Greek Revival building has six bays and a pediment across the front. Barker Burnell was the first to operate a general store here, followed by other owners who featured different merchandise. The Nantucket Looms was established in 1963 at the encouragement of the Nantucket Historical Trust. It has served as an outlet for interior designers and architects.

When the Hub was purchased by the Andersons in 1974, Debbie Anderson started a gift shop next door. The two shops were connected by an interior side entrance. The gift shop specialized in unique items for the home, including a line of Christmas decorations. Today, it continues to delight the eye with lovely collectibles from around the world, eclectic gifts and decorative accessories all displayed with the owner's love of a clean, white palette.

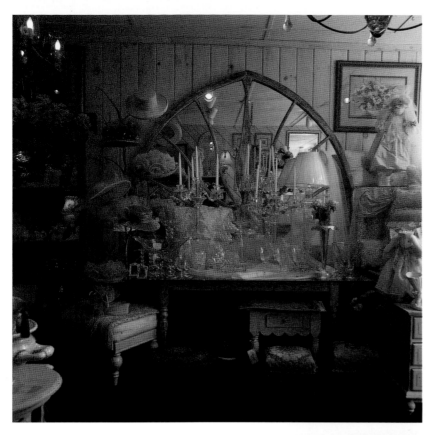

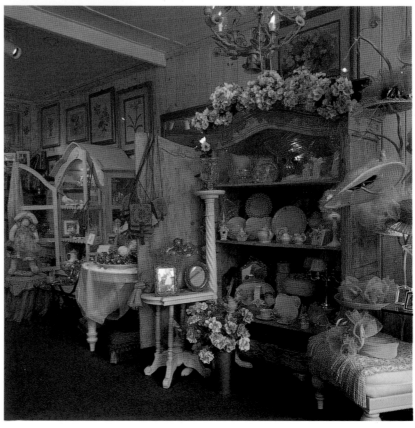

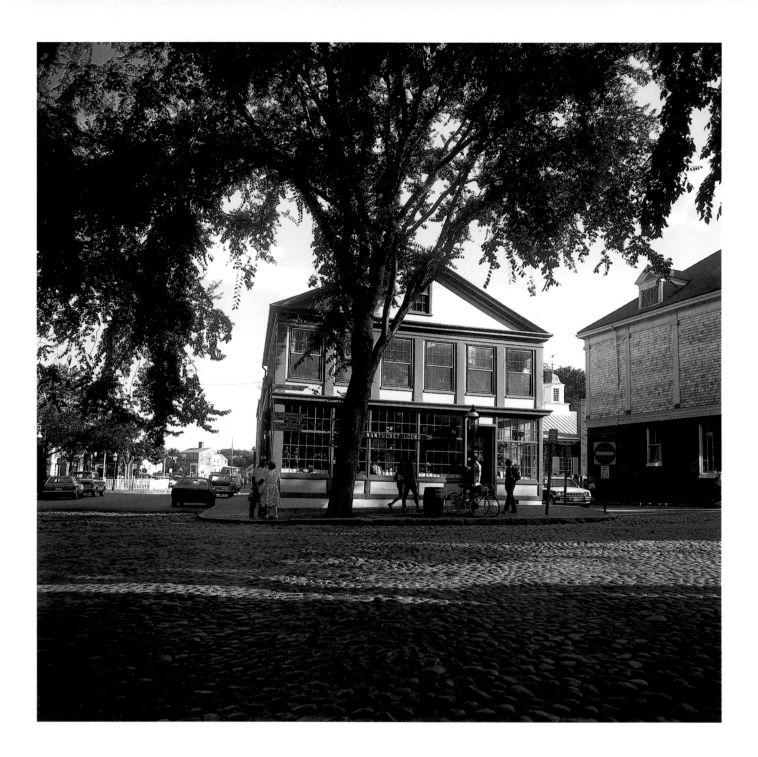

Main Street Square. The proprietors laid out Main Street around 1697. Its name was briefly changed to State Street in the early 1800s, but reverted to Main by 1833. The lower section is referred to as Main Street Square and was widened in 1847, when buildings on the north side were pushed back about twenty feet. Two handsome brick buildings on the south side of Main Street Square date back to 1892. The Espresso Cafe, housed in a 1910 structure, was for many years the favorite Sweet Shop.

The Nantucket Looms has been a familiar fixture on Lower Main Street for generations. Before that it was Gardiner's Gift Shop. Marshall Gardiner is responsible for the familiar compass sign, installed in 1922, on the building's side wall. A prolific photographer, Gardiner turned many of his images into hand-tinted color post cards, as color photography had not yet been perfected.

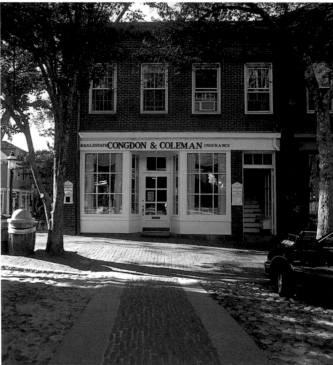

Above: Upper Main Street and Petticoat Row. Upper Main Street Square and Centre Street. At this junction is a large fire cistern, one of three that the town installed in 1833. The others are to the west of the Rotch Market at Lower Main Street and at the intersection of Main and Pleasant Streets.

Centre Street was part of the Wescoe Acre Lots plan of 1678 and therefore is one of the oldest streets in Nantucket. It starts at Main Street with two majestic, Federal-period buildings serving as anchors: the Pacific National Bank (built in 1818) and the Methodist Church (1822–23). The colossal Greek Revival columns were added to the latter's portico in 1840.

The nickname "Petticoat Row" was first applied to the stretch of Centre Street from Main to India (or Pearl) Street in 1848, when Andrew Macy sailed off to the California Gold Rush, leaving his sister Harriet to run his bookstore. Numerous wives managed businesses here while their husbands embarked on

lengthy sea voyages. In fact, women had been proprietors long before the term "Petticoat Row" was ever coined.

N. A. Sprague planted Centre Street's English maples, Chinese elms, and gingko trees in the early 1850s, about the same time Charles and Henry Coffin planted Main Street's legendary elm trees.

Opposite: Zero Main Street, headquarters of the First Winthrop Corporation. In 1964, the principals of the Island Service Company and Sherburne Associates joined to create a company with ownership in many downtown properties, including Straight, Island Service, and Commercial Wharves. Over the next twenty years, Sherburne continued to acquire, develop, and renovate properties, presenting Nantucketers with an organized waterfront that is as picturesque as it is efficient.

In 1821 the U.S. Post Office was located here, and the newly established *Inquirer* operated from the second floor.

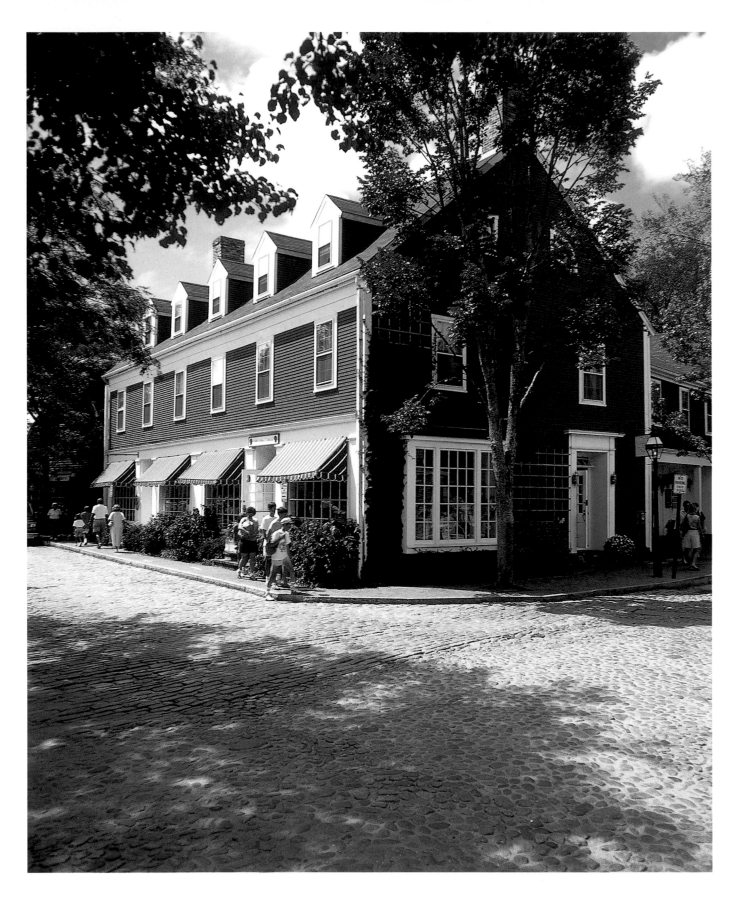

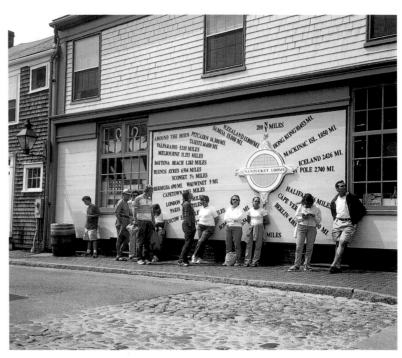

Opposite, top: The familiar compass had been posting the way to Wauwinet and New Zealand (and points in between) since it was first painted on the side of Gardiner's Gift Shop in 1922.

Opposite, bottom: The Club Car Restaurant is the last vestige of the Nantucket Railroad, which ceased operations in 1917. To the left is Rotch Market. One room here housed the first Customs Office in America (1783–1913). From the time the building was constructed, the town occupied half the space in exchange for deeding the underlying land to William Rotch. From 1804 to 1860, insurance companies occupied the other half. The Pacific Club, originally a group of retired whaling captains, acquired the building in 1861 and used it until recently. The structure, originally a light-colored brick, was painted red in 1891.

William Rotch and his sons were among Nantucket's most successful merchants in the eighteenth century. The building's sign bears the name of three of their ships: the *Beaver*, the *Dartmouth* and the *Bedford*. The first two were present at the Boston Tea Party, and the last was the first ship to fly the new flag of the United States in any British port. The *Beaver* made a historic voyage in 1791, rounding Cape Horn to open up the Pacific whaling grounds to Nantucket. If not for that trip, the island's whaling industry would have diminished because of the depletion of the Atlantic's whale population.

The Rotches thrived by controlling both input (whale oil) and output (wax candles) when they built the island's first candleworks in 1772. Forerunners of Henry Ford (who had his own foundry) and Isaac Singer (who owned the forests that supplied wood for his sewing machine cabinets), they embodied the concept of vertical integration.

Above: The Brotherhood of Thieves is a popular restaurant, opened in 1972 in an 1847 building, where patrons eat at long tables as in Durgin Park in Boston. Its name derives from an impassioned speech given in 1842 by Stephen Foster at the island's second anti-slavery convention, where he referred to the acquiescent clergy as being pimps, adulterers and a brotherhood of thieves. Needless to say, his fiery remarks set off considerable discussion and reactive outbursts—i.e., a riot was launched. (For more information, please see Page 206.)

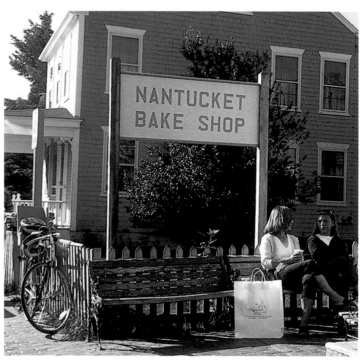

Out and about town. *Opposite, top*: A secret spot behind Zero Main Street offers a perfect place to rest, especially while spouses are having their hair coiffed at the adjacent beauty salon.

Opposite, bottom: One bakery or another has been located on Lower Orange Street for the better part of the past century. The Nantucket Bake Shop opened in 1976 and produces over one thousand loaves of fresh bread daily in the season. It specializes in Portuguese bread and other gourmet specialty breads. It offers a full range of old-fashioned bakery products, and ships bread to a large, devoted clientele throughout the United States.

Above: Strolling down Federal Street, past Marshall DuBock's Nantucket Gallery. Old maps show that the site of Federal Street was once the shoreline, but in 1743 the dunes were leveled to create the Bocochico Share Lots, of which Federal Street was a part. After the Great Fire of 1846, the street was widened, providing a suitable location for the Nantucket Atheneum library. It is a tribute to the Historic Districts Commission and dedicated individuals that newer structures, such as the Post Office and 23–21 Federal, fit well into the setting. Restoration work began downtown in the 1920s and gained additional impetus from Everett Crosby's 1940 survey, which advocated that the old be preserved, the garish eschewed, and commercialism camouflaged. Edouard Stackpole, retiring as director of the Mystic Seaport, turned his hand to publishing stories of Nantucket's past in Historical Association bulletins. In 1964, Walter Beinecke began development of the waterfront and marina, creating much of the waterfront appearance we enjoy today.

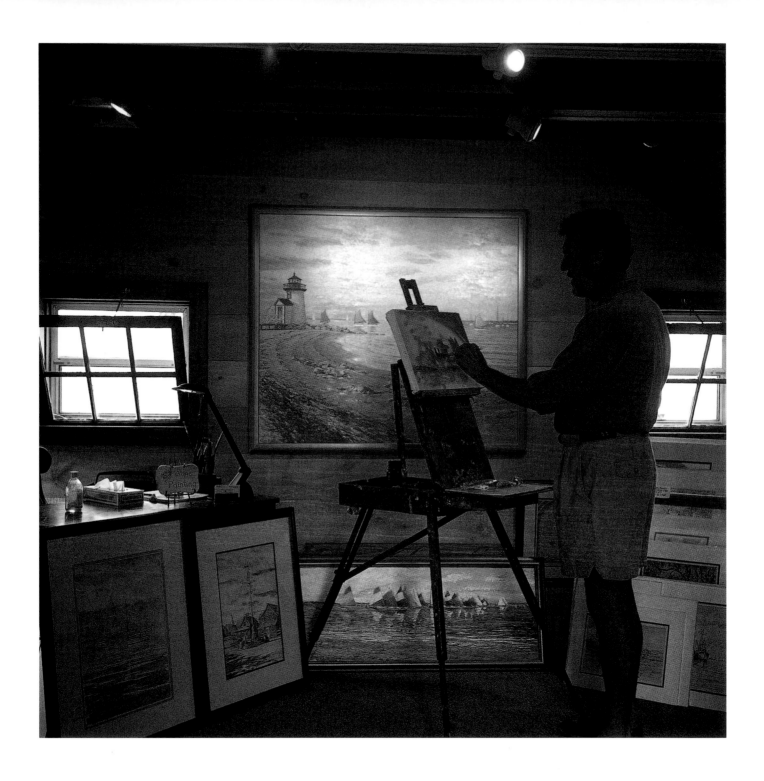

Above: G. S. "Greg" Hill has been painting since the age of twelve. He uses all mediums—oil, watercolor, and pencil—and is primarily self-taught. The artist's first show on Nantucket was in 1977; he and his wife Judi have been regular summer residents since 1979. He frequently paints upstairs at the Hills' gallery and gift shop. Greg and Judi are world travelers and receive inspiration for their creative works from around the globe.

Opposite: Most of the G.S. Hill limited-edition prints are displayed for sale at the gift shop. Both Greg and Judi pride themselves on designing and producing American-made gifts. In the photograph below, Judi is behind their display of lightship baskets, taking an order from an off-island customer. Hill's of Nantucket, on Straight Wharf, was established in 1981.

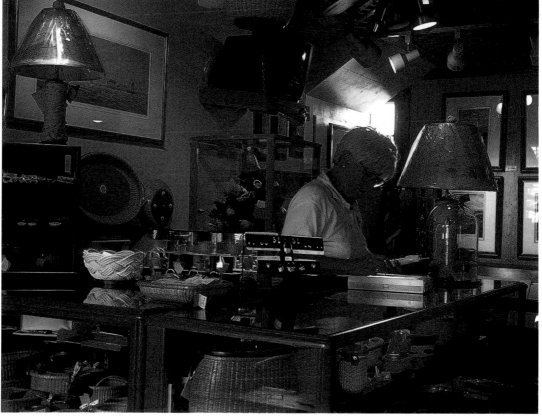

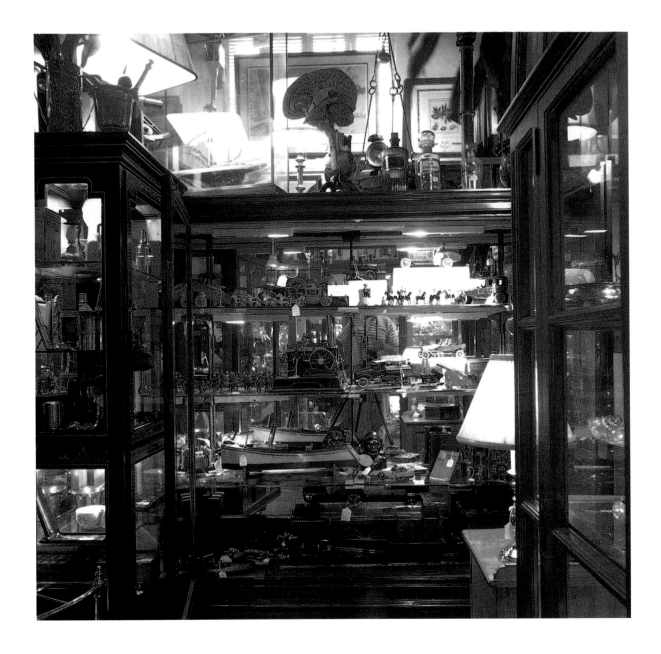

Tonkins of Nantucket was established thirty years ago. Bob and Dotti Tonkin had been running the Four Winds Gifts on Straight Wharf when they decided to focus on antiques as their principal line, opening a new store at Zero Main Street. It had a movable partition, so that as the large furniture pieces sold out during the summer, the sales area could be reduced accordingly. The Tonkins subsequently relocated to 33 Main Street, into quarters that had previously been a general store and also a health food shop (in my youth). They expanded to three floors and had a private showroom at One Liberty Street before acquiring an even larger space near the Memorial Airport. They now have over 13,000 square feet of exhibition space, making Tonkins one of the largest antique shops in the country.

Above: Model toys are always a delight for both the young and not-so-young. In the display case are English and French soldiers, carriages, aeroplanes, and motorcars dating from 1860 to 1930. In front of the case is a working steam model of the Great Northern Railway (whose trains were always a distinguished green color) from 1930.

Opposite, top: This view shows part of the vast antique silver collection, which includes a seventeen-inch English punch bowl, circa 1910, and a large bronze parrot head from France. *Opposite, bottom*: The elegant store on Main Street displays a wide variety of formal as well as country antiques, mainly from England and France.

The Tonkins sell merchandise for inside and outside the home. For example, they have designed a Nantucket basket door knocker, which is unique as well as functional. The taste this couple has imparted to Nantucketers' homes both on island and off is special, and the Tonkins' shops are always well worth the visit.

Views of Erica Wilson's Needleworks Shop on Main Street, housed in the Hussey Block, a building dating from 1847. When Erica first came to Nantucket in the early 1960s, her shop was in her eighteenth-century residence at 34 Liberty Street. By 1975, she had moved to her present location at 25 Main Street, and when the owner of the adjacent Nantucket Dry Goods retired, Erica expanded into 27 Main Street. The shop's main focus is needlepoint—pillows, hand-painted canvases, and specialty kits—but Erica's line has also extended into home decorating and clothing. *Opposite, bottom*: The children's area, which features needlepoint kits for small fingers in addition to clothing from around the world. *Opposite, top*: The Barnaby Bear collection by Erica's daughter-in-law, Wendy Rouillard, who has written and illustrated five Barnaby Bear stories as well as various activity and coloring books. She and Erica's son, Illya Kagan, met on Nantucket in 1993 and were married four years later.

Erica Wilson, born in Scotland, spent her childhood in various locations on the British coastline, as her father was an aircraft spotter during World War II. She did her first piece of embroidery at the age of five and grew up to attend the prestigious Royal School of Needlework in London, which was established to teach ladies how to make church vestments. In 1954, she sailed to New York on the HMS *Queen Mary*. She started teaching in Millbrook, New York, beginning the class with difficult gold church-embroidery. So challenging was this technique that her students would fall mysteriously ill and fail to show up for further sessions. She then shifted her emphasis to crewelwork, a variety of delicate stitches that form designs on an open background. Together with needlepoint, crewelwork became extremely popular. Soon people began contacting her with inquiries, and before long, she and her husband were making up mail-order kits, responding to orders that were pouring in at a rate of over one hundred per month. Their dining room became a workshop for printing patterns and assembling them into kits with color-coded yarns. The nation had embarked on a massive needlework bee.

Erica Wilson first came to Nantucket in 1962 to teach needlework in the space presently occupied by Nantucket Looms. Pillows and chair covers in her distinctive designs are now prevalent in homes all over the island. A tribute to her inspiration is a remarkable collection of thirty-two cushions in the chapel of St. Paul's Church, each worked by ladies of the congregation in the 1970s.

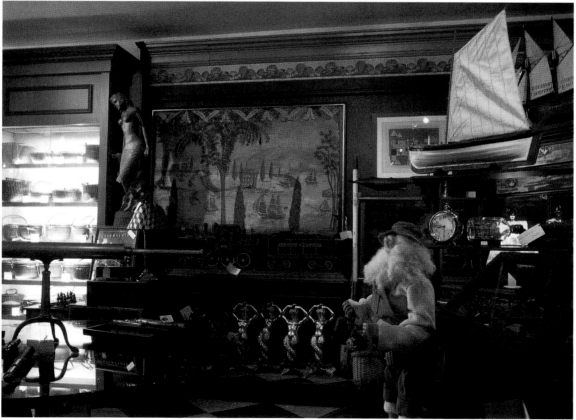

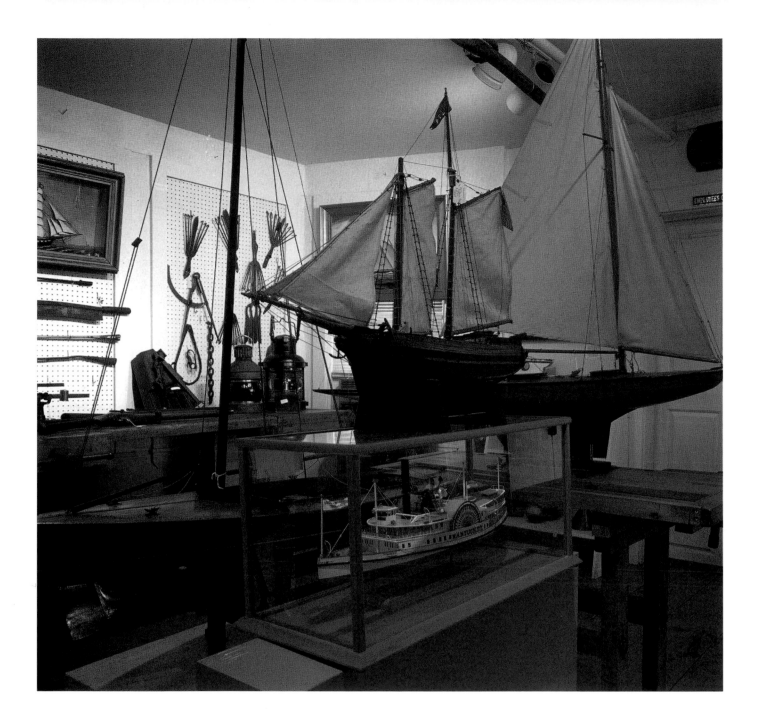

Nantucket has many antiques dealers. The Sylvias own the longest continuous operations, Sam Sylvia at Ray's Court and his brother Frank at Zero Main Street. Another antiques dealer, Val Maitino, operates from a showroom on North Liberty Street, while Bob Tonkin has showrooms both on Main Street and on Teasdale Circle near the airport. Shown in these photographs are the stores of Wayne Pratt (*opposite*) and Nina Helman (*above*). Mr. Pratt has been a dealer for decades, specializing in early American furniture. His signature diamond-square flooring travels to antique shows around the country, including New York's Winter Antiques Show which benefits the East Side House. These photographs show a variety of ship models, accessories and furniture.

Nina Helman's shop at 48 Centre Street contains a model of the side-wheeler *Nantucket*, the schooner *Polly* from Belfast, Maine, and in the background, a working pond sailer.

The eastern and western sections of Main Street Square. Main Street begins at the head of Straight Wharf, and the first broad stretch of three blocks is referred to as Lower Main, or Market Square. The area has always been the commercial nucleus of the town. Before the Great Fire of 1846, perimeter buildings housed a dozen groceries, sixteen dry goods stores, five hardware stores, two auction houses, five boot-and-shoe shops, four clock-and-jewelry stores, three ships' outfitters, two variety stores, five grain dealers, eight barbershops, a cordage store, a stationery shop, an oil-and-candle shop, a hat shop, and an apothecary. As is true today, farm wagons sold seasonal produce at the curb. After the Great Fire (which began in an overheated stovepipe in William H. Geary's hat shop, on the south side west of Union, and spread and gutted the Rotch Market, destroying every intervening building facing Main up to Orange and Centre—and a good deal besides), the north side of the

street was set back twenty feet to its present line. Over Congdon's Pharmacy (47 Main) was Pantheon Hall, where social dances were held. Music was provided by the Handy family performing in the orchestra gallery, which projected out from the upper wall and was reached by a ladder.

The horse fountain in the middle of the east end of the square was presented to the town by William Hadwen Starbuck and was first placed temporarily at the head of Orange Street in 1885. It was cast in iron by Henry F. Jenks of Pawtucket, Rhode Island. At the other end, white marble blocks in the paving in front of the Folger building (58–60 Main) mark the southwest limits of the spread of the Great Fire.

The obelisk at the curb alongside the Pacific National Bank denotes the north point of a meridian laid out in 1840, the south point of which holds a stone similar to the one located in front of the Friends' School on Fair Street.

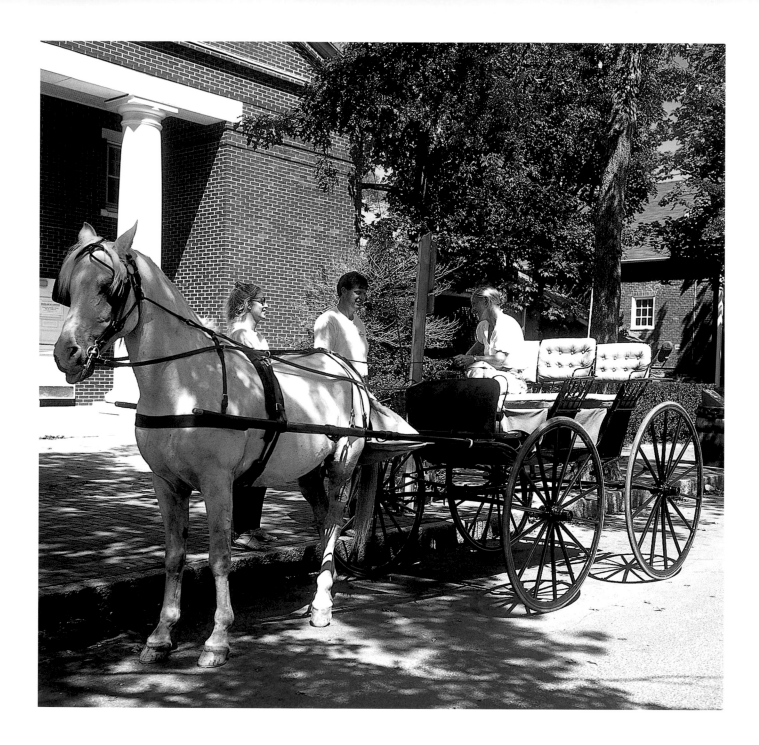

Above: A Nantucket surrey for hire, outside the Peter Foulger Museum. These two-seat wagons were introduced to the United States in 1872 from the English county for which they are named.

The Peter Foulger Museum was built in 1970 and is patterned after the Coffin School on Winter Street, which was founded by Admiral Sir Isaac Coffin in 1827 for descendents of Tristram Coffin. Although he could have charged no tuition, a modest tuition fee was imposed at the school, because it was generally considered that anything free was doubtful.

Opposite: The Whaling Museum on Broad Street was built in 1847 by William Hadwen and his partner Nathaniel Barney to serve as a candle factory. All structures on Broad Street (except for the Jared Coffin House) had been razed by the Great Fire a year earlier. Broad Street was originally laid out in 1678 and, like its sister Main Street, was widened during reconstruction after the fire. It, too, has cobblestones, but these days they are napping quietly under a blanket of macadam.

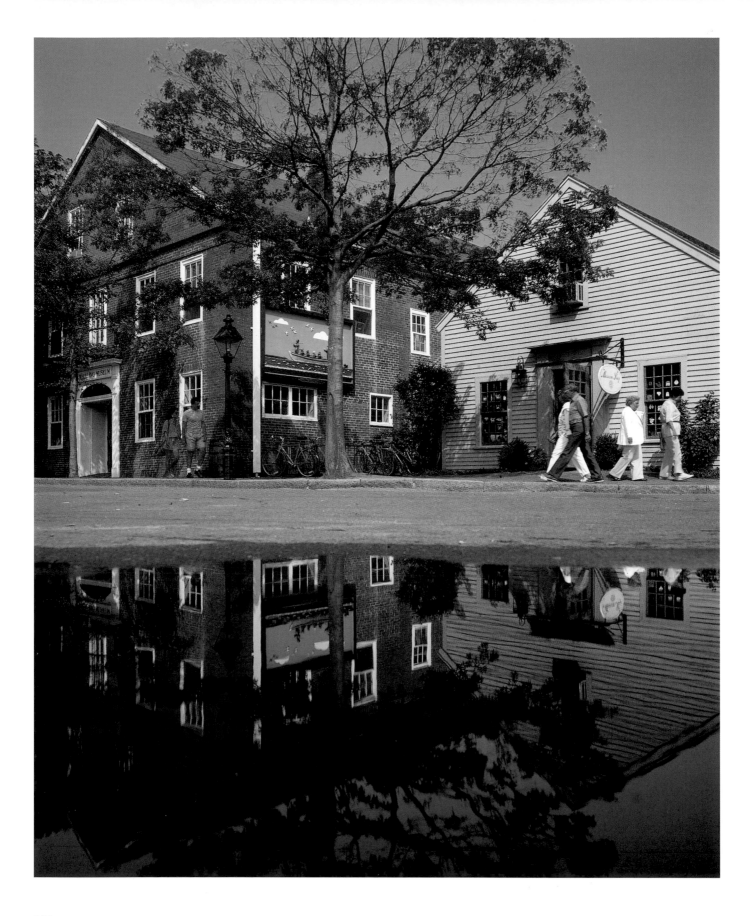

Above: The Navigation Room at the Whaling Museum, showing the original Fresnel lens used in the Sankaty Lighthouse (one of the first such lenses made) and other navigational memorabilia. A Fresnel lens was an innovative magnifying lens in that it was made of assembled cut-glass prisms rather than a single lens. The French engineer Augustin Jean Fresnel pioneered the idea, though several firms later produced such lenses. The lens in the Navigation Room was made in France in 1849 and brought to Nantucket in 1850. It was installed in Sankaty Head Lighthouse in Siasconset (more familiarly known as 'Sconset) and was originally illuminated with a single-wick whale oil lamp. The light at Sankaty was electrified in the twentieth century and no longer uses a Fresnel lens, but there are many Fresnel lenses still in use throughout the country and the world.

Opposite, top: The Cooperage. Wooden casks were as important to the whaling industry as were the ships themselves. The largest casks were over five feet high and four feet in diameter, and when filled with oil, they weighed about one ton each. The average whaleship had a capacity of about 800 casks of different sizes. After the whale oil was extracted and stowed down in the hold, water was poured over the casks several times a week to prevent shrinkage and resulting leaks.

Making the casks was an art, much like making lightship baskets today. Both follow the same principles of design, using a flat bottom with carefully shaped bent staves as uprights. The oak staves, held with iron hoops when assembled, had to fit so carefully together that they could be knocked down and stowed on board the ship in bundles until needed. A typical ship carried many more of these bundled casks, or "shooks," than her hold could accommodate if they were fully assembled. Thus when oil was obtained and the hold was filled to capacity, a whaleship would send some barrels back home aboard other ships that had available space. This enabled the voyage to extend for longer periods of time, increasing the profitability of the expedition well beyond what it would have been if limited to one shipload. Depicted here are the many special tools used to make casks, including circular planes, hole borers, cutting irons, and a shaving horse. Wood was drawn over the six-foot carpenter's

plane, and the fireplace was used to heat the oak and allow it to bend. The one-inch staves were made of white oak, split by hand with the grain, not sawed, as was the practice in ordinary barrel making methods. The staves of lightship baskets are made the same way.

Above, right: The Whaleboat Shop. A favorite exhibit at the Whaling Museum, the whaleboat shop shows a fine collection of antique tools and, in the background, an old steam-driven lathe. Here is shown a whaleboat in the making—one-half size—that will be three feet in beam and fifteen feet in length. The oak keel, stem, and stern posts are in place, and five molds are set up across the keel, ready for planking. The boat will be planked over these molds and the ribs steamed, bent and fitted inside the boat later.

Along the back wall of the boat shop is shown a small brick furnace which held an iron kettle filled with water. This produced steam, which was carried by the short pipe to the wooden steam box directly above the furnace; there, the planks were steamed so that they could be readily bent into the desired shape. Next to the furnace is an old foot-pedal lathe which dates back to the 1790s. At the left end of the shop is a work bench and an unusual collection of bits and vises.

Whaleboats ranged in length from twenty-eight to thirty feet, with beams of five-and-a-half to six-and-a-half feet. The oars were long, with the steering oar being about twenty to twenty-one feet long, the aft oar sixteen feet, the tub oar and bow oar each seventeen feet, and the midship oar eighteen feet. One long oar and two short oars were pulled on the starboard side, against two medium-length oars on the port side. Oarsmen's positions along the thwarts (or seats) were staggered, with every other oarsman sitting well away from the oarlock instead of in the middle of the boat, so as to balance the great length of the oar.

Each whaleboat carried a crew of six men. Whaleships carried seven boats, five at the ready on cranes called davits, and two spares overhead on the after-deck. A real, full-sized, fully equipped, ready-for-launching whaleboat is on exhibit in Sanderson Hall, on the second floor directly above the whaleboat shop.

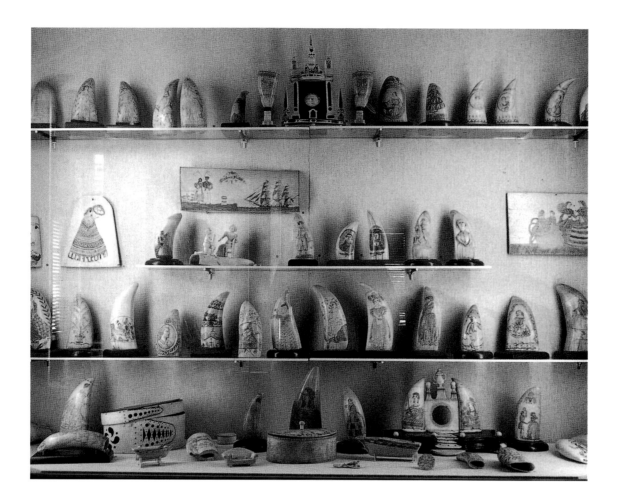

The Whaling Museum has an extraordinary collection of scrimshaw, including whales' teeth (*above*), model ships (*opposite, top*), and swifts (*opposite, bottom*), which were used in knitting.

Herman Melville was one of the first to use the word "scrimshaw" when he wrote *Moby Dick* in 1851. The word is of obscure origin; some suggest it comes from the Low Dutch word *scrimshoning*, which refers to "passing-the-time" work such as whittling. The whaling scrimshanders used two types of whalebone: baleen, a brownish-black bone commercially used for stays and corsets, and the white bone of the skeleton. Functional scrimshaw was made from about 1690 to 1900, and decorative scrimshaw began to surface around 1815 and continues to be made today. Nancy Chase and Robert Spring are among the best-known contemporary carvers on the island.

Elaborately decorated ivory pieces became prevalent with the onset of longer Pacific voyages after the War of 1812. The combination of these lengthy voyages, with their accompanying preponderance of down time and concentration on sperm whales—which were known for their large ivory teeth—resulted in some extraordinary works of art. While some scrimshaw was produced onshore, the majority was carved aboard whaleships that were embarked on voyages lasting over three years. The ultimate scrimshaw form is the yarn winder, called a "swift." This was a utilitarian object, essentially a reel whose diameter could be adjusted. A skein of yarn was placed over it and wound off into knitting balls. Swifts were often equipped with clamps to affix them to the edge of a tabletop. Although they were originally made for practical purposes, swifts have come to be admired as pure sculptures.

Pictures engraved on whales' teeth and pieces of pan-bone became popular in the 1820s. This was a prosperous time, when many functional parts of the household, including walls, furniture, and tools, were decoratively embellished. Thus scrimshaw carving fulfilled two equally important purposes, giving sailors a way to occupy themselves on long voyages and offering them a creative outlet for self-expression. Closer inspection of surviving pieces reveals many tiny holes that were marked to outline the design. These dots were then connected with a sharp knife and filled in with India ink in carbon black. Many of the carvings depict the ships on which the scrimshanders were sailing, with every aspect captured in exacting detail. Others were portraits copied from books and magazines. Some of the best-known pieces of decorative scrimshaw are a group known as "Susan's teeth". These are attributed to Frederick Myrick, who sailed on the ship *Susan* under Captain Frederick Swain from September 6, 1826, until the ship's return to Nantucket on June 9, 1829. Two of the teeth were acquired by the Peabody Museum in Salem the year after the *Susan's* return. This illustrates the high admiration for the artistry of scrimshaw, particularly the challenging work of carving entire teeth.

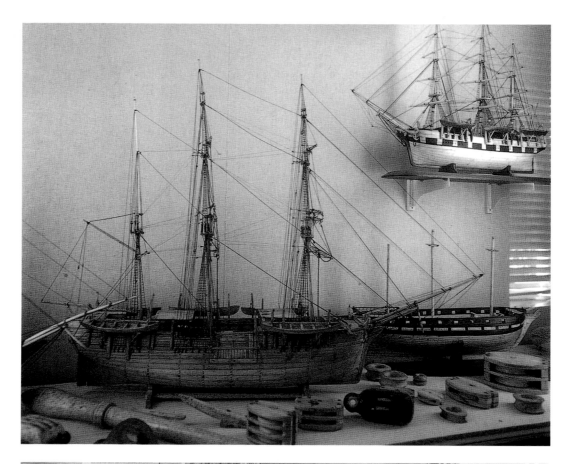

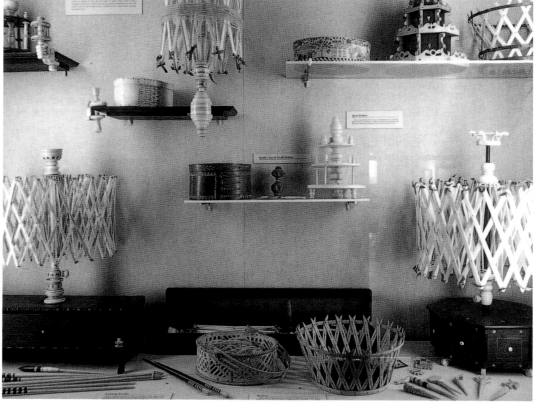

The gift shop at the Whaling Museum. This was created in 1981 by Grace Grossman when she was on the Board of the Nantucket Historical Association. She had also been instrumental in creating the shop at Sturbridge Village when she was active in that organization. Both the idea for the Whaling Museum gift shop and the construction of the building in which it is housed can be credited to her. She spent time locating craftsmen both on and off Nantucket to create early-American gifts that could be sold at the museum. Today, the Museum Shop continues to flourish and offers a variety of crafts that are evocative of the whaling era. All crafts, including the baskets, are reproductions and are displayed in a pleasing manner. The manager fills the shelves with the work of local artists, businesspeople, and authors. There is a special children's section as well as a select assortment of food products suitable for gift giving. And one of the most satisfying aspects of shopping here is that proceeds benefit the Nantucket Historical Association, the keeper and custodian of the island's most important treasures.

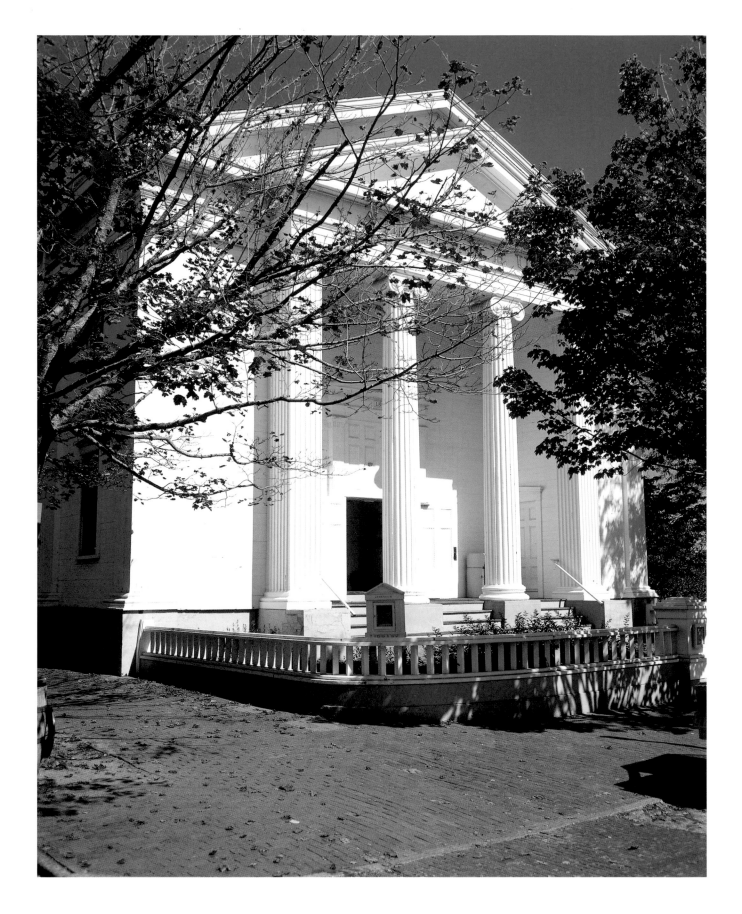

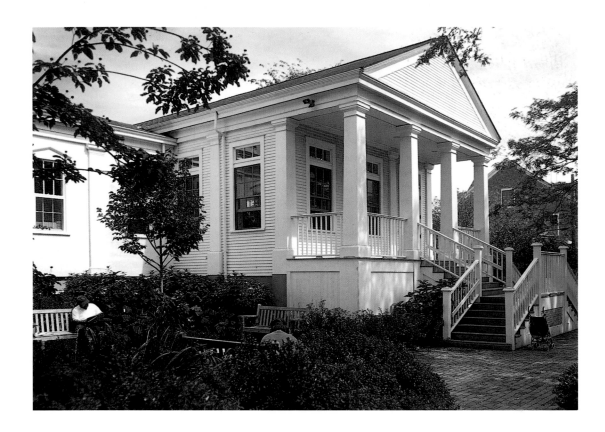

The Nantucket Atheneum, One India Street (1847), the island's public library. Its windowless façade is imposing and monumental, evoking the majesty of a Greek temple as a homage to learning. There is a double pediment on the south, with the outer one embracing the entire portico. The two Ionic columns flanking the entrance make a bold, elegant statement. This building is the masterpiece of Frederick Colemen, an architect who left his mark on Nantucket in the 1840s. He also designed the impressive Greek Revival houses at 94 and 96 Main Street (1840–45) and the First Baptist Church (1841), and he added the massive Ionic portico to the Methodist Church in 1840.

This Nantucket institution has a distinguished history. The genesis of the Atheneum's collection of books took place in an unfinished room of a candle-factory employee, David Joy. He and a small group of friends started the Nantucket Mechanics Social Library Association in 1820 with twenty-six volumes. Joy was an amateur chemist who invented a process for manufacturing spermaceti candles, the profits from which made him a wealthy individual. In 1827, the Association joined with the Columbia Library society to form the United Library Association. In 1833, David Joy and shipowner Charles Coffin decided that the United Library needed a new home and purchased the unused Universalist Church the following year; this would become the site of the present Atheneum building. The Nantucket Atheneum was incorporated with shareholders as proprietors. (Only in 1900 did it officially become a public library.)

The tragic fire of 1846 destroyed the Atheneum's collection of books which, by that time, amounted to over 3,200 volumes. To Nantucketers worldwide, it was like the burning of the library at Alexandria in an earlier millennium. There were no government funds or disaster relief. Raising money to rebuild and restock—from a community whose entire business district was a wasteland of charred rubble—was almost unthinkable. But it happened. The Atheneum that stands proudly on the site today is a tribute to the dedication of its early proprietors. Many of them had suffered deep personal losses as a result of the fire. Yet they dug further into their pockets, sold shares to others, and sought funds on the mainland for help in the rebuilding efforts. News of the tragedy spread throughout the country, and the shareholders' appeals resulted in contributions from almost every state of the Union. The saws hummed, the hammers banged, and within *six months* an entirely new Atheneum building was dedicated. The new structure was not merely a haphazard replacement for the old church, but instead was Frederick Coleman's masterpiece—as refreshingly alive today as it was then. It was a statement of bold design and, more importantly, a demonstration of the power of the Nantucket community to overcome, with amazing rapidity, the worst disaster in its history.

Maria Mitchell, who had become librarian in 1836, presided over the Atheneum's expansion and invited many important speakers of the day to give lectures in the Great Hall on the second floor. Speakers at the Atheneum from 1840 to 1856 included the following:

John James Audubon	1840	Louis Agassiz	1848
Frederick Douglass	1840	Herman Melville	1852
William Lloyd Garrison	1841	Lucretia Coffin Mott	1854
Theodore Parker	1846	Henry David Thoreau	1854
Horace Mann	1847	Horace Greeley	1855
Ralph Waldo Emerson	1847	Wendell Phillips	1856

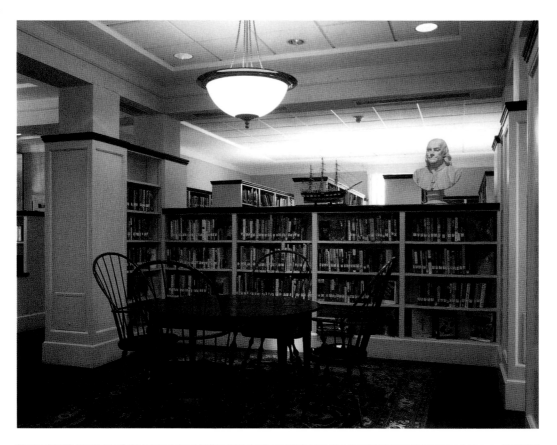

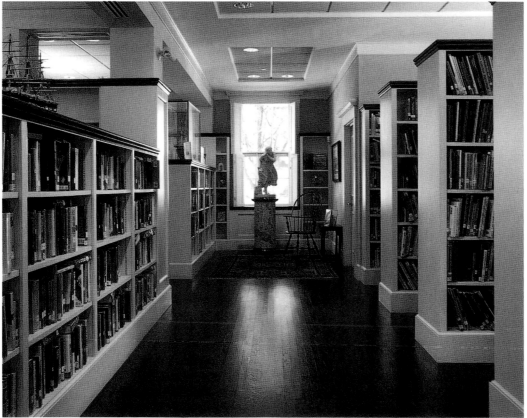

By the end of this past century, it was apparent that the Atheneum's building would have to be substantially restored and brought up to the current code of building requirements. An ambitious goal of raising nearly four million dollars for renovations, modernization and a new separate children's wing was announced in 1992. The children's wing was built on the Jethro Hussey property, which was adjacent to the main building and had been left to the Atheneum in 1922. During the construction phase, the library relocated to the Coffin School building on Winter Street, returning to its present location in 1996.

Today the new library has over 35,000 volumes and includes ample space for laptops and Internet research. It displays a magnificent collection of Chinese art gathered over the years by its significant benefactor, Frederick Sanford (1809–90), as well as scrimshaw, books, manuscripts and sculpture. Sanford was born on Nantucket and shipped out on his first whaling voyage in 1824 as a deck hand. But he spent the majority of his life in trading, eventually becoming a part-owner in six whaleships. He wrote, "[The] brightest days of Nantucket within my recollection were between the years 1820 and 1845. The busiest *one* day I remember was in November 1827 when seventy-two vessels passed Brant Point Light, outward bound, some to the Pacific, on a three-years whaling voyage, some to the coast of Chile for seals, thence to China for teas, others oil-laden to London, to Havre, to the Hague, and to almost every port on the Atlantic coast and West Indies. You who see the port in its decadence can have little idea of the scene of activity it then presented. A thousand workmen hurried down to the docks of a morning. The sound of hammer and adze began at sunrise, and ceased only at sunset. The multitudinous din of the docks continued often the night through. . . . It was indeed a busy scene."

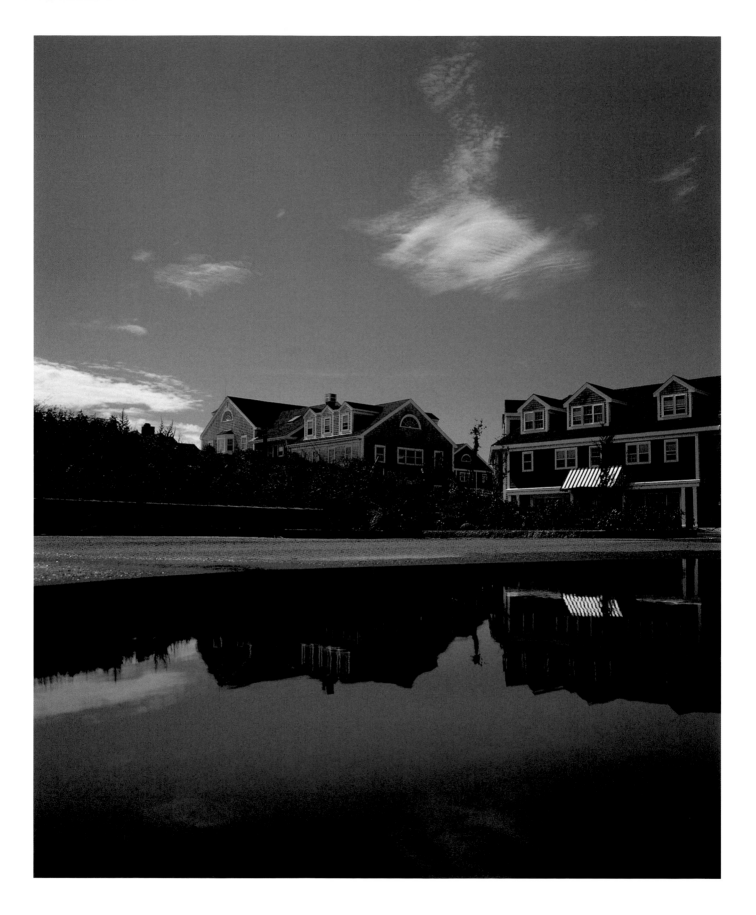

Bayberry Court at the Nantucket Commons (*opposite*) and the Nantucket Lightship Basket Museum. The Nantucket Commons was designed in 1988 by Shevalier Associates. Its development involved both the Historic District Commission and the Nantucket Conservation Foundation, owing to the presence of the wetlands at the edge of the site. This proved to be an excellent demonstration of how both private and public interests could be accommodated simultaneously.

The Lightship Basket Museum was started in 2000 and is housed in this 1821 building. With the advent of the positioning of lightships at Cross Rip and South Shoals came an interesting byproduct of the long hours spent at sea: basketmaking. Unlike the whalers-turned-scrimshanders, these seamen worked with rattan. During the summer they prepared the materials, and in the winter they wove them into baskets. The containers were round, oval, and often nesting. Their customers easily saw how

sturdy and useful they were, snapping the baskets up as soon as they were finished and sent ashore.

It has been suggested that lightship baskets are derivatives of the island's extensive cooperage industry. Coopers made casks and other wooden containers used for storing whale oil and vital ship supplies. There were 189 coopers on the island before the Revolutionary War. The lightship basket's construction is similar to that of a cask. It has a flat bottom, with staves acting as ribs for the rattan basketwork. In casks, the bottom sections of the staves are grooved to receive the flat barrel head. In lightship baskets, a slot is made in the bottom to receive the bent staves. Either way, the basic design is the same. The rim of the basket is comparable to the hoops of a cask. The lightship basket is therefore much more closely related to the products of the cooper than to the typical soft Indian basket.

Two of the more prominent lightship basketmakers of this past century were Mitchell Ray, a third-generation basketmaker, and his pupil, José Formoso Reyes. Mr. Reyes came to Nantucket in 1940 from the Philippines via Harvard. He sought a teaching position but, unable to secure one, turned to basketmaking. He used many of Mitchell Ray's molds, but carried the basket to a new level of design. While earlier baskets occasionally had flat tops, the majority had none at all. Jose Reyes created the familiar curved top, and he also made the baskets smaller and more oval, featuring a single handle. Thus the lightship basket became a handbag and found an entirely new market. Ivory pins and decorations added to their beauty.

Today there are about ninety members of the Nantucket Basketmakers and Merchants Association. Each basket is made by hand, and an average eight-inch handbag takes about forty hours to make. They are built with solid, wood bottoms and have oak or cane staves for the sides. Molds are used for the main part of the basket as well as for the tops, rims, and handles.

This photograph shows the working section of the new Light-ship Basket Museum. A basketmaker's demonstration is on the left, and José Formoso Reyes' actual workbench from his York Street shop is partly visible on the right. New baskets from old molds are on display, as well as some of the molds originally used by Mitchell Ray and José Reyes.

Basketmakers have a preference for different materials: maple, walnut, or oak for the bases, oak or cane for the staves. Bottoms are grooved to hold the staves, which are completely sanded and shaped to be of uniform thickness and width. This is not a randomly woven Tahitian totebag. The lightship baskets, more than anything else, have grown to represent a tangible piece of Nantucket and its rich heritage for people around the world. It is a piece of history even for those who do not live on the island. The lightship baskets bring people together.

One well-known basketmaking team is Susan and Karl Ottison, who operate year-round out of their shop in the Creeks area. This is indeed a lovely spot, filled with a pond and gardens on land where cows used to graze. The location was part of the Lewis Farm and has been in the family since 1890. Both are natives of

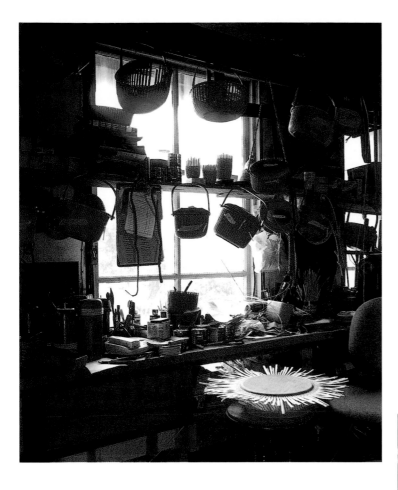

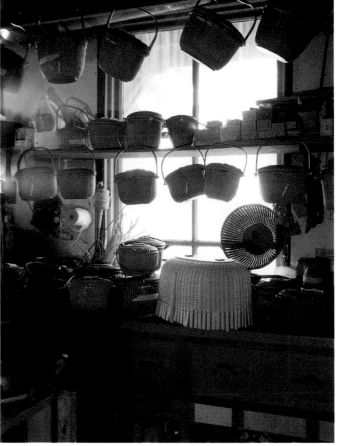

Nantucket, Susan has been making baskets for over thirty years, her husband for twenty. Her sister, Nancy Chase, is a prominent scrimshander and makes ivory carvings for the basket lids.

Above: Here at the Ottisons's workshop are a variety of baskets waiting for repair. Many were made by José Reyes in the 1950s and 1960s. The large oval basket upside-down on the bench is twenty inches long and will have a stationary handle. It will take over one hundred hours to make. Small egg-basket molds are visible to the right, as well as a small, oval egg basket already being made. This size is popular for floral arrangements and other table decorations.

Right: At the top are two old, swing-handle baskets in for major surgery. New pieces will be found to match the old, both in size as well as color. In the middle of the shelf, in front of the window, are "one-eggers" waiting to be finished off with rims and handles. In the foreground is the cover for a big picnic basket, seventeen inches in diameter, with a large, cherrywood plaque at its center. All of the Ottisons' covers are made freehand, without molds.

Opposite: The Old Mill (constructed in 1746) is the only one remaining of the four windmills that once stood on Mill, or Popsquatchet, Hills. The island's earliest mill was a water mill at Lily Pond (1666), followed by a tide mill (1675). Windmills were the predominant power source in the eighteenth century, but they became obsolete around 1800. In 1822, Jared Gardner paid $40 to buy the structure for firewood (a scarce commodity at the time); upon further inspection, he decided it would be a more valuable investment repaired than dismantled.

The Nantucket Historical Association acquired the Old Mill at auction in 1897 with funds provided by Caroline French, the benefactor of St. Paul's Church. The mill has since been restored to full operating condition, and is open to visitors, who may purchase cornmeal ground on the premises.

It is a testament to the mill's original designer and builder, Nathan Wilbur, that it is still going strong. The structure is held together by hickory wood pins; nails were too expensive then, and bolts were unknown. The top rotates into the wind with the help of a fifty-foot mast, which revolves around a circular stone track on the ground. (The mast currently in use was taken from the old sloop *Allen B. Gurney* in 1921, when it was converted to a teashop moored in the Easy Street Basin.) Canvas sails added to the blades catch the breeze. A brake activated by an oak beam and heavy stones prevents the blades from turning too fast. The "nether" (lower) grindstone is actually on the second floor, allowing cornmeal to be poured into a hopper below while it is being ground. The two-ton grindstone can be raised or lowered, depending on the friction required to balance the wind's velocity.

Above: The Fire Department's headquarters on Lower Pleasant Street (built in 1981). The department currently numbers twenty-one permanent employees and fifty volunteers. Until about 1900, most fires were fought using bucket brigades, since hoses were often too short to reach cisterns or other water sources. Each house was equipped with leather buckets used to draw water from the nearest cistern; the buckets were then continuously passed down to a hand-operated pumper. Sometimes a trough was dug next to the pumper to collect rainwater. Pumpers were operated by rival teams who would occasionally engage in fisticuffs while a house burned to the ground behind them.

The Hezekiah Swain house, One Vestal Street (1790). This is also known as the "Maria Mitchell House" after its most famous resident. Mitchell's father, William, purchased the residence shortly before she was born in 1818. He taught her mathematics and astronomy, and by the time she was twelve, she had charted a solar eclipse. Sea captains became aware of her skills and started bringing their navigational equipment to this prodigy to be checked and recalibrated. She passed her evenings on Vestal Street, studying the sky through her father's British-made Dolland telescope.

The family moved in 1836 to an apartment over the Pacific National Bank, where Mr. Mitchell was the treasurer. Cautious depositors, unaccustomed to entrusting their savings to a bank, were reassured by having a responsible party in residence upstairs. The Vestal Street house remained in the Mitchell family until 1903, when the Maria Mitchell Association purchased it.

In 1847, Maria Mitchell became the first woman to discover a comet, an unusual feat in an era when telescopes were still relatively primitive. She went on to become the first woman admitted to the American Academy of Arts and the first female professor of astronomy at Vassar College; she may have even been the first female professor in the country. Newly formed

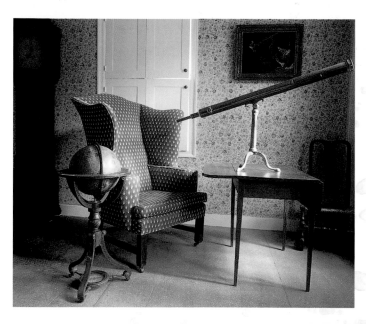

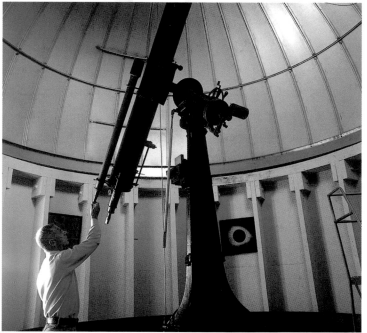

Vassar was itself an unusual institution at the time, dedicated as it was to the advanced education of women.

Above, top: This is the front sitting room of the Maria Mitchell House; it shows the three-inch refracting Dolland telescope, made in London in the early 1830s, that William Mitchell gave to Maria. The wing-back armchair also belonged to William, but he kept it. It was eventually donated to the Maria Mitchell Association by his grandson. The celestial globe dates from circa 1850 and was part of Maria Mitchell's collection. The tall case clock with the graceful bonnet top at the left of the window was made in 1789 by John Deverell in Boston and it was a wedding pres-

ent in 1812 from William Mitchell's father to William and Lydia Mitchell.

Above: In the Maria Mitchell Association's Loines Observatory is a refracting eight-inch instrument made in 1913 by the most famous American telescope maker, Alvan Clark. As with all Clark telescopes, this one produces very clear images through its double objective lens. It was donated to the Association in 1959 by Emma Loines, an educated amateur astronomer who owned several Clark instruments. In 1967, the dome was built especially for this telescope and named for her. The Association's Director of Observatories is shown here adjusting it.

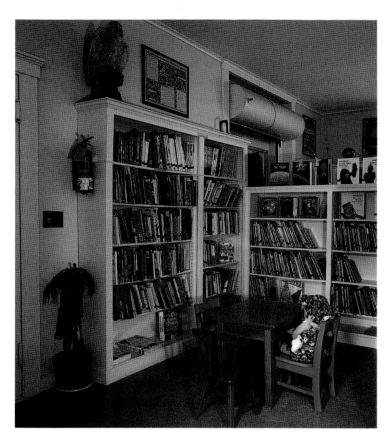

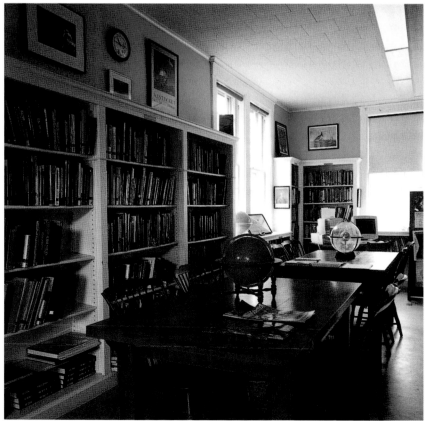

Opposite: These are interior views of the Maria Mitchell Association Library at Two Vestal Street. The library specializes in science books (especially astronomy) and literature, as well as the natural sciences (botany, ornithology, and nature studies). It contains more than eight thousand volumes. Through the library, the Maria Mitchell house, and the Hinchman House (a natural history museum), the Maria Mitchell Association receives more than 16,000 visitors a year. It is indeed an active and unique institution on the island, unique in that it is not even related to whaling.

Above: In the adjacent Hinchman House, now part of the Association's campus, is a large collection of birds donated by the Boston Museum of Science. This house, located at Seven Milk Street, was originally built by Thomas Coffin in 1810. It was purchased by Maria Mitchell's niece, Lydia Mitchell Hinchman, and willed to the Association in 1944. The Hinchman House is the focal point of the Maria Mitchell Association's Natural Science Department and contains a wildlife museum and gift shop. An extensive summer program is designed to put individuals in direct touch with the environment through experience and research, with emphasis on local ecology, birds, wildflowers and animals. The museum, research library and active summer camp program for children all make for a most successful organization that contributes to the island's interesting diversity.

Figureheads of Admiral Nelson (*above*) at Val Maitino's Antiques and Commodore Oliver Hazard Perry (*opposite*) at Sam Sylvia's Antiques. Nantucket figureheads evoke its nautical heritage. The practice of ornamenting ships' bows with good-luck emblems is an ancient one. The Egyptians painted eyes on the prows of their boats to help them safely find their way, the Romans mounted sculptures of boars and swans on their galleys, and the Vikings are legendary for the fierce mythological monsters that loomed threateningly as protectors of their dragon ships. In the sixteenth century, figureheads represented patron saints. Later sculptures often depicted the person for whom the vessel was named.

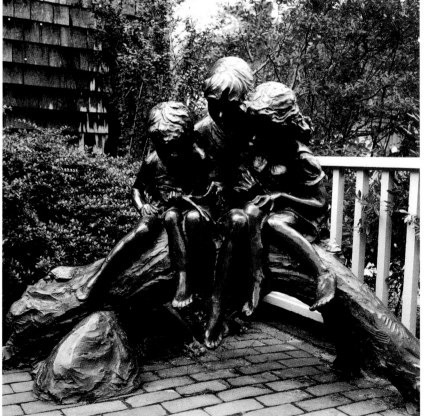

Outdoor sculptures at the Cavalier Gallery include: *Naiad # 4* by Glenna Goodacre (*above*), *Who's Watching Who* by Jane DeDecker (*left*) and *New Season* by Gary Price (*opposite*).

These bronzes are all made by the lost-wax process. After an initial sculpture is completed, a rubber model is made of it and filled with hot wax to produce a wax replica of the original. The wax replica is covered with several layers of liquid-refracting ceramic and fired in a kiln, allowing the wax to burn out and thus be "lost." Molten bronze is then poured into the ceramic mold at 2,100 degrees Fahrenheit. After it cools, the mold is carefully broken off. Additional steps finish the sculpture and give it the desired patina.

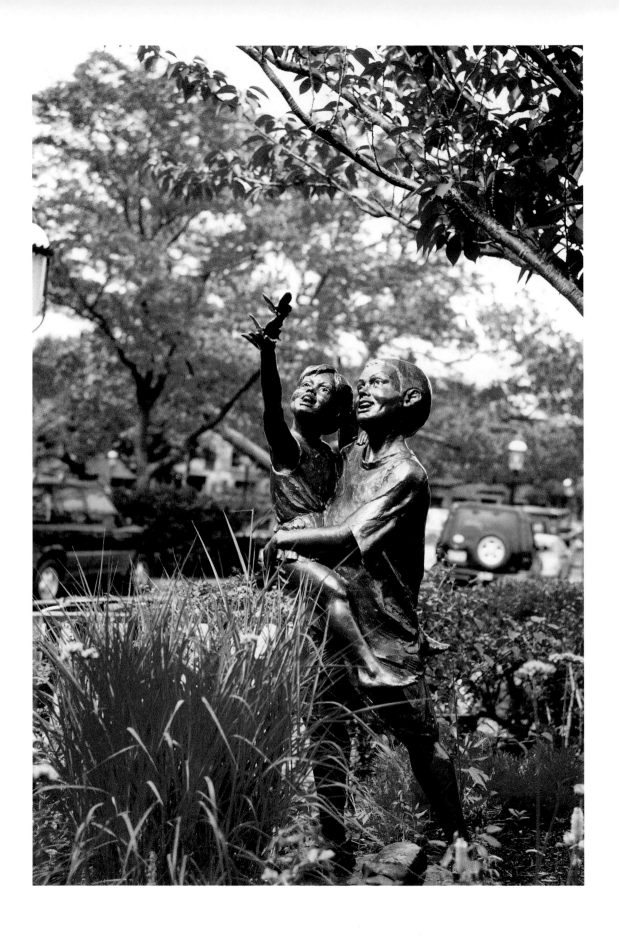

The Sailor's Valentine Gallery is located on Lower Main Street in the former Thomas Macy Warehouse (1846). This brick Greek Revival structure, with its pediment front gable, is similar in design to the Richard Mitchell & Sons' candle factory at 11 Broad Street, presently known as the Whaling Museum. Beginning in 1944, the Main Street structure was used by the Kenneth Taylor Galleries until the Nantucket Artists' Association took over in 1958. For many years thereafter, the Nantucket Historical Association operated several museum displays in the space until 1996, when it became home to the Sailor's Valentine Gallery (which had been established in 1981 at 40 Centre Street). The name comes from a form of folk art indigenous to the maritime history of Nantucket. Whalers away at sea for years at a time often fashioned mosaic arrangements of tiny seashells in compass cases and brought them home as gifts for their loved ones left behind. In creating these intricate works of art, the minds of the whalers' were reunited with the gifts' intended recipients.

The gallery represents an international collection of over sixty artists working in a variety of media. During the summer season, the exhibitions change weekly. Shown here are paintings by Denise Burns and Sonya Sklaroff and sculpture by Karen Petersen (*opposite, top*), an eel-grass boat turned into a sofa by Marcel Maison, paintings by Rachel Paxton and Lou Guarnaccia and sculpture by Swede Plaut (*opposite, bottom*), and paintings and limited-edition serigraphs by Ted Jeremenko (*above*).

In 1980, the gallery began a tradition of exhibiting contemporary sailors' valentines, rekindling an interest in a craft that had all but expired. This institution also provides a community service by hosting salons where independent curators, artists, musicians, and playwrights give lectures and workshops. Fundraising events that the gallery hosts or produces for a wide variety of non-profit organizations include those for the Nantucket AIDS Network, the Cottage Hospital, the Arts Alliance, the Arts Council, the African Meeting House, and the restoration projects of the Congregational and Methodist churches.

When Bill Welch, a skilled artist in oils and watercolors, came to Nantucket in 1967, it was his first encounter with the ocean. He fell in love with the island and has painted it ever since. Using over seventy different pigments, he paints in an impressionistic style and uses a challenging technique—painting from light to dark—which yields dramatic results.

He has been a *plein air* painter for over thirty years on the island, traveling the breadth of Nantucket to paint mostly street scenes, rose-covered cottages, and captains' homes. Welch is fascinated by architecture and its perspectives. The spontaneity of painting outdoors has always intrigued him, for the artist cannot control the scene or the light. He must interact with the environment and his subject, which is far different than painting in a studio.

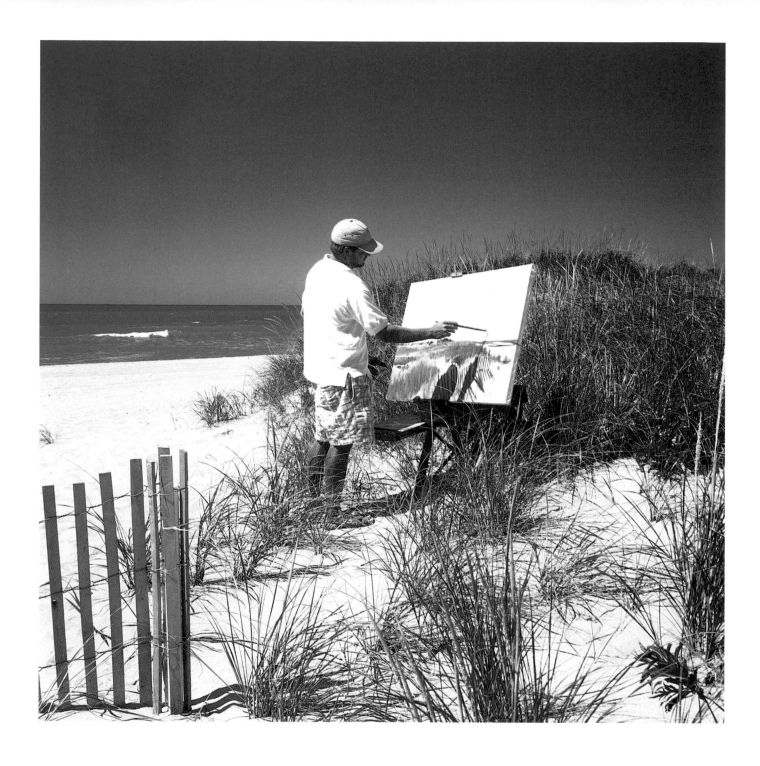

Illya Kagan has been summering on Nantucket since he was born. He now lives here year-round with his wife, children's book author and illustrator Wendy Rouillard.

He began selling his artwork at the Artists' Association of Nantucket in 1990. The sculptures of Vincent van Gogh and Thelonious Monk were photographed here. His first one-man show was at the Barker Gallery in 1991, where he had numerous subsequent shows.

Kagan's media are mostly oil and linen for painting, and terra cotta for sculpture. He also uses watercolor as well as pen and ink. For the past five years, Illya Kagan has painted in Aspen, Carmel, New York City, and on St. Bart's and Nantucket Islands. He takes his easel everywhere, even going so far afield as Provence and Tuscany.

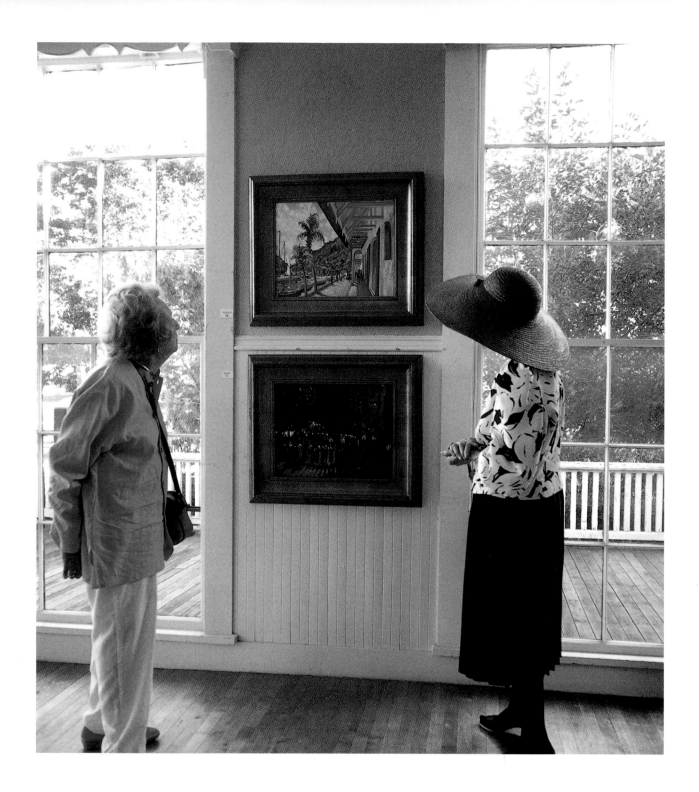

One of Illya Kagan's recent exhibits in the great ballroom of the Point Breeze Hotel on Easton Street, which was built by Elijah Alley in 1891, purchased by Charles Folger and expanded in 1904. For many years, it was known as the Gordon Folger Hotel. The establishment boasts three full floors, all recently renovated, and a high basement where a bowling alley and billiard room were once located. The hotel had its own generating plant and telephone system—both of which were unusual in their day. The ballroom is the largest of any hotel on the island and can accommodate up to 250 guests.

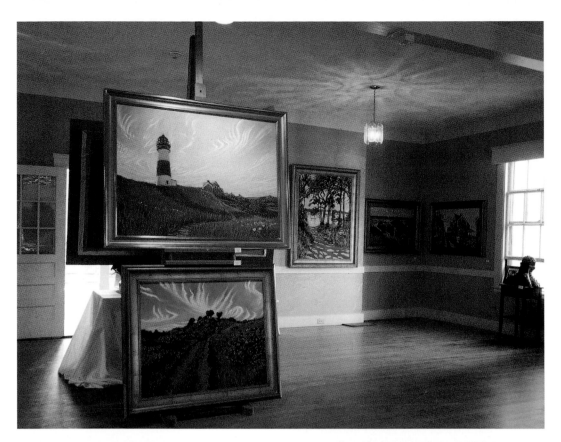

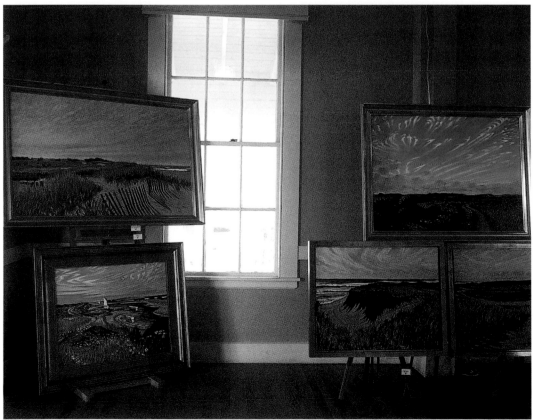

137

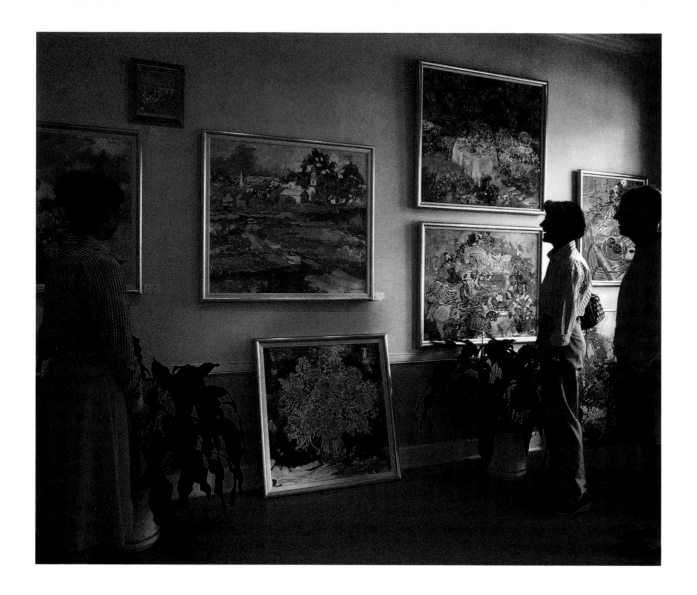

Sybil Goldsmith and Main Street Gallery. The Main Street Gallery originally opened in 1970 at 19 Main Street. Its founder was Reggie Levine, who was moved to open the gallery because there were only two other such spaces on the island at the time: the Lobster Pot and the Artists' Association's Kenneth Taylor Galleries. The new Main Street Gallery attracted a stable of accomplished artists who showed there for the ensuing decades, even as it moved to Federal Street and then on to 50 Main Street, where the photograph above was taken.

Long a mainstay of Nantucket's art world, Sybil Graham Goldsmith is equally at ease with a paint brush in her hand as with a number three wood. My grandparents used to call these spoons (a "driver" was a number one wood while a "brassie" was a number two wood with a brass-plated head); they were friends of Sybil's grandparents in Englewood, New Jersey. The latter couple began summering on Nantucket in 1915. Sybil spent her childhood summers with them here, first at Siasconset, then at Polpis and Quidnet. She took up both painting and golf at an early age. The two inclinations were apparently genetic: her

grandfather was a co-founder and President of Sankaty Head Golf Club, and her grandmother started an antiques shop called Squantum.

Sybil has always painted, whether doing textiles, landscapes or portraits. She has completed over three hundred portraits, showing some of them with the Royal Society of Portrait Painters in London in the mid-1970s. She works very closely with her subjects, getting to know their personalities, and has a particular ease in handling moving targets—which stems from her many years of painting in her home, with children and interruptions all around. "I painted in the kitchen and got interrupted there, and I painted in the children's room and got interrupted there," she says now. "I trained myself to paint no matter what was going on. It's like a state of mind. When the children got into the paint, I'd just clean it up and go back to work."

Today there is still a steady stream of grandchildren and friends constantly moving through her studio. She no longer paints in the kitchen or the bedroom, but in an airy, light-filled

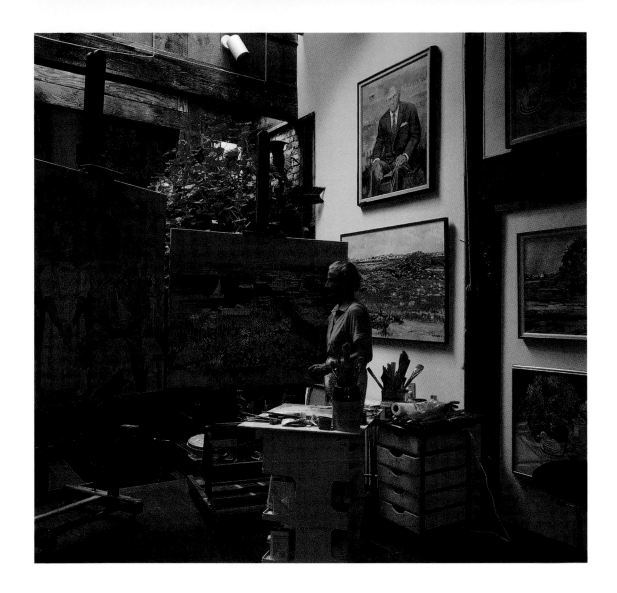

studio designed by her son, Graham Goldsmith, and located behind her eighteenth-century home on West Chester Street. The house is truly a fascinating place, filled with the varied memorabilia of a full life. In the living room of the West Chester Street home hangs her grandmother's wedding gown (Worth, Paris, 1880). On the coffee table is a brass fireman's hat, which served as her rain hat at Sarah Lawrence College. She also has a collection of miniature furniture made by an eighteenth-century cabinetmaker for sales purposes, and a collection of "whimsies" made of one piece of wood with numerous chambers with free-floating globes and cubes by sailors at sea. (Sybil Goldsmith has made whimsies herself, as well as needlepoint pillows of her cat and dogs. But, fortunately, she always returns to painting.)

Sybil taught painting for almost twenty years, which forced her to verbalize to others what she was doing instinctively. Her approach, which relies heavily on spontaneity, entails encouraging others to get into the canvas and just throw the paint around. She also believes in the "immediacy of perception"—in drawing one's attention right away, creating something that catches the eye and mind quickly. In isolating these types of images and infusing them with her vivid imagination, she creates Nantucket landscapes that often take on an element of fantasy. Her own emotions combine with bright colors and billowing clouds, bringing elements from all around the island together into one unforgettable scene.

Sybil's spontaneity is aided by the music she listens to as she paints, which is rap. She does a twist, pokes her brushes in the air, and transfers the same exuberant motion to the canvas. She likes the rhythm and short beat of the rap music and, as she says, "You can't paint to country music."

For over thirty years she showed at the Main Street Gallery in town and has been a close friend of Reggie Levine. Her shows there always sold out. The photo (*above, left*) captures one of these exhibits, which took place in 1985. Currently she shows her work by appointment, and continues her prolific output with the same cheerful and ebullient style that has become her trademark.

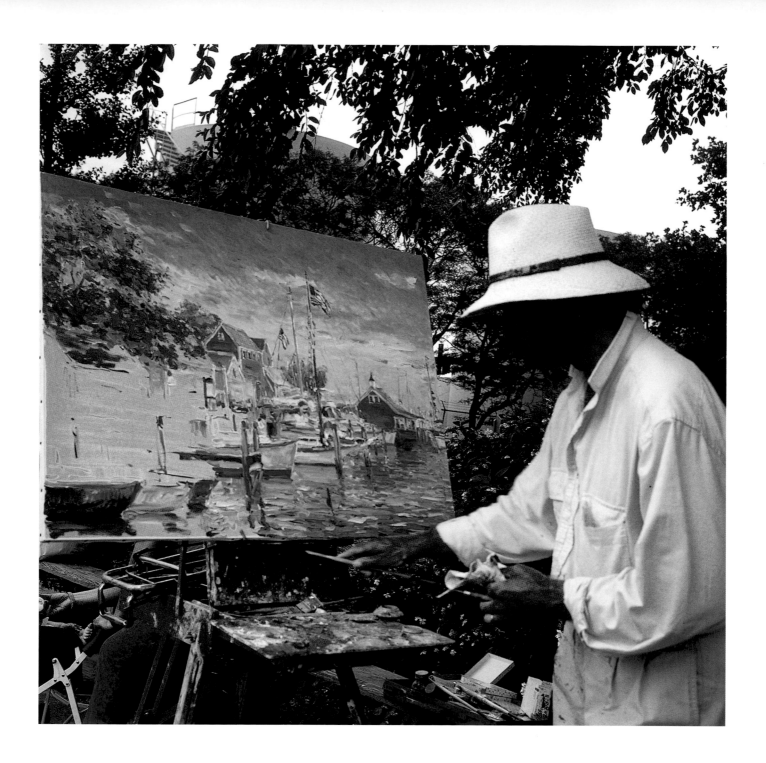

Above: and *opposite, bottom:* These artists are using oil paint with a difficult palette-knife application. Before the sixteenth century, other media such as tempera predominated; but by the early seventeenth century, oil paint had become the most prevalent medium in Europe.

Opposite, top: A diligent needlepoint craftswoman outside her studio on Old South Wharf. Erica Wilson was largely responsible for reintroducing this popular form of needlework to Nantucket in the 1960s.

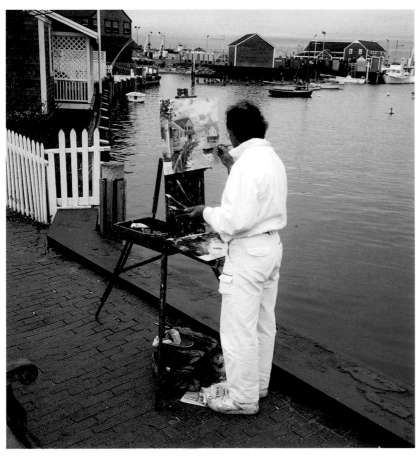

141

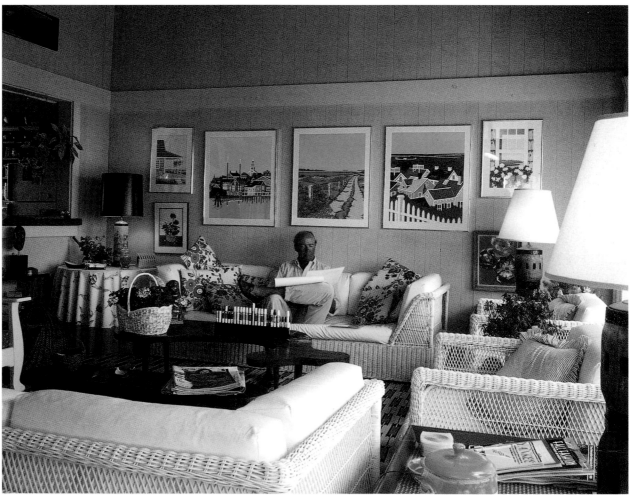

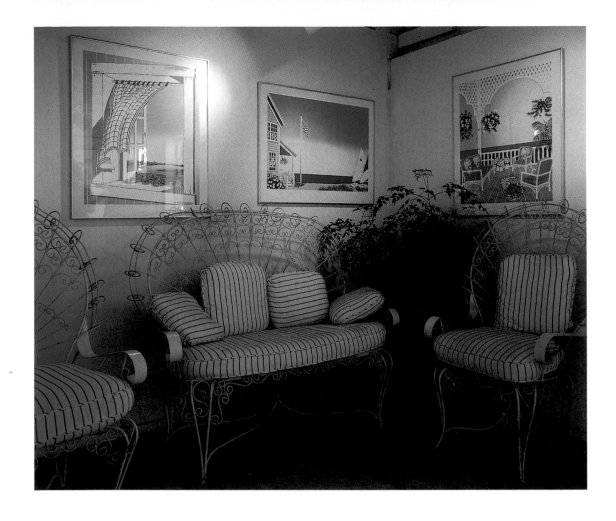

The Eric Holch Gallery and glimpses of the artist's vivid silk screens. Even in midwinter, his brilliantly colored prints evoke memories of sun-drenched, carefree summer days. To achieve the distinctive, crisp look of these serigraphs, Mr. Holch applies each color in a separate pull, often using up to fourteen colors in a single image. He generally limits each series to two hundred prints. The artist has been coming to Nantucket since 1950.

Eric Holch produced his first serigraph, or silk screen, in 1976 when he was twenty-eight and working for an advertising agency in Riverside, Connecticut. He sold it right away at the Main Street Gallery and decided to pursue what seemed like a fun adventure. Over one hundred limited-edition scenes have evolved since then.

In 1977, he joined George Davis, Sybil Goldsmith, Cynthia Lyman, and Bruce Dilts at the Granary Gallery on Old South Wharf. In 1993, he and Betsy Holch opened their own gallery in what was the last shucking shack to be converted to gallery space.

Silk screening (also known as serigraphy) is a form of print-making where inks or pigments are passed through fabric stretched across a frame. The color is applied starting from one end of the frame and is drawn across the picture with a flat tool, such as a squeegee. Masks are applied to the image to block the areas not receiving a certain color. A comparable form of stencil painting was used in China beginning around A.D. 1000. In Europe, however, serigraphy was generally unknown until the nineteenth century, and even then it was mostly confined to fabric design. American artists adopted the technique in the early 1930s, and silk screening grew in popularity as a taste for bold, vivid patterns and colors developed in the 1960s.

Eric Holch first starts with a sketch laid out with design markers and then uses color swatches to select the color and sequence. Unlike oil painting, in serigraphy the color progresses from light to dark. The artwork comes alive with each color application. The process is so precise that a large print can take four months to complete (and that includes drawing, editing, and printing). Holch is drawn to flat planes, bold colors, and an absence of interfering detail—it is a bit like looking through squinted eyes. He emphasizes strong light, which helps to wash out the detail, leaving only the essence.

An extension of his fresh look at familiar objects is his line of bold neckties, which brighten many corporate boardrooms around the world.

The photograph above was taken at the Granary Gallery on Old South Wharf, formerly known as the Island Service Wharf. A grain-storage facility did, indeed, once occupy this site. "Granary" comes from the Latin *granarium* and is where grain, or *granum*, is stored. Grain or corn brought over from the mainland was kept here.

Above: NARTA is the Nantucket Regional Transit Authority. It was formed in 1995 to reduce traffic congestion during the summer months. At first the rides were free and the riders skeptical; now there is a modest fare, and the service has grown in popularity, offering a pleasant alternative way to get around the island. From Memorial Day through early October, nine buses provide service to and from 'Sconset and various mid-island destinations and beaches. The buses are equipped with bicycle racks on the front.

Opposite: The Gaslight Theatre at One Union Street was opened in 1974 in the former Wanacomet Water Company garage. It seats about one hundred moviegoers and still offers real butter on the popcorn. Initially, the theatre specialized in silent films, but "talkies" have since been added. The adjacent White Dog Café opened in 1978 and is named after the proprietors' pet.

Early evening downtown, with views of some of the shops along India, South Water, and Main Streets. The Camera Shop and Wayne Pratt's antique store on Main Street occupy a handsome brick structure that was built in 1892 and remodeled in 1912. Many of Main Street Square's brick buildings, known as "blocks," were designed for several tenants.

The timelessness of Nantucket is uniquely reassuring. The town's history is displayed in a quiet, fulfilling way, reminding visitors and residents of the people and events that preceded us, at the same time reminding us of a continuity that will be with us tomorrow.

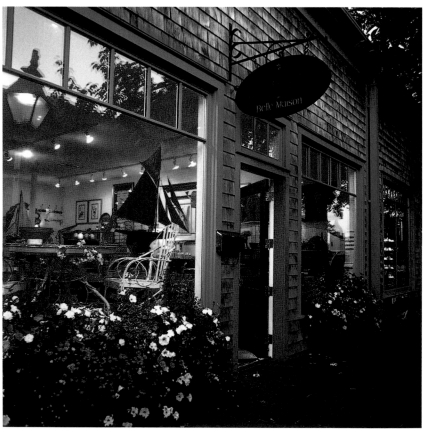

Main Street shops near the horse fountain. When Main Street was widened after the Great Fire, the stores where the Nobby Shop now stands were the only ones rebuilt on their original sites. Their construction was financed by Peter Folger, whose handsome brick residence at 58 Main Street helped to brake the westward advance of the flames.

The antiques store (*left*) is in an 1888 structure that has also been home to Hardy's and the A&P. The latter first opened on Nantucket in 1922, with a branch in the small, white structure at the Civil War Monument further up Main Street. It relocated to new quarters adjacent to the Nantucket Boat Basin in 1967, when Hardy's moved in.

The 1947 Ford Deluxe Station Wagon came to the island as a baby and has never ventured off since. Ford made the same car from 1941 to 1948, curtailing production during the war years.

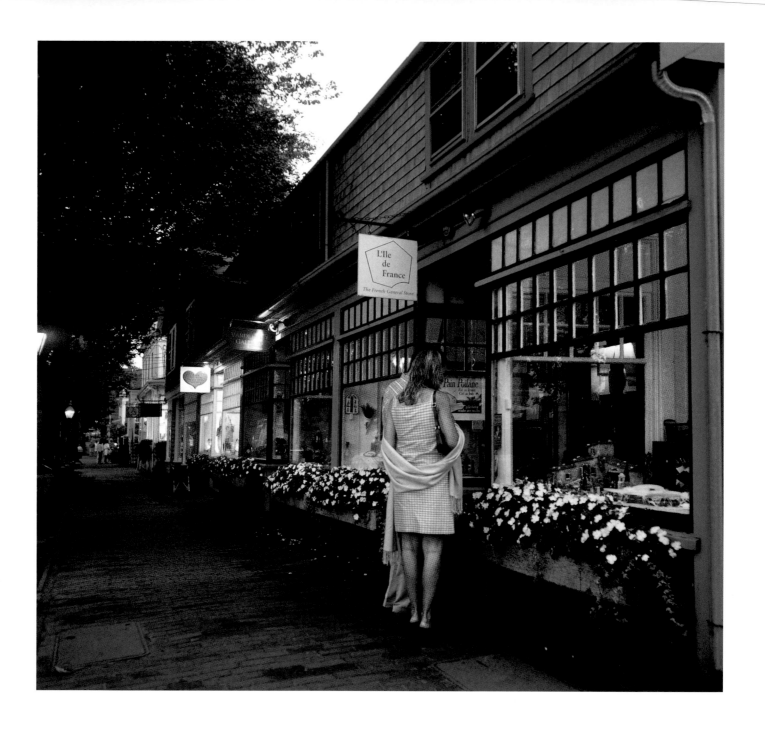

Shops along Federal, India, and Main Streets. India Street was part of the layout of Wescoe Acre Lots in 1678 and thus, along with Centre, is one of the island's oldest streets. It was originally called Pearl Street but by 1811 became known as India Row, after the number of residents who lived there with ease and affluence. The upper part of India Street dropped the name Pearl, and by 1960 the entire stretch had adopted one name.

Opposite, top: Coffin's Gift Shop is one of the island's oldest businesses. It was located at 51 Main Street for over fifty years before relocating to lower India Street.

Opposite, bottom: The building adjacent to Coal Alley was occupied by the Union News Room and, upstairs, by the *Inquirer and Mirror* until the latter moved across the street to a location above Mitchell's Book Corner in 1887. The *Inquirer,* one of the oldest continuously published newspapers in the country, was started in 1821. The *Mirror,* launched in 1845, merged with the *Inquirer* in 1865. When I was growing up, the paper still had a large blanket format that required long arms to hold it open. Since I did not yet have long arms, I spread it out on the table.

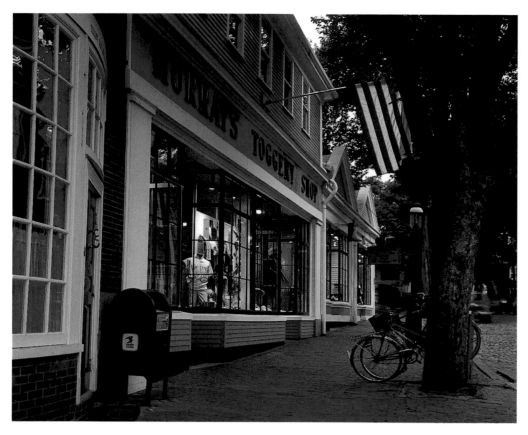

Upper Main Street and Centre Street. *Opposite, top:* Murray's Toggery Shop is located adjacent to the first R. H. Macy dry goods store prior to its relocation to Manhattan. *Opposite, below:* The Quaker Meeting House, 28 Centre Street. This simple, Greek Revival-style building was built in 1850 as the Centre Street Gurneyite Meeting House, the last such meeting house built on Nantucket. The Gurneyites were one of three Quaker factions on Nantucket and followed the teachings of Joseph John Gurney, who felt that "scriptural authority outweighed personal revelation." Meetings were held in this facility until 1897, when there were only three surviving members. Later it was used as a Baptist church, and afterward as a dining hall for the adjoining Bayberry Inn (now the Roberts House). Adjacent to the meeting house is a series of shops gathered around a courtyard. *Above:* Evening strollers contemplate the offerings of the Nantucket Gourmet as one of its attendants takes a break from duty.

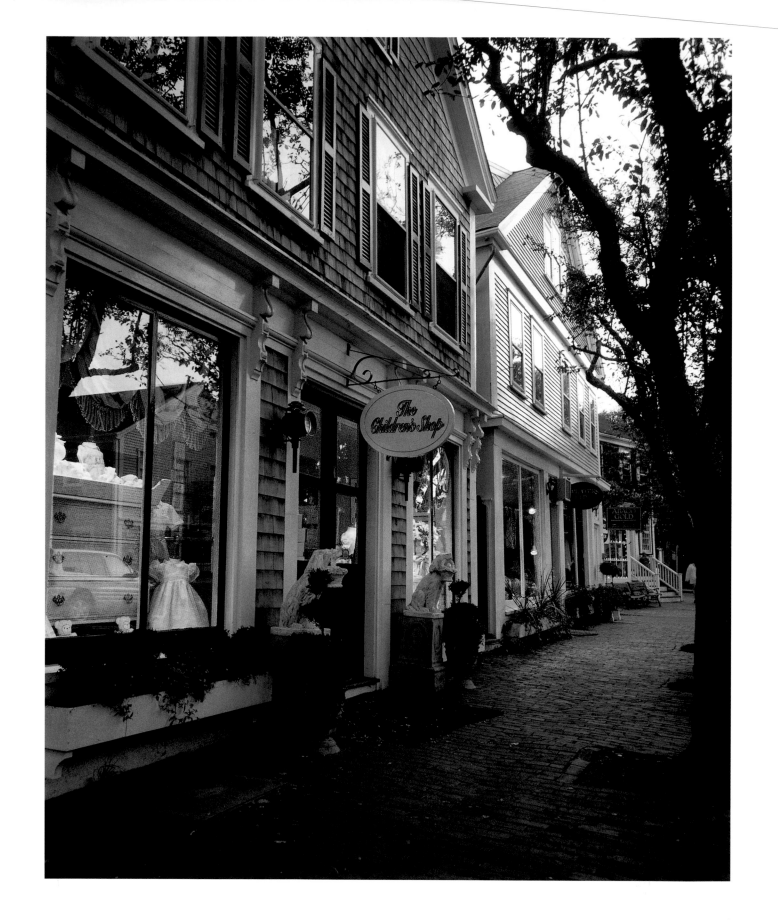

Opposite: Galleries and shops line the stretch of Centre Street between Main and Broad Streets. *Right, top:* The guest house and shop were moved to this corner of Hussey Street in 1900 from Howard Street. *Right, bottom:* The building at 14 Centre Street is only one of two structures on this block to survive after the 1846 fire, the other being its larger neighbor to the south, the Methodist Church. At the time, it was Mr. Upham's residence, with two shops on the street level and living quarters above. The large, plate-glass windows are from a more current period.

Centre Street, once cobblestoned, was originally laid out as part of Wescoe Acres Lots in 1678, and, together with Broad and Pearl Street, is one of the island's oldest thoroughfares. Wescoe, from the Indian word meaning "white stone," is believed to describe the quartz blocks underlying sections of this area. The Wescoe Lots were bounded by Liberty Street to the south, Broad Street to the north, Federal Street to the east, and Gardner Street to the west.

In the first quarter of the nineteenth century, downtown Nantucket buildings were built using a variety of materials and styles (such as timber-framed, clapboard, or shingled), with little or no separation between structures. The Great Fire of 1846 obliterated thirty-six acres—or one-third—of the town's buildings, along with immensely valuable inventories of whale oil and other valuable commodities stored in downtown warehouses. A brief surge of rebuilding ensued, which included the renovation of the magnificent Atheneum; but the whaling industry began a steep decline, and the island temporarily lapsed into a scarcely known backwater.

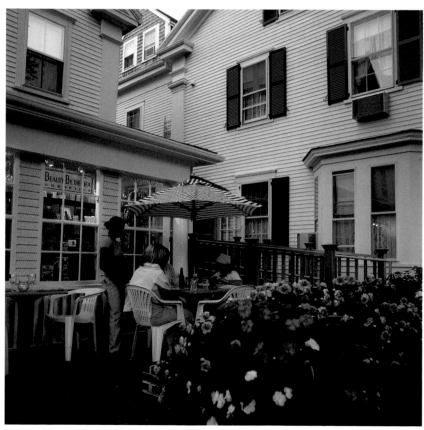

Opposite, top: A gift shop at 46 Centre Street, originally built in 1760 as a residence for Captain William Brock. It was later the home of Captain George Pollard, whose ship *Essex* was rammed by an angry whale in 1820, leaving him and a few other survivors to spend a hellish three months at sea in an open whaleboat. The grim story, powerfully recounted by Nathaniel Philbrick in his recent book *In the Heart of the Sea*, was Herman Melville's inspiration for *Moby Dick*.

The Seven Seas Gift Shop was started in the early 1960s by Fran Howard and her husband. They also ran the Port of Call Gift Shop on Lower Main Street. Fran encouraged me to produce small, black-and-white photographs of Nantucket scenes, which I mounted and sold in her shop. The retail price was $6.50. This was the start of my professional photographic pursuits. Now the prints go for more, but I prefer to concentrate on the book format.

Opposite, bottom and above: *Alfresco* dining is popular during the summer months, as evidenced by these customers, eating out on Federal Street and Centre Street. "Petticoat Row" earned its name not just because long voyages by the whalers left their wives in charge of the businesses there, but because the island had a historical acceptance of strong and capable women doing advanced work in their fields. They were teachers, abolitionists, astronomers and mostly Quakers: the Society of Friends believed in the equality of men and women in all aspects of life. In other parts of the country a woman's place was in the home, but on Nantucket, a woman in the workplace was typical.

The standard set by Mary Starbuck, who adopted the Quaker faith in 1701, opened doors for women on Nantucket as much as whaling did. As Main Street became the location of the island's service businesses (ships' outfitters, candle factories, and tobacco shops), Centre Street became the dry goods and commercial street. Women were at work here and also at stores all over downtown and eventually in Siasconset.

Even today, half of the shops on Main and Centre Streets are run by women either solely or in partnership with their husbands. They also run most of the island's publications.

Shops are open on evenings during the summer. *Opposite*: The building that houses Four Winds Gifts first started life as the Old Blacksmith Shop (circa 1855). Before it became Four Winds, it was Morgan Levine's craft shop. Mr. Levine was the first one who saw promise in my photography; he gave me encouragement that no one else had previously. *Above*: A stroll along Main Street after dinner is pure delight. It would be nearly impossible to visit all the shops in one evening, so it is best to select a few here and there, taking a meandering course that may end up at the Boat Basin and South Wharf, or perhaps at the Espresso Café for some ice cream. The pace is slow during Nantucket summers, and there is usually no pressing agenda.

Opposite, top: The Pacific National Bank, 61 Main Street (built in 1818), is the finest example of pure Federal-style architecture on the island. Walls of Flemish brickwork (alternating stretchers and headers in each course) surmount the raised granite foundation. Two bays were added along Main Street in 1894. On the roof is a small observatory installed by William Mitchell, the bank's treasurer from 1837 to 1861. A former teacher, he had a longstanding interest in astronomy, which he passed on to his more famous offspring, Maria; she went on to become one of the country's foremost astronomers.

Opposite, bottom: The Peter Folger house (58–60 Main Street), now in commercial use, was originally built in 1831 as a residence, and was the second all-brick house after Jared Coffin's "Moor's End." The architect, inspired by Asher Benjamin's work on Beacon Hill, used curved façades and harmoniously combined Federal and Greek Revival elements. After the fire of 1846, the house was converted to storefronts with floors lowered to street level. R. H. Macy & Co., the dry goods store, was among the tenants. *Above*: One of the enticing shops on Centre Street, in an 1850 structure.

Straight Wharf (*above*) and Centre Street (*opposite, top*). This wharf was built in 1723 by Richard Macy essentially as a direct extension of Main Street—hence its name. It is believed to be in the same location as a wharf built by cooper Joseph Coffin in 1716. Since its inception, Straight Wharf has been most closely associated with fishing. During the boom whaling years, thousands of ships tied up here, loading and unloading, and all of the businesses on and around the wharf were whaling-related. The successful whaling merchant William Rotch built his familiar red-brick warehouse on this thoroughfare in 1772. He supervised the construction of hundreds of ships, including the *Dartmouth* and *Beaver*, which were involved in the "Boston Tea Party" in 1773. Like many other whaling merchants, Rotch had an ownership in Straight Wharf.

The Great Fire of 1846 destroyed the wharf; but despite the overall economic setback caused by the fire, Straight Wharf was rapidly rebuilt—so important was it to Nantucket's welfare and way of life. One of the first structures built along its way was Thomas Macy's brick warehouse, which has recently served as an art gallery.

With the collapse of whaling, Straight Wharf entered a new commercial chapter as a lumber and coal yard. There were grain warehouses and an ice house. Today, the wharf is as busy as ever, as it is the embarkation point for Hy-Line and other cruise vessels, fishing and excursion boats, and various types of pleasure yachts.

Where Main Street and Straight Wharf officially join hands is Harbor Square. This area was enlarged by Sherburne Associates in 1964 when the wharf and marina were constructed. A new tavern restaurant and expanded bandstand gazebo have now become many visitors' first destinations when they arrive on the ferries. Summer concerts, for many years held at both this location and also further up Main Street, are now conducted on the great lawn at Children's Beach. *Opposite, top*: The parasols are in the window of the Centre Street store Irresistibles, before it became Weeds.

Opposite, bottom: Cap'n Tobey's Chowder House opened in 1954 in the facilities of a former ice plant. The lounge area still has freezer walls. The restaurant specializes in quahog chowder, as well as other family-style seafood dishes.

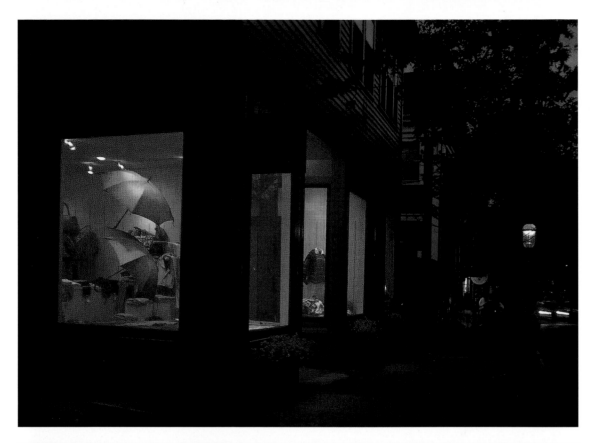

Old South Wharf. Shown here are Barbara Capizzo's gallery (*above*), Barbara Van Winkelen's gallery (*opposite, below*), and The Old South Wharf Gallery (*opposite, top*). The Old South Wharf gallery shows a variety of artists' works, with a new exhibit each week during the summer. It is run by Mary Beth Splaine and represents many of the island's finest established artists as well as its up-and-coming new artists.

The wharf was built between 1760 and 1762 and known simply as South Wharf. (It was not considered old at the time.) It was the third wharf built, constructed when whaling was on the rise. It was a busy wharf serving the whaling industry and, during the twentieth century, was referred to as Island Service Wharf. The many fishing shacks and the grain elevator that occupy the wharf date from its earlier industrial period.

Nantucket has been attracting artists since the late 1700s. First came the topographical painters, followed by landscape, portrait, and genre painters. In 1870, Eastman Johnson purchased a home on Cliff Road and painted memorable scenes for the next twenty years. Other notable artists have worked on the island: George Innes, Childe Hassam, and Theodore Robinson.

In the early 1900s, several artists joined with Florence Lang to develop an artists' colony. Mrs. Lang turned an old hot-and-cold saltwater bathhouse on Easy Street into a gallery for artists, which displayed summer exhibits until 1943. In 1920, she renovated former fish houses and scallop shanties and rented them to artists as studios. She also turned a candle factory on Commercial Wharf (now Swain's Wharf) into an exhibition space.

In town, a summer Sidewalk Art Show, organized by Maude Stumm and Ruth Haviland Sutton, ran from 1930 to 1983. The Kenneth Taylor Galleries opened in 1944 in the Thomas Macy Warehouse (built in 1846) on Straight Wharf. (This is presently the home of Sailor's Valentine Gallery.) That following October, a group of island artists joined to form the Artists' Association of Nantucket. It held annual exhibits at the Kenneth Taylor Galleries until 1988, when it moved first to the Little Gallery next door and then to its own, new space on Washington Street.

The Lobster Pot Gallery opened in 1960 on Old South Wharf. The wharf was completely renovated in 1967 and turned into the island's premier artists' colony.

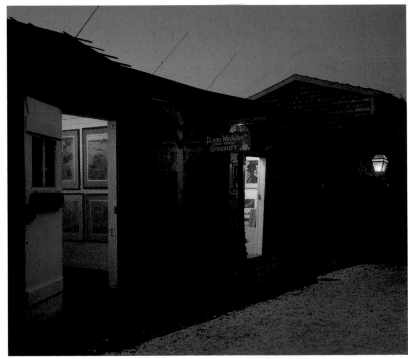

Above: The galleries of Old South Wharf are asymmetrically laid out along an open courtyard. Some façades seem to push forward, others to recede; but the ensemble is unified by colorful flowerbeds and the bustle of summer visitors, interspersed with artists and their easels. Robert Perrin was one of the first painters to open a gallery on what was then called the Island Service Wharf. Other well-known artists who show or have displayed their work here include Sybil Goldsmith, Greg Hill, Donn Russell, Barbara Cocker, Tom Mielko, Kerry Hallam, David Hostetler, Eric Holch, and Illya Kagan.

Opposite: Dusk at the Steamship Authority on Steamboat Wharf. This is Nantucket's northernmost pier and was once known as New North Wharf. It was built for the packet boats and was the regular point of debarkation for island passengers. From 1881 to 1917, the Nantucket Railroad had its terminus here, running branch lines to Surfside and Siasconset. It was rebuilt in 1915 and is now owned by the Woods Hole, Martha's Vineyard and Nantucket Steamship Authority.

166

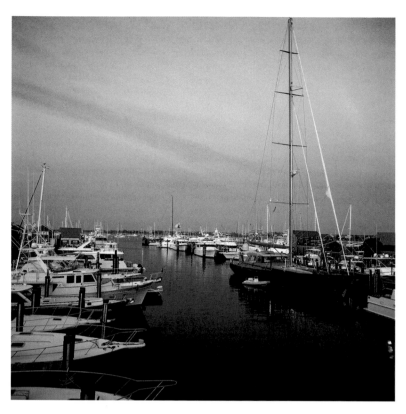

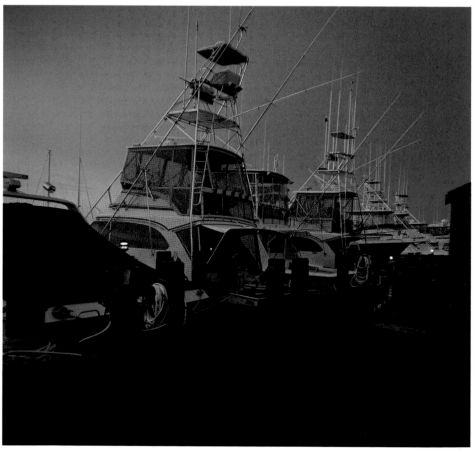

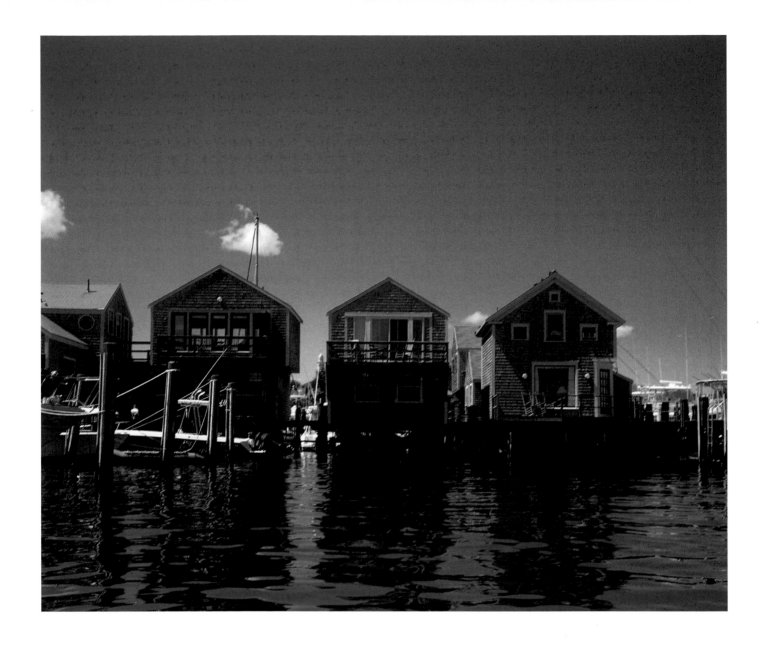

Swain's Wharf. The last of the five major wharves to be built was Commercial Wharf in 1816. It was an extension of Coffin Street. The principal backers were Gilbert and Zenas Coffin, who ran their whaling operations from a brick warehouse at the head of the wharf (which later became the headquarters of the American Legion). Commercial Wharf, which was acquired by Obed Swain in 1950, who then changed its name, was one of Nantucket's busiest. It is also still the only one with a base of granite blocks, enabling the wharf to support considerable activity. Among the businesses located on the wharf were a candle factory and a sail loft. Both this and South Wharf survived the Great Fire and saw their commerce increase dramatically while the other wharves were being repaired. Today, Swain's Wharf is all residential—with family-owned cottages nestled among the overnight accommodations of the Nantucket Marina. And, like Old South Wharf, Swain's has slips of motor yachts flanking its sides from June through October.

At the end of the day, yachts tie up at the Nantucket Boat Basin. *Opposite, top*: A ninety-foot Helios cutter rig keeps company with power cruisers This photograph was taken from the upstairs balcony of the Anglers' Club. *Opposite, bottom*: A row of sport fishermen tied up on outer South Wharf at sunset. The boat in the center with the tall fishing bridge is named *Impaction*. It is owned by a dentist.

Above: The Nantucket Boat Basin offers twenty-five cottages on stilts to rent for vacationers planning longer stays on the island.

Dawns and sunsets over the waters of Nantucket are a spectacular sight. When close to the horizon, the sun's rays pass through a denser layer of atmosphere than when they come from directly overhead. At noon, the shorter light waves from the blue zone of the spectrum collide with atmospheric particles and are scattered. The longer, red light waves of daybreak and nightfall penetrate the atmosphere more strongly, therefore accounting for the wonderful warm hues that we experience during these ephemeral transitions between night and day.

In this photograph, the open arms of the marina stretch out to embrace the sunrise. Everything remains quiet except for the gentle waves lapping against hulls, the creaks of stretching hawsers, and the occasional cry of a gull.

The Nantucket Boat Basin owes its origin to Walter Beinecke Jr., an heir to the Sperry and Hutchinson Company, which produced green stamps. In 1960, he was pondering ways to revive Nantucket's slumping economy. He decided that a revitalization of the harbor, and the creation of a first-quality marina as a destination for motor yachts, was the only way to go. Once the boats started to come, other visitors would surely follow. The question was, where to locate the marina? Two consultants arrived independently at the same conclusion: build it in the section of Monomoy called the Creeks—a modern, steel-and-cement marina. But Mr. Beinecke reasoned that it would be too far away for the yachtsmen to take advantage of the town. His objective was to revitalize *all* of Nantucket, which meant the shops and restaurants as well as the marine fuel pumps. Instead, he launched a somewhat controversial plan of revitalizing and rebuilding the harbor front with the Boat Basin as its leading edge. Like Robert Moses in New York and others along the way whom we now regard fondly, Beinecke went through his share of angst. Under Sherburne Associates, he became a one-man development agency. He put people to work to kickstart the tourism industry, and this, in turn, created more jobs and opportunities for the island. In the process, he acquired two downtown hotels, which are now part of Nantucket Island Resorts. Much of the remaining retail property is part of Winthrop Corporation's investments.

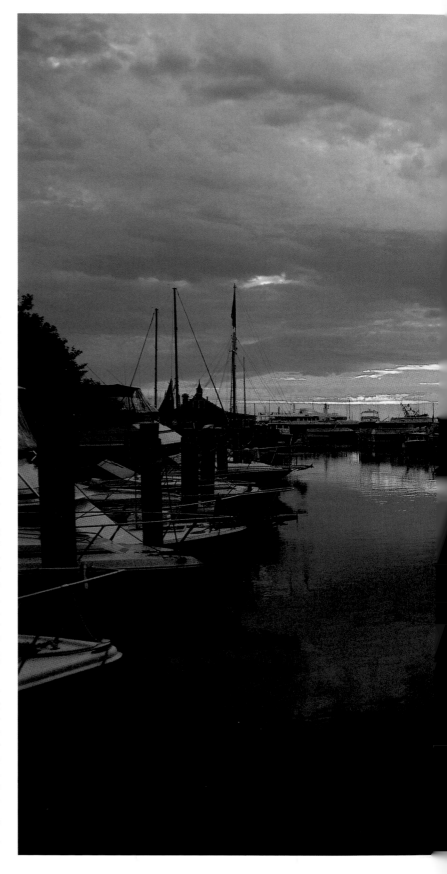

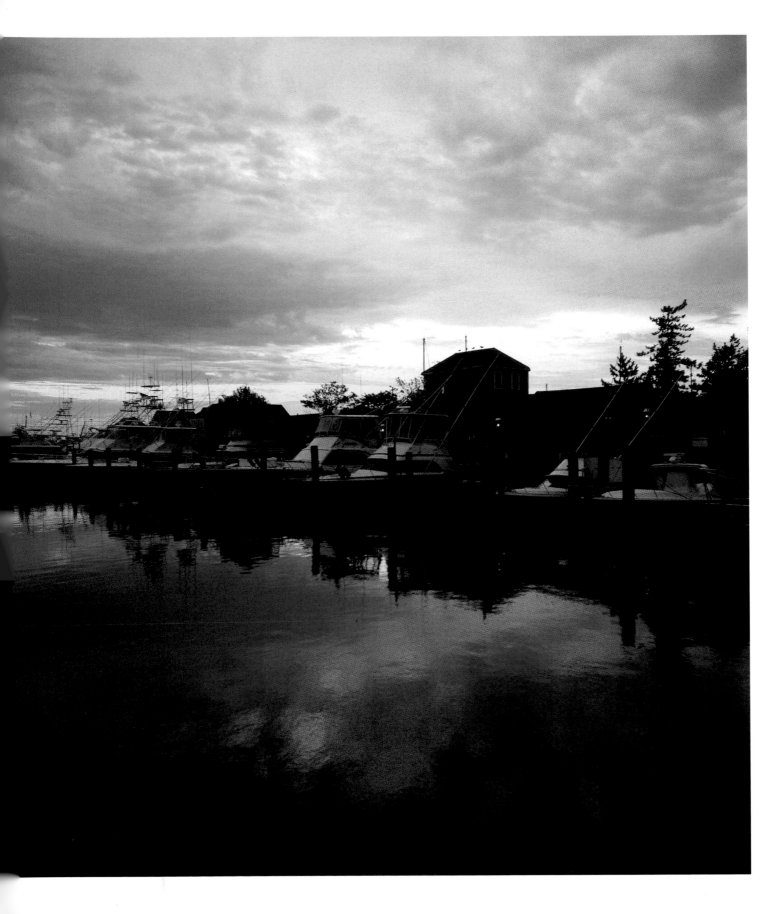

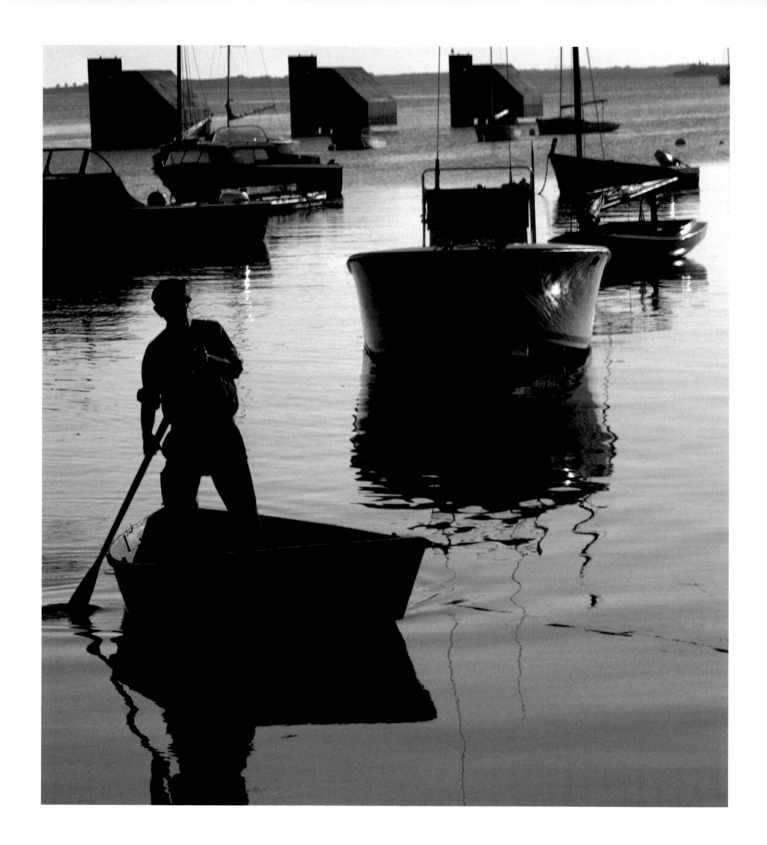

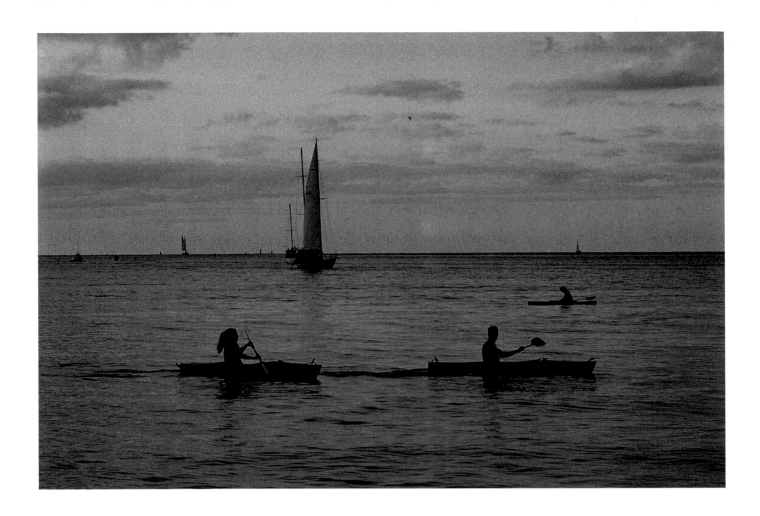

Paddling around the harbor. The man is using his skiff in an unorthodox way, but, like a gondolier, he has mastered the skill. The kayakers, with their double-bladed paddles, are moving more quickly in the harbor. While the single-blade paddle of the canoe is helpful on rivers, the double blade of the kayak's paddle provides more power and stability in the open water, especially where winds and tides must be taken into account.

Sea kayaks, which are essentially water-tight canoes, were used as hunting craft in the Arctic for thousands of years before the birth of Christ. During the tenth century, the Thules (predecessors to the Inuits, or Eskimos), migrating across the upper regions of Canada, brought the design to new levels of refinement. The first European explorers in the Americas were impressed with the speed and maneuverability of the kayaks, which hunters used in pursuit of marine mammals often weighing thousands of pounds.

But interest in kayaking waned until the early part of the last century when, in 1907, a German tailor, Johaan Klepper, began commercially producing a kayak with a wood frame and a canvas-and-rubber hull. This became popular with tourists traveling by train to seacoasts and lakes, because it could be broken down to fit inside two duffel bags.

The early design prevailed, with limited appeal, until the 1950s and the advent of fiberglass, which revolutionized the construction of first powerboats and sailboats, then kayaks. The new kayaks were rigid, lightweight, and durable. The idea of the sea kayak as a recreational craft began to blossom. In the early 1980s, it was much in demand in the Pacific Northwest as well as in the Atlantic Northeast. Now, with the introduction of the less expensive rotomolded plastic kayaks, U.S. sales of sea kayaks now outpace those of both river kayaks and canoes. The folding Klepper is still available and can be checked as airline baggage. For the rest of us, renting a sea kayak on the shores of Nantucket (there are now three rental locations) is an easier way to enjoy the ride.

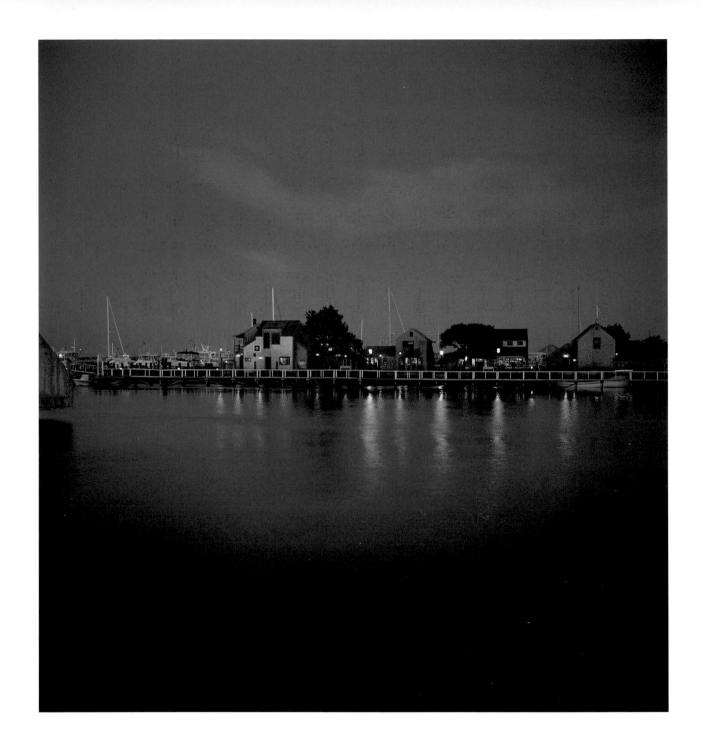

Cottages at the end of North Wharf (*opposite*) and shops on Straight Wharf (*above*). Here the architecture reaches out to the water's edge and continues out over it. Many of the cottages on Old North Wharf had to be rebuilt after the violent "no-name" storm of October 30, 1991. Those shown here are called The Nautilus and Peru. The Sanford brothers named The Nautilus after the spiral mollusk, as well as for Jules Verne's fantastical submarine in *Twenty Thousand Leagues under the Sea*. The Peru was the former ticket office and landing stage for the catboat *Lilian*, which made daily pleasure excursions up the harbor and out to Wauwinet.

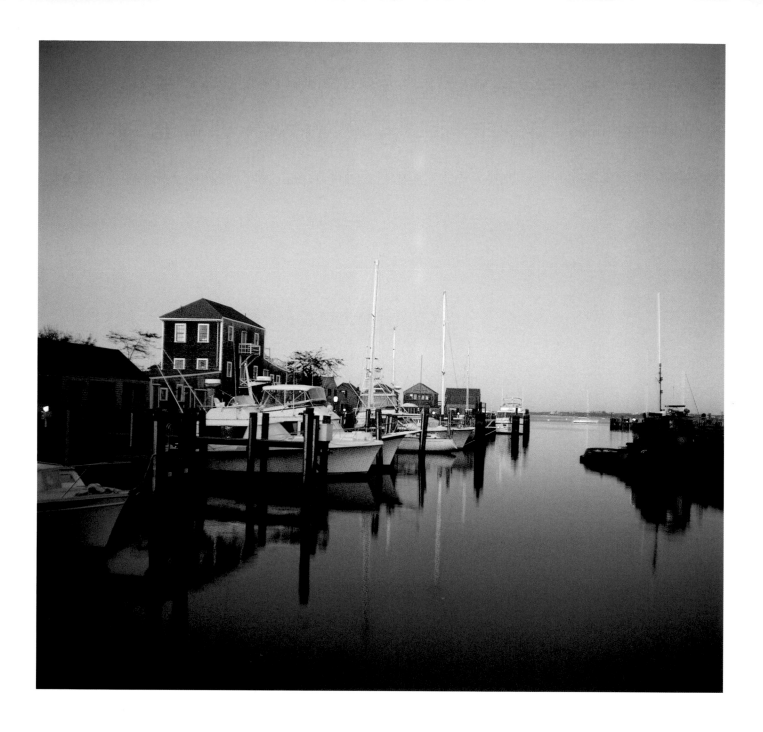

Old South Wharf (*left*) and Straight Wharf (*right*) welcome the evening's arrival of the Hy-Line's *Great Point*. While Nantucket's harbor bustles in the summer today, it hardly compares with the level and variety of activity during the island's peak whaling years. The industry was labor intensive, and the wharves were dominated by ship outfitters and cargo handlers. Shipping volume increased incrementally: from twenty ships in 1730, the fleet grew to fifty by 1748 and was up to two hundred by the 1760s. Toward the end of the eighteenth century, the ships employed over two thousand seamen, approximately the size of the year-round adult male population today.

Headmatter (the common name for spermaceti, the waxy substance in the large cavity of the sperm whale's head) faced rapidly increased demand. This growth was spurred from two major sources. One was Britain. London ordered the installation of street lamps to improve public safety, by the mid-1740s

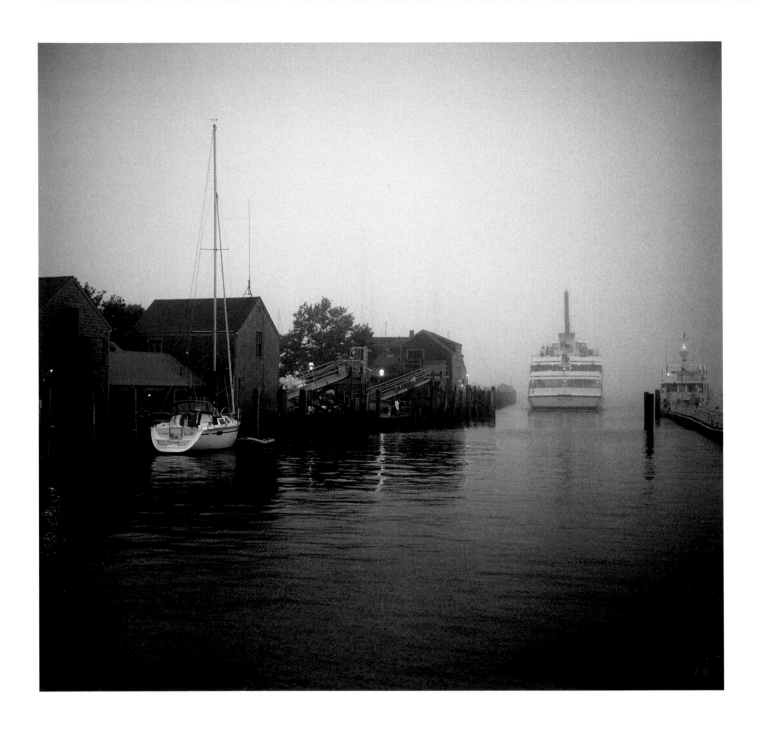

becoming the best-lit city in the world. Other cities, including Birmingham, placed lamps on principal thoroughfares and near docks, warehouses and mills. And the burgeoning British textile industry also used whale oil to process wool prior to spinning. Meanwhile, closer to home, local candle manufacturers spurred demand for headmatter. Jacob Rivera of Newport, Rhode Island, had developed a method of pressing oil from the spermaceti. His process produced candles that were valued for their clear, bright light. Twelve candle factories were operating in Rhode Island and Massachusetts by 1763, while the headmatter then available could supply only four factories adequately. Savvy Nantucketers seized upon this seller's market. William Rotch and Joseph Starbuck recognized the opportunity for vertical integration and began to manufacture candles locally, with the headmatter harvested by Nantucket whalers.

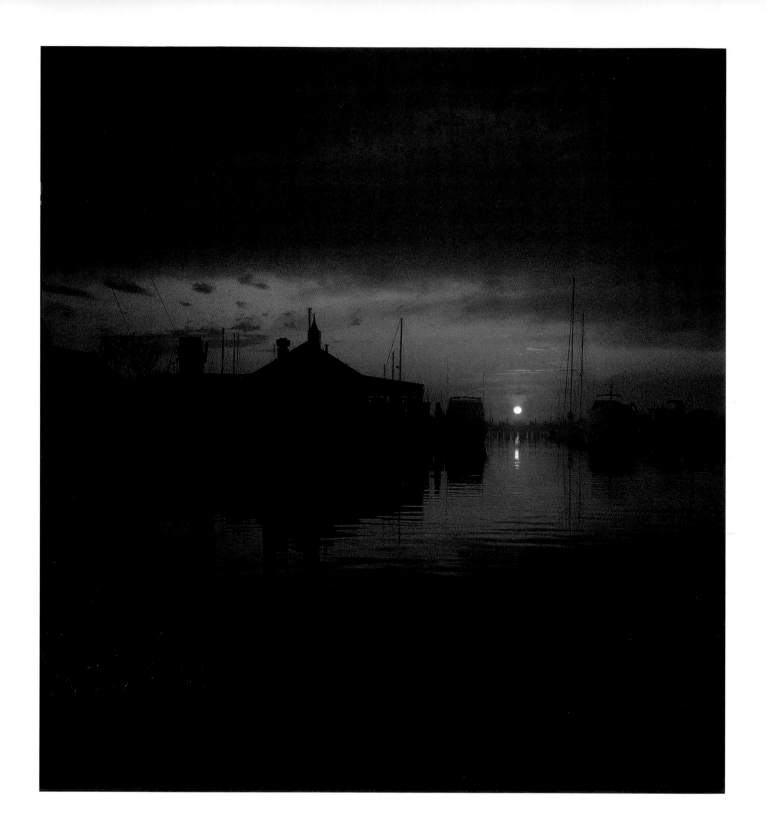

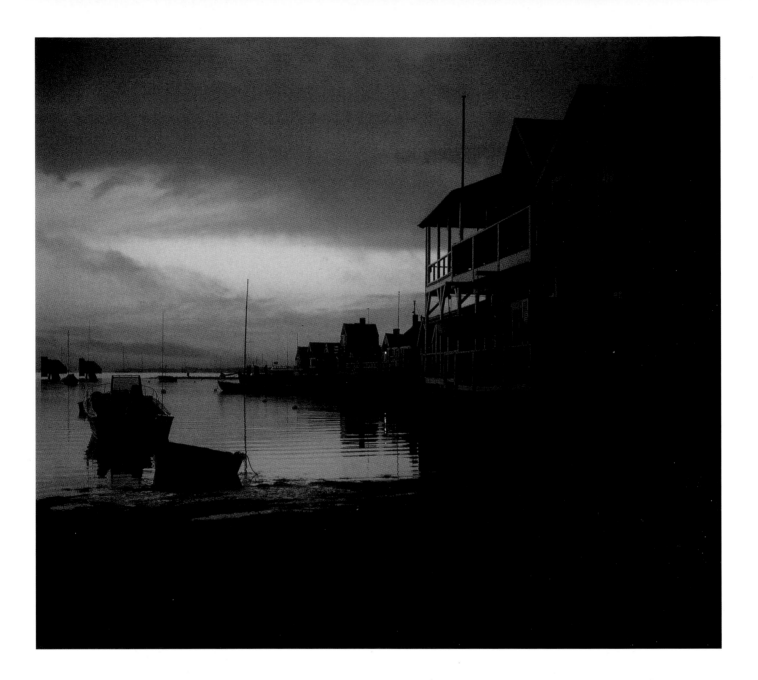

Opposite: The Ropewalk Restaurant offers dining and conviviality overlooking the harbor at the end of Straight Wharf. Its name recalls a once-vital Nantucket industry, ropemaking. Ropewalks were long, covered sheds where hemp fibers were laid out and where ropes, ranging from four-stringed hawsers to massive whale lines, were manufactured. In the eighteenth century, the island had ten ropewalks in operation, so important were their products to the rigging and outfitting of whaleships. Since the ropes were intended for nautical use, they were measured in fathoms (a unit equal to six feet), rather than feet or yards.

Most of the eighteenth- and nineteenth-century commercial buildings that lined Straight Wharf have been replaced or greatly altered over the years. Fishing shacks and a grain elevator were saved and restored on Old South Wharf as part of the marina project. Two substantial brick structures—the Rotch Market (constructed in 1772) and the Thomas Macy Warehouse (1846)—still stand along Main Street and its extension onto Straight Wharf.

Above: Dawn at Easy Street Basin. The lofts and boat houses of Old North Wharf frame this most picturesque spot. This photograph was taken on my birthday and turned out to be a lovely present. My father used to ask me at the end of the day if I got any good shots, and my answer was always the same: "Let's wait and see." Often, the pictures that I thought would be winners turned out to be disappointing. But mixed in with the day's work was frequently a surprise or two.

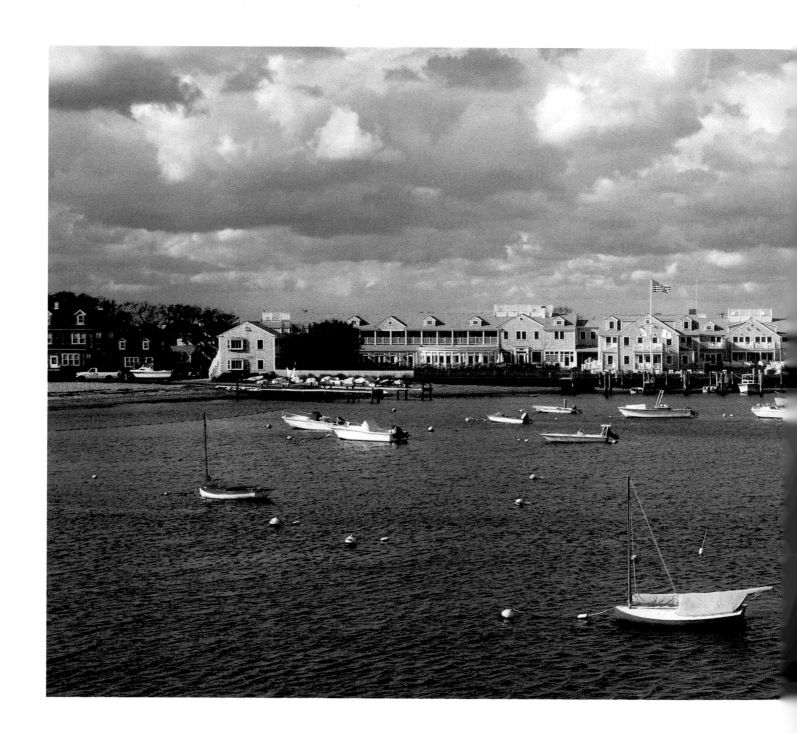

Hotels and Churches

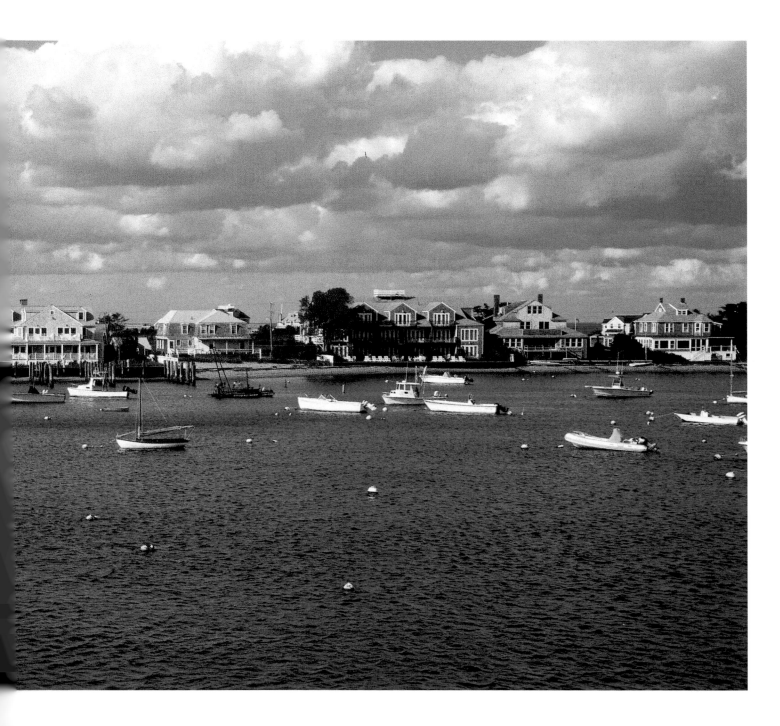

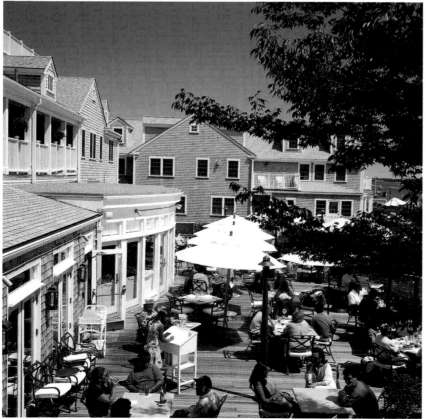

The White Elephant Hotel (1963, 1989, 2001). This was originally a collection of buildings gathered together, beginning in 1917, by Mrs. Charles Walling. The hotel opened in 1920, rivaling the former grandeur of the Nantucket Hotel, and even incorporating two of its predecessor's wings into the new structure. It contained ninety guest rooms and nine cottages. That original White Elephant was dismantled and replaced in 1963 by Walter Beinecke and the Lawrence Millers (father and son). Two sections of the old hotel were moved to Swain Street to serve as accommodations for the staff, and another section was rolled across Easton Street. The architect of the new hotel was Errol Coffin, who handled the restoration of the Jared Coffin House.

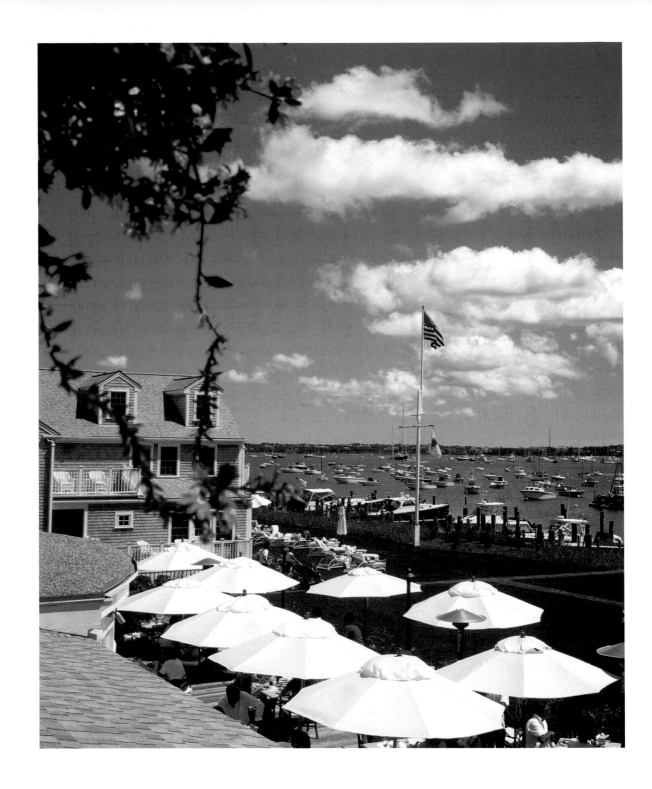

Diners relishing an *alfresco* luncheon on the White Elephant's patio. A second-floor balcony was added by Errol Coffin to provide outdoor seating for those guest rooms overlooking the terrace, pool, and harbor.

The hotel is located on the eponymous Easton Street, named for George Easton (1785-1875). His family members were early real estate promoters as well as owners of a wholesale cranberry business on the island. There was a ropewalk on this site in the early 1800s, followed later by a marine railway station. It did not become residential until the early 1900s.

In June 1998, Steve and Jill Karp purchased the White Elephant and decided to renovate it extensively, bringing it up to the standards of their *Relais & Chateaux* inn, the Wauwinet. Under the direction of Neil Parent and the Boston architectural firm Arrowstreet, the hotel has grown substantially while using traditional Nantucket materials and forms. The open porches evoke the island's nineteenth-century hotels. The interiors were designed by Kuckly Associates of New York, which created a feeling of simplicity and understated elegance. The main dining room, lounge, and broad terrace still prevail, but a new addition is the elegant lobby, with a boldly-carved walnut table at its center. Bronze lanterns, stately lamps, and brown-checked linen curtains flowing from thick, walnut poles all reflect an atmosphere of luxury and ease that continues throughout the hotel.

The library is a gathering spot to read, play bridge, or sit by a crackling fire on a cool evening. The fabrics in this room are sporty and tailored.

The new White Elephant has fifty-four guest suites (many with their own fireplaces and harbor views) and twelve garden cottages.

The serene, welcoming ambience of the White Elephant Hotel (*above*) and the Wauwinet (*left and opposite*), both owned by Nantucket Island Resorts. Visitors seeking relief from the bustle of downtown can find sanctuary here.

Wauwinet was the *sachem* of Nantucket's northeast and central territories. There were excellent fishing grounds to the east of the island, and as whaling declined in the mid-nineteenth century, commercial fishing gained in importance. The best access to this area was via the narrow strip of sand known as the "Haulover," which separated the head of the harbor from the open ocean. The fishing boats, large wooden dinghies, were rowed up the harbor and laboriously dragged across the sand supported by two oars parallel to the boat and a third one perpendicular. At the end of a weary day, the process had to be repeated.

In 1876, Captain Asa Small and Captain Reuben Kenney, both from Harwichport, purchased land on the Haulover and constructed a large inn there. Guests had the option of harbor or ocean bathing. The proprietors were somewhat ahead of their time; while inns and resorts were newly flourishing, swimming was still regarded as a somewhat outlandish form of recreation.

Interior views of today's Wauwinet. The original Wauwinet House featured a large, multi-purpose entertainment room that filled the ground floor. Ingeniously hinged walls could be opened to catch fresh sea breezes. When the inn opened for business on June 14, 1876, the proprietors hosted a gala evening, inviting the Masons, Odd Fellows, and Daughters of Rebekah. The festivities included a shore dinner, followed by polkas, waltzes, and quadrilles. Two steam yachts inaugurated daily service to Wauwinet that same year, and the larger catboat *Lilian* began excursions in 1888. The owners began to build simple rental cottages on the property in 1900. Cottages were not provided with kitchens, as all meals were taken in the Wauwinet House dining room.

The hotel continued to flourish under the Backus family's ownership. The facilities were extensively remodeled in 1934 by Alfred Shurrrocks, who had also done work on the "The Oldest House" as well as other early homes on the island. The Casino, Wauwinet's restaurant, was housed in an adjacent building, featuring elaborate though modestly priced seafood dinners and dancing with full orchestra accompaniment. Following the remodeling, Kenneth Taylor reopened the inn in 1936 to high praise. An article in the trade publication *Hotel*

and Restaurant News of August 16, 1936, lauded the refurbished Wauwinet for its refined, gray-shingled Colonial lines and a porch reminiscent of Mount Vernon. The writer rhapsodized about this corner of the island: "But to enjoy the sea wind's gifts, you must go where the winds can find you, and they are shy of dusty corners and land-heated streets. One of their favorite places is the island of Nantucket, and out there they frolic at their best on that fascinating stretch of land at the island's eastern tip—called Wauwinet."

The sentiment holds just as true today. These photographs show Wauwinet interiors whose décor is inspired by American folk art, with painted floor rugs, primitive wall hangings, and a carefully orchestrated look of eclecticism. The extensive redecoration was done by the firm of Martin Kuckly. The former Casino has reopened as Topper's. It has received *Wine Spectator's* Grand Award, and has a wine cellar with over 20,000 bottles. The inn is now a member of the renowned *Relais & Chateaux* group. Today, the Wauwinet, now over one hundred years old, attracts visitors from overseas as well as the mainland (or, as it is referred to on the island, "America").

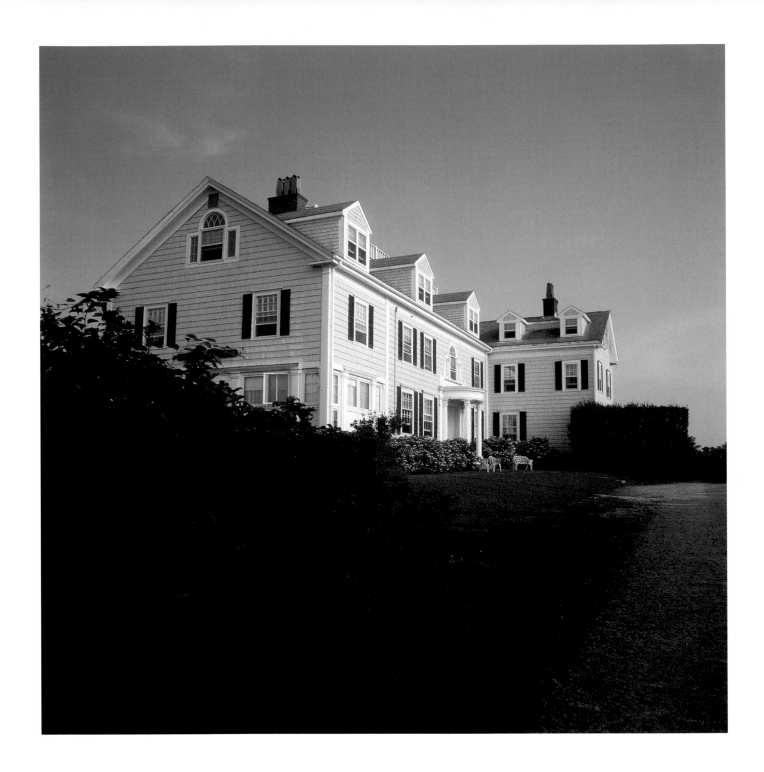

Opposite: The broad lawn of the Wauwinet is perfect for croquet, and the inn's 1946 Ford Super Deluxe Station Wagon meets guests the old fashioned way.

Above: The Westmoor Inn on Cliff Road (1917). Wilhelm Voss of New York, who had had the foresight to marry into the Van-derbilt family, built this lovely Federal-style house as a private residence. Unfortunately, the Voss family found the location too remote, and the Hamptons offered them more social visibility. The house went through many hands before the Holdgate family converted it to an inn in 1953.

The Jared Coffin House, 29 Broad Street (1845). This is Nantucket's oldest continuously operating inn. Originally a private home, it was acquired by the Nantucket Steamboat Company and opened as the Ocean House Hotel in 1846. During the island's lowest economic ebb, the building was bought by two men who had the foresight to anticipate the island's potential for tourism. Their purchase coincided with the Massachusetts Old Colony Railroad's efforts to promote tourism on Cape Cod. At the same time, people began to appreciate the challenge of game fishing, particularly for the blues so prevalent around Nantucket. Tourism thus began to transform the island's flagging economy over one hundred years ago.

The hotel has passed through various hands over the years. The Nantucket Historical Trust acquired the property from Treadway Inns in 1961 and spent the next two years restoring it with period antiques and furnishings. Local crafts—Erica Wilson's needlework and Nantucket Looms' textiles—contribute to the authenticity of the décor.

Jared Coffin built this house, perhaps the finest on Nantucket, in 1845 at the instigation of his wife. She felt that their former imposing brick residence, Moor's End on Pleasant Street, was too far out of town. Their new house survived the Great Fire a year later. Yet Mrs. Coffin missed Boston society, and Jared Coffin foresaw a prolonged period of recovery and hard economic times ahead. The couple moved back to Boston just a year after the house was completed. It was never again a private residence.

Today, the Jared Coffin House consists of a collection of adjacent historic buildings in addition to the three-story brick resi-

dence. There are sixty guest rooms in all, each furnished with canopied beds and other decorative touches suggestive of the 1840s. The photographs show the gracious triple parlors on the first floor of the main house. There were actually two double parlors, but one of them has become the registration area. The pastel portraits in the east and west front parlors are by George Fish, and now reside in the Children's Library of the Atheneum. This gracious lobby is a comfortable place to sit quietly and slip back in time.

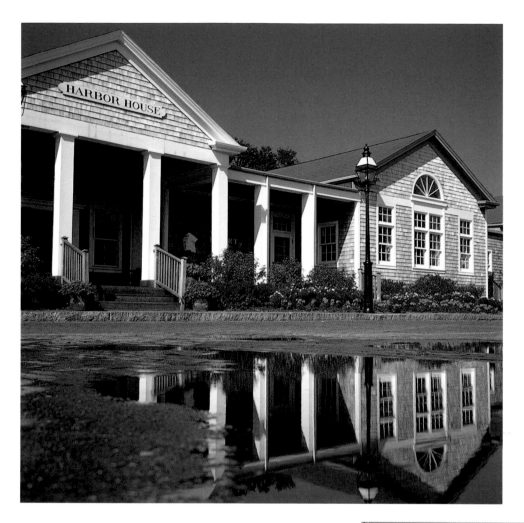

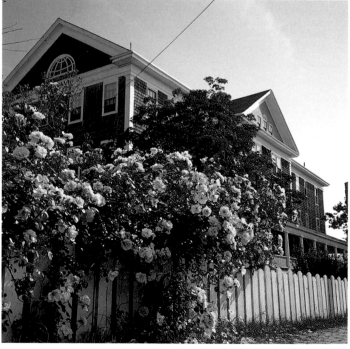

Above: The Harbor House is part of the old Springfield House, a large, rambling structure built at the corner of North Water and Easton Streets in 1883. The original Springfield House, built in 1864, was at 21 North Water. The newer building is three stories high with a veranda in front extending to the adjacent dining room. The Harbor House enhanced its facilities in 1979, adding the Meeting House as well as individual townhouses on the lawn sweeping down to South Beach Street.

Right: The Point Breeze Hotel on Easton Street (1891, 1904). Charles Folger purchased the property from Elijah Alley in 1888. Three years later he opened the Point Breeze Hotel, three full stories set above a high-ceilinged basement which boasted a bowling alley and billiard hall. Point Breeze also offered the latest amenities, including an electrical signaling system (powered by its own generator) and telephones. Electric lighting was added shortly thereafter. The original structure was destroyed by fire in 1925, but an adjoining pavilion built in 1904 still stands and serves as Chancellor's Restaurant. The Point Breeze was extensively renovated in 1997 by the Gonnella family. Its capacious ballroom, with windows on three sides, is a popular spot for receptions.

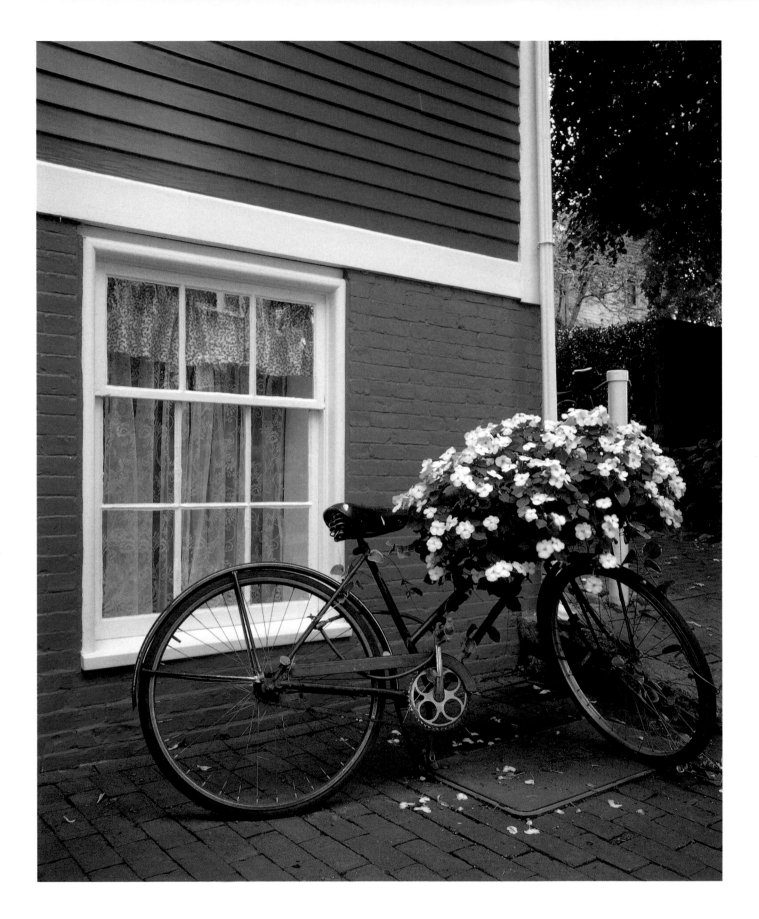

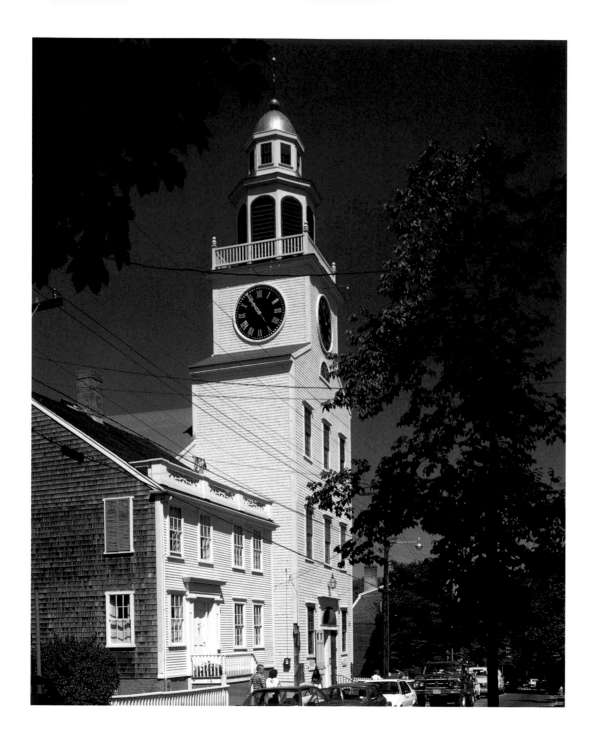

The Unitarian Church, 11 Orange Street (1809, 1830), stands squarely on the "Street of Captains" with no setback. Initially constructed as the Second Congregational Meeting House by Elisha Ramsdell, it became Unitarian in 1824 and has often been referred to as South Tower since then. Its bell had been purchased in Lisbon in 1811; concealed during the War of 1812, it was finally hung in 1815 after a struggle to raise sufficient funds for the installation. (Hearing of the islanders' plight, a wealthy Boston congregation with a newly constructed belfry—but no

bell—had written to inquire whether the Nantucketers would care to sell theirs. The reply, expedited on the next packet, was a terse inquiry as to whether the Bostonians would care to sell their church.) Given their knowledge of lifting heavy whale oil casks out of ships' holds without toppling the entire ship, the Nantucketers realized that the heavy bell would have to be raised within the spire itself rather than outside of it. They removed the inner planks, hoisted the bell directly in the center of the steeple, and rebuilt the flooring afterwards. The bell was

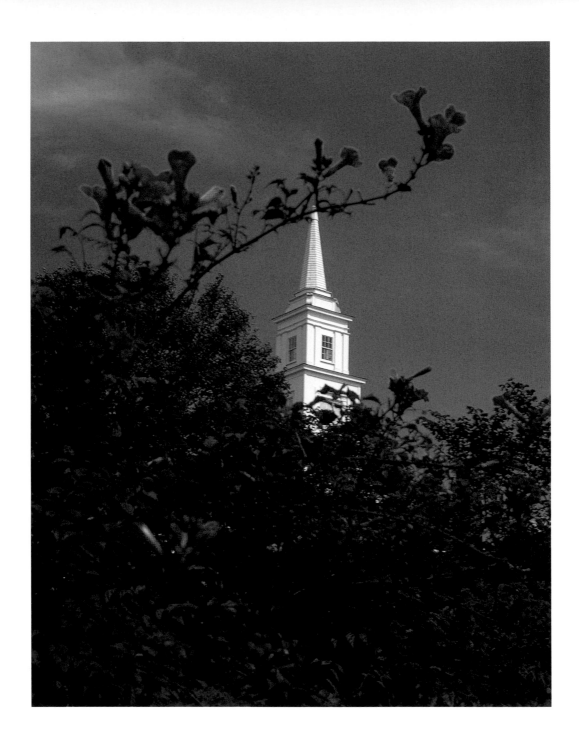

rung by hand until 1957, when an electric mechanism was installed. The South Tower bell and clock became the town's official timekeeper in 1848. It chimed three times a day, perpetuating a custom established in 1811 by the former town timekeeper, the Paul Revere bell in the Old North Church. Today the bell rings fifty-two times daily, a tradition of unknown origin. Many suppose that fifty-two measured chimes take about three minutes to complete, and a bell ringer can more easily count strokes that keep track of a clock's second hand.

Above: The First Baptist Church, One Summer Street (1841). Its 1,600-pound bell, cast in Troy, New York, was installed in 1854. The plans of the church's architect, Frederick Coleman, originally specified a front portico, but this element was never executed. This church, with its graceful, unpretentious lines, may be Nantucket's prettiest. The lofty steeple, reconstructed once in 1961, was replaced again in 2000 with a light, fiberglass structure.

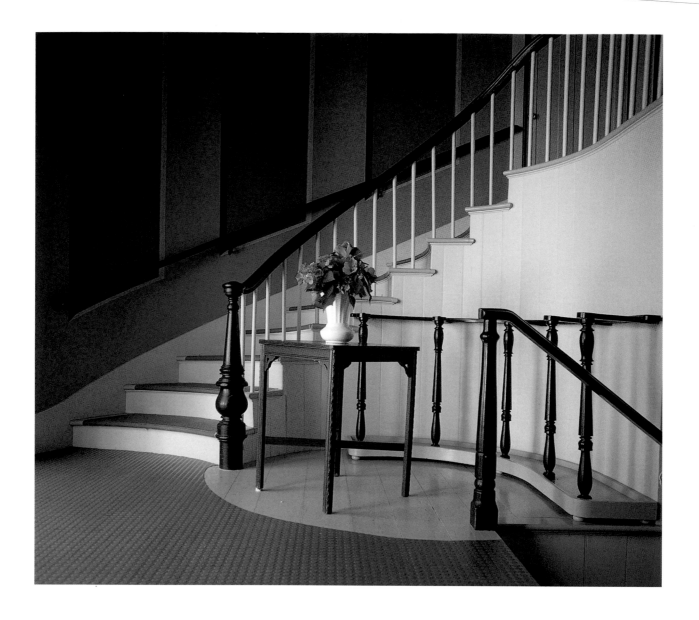

Above and opposite, top: The interior of the Unitarian Church, also known as South Tower. The apse is remarkable for its trompe l'oeil decoration, some of the oldest in America. The painting was executed in 1843 by Carl Wendt, a Swiss fresco artist. He used a subtle palette of warm and cool grays, adding an almost baroque touch to this otherwise chaste interior. Wendt also decorated the magnificent old Treasury Building in Washington, D.C., introducing the trompe l'oeil technique to the United States. South Tower's famous Goodrich organ was installed in 1831 and is now the oldest American organ still in its original setting.

Opposite, bottom: Old North Church or the First Congregational Church on Centre Street. This church was built by Samuel Waldron of Boston in 1834 on the site of Old North Vestry, which was preserved and moved to the rear of the new building. The church originally had only three windows on each side,

but the nave was lengthened in 1850, receiving a then-fashionable tin ceiling (since removed) and an imposing new façade. Construction was finally completed in 1968 when the familiar spire was added to the tower—lowered by helicopter. The steeple is 125 feet high, and its observation platform is a strenuous ninety-four steps up from the ground.

The Old Vestry (1725), which still adjoins Old North Church, had a peripatetic past. It was disassembled and taken from its original site on the edge of town to Beacon Hill in 1765, then subsequently moved farther back on the site to accommodate the "new" Congregational church in 1834. The old building was so painstakingly constructed that despite the disassembly and the move, all the doors to the pews swing smoothly on their hinges. The Old Vestry's bell, installed in 1800, was the first on the island, and the church itself is among the oldest continuously used church buildings in the United States.

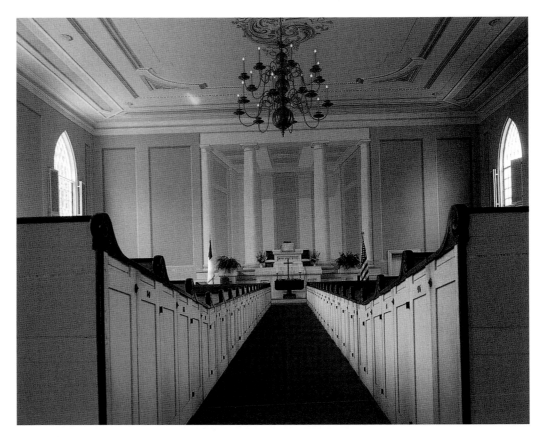

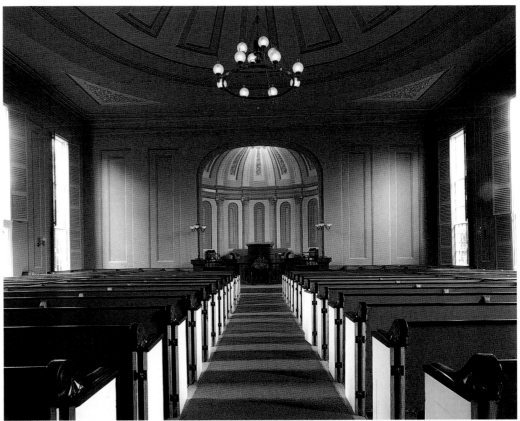

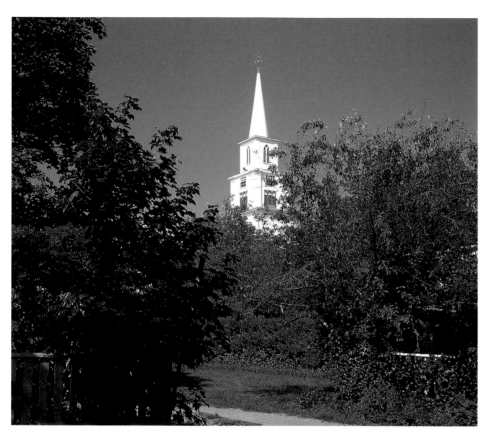

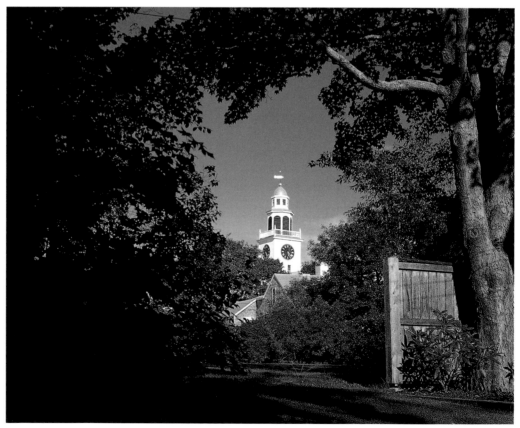

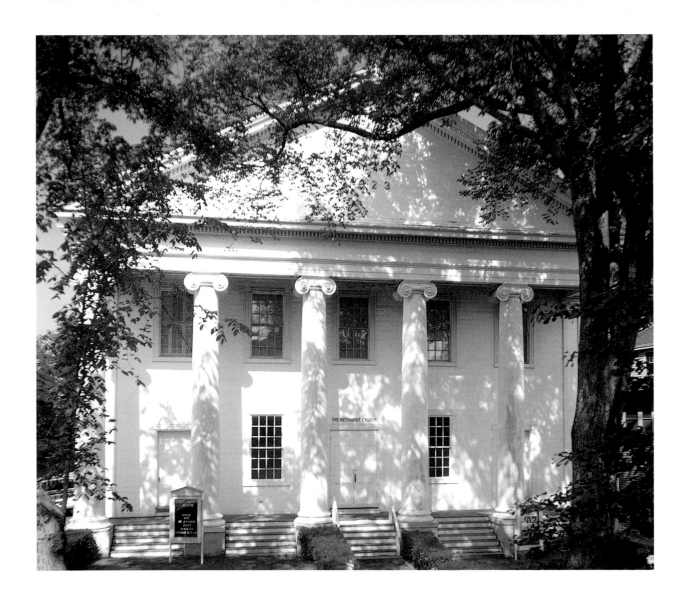

Exterior views of the Congregational (*opposite, top*), Unitarian (*opposite, bottom*), and Methodist churches. The Methodist Church on Centre Street (1823) was given its distinctive façade in 1840 when Frederick Coleman, the Atheneum's architect, added the pediment with its handsome dentil molding and six plain, Ionic columns. Although the building is not much taller than its neighbors, the massive columns make it an imposing presence. The early parishioners, being pragmatic Nantucketers, used the basement to store whale oil. The Methodist Society in Nantucket dates to 1799.

This was once the largest Methodist congregation in southeastern Massachusetts. Its 1823 sanctuary could accomodate seven hundred worshippers. But the third quarter of the nineteenth century saw the beginning of a steady decline in membership. In 1995, the church was down to five active members. Now, however, a new minister and activity have turned the tide. The church is supporting itself through a growing membership as well as its old practice of renting out space—this time to the Actors' Theatre.

The present variety of denominations came rather late in Nantucket's history. The first religious group on the island was the Religious Society of Friends who found a welcome refuge here from the intolerance of many mainland colonies. Quakers first arrived in Nantucket in 1670, and until their influence began to wane in the 1840s, their hold on the island was strong. Homespun clothing in somber colors was the norm, jewelry and cosmetics were frowned upon, and social dancing was forbidden. Quakers who married outside the group, to Baptists or Presbyterians, for example, were shunned and banned from the Friends' meetings. Because the Quakers predominated in Nantucket's early years, the rise of other Protestant denominations came relatively late. At that point, churches had to choose sites wherever suitable lots could be found tucked in amid the existing structures. There is thus no Nantucket equivalent of the classic New England village green. Nantucket's churches represent all the popular styles of the nineteenth century: Meetinghouse (North Vestry), neo-Gothic (Congregational), Greek Revival (Baptist, Methodist, Unitarian), and Romanesque (Episcopal and Catholic).

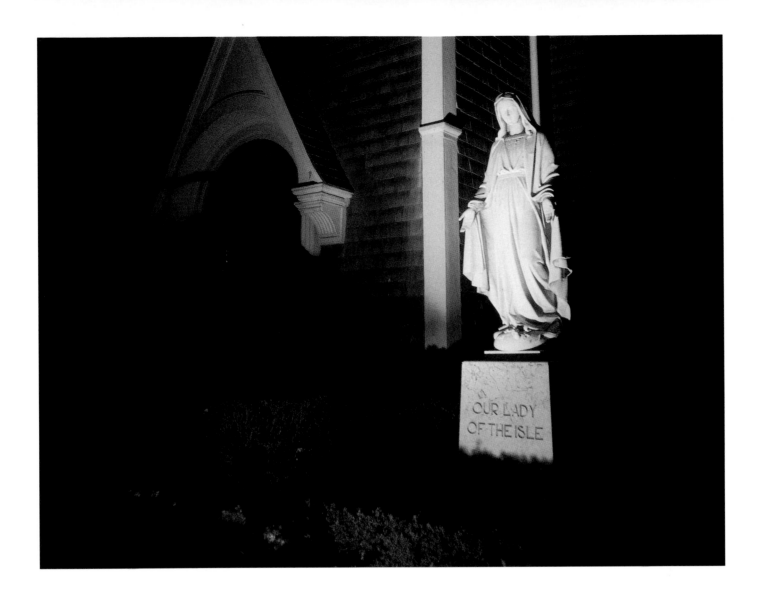

Opposite, top: St. Paul's Church, 20 Fair Street (1901). The present Episcopal church was built through the benevolence of Caroline French, the daughter of a prominent Boston and Nantucket merchant, Jonathan Church. The building is a true Richardson Romanesque revival church with brownstone trim, pointed arches, and radiant Tiffany windows. The style harks back to European sanctuaries of 1000 to 1200. Its massive stonework and turreted tower speak of a different era, in contrast to the simpler white clapboard of Nantucket's other Protestant churches.

The island's earlier Episcopalians first worshipped as a congregation in an old meeting house, retired by the Quakers, on Broad Street just east of where the Jared Coffin House now stands. Trying to evoke the atmosphere of traditional Anglican churches, the Episcopalians covered the wooden walls with plaster and attempted to create the look of a traditional stone structure. This building perished in the Great Fire of 1846 as the "stone" caught fire.

Opposite, bottom and above: St. Mary's Our Lady of the Isle Church on Federal Street. This is a very Nantucket translation of the neo-Romanesque style, with gray shingles and white trim. The graceful statue in front lends an aura of peace to the bustling downtown scene. Roman Catholicism came to the island in 1849 with the celebration of mass at various locations in town. For many years, worshipers met at Harmony Hall on Federal Street, which was consecrated as St. Mary's Roman Catholic Church in 1858. The present church was built in 1897. This is primarily Romanesque Revival style, with fully arched windows and doors, a large, round window in the gable peak, and a massive square bell tower. The church has undergone a successful interior redesign and overall renovations, including the new stained-glass window over the altar by artist and spiritual leader Barbara Cunha. This two million-dollar renovation was supervised by D. Neil Parent Associates under the direction of Pastor Thomas Lopes.

Over the years, Neil Parent has designed many of Nantucket's public buildings, including those on Steamboat Wharf, at Freedom Square and the Memorial Airport. His latest is the new White Elephant Hotel on Easton Street.

The African Meeting House. This handsome 1825 structure is at the intersection of York and Pleasant Streets, also known as Five Corners. It is the nation's second-oldest building still standing that was built by free African-Americans for their own use. Originally it was a combination school, church, and general gathering-place. As a school, it operated until 1847, at which time the town, after a momentous struggle of eight years, voted to desegregate the public school system and admit black children. The Meeting House continued as a church and community hall until 1912, when it entered a long period of changes in ownership and usage. It has finally been restored to its former appearance and is now owned by the Museum of Afro-American History in Boston.

For many years, this neighborhood on Nantucket was called New Guinea, a name derived from the West African countries along the Guinea coast, where Nantucket whalers landed in the mid 1700s. Blacks came to Nantucket early in the 1700s, and some of them began owning property even then. Quakers encouraged all slaves on the island to be emancipated; by 1773, Nantucketers had proudly eliminated slavery on the island. Freed blacks often stayed on, bought land, and supported themselves by working in the whaling industry. The freedom and independence they enjoyed on both the island and its whaleships signify a

significant chapter in our country's history, embodying the spirit of Nantucket as an independent, free-thinking society.

The whaleships needed cheap, bountiful labor, and blacks provided an alternative work force to the declining American Indian population. Blacks, American Indians, and others from the South Seas islands ended up in Nantucket's New Guinea, as did Portuguese-speaking blacks from Cape Verde, who had come to Nantucket as crew members on the whaleships.

The Africans, numbering over five hundred by this time, maintained a vital presence on the island, contributing to the economy as tradesmen, seamen, and clergy. One of the most famous was Absalom Boston. Born in 1785 to Seneca Boston and Thankful Micah (who was a Wampanong Indian), he began his working years in the whaling industry and by the age of twenty had earned enough money to buy property. By the age of thirty, he was the proprietor of a "public inn." And when he turned thirty-seven, his whaling skills were such that he became the first black captain of an all-black crew. The vessel was the *Industry*, sailing from Nantucket in 1822. The excursion was successful in sending a very clear message to the rest of the world about black independence. The economic side of the voyage was less fortunate, since the *Industry* returned after a

short voyage with only minimal success. Absalom Boston retired from the sea and spent the rest of his life managing his holdings and serving as a leader and advisor to the blacks on the island. He became a trustee of the African Baptist Society, which was a group of concerned citizens that was responsible for securing land for the Meeting House. Later, when his daughter was prevented from attending the public school, he campaigned for its integration, which finally occurred in 1846—well after she had graduated, but early by U. S. standards.

Although Absalom Boston no longer shipped out, he remained close to his comrades. In 1830, the *Loper* returned with an almost entirely black crew and a successful voyage. Boston led a parade of celebration through town that gave recognition to the men and their accomplishments. In 1891, he was the leader of the black contingent that gathered at the Atheneum to hear one of the leading abolitionists, Frederick Douglass, speak. Joining the group were William Lloyd Garrison, Wendell Phillips, and William Coffin. Douglass gave additional talks on Nantucket in subsequent years, which helped the town with its internal struggle over school integration. The island was more progressive in its treatment of blacks than elsewhere in New England, but it was by no means an integrated society.

The move to integrate the schools started a 1840, when a young black girl Eunice Ross applied to the high school after finishing her primary education at the African School. She was denied admission, but the abolitionists took up her cause in 1842 at the island's second anti-slavery convention. The atmosphere became highly charged when Stephen Foster spoke of the clergy as being pimps, adulterers, and a brotherhood of thieves. The occasion was the island's second anti-slavery convention, with William Lloyd Garrison and Frederick Douglass also on hand. Foster's fiery remarks forced the conventioneers to flee their meeting place at the Atheneum and relocate across town. It was an evening of unhappy emotions. Several years of acrimonious debates followed, including a two-year boycott of all schools by black families and a petition to the Massachusetts Legislature to integrate the schools. (The Atheneum itself was fully open to all.) Finally, the vote to integrate Nantucket's schools was passed in 1846, and the York Street School closed forever. Absalom Boston's daughter was granted admission, but it was too late. When he died, Boston left a sizable estate, including vacant land, two houses, and a store. More important, however, he left a proud legacy of individual perseverance and strength for future Nantucketers, black or white.

The three-hundred-year-old Jethro Coffin House on Sunset Hill (*ca.* 1686) is also fondly known as the Oldest House. Up from the main thoroughfare of West Chester Street, it has withstood the changes to Nantucket plus storms, fires, and even lightning in 1987. It was built as a wedding present for Jethro Coffin (age twenty-three) and his bride Mary Gardner (age sixteen). Jethro was a grandson of Tristram Coffin, one of the first settlers. John Gardner, Mary's father, was a later participant invited by the original group to become "halfshare men." John Gardner believed that everyone should have equal votes—no distinction between the percentage of his shares. Eventually he got his way. The Gardner family supplied the land and the Coffins the lumber, which came from Peter Coffin's mill in Exeter, New Hampshire. The wedding was delayed because Tristram wanted to see the property deed, which John Gardner had neglected to transfer to his soon-to-be son-in-law. When the paperwork was completed, the ceremony proceeded, uniting two strong and independent families.

The architecture is typical of the period—the building is a lean-to with one-and-a-half stories in the front and a long, gently sloping roof to the rear. The small windows were a function of the high cost of glass, a luxury that had to be imported from England.

Above: The hall of the Oldest House was the site of most day-to-day activity in the home, including cooking, eating, and socializing. Furniture was stored against the wall and pulled out into the room as needed. The overhead chamfered summer beam and the eight-foot-wide fireplace are characteristic of early island dwellings ("summer" is not just a season, but also a large horizontal supporting beam or lintel). *Right*: The Coffin family slept upstairs in rope beds. A large key may be seen on the edge of the middle bed, which is a child's trundle. After a while, the ropes would sag and had to be tightened, giving us the expression "sleep tight."

Nantucket Homes

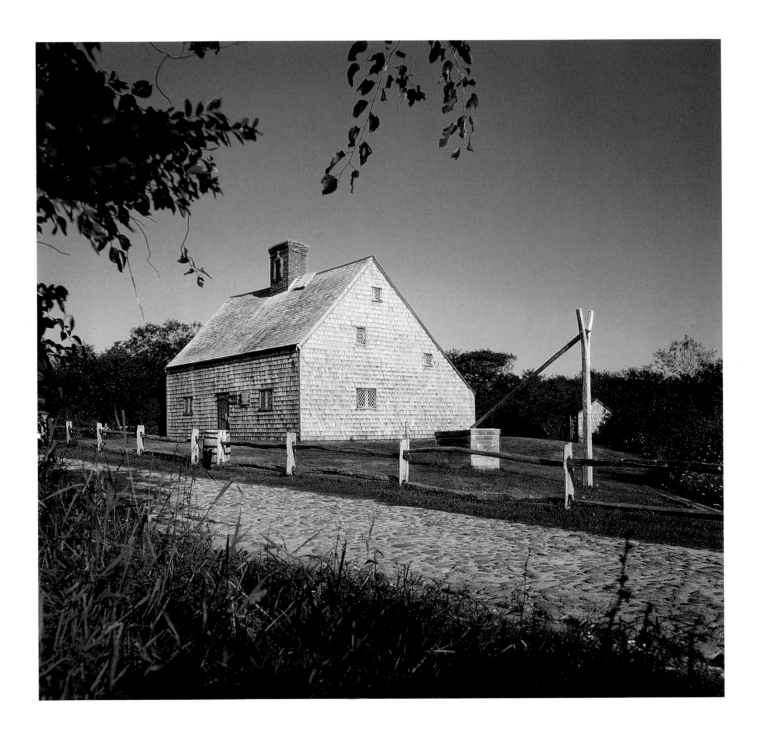

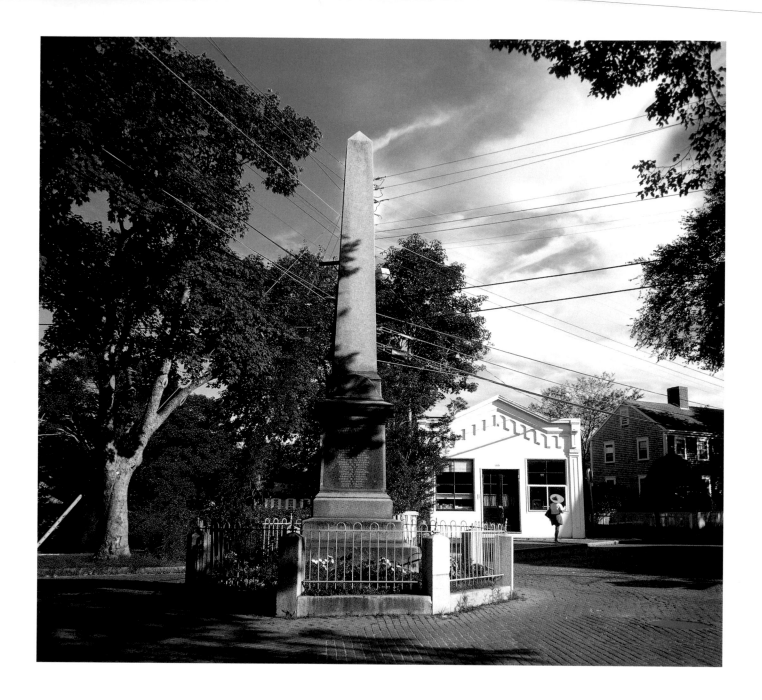

Above: The Civil War Monument, erected in 1874 at the top of Main Street, commemorates Nantucket's veterans of the conflict. The island sent 339 men, 56 more than its quota, to support the Union cause. The base of the obelisk is the former millstone of Round-Top Mill, the last of this island's five windmills to be built and the last to be dismantled (1873). The modest white structure in the background was once a branch of the A&P and, more recently, MacCaulay's Dry Cleaners.

Opposite, top: The Joseph Mitchell house, 100 Main Street (*ca.* 1730, 1810). William Hadwen lived in this two-family house with his business partner Nathaniel Barney before moving to the stately residence at 96 Main Street. Hadwen and Barney built the brick candle factory on Broad Street, which now houses the Whaling Museum.

Joseph Mitchell later purchased the residence, but had little time to enjoy living there. He first went to sea at the age of fourteen, became a captain at twenty-eight, and prospered in the California Gold Rush as a commander of ships rather than as a miner of gold. Whaling voyages were long, arduous, and lonely. Mitchell spent most of his life on shipboard, separated from his wife and family.

Opposite, bottom: The James Bunker house, 102 Main Street (*ca.* 1740), one of the two earliest houses to be constructed with two full stories front-to-back.

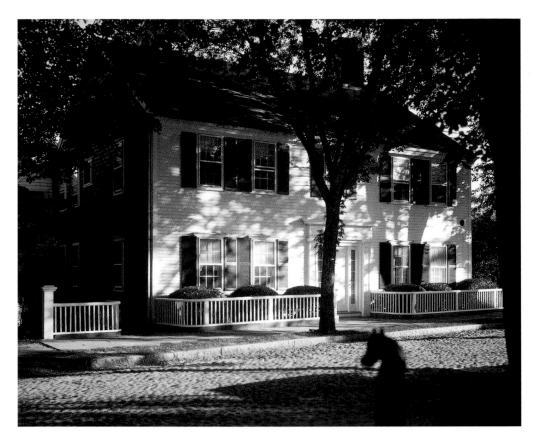

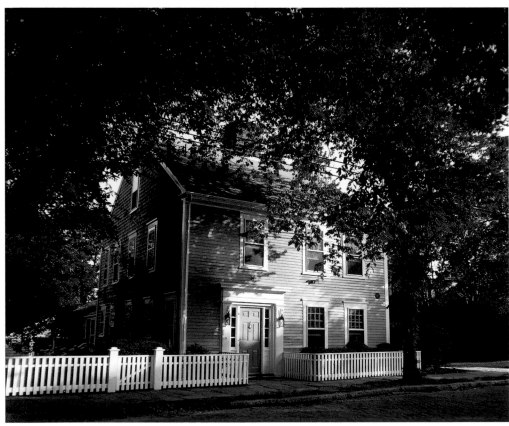

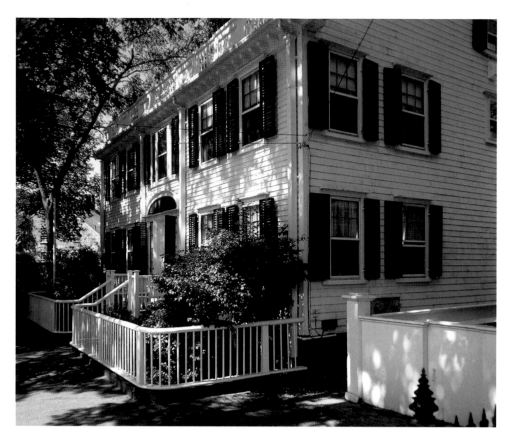

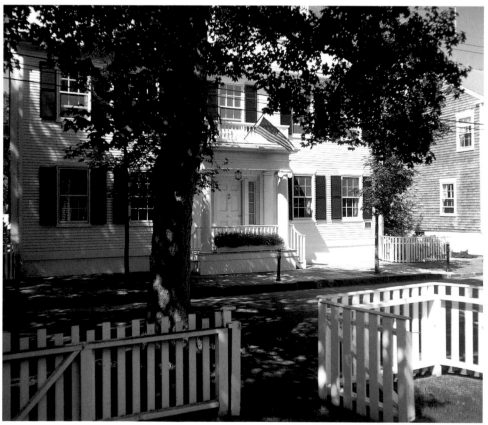

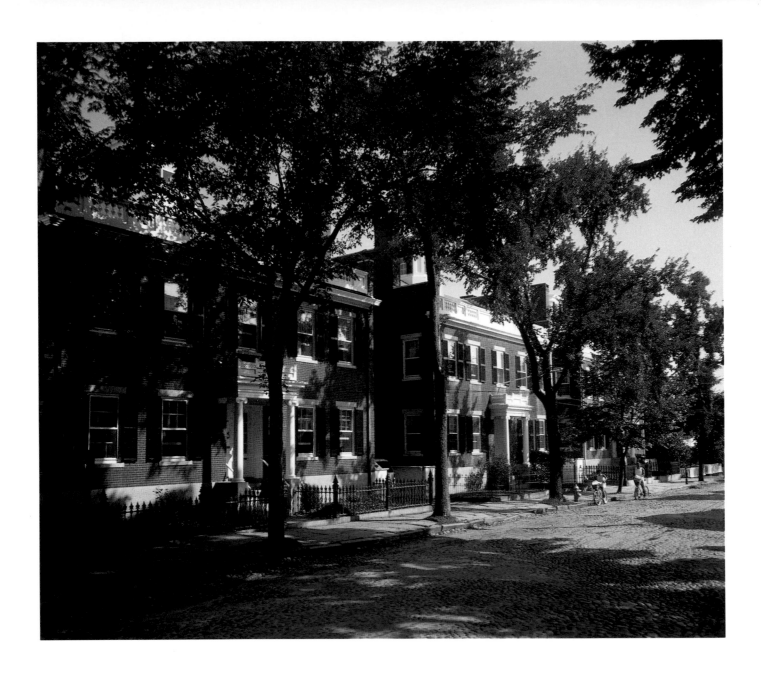

Above: The identical Three Bricks at 93, 95 and 97 Main Street (1836-1838) were built by Joseph Starbuck for his sons William (East Brick), Matthew (Middle Brick), and George (West Brick). The houses sit squarely on the street, making a bold statement. Starbuck, a Quaker, selected a conservative Federal/Greek Revival style, with four end chimneys, granite steps, Ionic porticos, recessed doorways, and square cupolas. The most successful whaling merchant of his time, Starbuck launched a new ship, the *Three Brothers,* in 1833; the vessel completed seven consecutive successful voyages by 1865. Jared Coffin took inspiration from the Three Bricks when he built his own house—which incorporated a third full story—at the top of Broad Street six years later.

Opposite, top: The Thomas Macy II house, 99 Main Street (1770, 1830), originally built for Valentine Swain. The son of Obed Macy, Thomas was a historian and the uncle of R. H. Macy. He added the five-bayed front section in 1830. The façade has an elliptical fanlight and sidelights around the door. The fan is blind, as the ceiling of the original, more modest, house behind was not high enough to accommodate a glass window. Not content with a plain picket fence, Macy adorned the skillfully crafted railing that curves out, down the steps, and along the sidewalk with an elegantly crafted, rounded top.

Opposite, bottom: The Isaac Macy house, 7 Pleasant Street (1825), designed by John Coleman in the early Greek Revival style with an Ionic portico. John and his brother Frederick were Nantucket's most influential architects in the 1830s and 1840s.

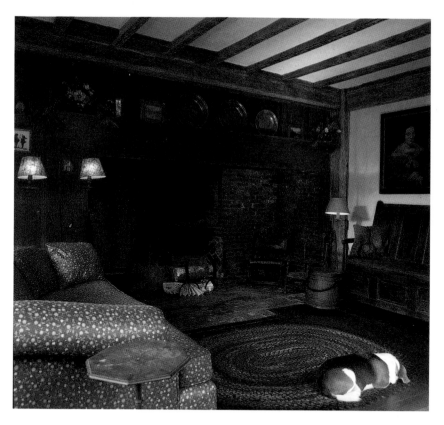

Opposite: The Josiah Coffin house, 60 Cliff Road (1724), was built by a son of Jethro and Mary Coffin (the Oldest House) for his own son. Like the Oldest House and the Elihu Coleman house (1722), this structure is a lean-to, facing south. Nantucketers used compasses to position their houses, often with extraordinary accuracy. In the late 1800s, Henry Mitchell (Maria Mitchell's father) calculated that one side of this house would have been precisely aligned with magnetic north in 1723, exactly the year when its plans were laid out. Completed almost forty years after the Oldest House and just two years after the Coleman house, this building has a more elaborate façade and chimney stack than either of them, with heavy brackets under the main cornice and more windows on the façade to take advantage of the southern orientation.

Above: The Job Macy house, 11 Mill Street (1790). This house reflects the Georgian style, a new taste that emerged toward the end of the eighteenth century and featured full second stories and symmetrical facades that often included bays, porticos, and large windows. Job's Quaker father, Richard, admonished his son that if he proceeded with plans to build an ostentatious two-story house instead of an unassuming lean-to, he would never set foot in it. As far as we know, Richard never went back on his word. The disruptions of the Revolutionary War and the ensuing decade had weakened the Quakers' formerly unchallenged position as arbiters of Nantucket society. It was becoming increasingly acceptable to celebrate the prosperity earned through arduous whaling ventures with more elaborate dress and imposing architecture.

Parked in front of the house is a 1947 Ford Deluxe Station Wagon.

This area, down from Mill Hill, was originally a commons ringed by simple, gray, cedar houses. Later came bustling commercial activity along the (aptly named) New Dollar Lane, with its shops and homes of coopers, boat wrights, blacksmiths, and, of course, Joseph Starbuck and his candle works.

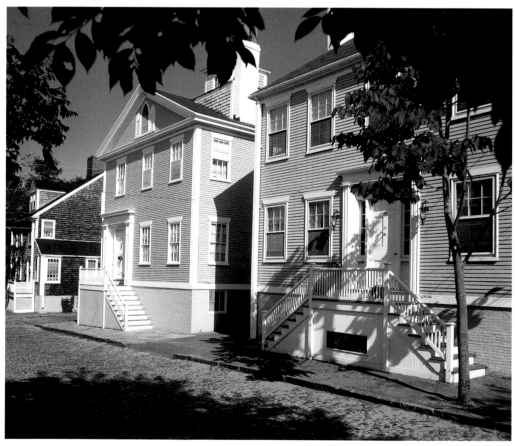

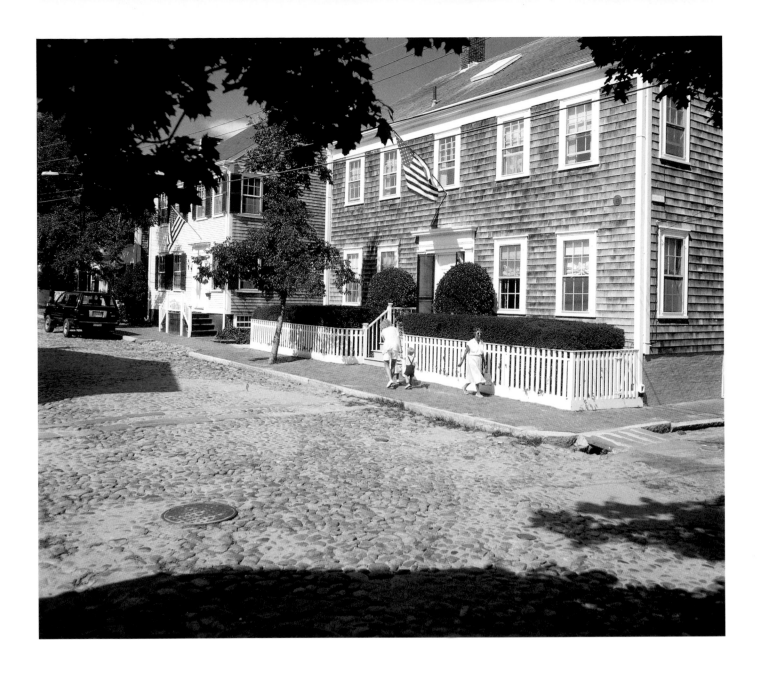

Opposite, top: The Christopher Starbuck house, 105 Main Street (1690, 1753). The building was relocated from the site of Nantucket's first settlement in Sherburne. The lumber for the island houses had to be shipped at great expense from the mainland, and it was far more economical to move existing homes that to start new construction. There were, in fact, two separate settlements called Sherburne, the first near Capaum (which means "protected harbor"), and the second one being the Nantucket town we know today, which adopted its current name in 1795.

Christopher Starbuck was living in this house when he formed a trading company in 1767 in partnership with Nathaniel Macy and Joseph Swain. With twelve vessels, they began trading whale headmatter with the mainland in exchange for dry goods and other merchandise. Within four years, the company was engaged in international trade, selling a wide variety of items such as Russian duck cloth, anchors, sail needles, and English silk. The Revolutionary War put an end to this business, and the partners faced a prolonged rebuilding period thereafter.

Opposite, bottom: The George Macy house, 86 Main Street (remodeled *ca.* 1834 for Ann Coffin Crosby) and the Job Coleman house, 88 Main Street (*ca.* 1830). The George Macy house features a cupola, an architectural element that had become popular by the 1830s. The one on the Henry Coffin house, which had been built across the street the year before, probably inspired Macy.

Above: The Charles Clark house, 87 Main Street (1830), and the Jacob Bunker house, 85 Main Street (ca. 1725, 1795).

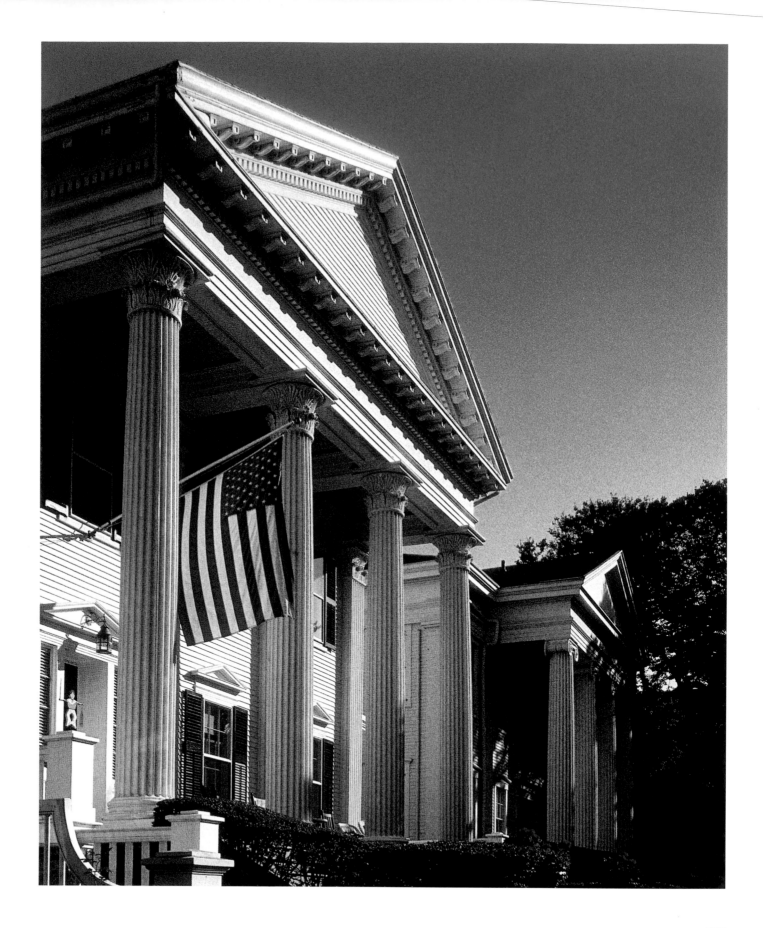

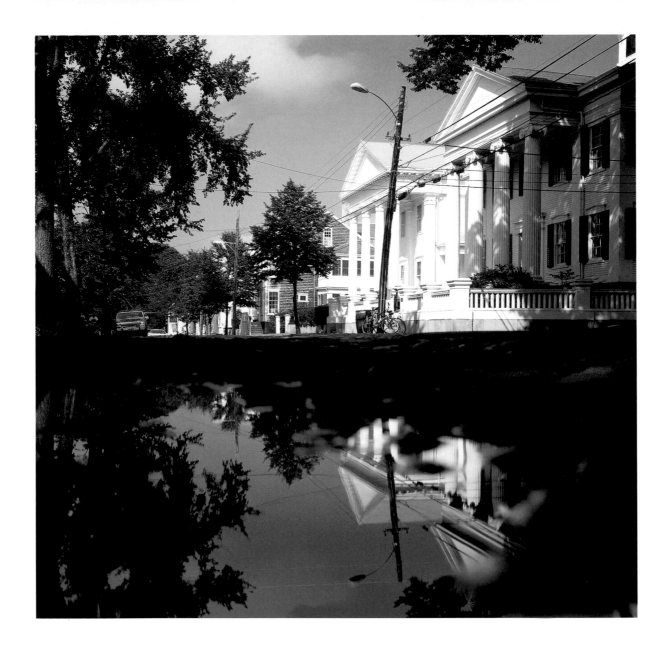

The William Hadwen houses, 94 and 96 Main Street (1840-1845). Frederick Brown Coleman's bold but refined designs are a tribute to Hadwen's taste, shaped by his background as a silversmith and Newport resident. Soaring columns, recessed porticos, and high foundations were new features in these buildings, which are masterpieces of the island's Greek Revival period—an era of island prosperity that was reflected in sophisticated architectural design. These are the last major houses Coleman built, although his work on Nantucket would culminate with the construction of the Atheneum two years later.

There is a rain-fed, sunken cistern at the nearby intersection of Main and Pleasant Streets, one of several installed many years ago to ensure an adequate supply of water in the event of another fire.

The beauty of Nantucket lies chiefly in its architecture: street after street of sturdy, self-reliant structures—some simple, some grand, all trim and organized—that have stood side by side for over 150 years. And Main Street is by no means the island's only handsome thoroughfare. Pleasant, Orange, Liberty, and Union all offer a rich and varied architectural vocabulary while speaking a common language. Main Street is the same as it was a century ago except for the cars, moving at a snail's pace in deference to the cobblestones, which are inviting to the eye but hard on feet and bicycles ("cobble" comes from the Old English word for lump or loaf). They were first laid in 1831 on Lower Main Street, as well as on Broad, Centre, and Orange Streets, to allow carts to more easily move up to the shops from Straight Wharf. By 1852, they extended as far as Pleasant Street.

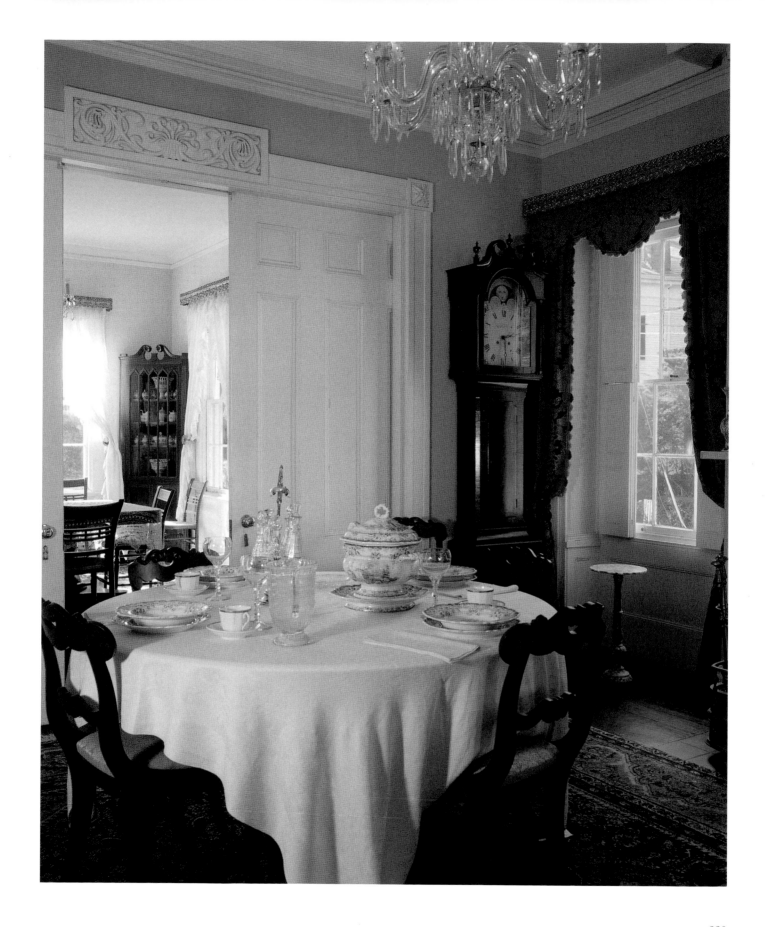

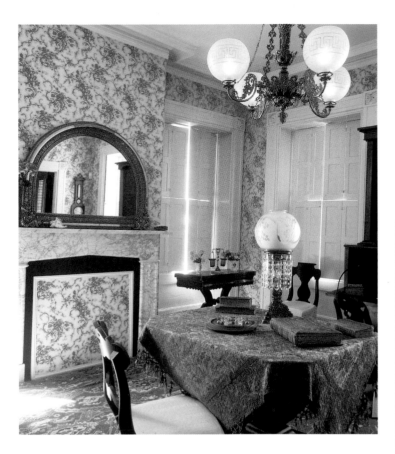

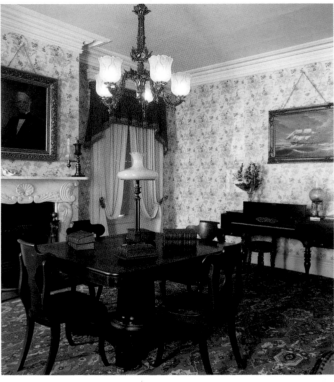

Above: The formal parlors in the front of the William Hadwen house at 96 Main Street. A portrait of William Hadwen hangs over the mantle in the right photograph. Wall-to-wall broadloom carpeting has now been installed by the Nantucket Historical Association, replicating what is believed to have existed at the time. The pattern was copied from a sample found in the West Brick across the street. As bare floors with area rugs were not considered fashionable at the time, large looms for making wide carpets were kept busy providing wealthy Americans with complete floor coverings.

Opposite: The rear portion of the Hadwen house's double parlor was the family's dining room, once connected to the basement kitchen by a dumbwaiter. The breakfast room used by the Satlers (the third, and last, family to own the house, from 1923 to 1963) can be glimpsed through the pocket doors in the background. Subsequent to this 1992 photograph, the Nantucket His-

torical Association has changed the appearance of the downstairs from Colonial to Federal in keeping with the interpretive feeling of how the Hadwens would have lived at the time.

William Hadwen built 96 Main Street for himself and his wife Eunice (the daughter of Joseph Starbuck), whom he married in 1822. The companion house, 94 Main, was built for his niece, Mary Starbuck Swain, and her husband, George Wright. Mary's parents, Mary and William Swain, lived next door at 92 Main Street. Hadwen was not a native of the island. He was born in Newport and started a jewelry business in Providence with Jabez Gorham in 1812. Gorham continued the business on his own after 1818, when Hadwen moved to Nantucket and started his own jewelry store in 1820. He seems to have rapidly made his way in island society, entering into the whale oil business in 1829 with his brother-in-law Nathaniel Barney. These handsome residences are eloquent witnesses to his success.

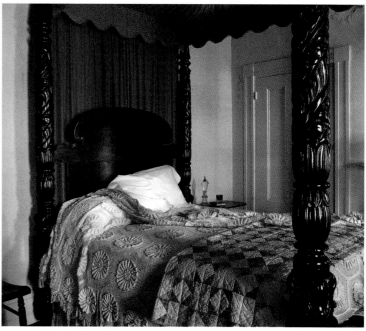

Above, top: A view of Eunice Hadwen's bedroom upstairs, showing a whalebone-and-ivory swift (used to card flax) with the initials "EH" and a knitting basket. James Hathaway's painting *Little Nantucket Girl* hangs over the fireplace.

Above: William Hadwen's bedroom. There is a whale oil lamp on the candle stand next to the bed. The "autograph" patchwork quilt was stitched on Nantucket with each square signed by the woman who worked it—a sign of pure love and dedication.

Opposite: A festive dolls' tea party in the children's room. The second resident of the house (from 1864 to 1923) was Joseph Barney, the son of Hadwen's first partner in the Hadwen Barney Candleworks (now the Whaling Museum). Barney moved into the house with his four children, and the Historical Association has evoked the feel of their era in this period display.

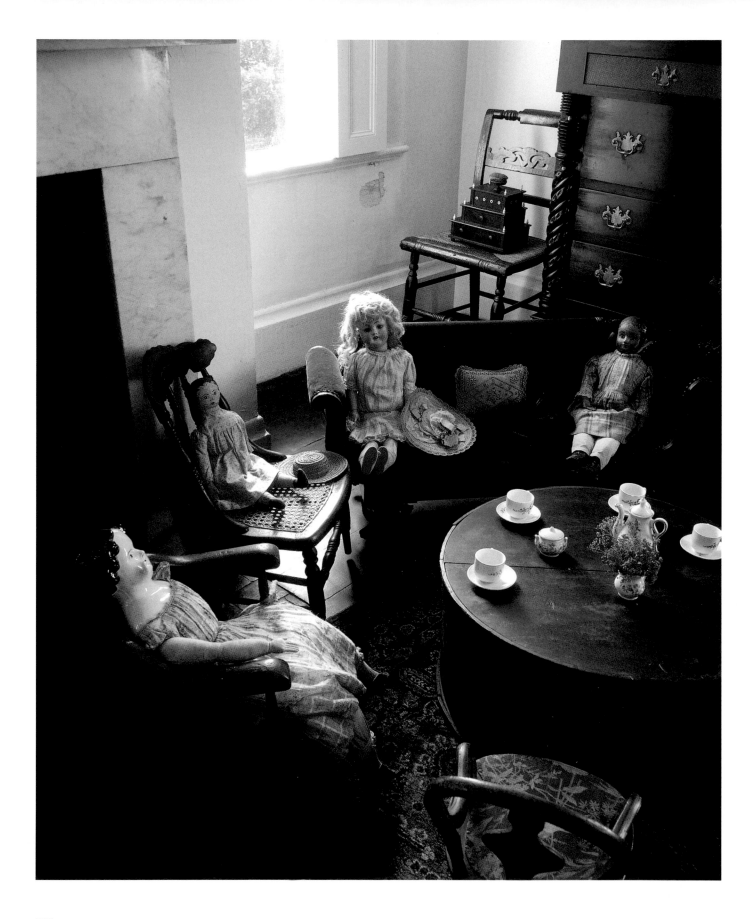

There are secret gardens tucked here and there in town. *Above, top*: The garden of the David Joy house on Centre Street. One of Captain Joy's whaleships, the *Peru,* was the first to enter Nantucket harbor by means of "camels." The Coffin brothers' *Constitution* was the first ship to exit in this manner. *Above*: This wishing well is on Mooers Lane, named for Captain William Mooers, who in 1783 sailed the *Bedford* into London displaying the new United States flag for the first time in British waters.

Opposite: The herb garden behind a Fair Street guest house is edged with thyme and salad burnet. Also growing are sage, lavender, sorrel, lemon verbena, chives, and parsley. Growing from the window boxes are morning glory vines, and to the left of the door is a rambler rose.

A garden is a restorative spot to work or sit in. Nature's gentle beauty is like the love of God, always present, growing and changing. The flowers represent the purest form of love because they bloom whether we are present or not.

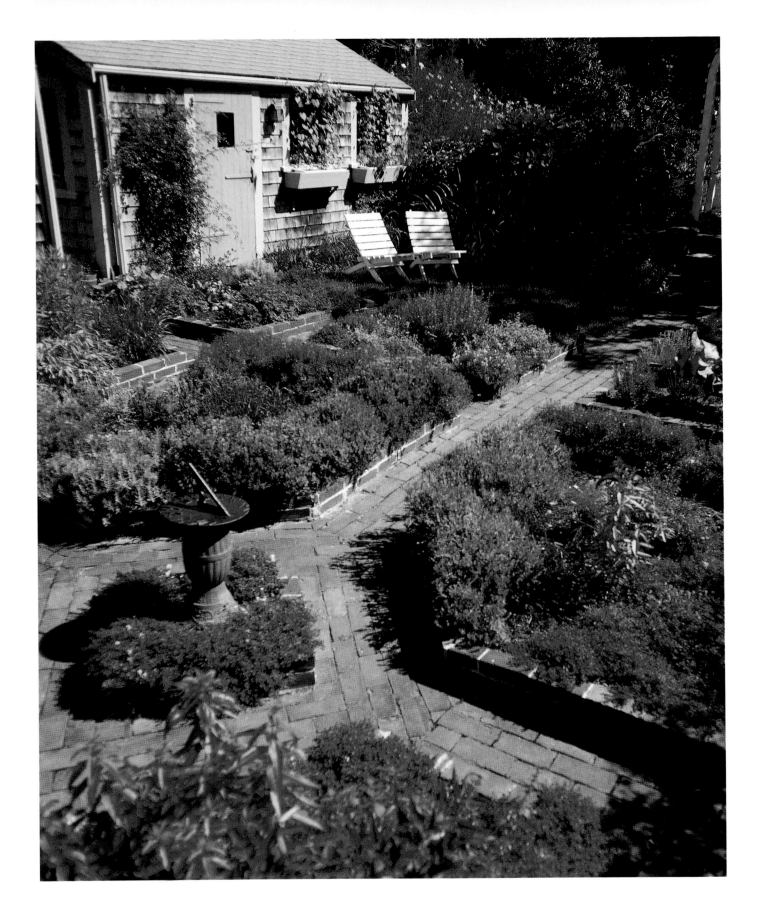

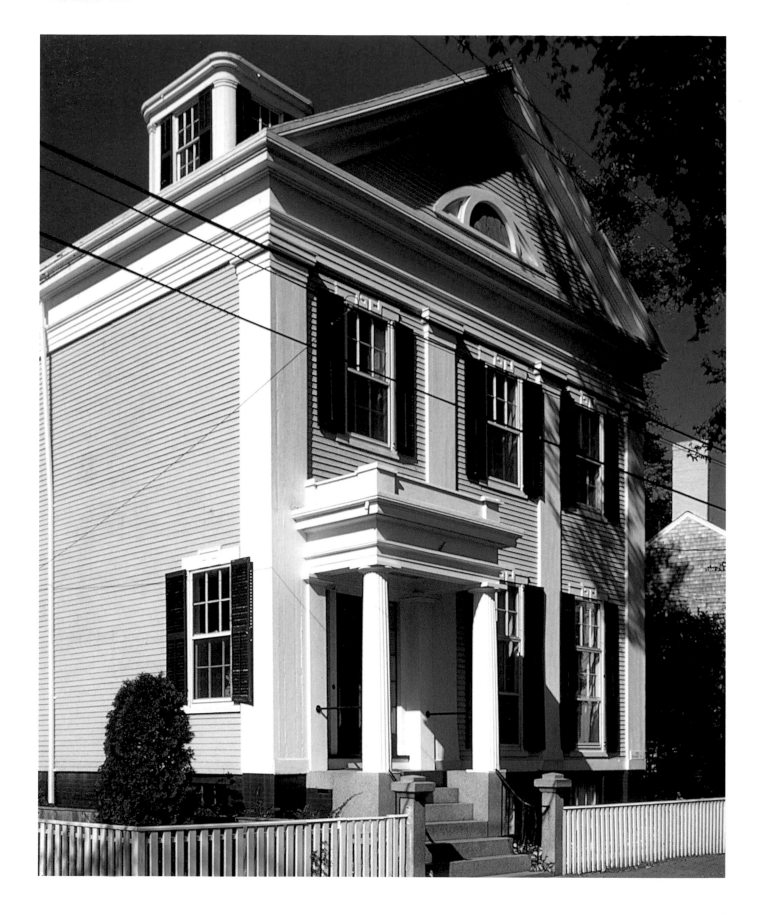

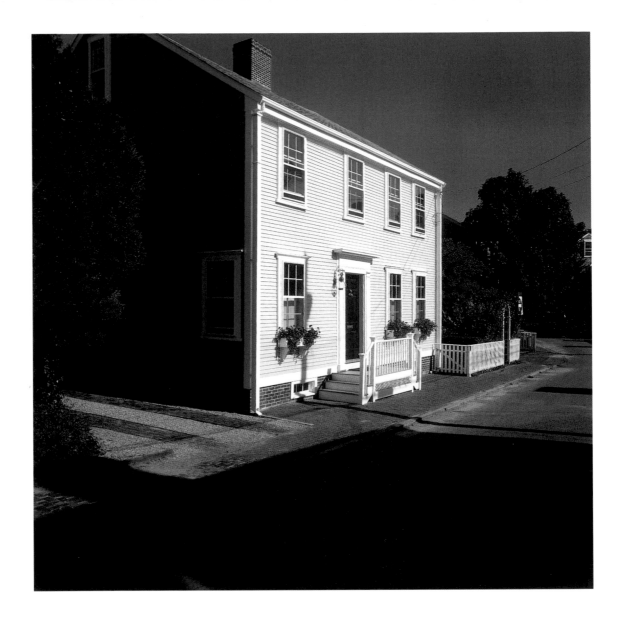

Opposite: The William Crosby house, One Pleasant Street (1837), was given by Matthew Crosby, who lived at 90 Main Street, to his son and daughter-in-law, Elizabeth Pinkham. Her father, Seth Pinkham, was one of the first to chart the notoriously treacherous Nantucket Shoals. The home was elegantly fitted with tall, triple-sash windows, marble mantles, silver doorknobs, hand-blocked wallpaper, and the island's first Chickering piano. It was a happy and fashionable union. The couple was renowned for their hospitality and festive gatherings, where they introduced delicacies including frozen mousse. They experienced a severe economic setback in 1838, however, when a fire destroyed a number of warehouses in which William Crosby's whale oil had been stored. The Great Fire eight years later completely ruined them, and the house passed out of their hands less than ten years after it was built.

The Crosby house is a fine example of pure Greek Revival, a style that prevailed on the mainland from about 1820 to 1860.

Three factors contributed to its widespread popularity: the country's commitment to the Greek ideal of democracy and teachings on law and philosophy; a sympathy with contemporary Greeks, who were engaged in their own struggle for independence from the Turks; and the War of 1812, which reinforced sentiments of national pride, embodied in the classic revival style.

A gully runs behind the houses on Pleasant Street from Main to Milk Street. Many of the whale oil factories and warehouses belonging to the firms owned by Starbuck, Hadwen & Barney, and Swain & Coffin were located here in the early 1800s. This explains why cobblestones, which facilitated the movement of heavily laden carts, were laid up Main Street all the way to Pleasant, but not as far as Milk. The area in front of the monument is paved with vitreous brick instead.

Above: The Frederick Arthur house, 30 Fair Street (1828). Captain Arthur mastered four whaling voyages between 1823 and 1844.

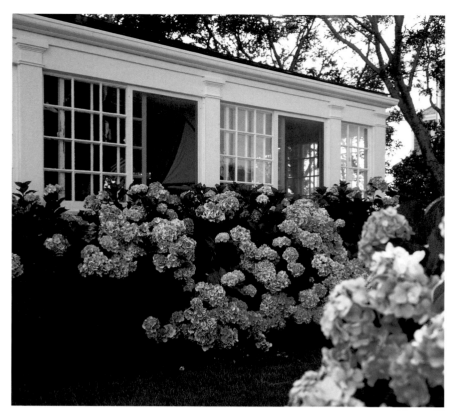

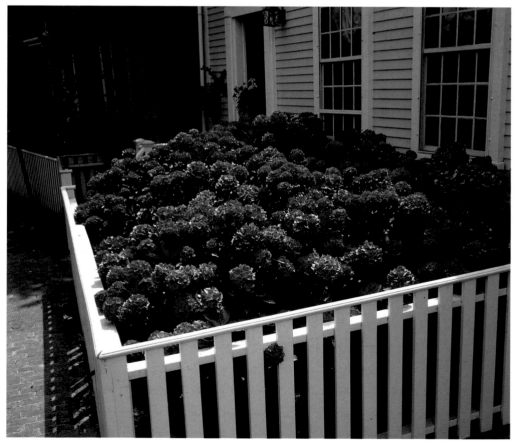

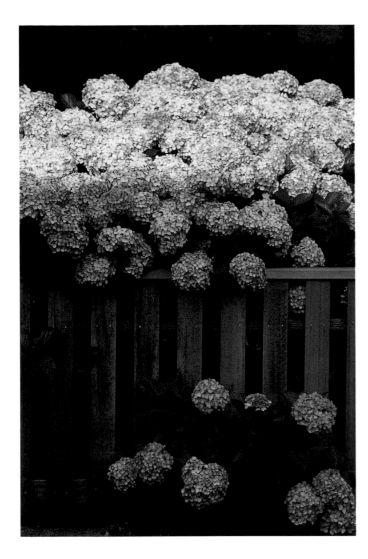

large shrub or small tree that can grow to twenty or thirty feet. There is a very nice specimen on Gardner Street that blooms in late July/early August. The flowers are produced in small, round globes and "fade" to light pink as they age; this is also a very hardy breed.

3. Climbing hydrangea (*H. anomala*): native to China and the Himalayas, blooms earliest of all hydrangeas—in June—with white, flat-topped flower clusters. It is a vigorous climber (remember them clambering up the balconies of the White Elephant years ago?), and can pull the shingles off the house.

4. Single or lacecap hydrangea (*H. macrophylla* var. serrata or *H. macrophylla* var. 'Mariesii'): originally from China, has the same hardiness as the climbing variety, with blue-lavender flowers in a flat flower cluster. The center consists of tiny, button-like flowers surrounded by a ringlet of large, flat, sterile flowers.

5. Double hydrangea (*H. macrophylla macrophylla*): this is the most familiar and most widely planted type on the island. It is in this species that one sees the most variation in color. Double hydrangea only thrives in a narrow band of growing zones, where winters do not get too cold but summers do not get too hot.

Chinese and Japanese hydrangeas were probably first introduced to Nantucket in the early part of the twentieth century; in fact, they were not even introduced to the U.S. until then. Russell Pope obtained some of the flowers early in his nursery career and began propagating them, especially a variety called Nikko Blue, a double hydrangea with deep, thick, green leaves and bright blue flowers.

Hydrangea flowers vary in shade and color from plant to plant depending on variety, location, and soil type. If one plants a blue variety, one is not going to get pink flowers. If one plants a pink or red variety (there are plenty now being introduced to the nursery trades), one is not going to get blue flowers. The intensity of the color of the blue flowers can be increased by adding acidic ingredients to the soil. Nantucket's soil is already naturally acidic, so blue hydrangeas will take on an intense hue. Hydrangeas planted in the shade tend to produce fewer and paler flowers, while those planted in the sun are more and brighter.

Hydrangeas tend to flower on last year's wood and break out of dormancy early. In colder parts of the country, this means that a late frost usually kills the flower buds. Deer and rabbits don't eat hydrangeas, except perhaps at Tom Nevers, where they eat everything.

Above: Hydrangeas on New Dollar Lane. The lovely gardens we enjoy today were different in the whaling era, overwhelmed as they were by the noise and oil. *Opposite*: Hydrangeas on the Cliff and on Prospect Street. These deciduous shrubs are native to Asia and the Americas. The oval leaves grow in opposite pairs, and the flower heads are often composed of small, fertile flowers and large, sterile flowers. Two forms of the shrub *Hydrangea macrophylla* make popular ornamentals on Nantucket: lacecaps, which have heads with large, sterile flowers surrounding fertile ones; and mop-heads, or hortensias, which have heads composed entirely of large, sterile flowers. Both shrubs produce blue flowers on acid soil and pink on alkaline soil. Many shades of deep pink and even cranberry have now been bred.

There are five main varieties of hydrangeas flourishing on Nantucket:

1. Oakleaf hydrangea (*H. quercifolia*): native to the U.S., blooms in July with large, elongated, white panicles (flower clusters) on deeply and sharply lobed leaves.

2. PeeGee hydrangea (*H. paniculata*): native to China, is a

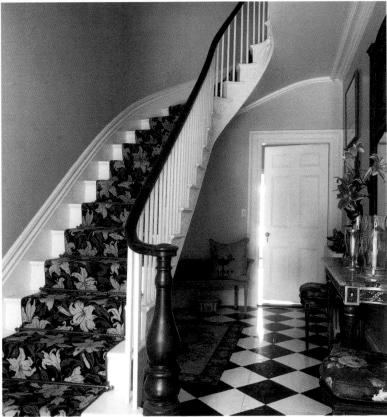

The Francis Macy house, 77 Main Street (1790, 1836). A New York journalist, Charles Henry Webb, lived here in the 1890s. He was instrumental in arranging the publication of the first short story by one of his colleagues, Samuel Clemens.

The house was in the Mitchell family from 1905 until the present owner purchased it in 1986. It had become the Mitchells' secondary residence on Nantucket after they bought a home on Polpis Road, and had been rented out for many years. Basic maintenance had been seen to, but little else; thus the house was in its original state, albeit a bit neglected. No alterations had been made, so the job was to restore the house to its original condition while bringing it into the twentieth century in terms of electrical, plumbing, and heating systems. The one major renovation was the kitchen, which not only dated back to 1900 but was sorely in need of repair. The new kitchen was cabinet-made on Nantucket, with the same standards as those once held for ship-building. The new owner feels that this is her gift to the house, since she sees herself as merely the house's steward.

For the rest of the house, the challenge was to restore all the windows and missing moldings, repair the plaster, and restore the floors. Then, once all that was done, the painting and decorating could begin. There are some points of interest here. All of the eight fireplaces had been fitted with coal grates but had no fireboxes. These were created out of old brick. A sad development occurred when insulation was blown between the inside and outside walls, destroying the natural vapor barrier that had been built into the original design. Over the years, the new insulation has been carefully removed.

Left, above: One of the most charming features is the sumptuous dining room. The walls are covered in a Rose Cumming fabric, "Birds of Paradise." The Chippendale table can expand to seat sixteen, and the chairs are Irish Chippendale. The candlesticks are etched glass, not silver, while the chandelier is from Nestlé. The hens and chicks are antiques, as are all of the objects on the sideboard. In this room, the floors are bare wood, so that chairs slide easily and spills are unimportant. The flowers are all silk, ready to greet the owner no matter how long she has been away.

Left, bottom: The majestic, curved front staircase is covered in a Stark carpeting called "Calla Lilies" and is characteristic of staircases in whaling mansions built at this time. The console on the right wall is wood, gilt, and faux marble—painted by the owner. She also painted the floor herself. Originally, broadloom carpeting was used throughout the formal part of the homes because this was a new product and bespoke the prosperity of the time. Wide pine floorboards were to be completely covered over if at all possible.

Right, top: The living room of the Francis Macy house. The owner glazed these walls herself and also painted the sofa frame, which is covered over in a Rose Cummings silk. The miniature drop-front desk behind it is made of etched ivory in the Vizagapatam style.

Since she has been associated with the Isabel O'Neil Studio for the Art of the Painted Finish for over thirty years, the owner has developed many painting techniques for mantelpieces, furniture, walls, and floors. She has glazed many of the walls in the house herself. Glazing is essentially the application of a transparent coat of color over an opaque base of color. The choice of colors, the medium in which the color is used, and the method of application are what determine the finished result. Thus the choice of a single color (for example, a bright coral, as in the living room), made transparent by mixing it into a glazing medium and applying it evenly over an opaque coat, will produce a porcelain-like finish. The choice of many different colors, again made transparent and applied in a studied but irregular pattern over an opaque base, can simulate marble.

Right, bottom: This is the Beach Room, originally a two-car garage. The outside garage doors have been left in place, but large French doors have been added to the side facing the flower gardens. The owner designed and painted the coffee table in the foreground. She also painted the faux stone floor. An Irish cupboard in the background is newly constructed of old wood and contains hand-painted, antique bird plates. Various Chinese porcelains and a bird cage complete the garden-room feeling of the space. A muted palette of colors has been selected for this summer room, providing a neutral and soothing background to the vibrant flower garden viewable from the French doors that fill two walls.

Opposite: Two of the charming bedrooms. The beds upstairs are antique French cane, the walls are glazed in a soft, fuzzy peach. The "Siasconset bedroom" is in the original part of the house, which was moved back from the street in 1836. The floors are wide, old floorboards painted in a fashion typical for a 'Sconset cottage—white for a crisp and clean counterpoint to the busy walls and ceiling. The latter are covered in the Rose Cumming pattern "Maureen."

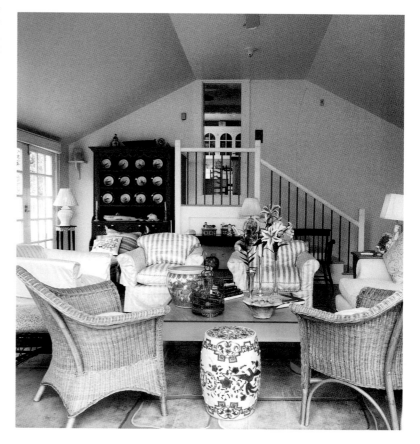

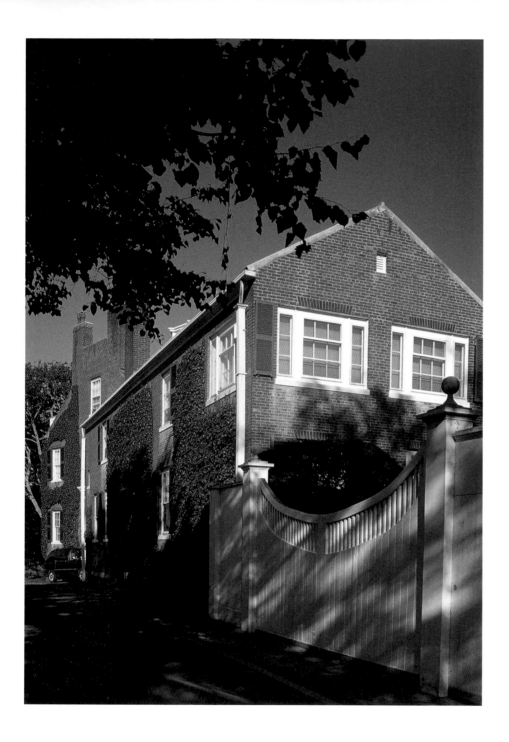

Moor's End, 19 Pleasant Street (1829–34). The first important brick house on the island was built for Jared Coffin, who had made his fortune in whaling. Other prominent island residents recognized the social prestige of this mansion and soon embarked upon building programs of their own, most of them more centrally located on Main Street.

Opposite, top: The sitting room contains a rare set of fifteen Empire wallpaper panels called "Les Sauvages de l'Ocean Pacifique," designed by J. C. Charvet and produced in 1904 by Joseph DuFour et Cie in France. The scenes depict natives of the Sandwich Islands and New Zealand. Two other sets hang in the Museums of Fine Arts in both Philadelphia and San Francisco. *Opposite, bottom:* The magnificent dining room has two fireplaces on one side and murals of whaling scenes by Stanley Rowland on the other.

The rose gardens behind the Moor's End walls are very special indeed, flourishing under the tender care of the owners.

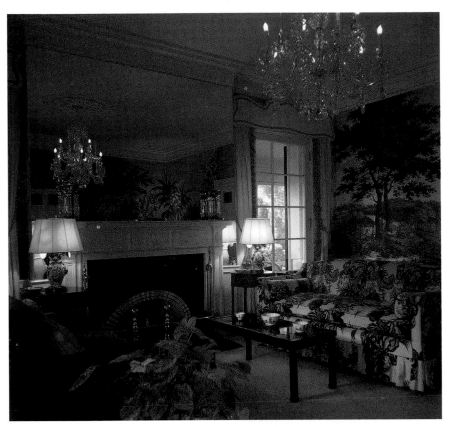

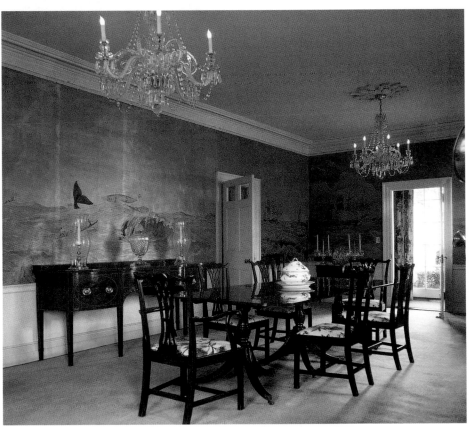

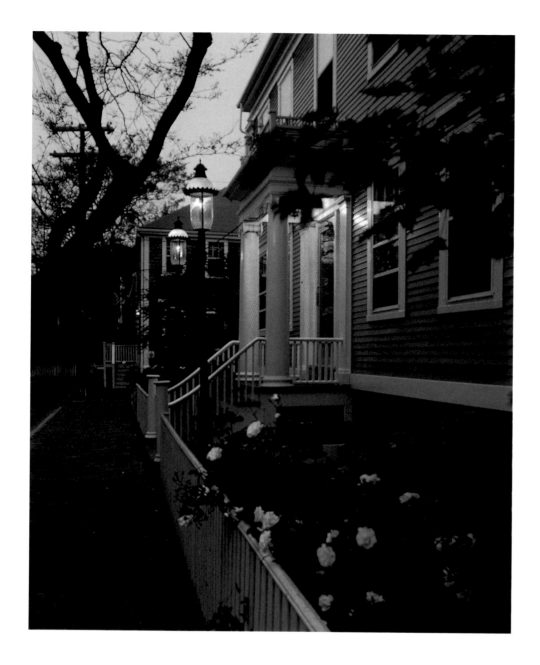

Above: The Harrison Gray Otis Dunham house, 56 Centre Street (1842). This structure, now incorporated into the Jared Coffin House hotel complex, was built for the owner of the whaleship *Nantucket*. The house survived the conflagration of 1846 because of the protection offered by the brick Jared Coffin House.

Opposite: The Richard Gardner III house, 32 West Chester Street (1723). This is one of the earliest houses owned by a whaling captain and has two full stories. It was built the same year as was Straight Wharf. At that time, the town's center was gradually shifting from the old Sherburne settlement near Capaum to the Great Harbor, as sheep raising gave way to fishing and whaling.

Captain Gardner perished at sea just two years after he moved in. The house was then owned by the Brock family. Priam Brock was carried down by a whale at the age of twenty-two when he was captain of the *Franklin*.

The first Richard Gardner, an Englishman, lived on Sunset Hill near his niece Mary Gardner and her husband Jethro Coffin. In 1667, he was granted an area called Crooked Record, an irregular plot roughly bound by the present-day streets of Gardner, Liberty and Lily on the east, Main on the south, New Lane on the west, and West Chester and Centre on the north. His son, Richard II, built the house at 139 Main Street, and his grandson Richard III built this one on West Chester. Early Nantucket houses (1680–1740) reflect the design of contemporary English cottages, usually facing south with no roof overhang, to maximize precious sunlight and heat.

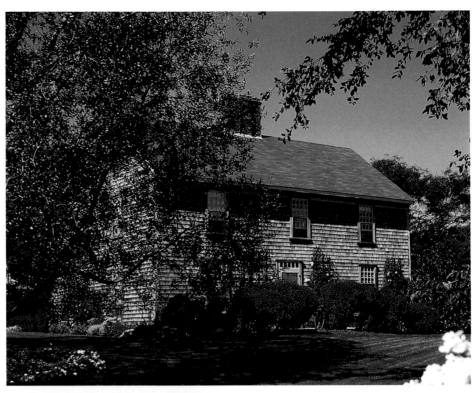

Interior views of the Richard Gardner III house show an extraordinary collection of museum-quality antiques with which the owner lived as if they were ordinary furniture. *Opposite*: The whalebone swift, used for winding wool, was made at sea. The early eighteenth-century wall clock is known as a "wag-on-the-wall." The wing chair is upholstered in a replica of a traditional flame-stitch pattern. The unusually large and handsome library is composed primarily of Quaker study books, collected by the Brock family between 1822 and 1902.

Above: The keeping room, which is the sitting room at the rear of the house, contains fine examples of early nineteenth-century furnishings. A hidden door to the left of the fireplace leads to the second floor. To the right of the fireplace is a unique Nantucket knitting basket made by José Reyes. The eighteenth-century Queen Anne chairs are from the Hudson Valley, and a cobbler's bench now serves as a coffee table.

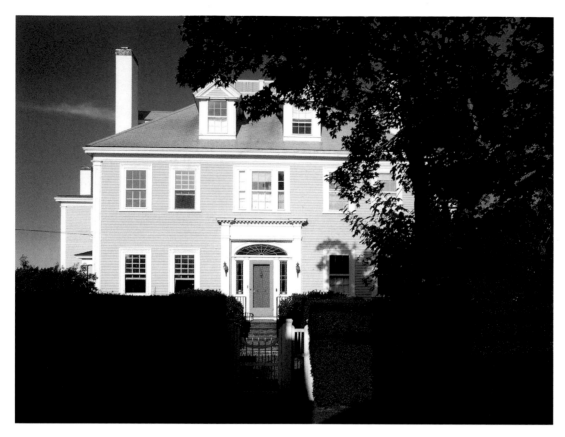

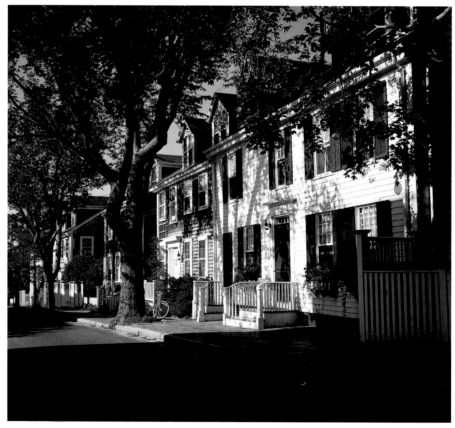

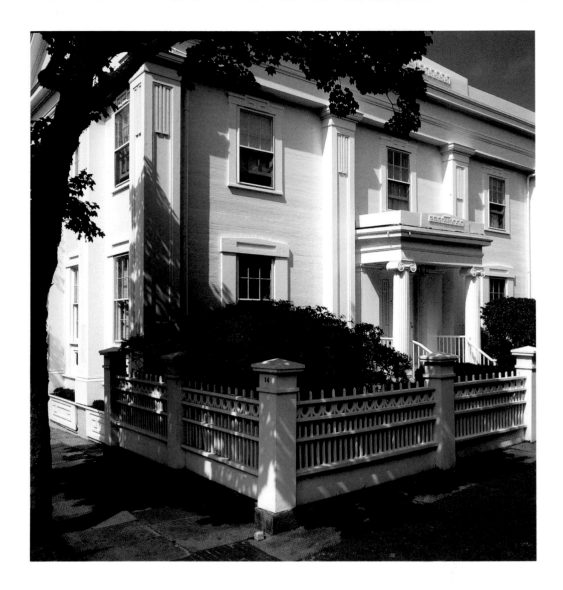

Orange Street was home to 176 captains over the period of a century, a record unsurpassed by any other street of its length in America. It was first laid out in 1726 with the opening of Nantucket's third subdivision, the West Monomoy Division (following Wescoe Acres Lots in 1678 and Fish Lots in 1717). The new Monomoy lots ran between Quanaty Bank and Pleasant Street, with Union and Washington Streets added subsequently. The eastern side of Orange was called Quanaty, or "long hill," and the western side was called Wescoe Hill, meaning "at the white stone." The side streets were not named until considerably later, when Orange Street had already been paved with cobblestones.

In the second half of the nineteenth century, many Orange Street residents converted their homes into caravansaries to accommodate the island's nascent tourism business. The horse fountain donated in 1885 by William Hadwen Starbuck (who also provided the new town clock for South Tower) was originally at the intersection of Orange and Main Streets. It was later moved to its present location in Main Street Square.

Opposite, top: The John Nicholson house, 30 Orange Street (1831). The proportions of this handsome, five-bayed dwelling follow Pythagoras's golden rectangle: the height to width ratio is 5:8. At the peak of the whaling era, many captains built large houses with double chimneys and elaborate façades, in contrast to the Quakers, who favored modest, asymmetrical layouts. *Opposite, bottom*: The Nathaniel Woodbury house, 22 Orange Street (1760).

Above: The Levi Starbuck house, 14 Orange Street (1838). William Andrews designed this handsome Greek Revival house in a massive, square style, with the wooden sides having flush boards rather than clapboards. The middle windows on Orange Street are blind—glazed sashes over closed shutters hiding a solid wall. The house thus appears to have three full bays on the side, whereas it really only has two. The windows contain the original glass. This house, sitting sideways on its lot behind a monumental fence to set off its grand entrance, was completed when the last of the Three Bricks was built, and seven years before the William Hadwen houses.

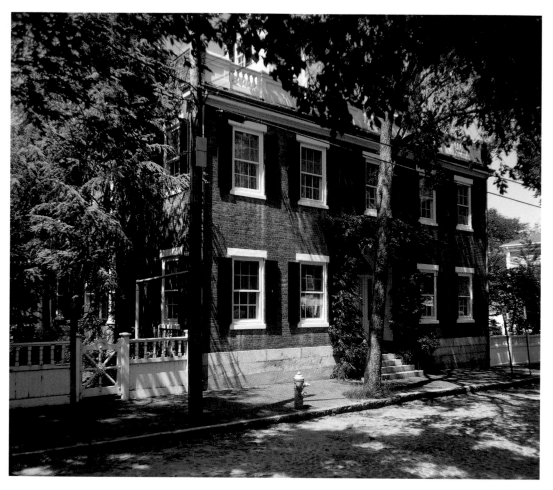

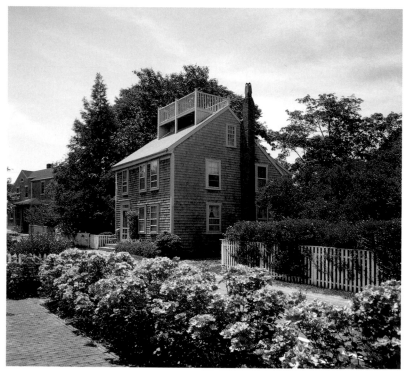

Opposite, top: The Frederick Mitchell house, 69 Main Street (1834). Frederick Mitchell was a whaling merchant and later became president of the Pacific Bank. In 1889, Caroline French, a principal benefactor of St. Paul's Church, lived here. For many years this was the rectory of the church, and from 1914 to 1955 it was a "church haven" for the clergy. (*Opposite, below*) The Peter Paddock house, One Bloom Street (*ca.* 1727), moved here in 1830.

Above: Petunias growing in an urn at Sam Sylvia's antique store on Ray's Court. This is where visitors will find the figurehead of Commodore Oliver Hazard Perry on page 127. Petunias are annuals of the nightshade family. They originally came from South America, where the Indians referred to a related tobacco plant as *petun.* The first double petunia appeared from the seed of a single petunia in a private garden in Lyon in 1855. Now they are cultivated everywhere.

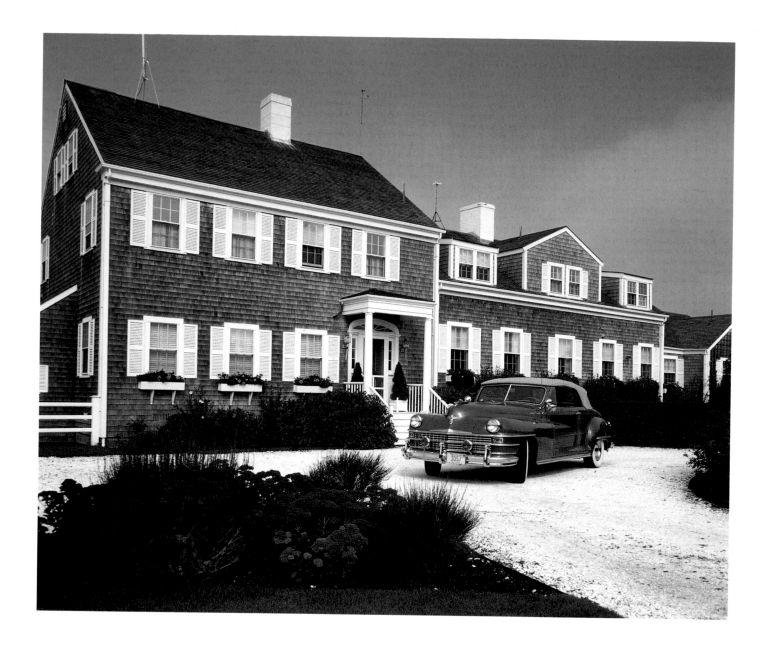

Summer houses along Hulbert Avenue and Cliff Road. Hulbert Avenue is named for one of the first families to live here, in an area called Beachside. It was a sandy slough that was drenched at high tide and was eventually filled in by the nearby Nantucket Hotel to keep the area from flooding. Unlike the houses on the Cliff, these were designed with minimal lawns because their owners preferred sailing over gardening. The majority of the Hulbert Avenue homes were built in the 1930s and 1940s, whereas the grander Cliff Road homes were built before and just after World War I. Many of the homes have docks and moorings. They also lack the wide verandas typical of the Cliff homes, reflecting a new era when evenings were not spent rocking on the porch but rather inside, listening to the radio or watching television.

The lovely 1947 Chrysler Town & Country straight-eight convertible offers more show than go. It has gyromatic transmission with Fluid Drive. The car starts up in second gear, and at twenty m.p.h. it slips into third. First gear is rarely used. Two heaters and two spotlights were standard equipment.

Hulbert Avenue is named for Edwin Hulbert, who lived at No. 73 beginning in 1880. This was the first and, for many years, the only home on the avenue. With the development of Hulbert Avenue in the 1920s, Nantucket had three distinct summer social sets. There was the Cliff Road group, given to socializing and golfing; they were instrumental in establishing the island's golf clubs. The Beachside (Hulbert Avenue) group were sailing enthusiasts who organized the Nantucket Yacht Club from the

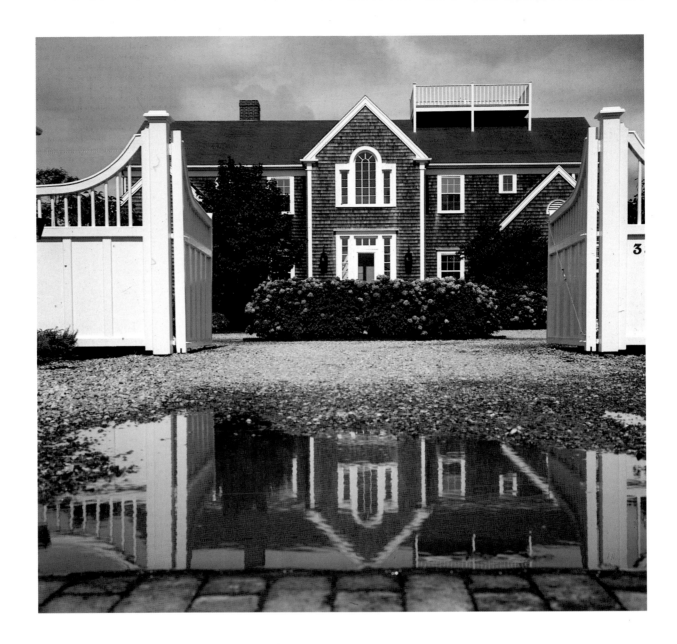

old Athletic Club. The 'Sconset Bluff crowd founded the 'Sconset Casino to satisfy their appetite for tennis. And a fourth group evolved in the 1960s—the historic preservation contingent—composed of individuals interested in purchasing and restoring the island's trove of old homes.

The house on Cliff Road in the above photograph stands on the former site of the Sea Cliff Inn, which was designed by Robert Slade and opened in 1887. The hotel dominated the neighborhood for eighty years and was influential in changing the former North Street's name to the more tourist-friendly Cliff Road. The Sea Cliff Inn was built in the Queen Anne style, featuring both shingles and clapboard with a variety of dormers and roof details. It had two large parlors, reception rooms, a bil-

liard room, and a three-hundred-seat auditorium. Patrons headed for the beach did not have to trudge through sand dunes; a half-mile boardwalk stretched from the hotel to the West Jetty Beach. The main building was razed in 1972, but one of the hotel's guesthouses still stands on Cliff Road.

The first Nantucket summer homes were built in the Cliff Road area and had unlimited access to the beach. A public right-of-way ran along the Cliff behind the houses, as one does today along the Bluff in Siasconset. Many of the Cliff residences were imposing edifices designed to be run by large, imported staffs.

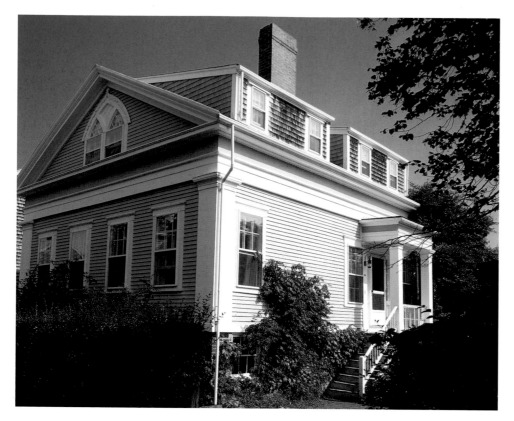

The Edward Kelley house, 34 India Street (*ca*. 1846). This Greek Revival house originally had its entrance on the eastern side, facing town. Now it is on the western side, facing a large lot that once contained the family's barn. The house has end chimneys, heavy pilasters at the corners supporting its entablature, a four-bayed façade, and Gothic, pointed windows in its pediment. This home has wonderful character. All homes do. They are as individual as the people that dwell in them.

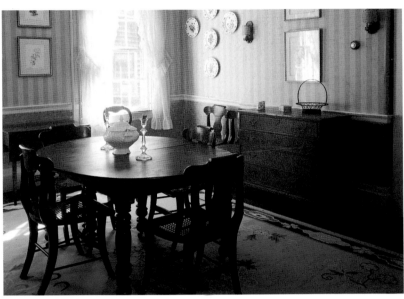

India Street, originally known as Pearl Street, was part of the Wescoe Acres subdivision of 1678 and is thus one of the island's oldest streets. Wesko, or Wescoe, means "bright or white stone" and is believed to describe the quartz block underlying sections of this area. This division was bound by Federal, Liberty, North Liberty, and Broad Streets, with Pearl running down its center. The land was divided into twenty long and narrow strips, running east to west, with each lot having an end on the harbor. (At the time, Federal Street marked the water's edge. But in 1743, the dunes were leveled to create the Bocochico Share Lots, of which Federal Street was a part.) By the turn of the nineteenth century, it was referred to as India Row. In 1811, Joseph Samson, an observant visitor, wrote an article on Nantucket for the *Philadelphia Portfolio* in which he described India Street as hav-ing been so named because of "the number of residents who live with ease and affluence thereon." Edouard Stackpole points out that a little more research on the part of the writer would have revealed that there were a number of shipmasters living along India Street who made lucrative voyages to both the West and East Indies. Most of the dwellings were built from money directly connected with marine trade to both the West Indies and the Far East. In fact, Stackpole observes, there is probably no single street that has as wide a range of maritime history as does India Street. Whaling masters, coastwise skippers, merchant ship captains, and schooner captains were all residents of this thoroughfare, living in homes ranging from small dwellings to mansions. The name of the street reverted to Pearl until the 1930s, then back to India Street.

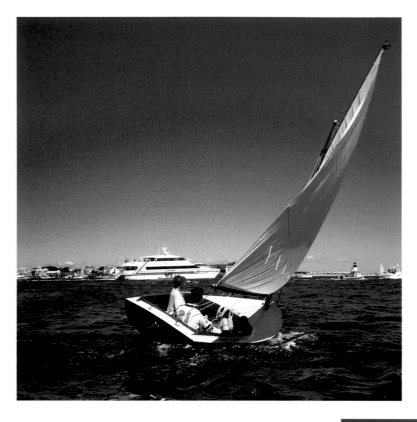

Sailing for pleasure is a recent pastime for Americans in general and for Nantucketers in particular. As recently as World War I, the Nantucket Athletic Club (predecessor to the Yacht Club) offered no outdoor facilities. Sailing was largely for fishing, scalloping, or occasional group excursions. This was accomplished with catboats, which had centerboard hulls, wide beams, and large, single, gaff-rigged sails. Most were built by the Crosby family in Osterville beginning in 1881. In 1921, John Beetle, a sailor and manufacturer, produced a smaller, twelve-foot catboat which the Nantucket Yacht Club selected in 1925 for its fleet. Beetle's boats had different-colored sails and became known as the "Rainbow Fleet." Today, Rainbows are a popular addition to Nantucket's annual Opera House Cup Race.

There is nothing to compare with casting off and setting sail. The splash of the waves and the wind in your face simply dissolve all worries. You are truly free in this moment.

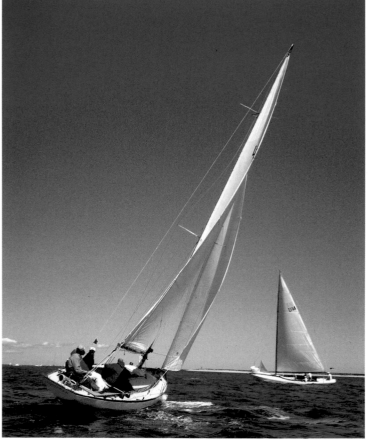

Sailing and Beaching

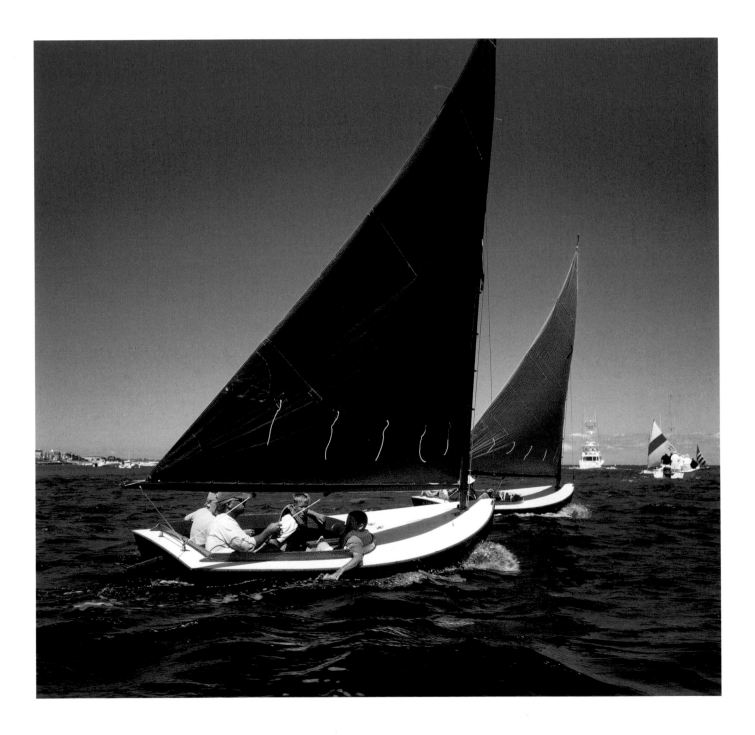

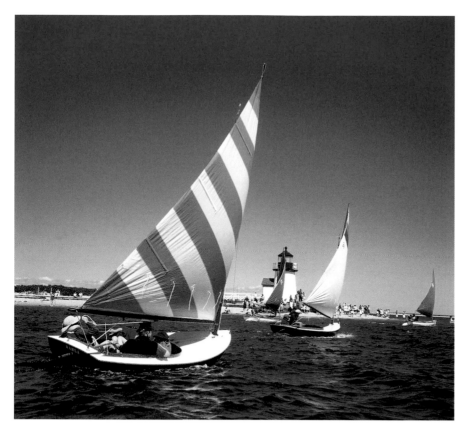

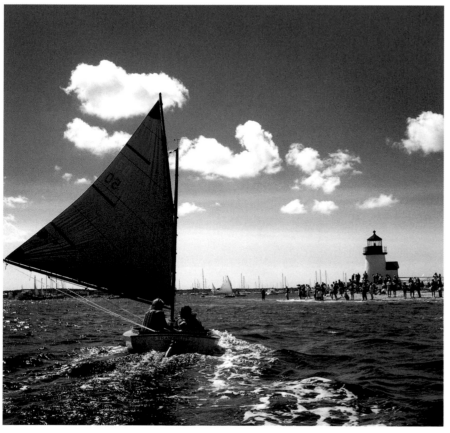

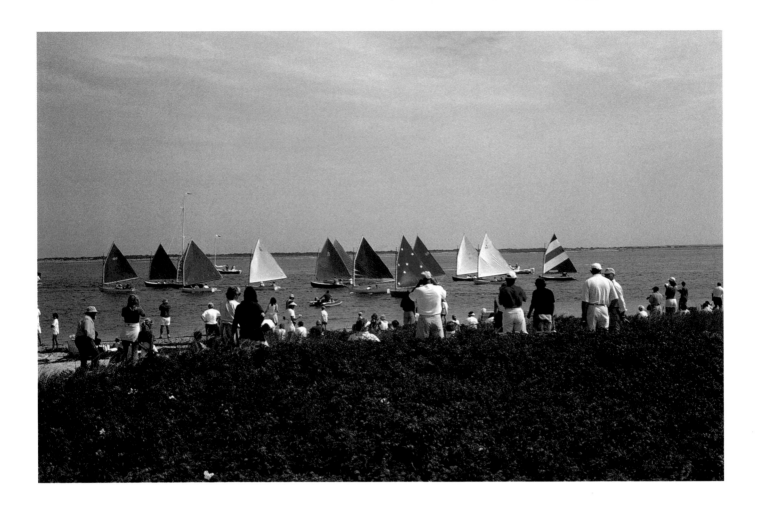

The Rainbow Fleet in action. At one time there were more than eighty Rainbows in Nantucket's famous fleet, which was immortalized in a 1930s photograph by Marshall Gardiner showing the boats rounding Brant Point. The Rainbows of today are mostly built at the Concordia Yacht Yard, outside of New Bedford, in the old-fashioned way: cedar sprung over steam-bent, oak frames.

The Rainbow Fleet is indebted to Eric Holch for developing its revival and to Anne Cross for organizing its annual parade of sail, traditionally held in the harbor on the morning of the Opera House Cup race. The race is open to sailboats of all sizes—provided they have wooden hulls. Thus the Rainbows do qualify, but they have their own race in the harbor, leaving their larger cousins to sport outside the jetties.

Beetle's boats were preceded by sixteen-foot Cape Cod catboats, which were introduced to Nantucket in 1922. There were initially seven of these at the Yacht Club, each with a different-colored sail (yellow, light-blue, dark-blue, and orange, for example); they were commonly referred to as Big Rainbows. They had some serious sailing flaws, however, as C. S. "Butsy" Lovelace observed in a magazine article: "She had a very hard weather helm, and when running free, tended to root and plunge, and her bows would go under in a good following sea. Only the strongest men could handle her." As a result, the Nantucket Yacht Club sought a smaller, more maneuverable boat, especially for its younger sailors. A twelve-foot catboat was

found in 1925, at John Beetle's yard in New Bedford, and this design was settled upon for the new Rainbow Fleet.

The Beetle family had been producing whaleships and other sailing craft for generations. They knew the business. When the first Beetle cats began arriving at the island in 1925, Austin Strong, Commodore of the Yacht Club in 1930, urged each owner to fly a different-colored sail. By the end of the decade, there were more than eighty Rainbows in the new fleet.

The familiar photograph of Rainbows rounding Brant Point was taken by Marshall Gardiner in 1930. The boats were actually strung along and held in position while Gardiner took the black-and-white photograph, which was subsequently hand-colored at his Gardiner's Gift Shop. (This store was located where Nantucket Looms is today, and the familiar compass sign on the building's side originated with Gardiner.)

The Beetle Cat Rainbows are still made the old-fashioned way by the Concordia Company, which purchased the rights and molds from the Beetle family in 1946. (They experimented with a fiberglass hull, but this trial proved unsuccessful.) But as newer boats made their way to the island, the Rainbows' popularity waned—in fact, by 1975, the class had almost died out. The personal involvement of Nantucketer Alan Newhouse in rounding up the remaining fleet, finding new, dedicated owners, and promoting the resurrection of the class has contributed to a renewed interest in these boats.

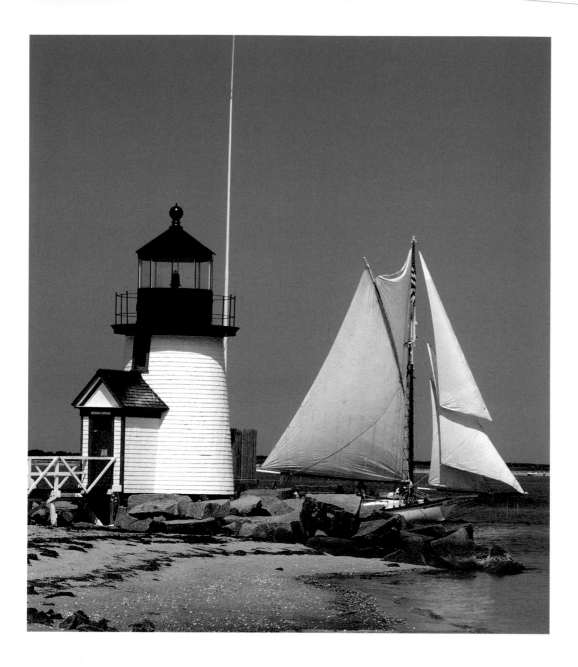

Rounding Brant Point are two Nantucket favorites, the *Endeavor*, shown above, and the *Piera*, on the facing page. The former is Nantucket's most favored sloop for sailing cruises. This class of sloop is known for its long bowsprit, a bold, sweeping sheer, and a curvaceous stern. It is thirty-one feet long with an eleven-foot beam, and it draws five feet. The sloop was built entirely by hand in 1979 by her captain, James Guenther. It took over two years to build, with each part of the vessel carefully researched, designed, and handcrafted to replicate the original wooden vessels of the 1890s. The *Piera* is a forty-five-foot wooden-hull sloop, designed by Philip Rhodes and built in 1955 by Abeking & Rasmussen in Lemwerder, Germany. It is the only wooden-hull sailboat on Nantucket with its own woodie Ford station wagon.

The *Piera* is one of many boats that sail in the Opera House Cup race. This race was started in 1972 by Gwendolyn Gaillard as a tribute to classic sailboats. It is open only to those with wooden hulls. Gaillard began sailing as a young girl in the 1930s on the Long Island Sound. German submarines ended racing during the war years, however. In 1946, she and her husband began the Opera House Restaurant on South Water Street, and hence the August race, which she organized for her sailing customers.

Unlike many sailing spots off the mainland coast, Nantucket is known for always having a nice, steady sailing breeze. But the harbor is a busy spot in the summer, with steamers and ferries making regularly scheduled arrivals, and motor yachts at the Marina adding to the action. Actual mishaps are rare, but close calls are common.

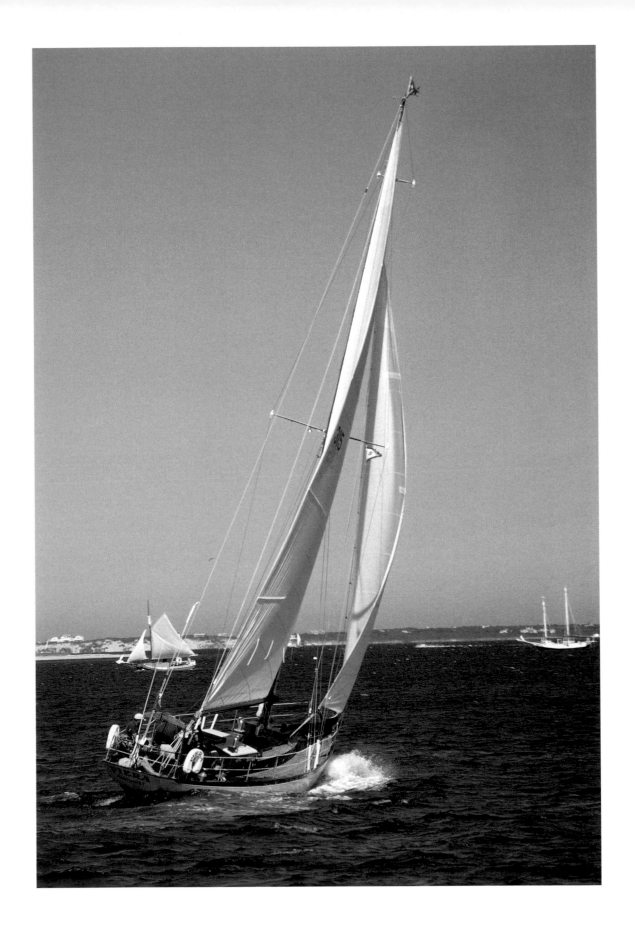

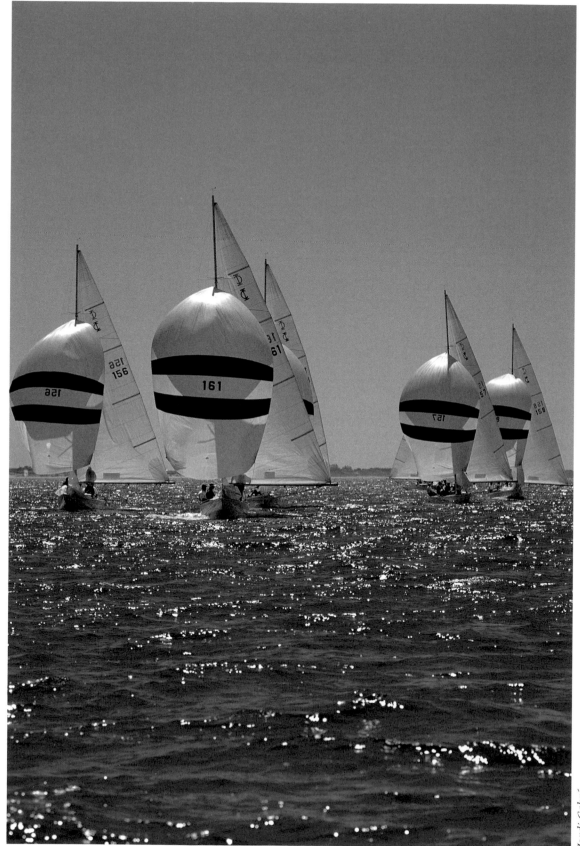

Nantucket's One-Design Fleet. These boats are known as International One-Designs, or IODs. They have their origins in the 1930s, a period when racing was a difficult and expensive prospect. Many were transported to the various racing sites on steamships. Cornelius Shields and a group from Larchmont conceived the idea of designing a new class of boats that would have lines similar to the larger sloops, but would be smaller and more easily handled. The original design is based on the *Saga*, which Corny Shields saw in Bermuda in 1936. It was owned by the Trimingham family. They agreed with Shields' observation that maintaining a one-design fleet in each major racing port would enable sailors to save money and time transporting their boats. Shields engaged the Norwegian designer, Bjorne Ars, to create a thirty-three-foot boat with similar lines to the six-meter *Saga*. The result was a gracious vessel that made her first appearance in Long Island shortly thereafter. Positive reaction resulted in orders for twenty-five boats, spreading the beautiful IODs throughout the sailing world. In addition to Norway and Sweden, the IODs were seen at Northeast Harbor, Marblehead, Fishers Island, the Long Island Sound, and Nantucket.

Today, Nantucket's IODs are made out of fiberglass by C.W. Hood Yachts in Marblehead. The design remains the same as it was in 1936—thirty-three feet long with a deep keel and a six-and-a-half-foot draft. Its stern and bow stick out above the water more than do those of most other boats, giving the IOD a distinctive profile. These are the lines Corny Shields so admired on the six-meter sloop he saw in Bermuda Harbor, almost seventy years ago.

Combined with its graceful appearance is its relative ease of operation compared with other boats of its size. IODs are slow to get under way and slow to stop, but once under full power, they move fast. There are eight boats in the fleet at present, and the fleet itself is an association with twenty-five members. None of the boats is owned by the same group. Each week the boats rotate among the crews. All boats are the same, with the same fittings and sails. This ownership arrangement ensures that the IODs are a true fleet rather than simply a collection of individual boats; after all, belonging to a fleet is part of the fun of sailing.

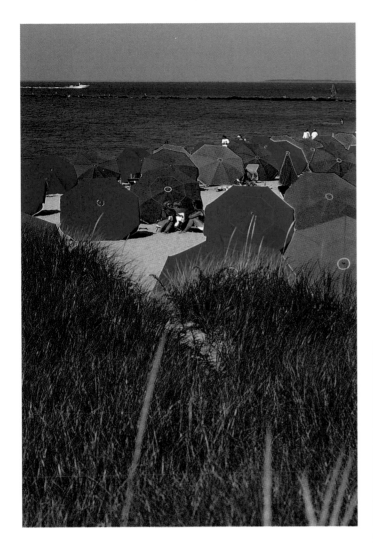

One of the most popular spots for a quick swim is Step Beach, reached from Cliff Road by going down several flights of wooden stairs. (Despite the new signage proclaiming it to be "Steps Beach," most longtime residents still refer to it in the singular—though the steps are undeniably multiple.)

Nantucket has made a regular practice of changing its street names by accident or oversight. Cooper Street, where a cooperage or barrel-making shop once stood, has become Copper Street. My favorite is Fayette Street, which is LaFayette according to the sign at one end. The "La" seems to have fallen off the sign on the other end. Francis Street is like the *Telegraph* steamer that had a different name on the port side. It is either Francis or Frances, depending on which street sign is observed. Despite these changes, one sign in town assures us it is Still Dock Street, and indeed it still is.

Whatever name they bear, almost all roads eventually lead to a beach, the most important destination on a fine summer day.

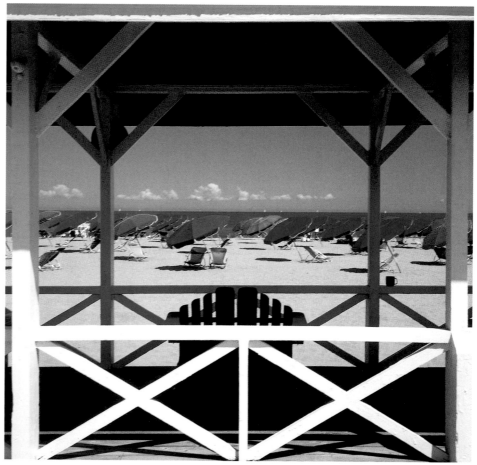

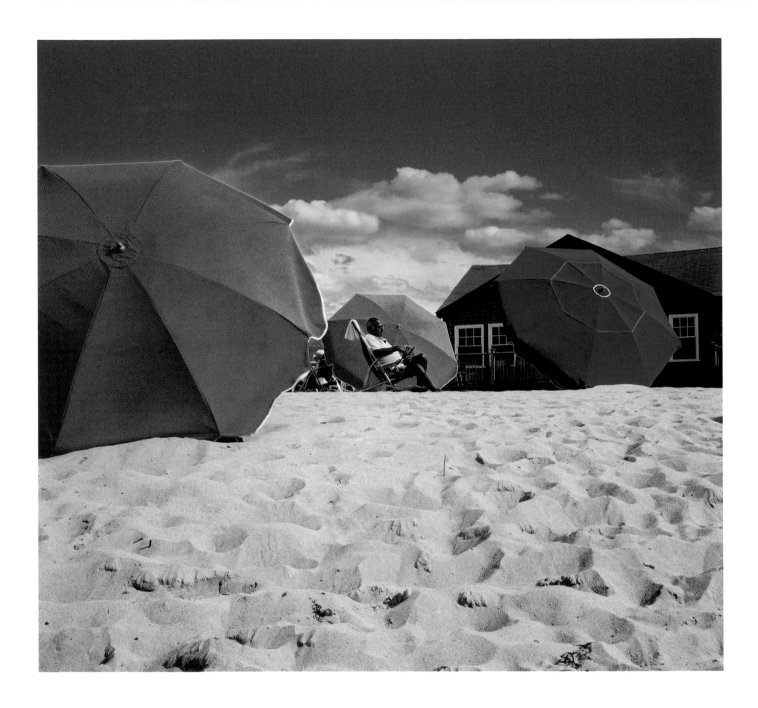

Cliffside Beach Club. The Galley Restaurant at Cliffside is the only spot on Nantucket where diners can sit on a beachfront patio surrounded by vivid petunias. These flowers, native to Brazil and Argentina, are members of the nightshade family. Their name derives from an old French word for tobacco, *petun*. Like some other herbs, they winter kill and often come back the next year, but they are frequently treated as annuals.

Cliffside Beach was originally called Conrad's Beach after Murray Conrad, who opened a bathhouse here in 1924. No one in those days would have dreamed of arriving in swimming suits. Conrad's pavilion was frequented by guests in silk suits and hats, who rented his four hundred changing rooms twice a day to change into none-too-revealing swimming attire. The club is private now, and members are assigned the same, large beach umbrella for the season. Like good seats at the opera, the most desirable umbrella locations must be earned over time. Older members occupy the most sought-after places near the water, while newer members wait their turn. The club added overnight accommodations in 1970 and expanded its guest facilities in 1983 and 1984, using siding from the club's old changing rooms for bedroom paneling. Additional renovations were done in 1986 and 1990.

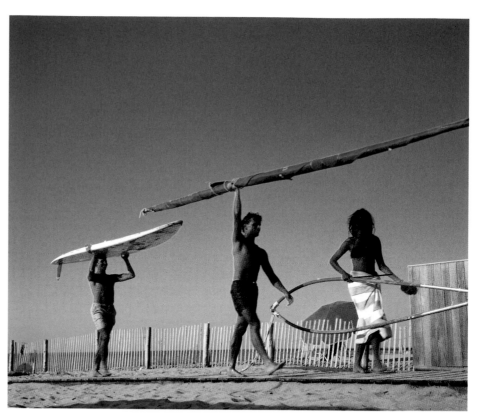

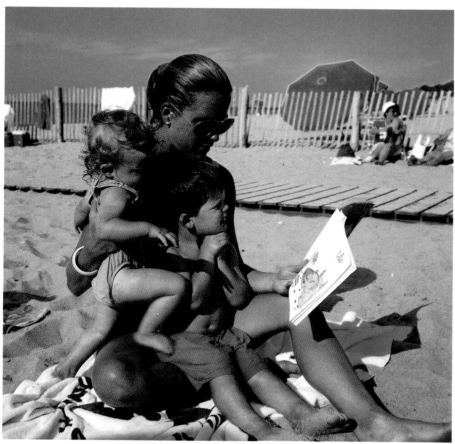

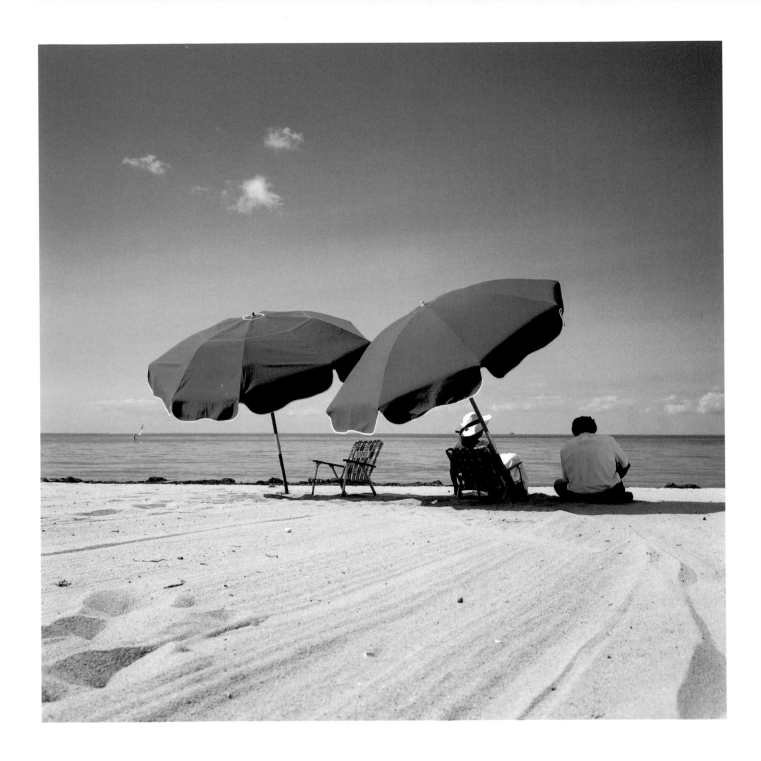

Galley Beach, sometimes referred to as "The Strip," is a narrow ribbon of sand running between the two Cliffside Beach Club properties. This is a favored spot since there is access by a level boardwalk, without having to tackle Step Beach's long climb down and back from Lincoln Circle. Family members and friends are seen in these photographs.

Large beach umbrellas like the ones shown here hark back to their original purpose—shelter from the sun, not from the rain.

Their name derives from *umbra*, the Latin word for shade. In ancient times, umbrellas were emblems of rank: the Egyptians and Babylonians permitted only the nobility to use them. The English (who else?) grasped the implement's potential versatility in the 1700s, when the heavy wood-and-oilcloth umbrella was developed for fending off the rain. Lightweight parasols (the word is French, meaning to ward off the sun), favored for protecting ladies' complexions, came into use in the 1800s.

The most popular bathing spot on the sound side of the island is Jetties Beach. It offers calm water for swimming and a broad, clean, guarded beach that is an easy bike ride from town.

The veranda of the Edwin Hulbert house at the eponymous 73 Hulbert Avenue (1880) offers a perfect view of this beach. The house is known for its Victorian features (rare in Nantucket), which include a wide porch with uninterrupted views of the entrance to the harbor. Hulbert, the discoverer and subse-quent operator of the Calumet and Helca copper mine, built this residence, the first on the avenue. The Nantucket Hotel once presided over the eastern end of the street, but it was eventually razed as more vacationers developed a preference for owning summer residences rather than staying as guests in an inn. Woodrow Wilson visited this house in 1917, invited by the Peck family, who lived here at the time.

Sunfish, sailboards, and bicycles at Jetties Beach. The first sail-board was patented in 1969. Its design, created by Fred Payne, Jim Drake, and Hoyle Schweitzer, consists of a board attached to a mast by a universal joint. There are now over 10,000 sail-boards in use, with large fleets in the United States, Germany, Holland, Denmark, South Africa, and Japan.

The Sailfish, essentially a fixed mast attached to a surfboard, was created in 1947 and put into production by Alcort Incorpo-rated, the namesake company of Alex Bryan and Cortlandt Heyniger. The larger Sunfish was designed in 1952 to accommo-date an intrepid expectant mother who required a small cockpit to hold her on board. The fourteen-foot Sunfish has proliferated to some 300,000 units over thirty years, and is undoubtedly the most popular sailboat ever made. *Fortune* named it one of the twenty-five best-designed products in America.

270

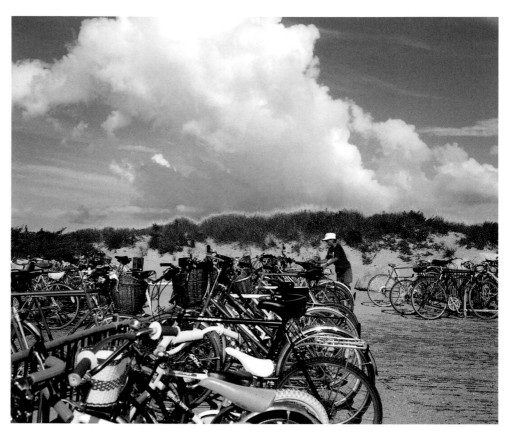

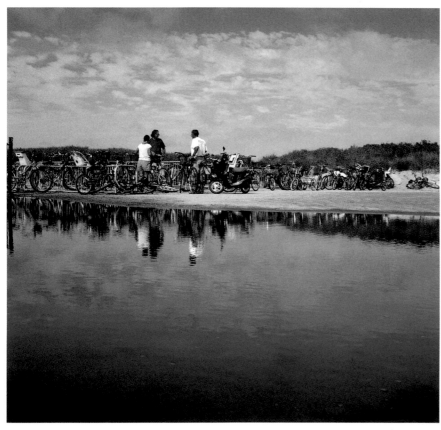

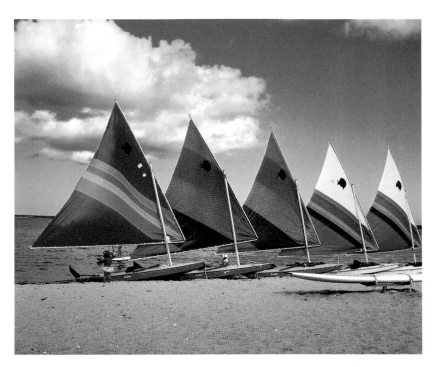

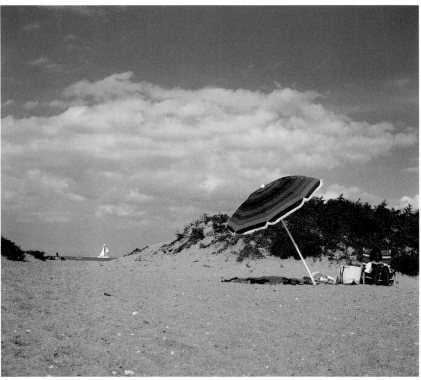

Sunfishing, reading, and kayaking are popular at the Jetties Beach. Shown are open-surf kayaks, available for renting at the Nantucket Island Community Sailing. They provide both single and double shells. Sea kayaks have been used by Eskimos for thousands of years, but have only become popular with vacationers in the past few decades. Now Nantucket offers three locations to rent them, and for the first time, sales of sea kayaks have surpassed those of canoes in the Northeast.

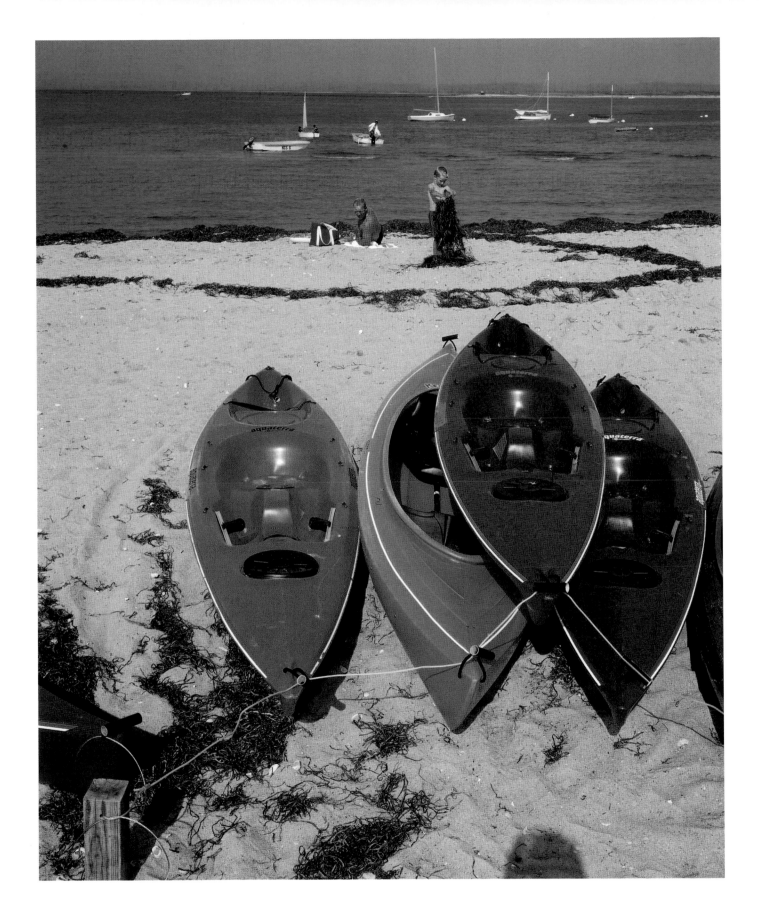

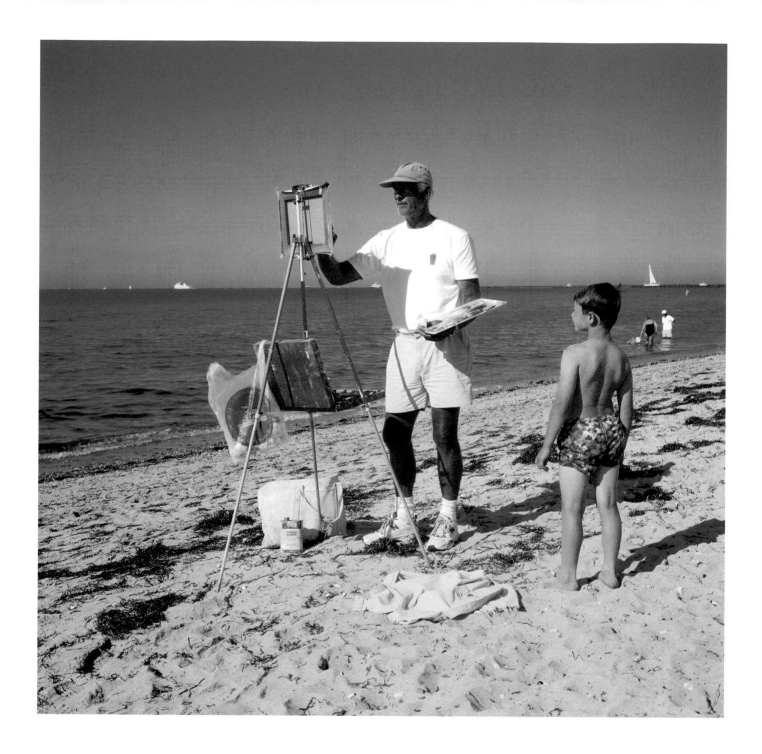

Beachtime activities at the Jetties and Cliffside. Painting, sailing, and sandcastle construction complement the traditional pastimes of swimming and reading.

Swimming gradually gained popularity as a recreation in the nineteenth century. As early as 1848, the Ocean House (now the Jared Coffin House) advertised "good accommodations for sea bathing." In 1864, Eban Allen erected a structure on the shore with changing rooms available from 10:00 A.M. until 1:00 P.M. and again from 4:00 P.M. until 7:00 P.M. (Evidently, he had a healthy respect for the effects of the midday sun.) The Cliffside Shore Bathhouses, established later, received a steady flow of customers with the 1887 opening of the Sea Cliff Inn. The hotel had a long boardwalk leading down to a spot on what is now known as Hulbert Avenue. Charles Hayden, who opened his Clean Shore Bathing Rooms in 1869 on the site of the present-day Children's Beach, set up a branch operation near here in 1880.

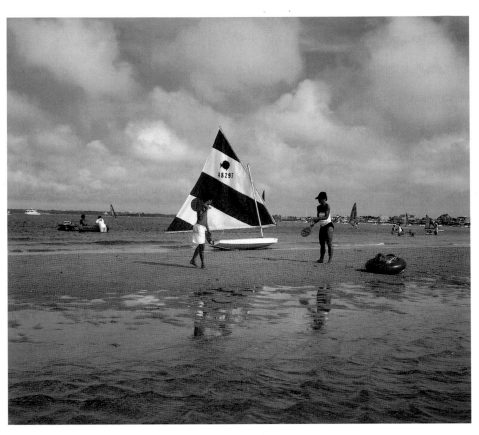

Sand castles at the Jetties. Sand sculpture has always been popular, and children of all ages eagerly anticipate the annual Sand Castle Day in August. The contest was started by the Nantucket Island School of Design together with the Nantucket Chamber of Commerce in 1973. Every summer, contestants gather in good-spirited competition. Whether they receive a prize or simply enjoy the camaraderie surrounding the creation of a special project on the beach, everyone wins.

This 1992 photograph (*above*) shows the *Pride of Baltimore* on a rare visit to Nantucket. The graceful lines of this clipper ship are unusual. The masts are aft-raked, giving her an arrow-sharp profile. Clipper ships were extraordinary speedsters in their day.

Afternoon at the beach. During the summer, late afternoon is a special time. The water is warm, and the sun is more gentle. There is no need to rush home. In fact, few would contemplate starting an evening cocktail party before 6:00 P.M.

When serious swimming and reading are done for the day, there is still time to linger and relax, time to splash in the water or stroll. A leisurely walk on the beach, alone or with a friend, is very special. The solitude by the gentle waves brings peace, harmony and truth. The pretty, iridescent, circular yellow shells one finds here are called Jingle Shells (*Anomia simplex*). These are wonderful for wind chimes and are so attractive they are hard not to pick up and admire. They thrive along the cost of the Americas, from Massachusetts to Brazil.

One day my father revealed that he did not like stepping on the stones at Cliffside—his favorite beach. I said, "they only hurt you if you let them."

Sandy beaches, literally a large pile of sand sitting on bedrock found 1,600 feet below sea level, circle the island. Tides, currents, waves, and rainfall are continuously resculpting the island's shores. In some areas, the erosion is fifteen to twenty feet a year, especially on the South Shore. Along with the seashells and pebbles are eel grass (the dark green ribbons) and codium (which is brighter green and grows to look like a mop head.) Codium invaded these waters by attaching itself to ocean-going vessels in Japan. Whatever its origins, it has become a fun toy for the children.

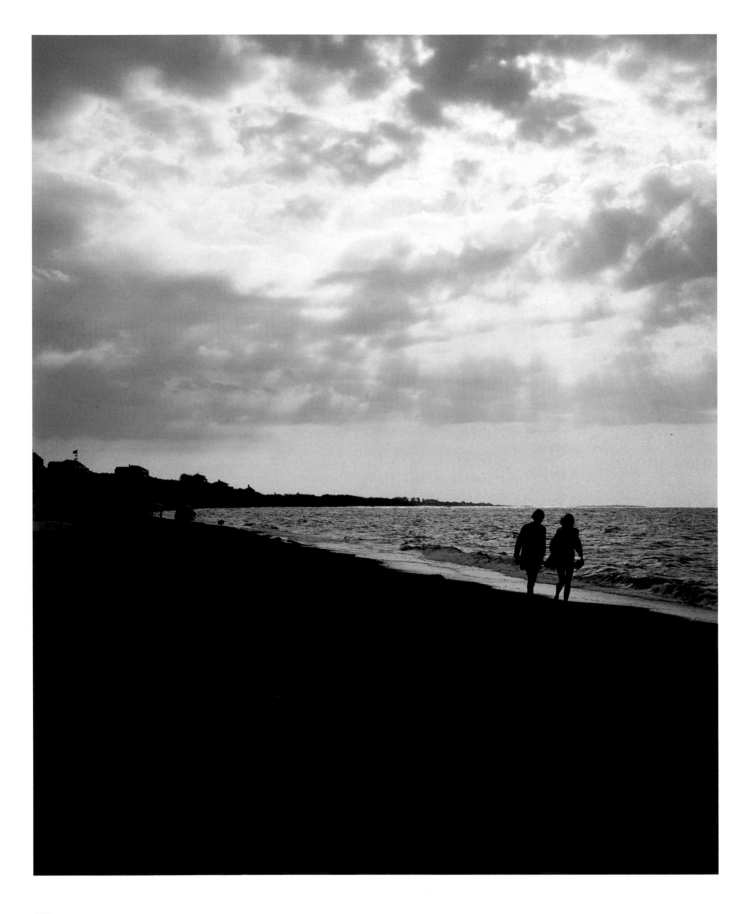

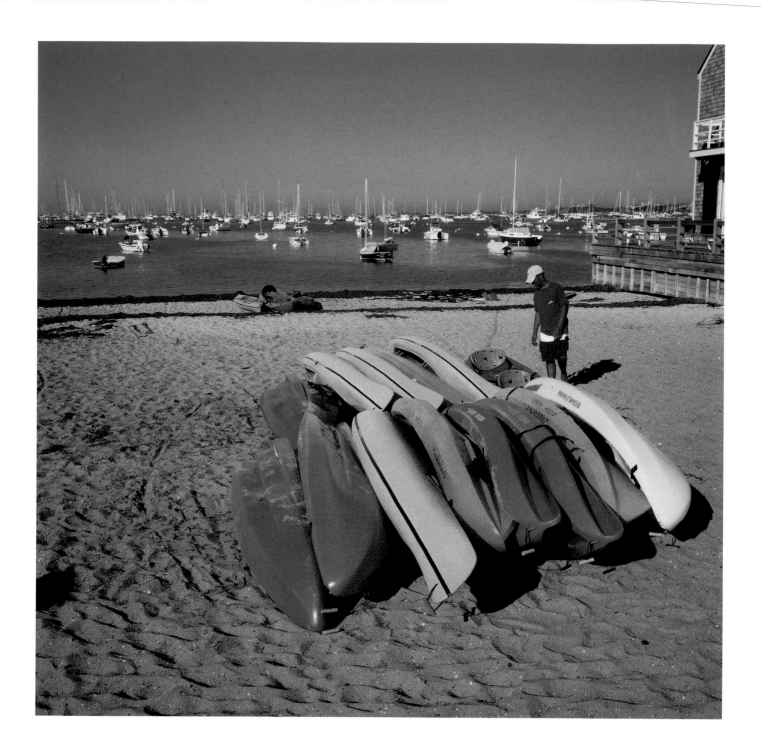

This peaceful spot is at the intersection of Francis Street and the Washington Street extension. The condominium apartments were built in 1989 and offer splendid views of the harbor. Kayaks may be rented here during the summer season.

The kayak is the form of canoe developed by Eskimos. Originally, it had a seal skin stretched over a frame made of either birchwood or whalebone. It was comparatively small and light, and its distinguishing feature was the skin covering the entire craft except for the well. Often the operator wore a waterproof shirt that fit over the well opening, making the kayak completely waterproof even when tipped over.

In these boats the Eskimos made journeys of hundreds of miles, riding over all kinds of turbulence. Kayaks use a double-blade paddle, which is more effective on wide bodies of water affected by wind and tide than is the typical single-bladed canoe paddle.

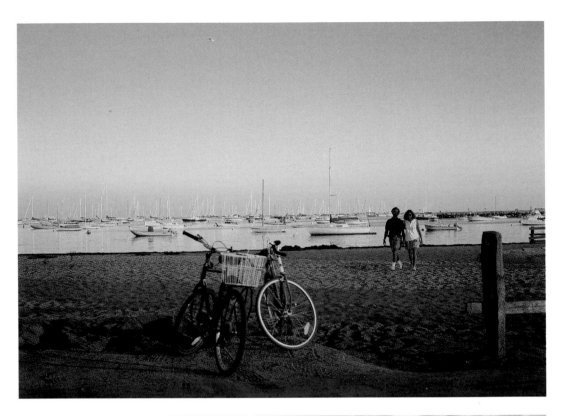

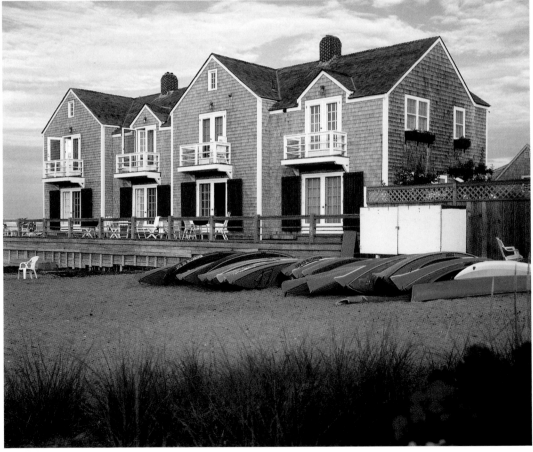

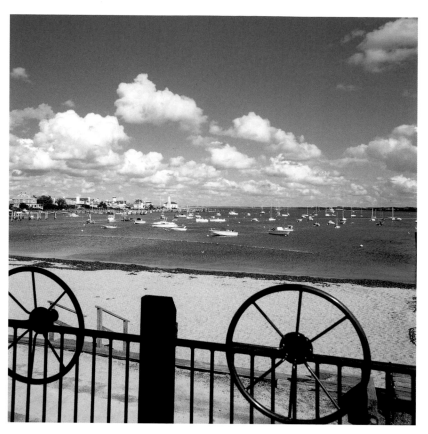

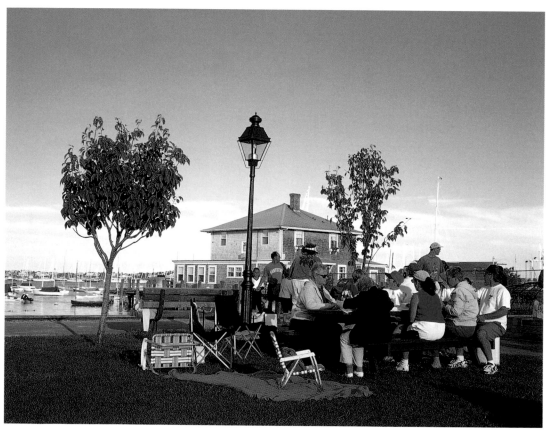

Children's Beach. This was one of the first bathing spots on Nantucket, where Charles Hayden opened his Clean Shore Bathing Rooms in 1869. He later branched out to a second location near today's Jetties Beach, in direct competition with Eban Allen's Bathing House near Cliffside. As hotels were established along Brant Point, the popularity of Hayden's establishment waned, and eventually his bathing rooms closed. But true to their tradition, Nantucketers salvaged the buildings, one of which became part of the new Nantucket Athletic Club (now the Nantucket Yacht Club) and today serves as a bunkhouse for summer employees.

The town, which has owned Children's Beach since 1914, has erected a popular playground and snack bar. Summer concerts have been relocated here from the bandstand in town, affording more space to spread out for a picnic supper.

Dionis and Washing Pond are two popular beaches on the north shore. Dionis was the name of Tristram Coffin's wife, who joined her husband here in 1660, a year after the first group of nine proprietors landed on Nantucket. One of the early settlements was at the harbor of Capaum (now closed to the sound) very near Washing Pond. "Capaum" is the Indian word for "enclosed harbor."

This a great spot for families with young children because the water is gentle and shallow for quite some distance. The grown-ups read, snooze, and play backgammon. This game, one of the oldest known, was played by Egyptians as far back as 3000 B.C. In more recent times, the English referred to it as simply "tables," and this is what Chaucer, Byron and Shakespeare called it as well. Its popularity in the U.S. was revived in the 1930s.

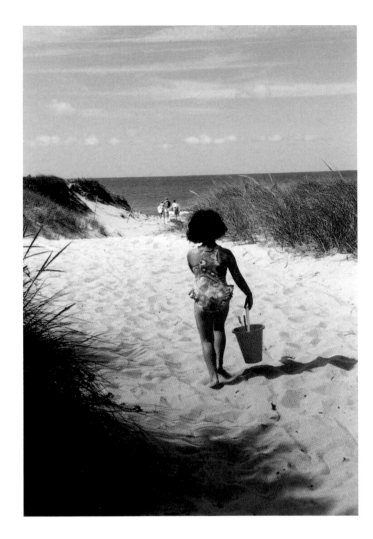

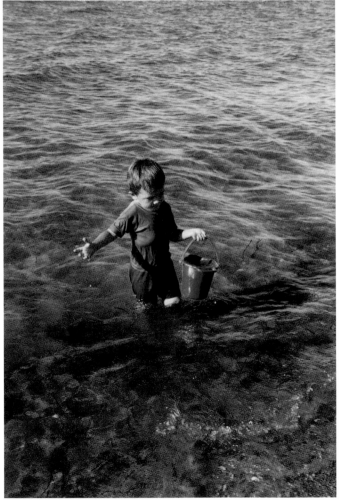

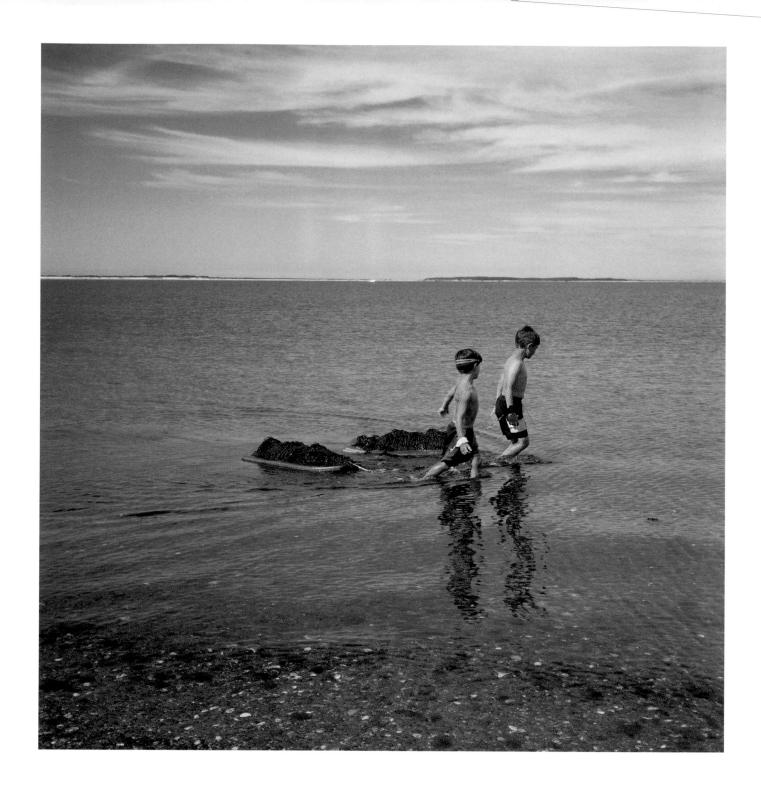

Pocomo Beach, a favorite with local residents, is one of the more remote spots on the north shore. At low tide, wonderful pools are left behind, and there is only the gentlest drop-off, making swimming particularly pleasurable for little ones. The boys in the photograph above have collected construction materials for their seaweed city, transforming Boogie Boards into seafaring barges.

What better way is there to commune with God than emersed in Nature? A garden, a grove or a beach offer the perfect setting to be alone and aligned with God and to realize, in this moment, He is always in agreement with us. God always says "yes."

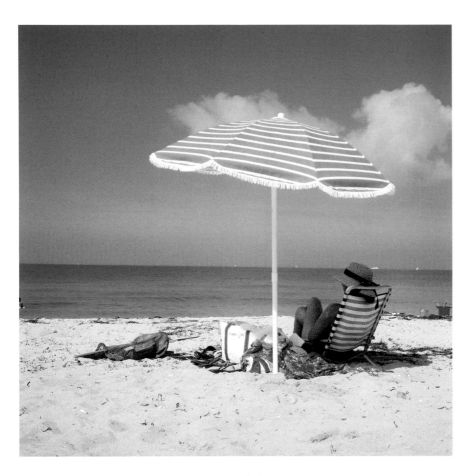

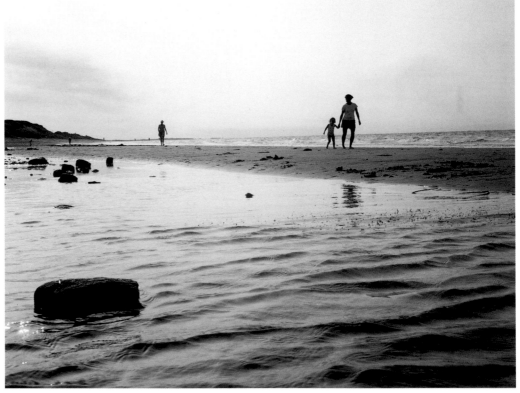

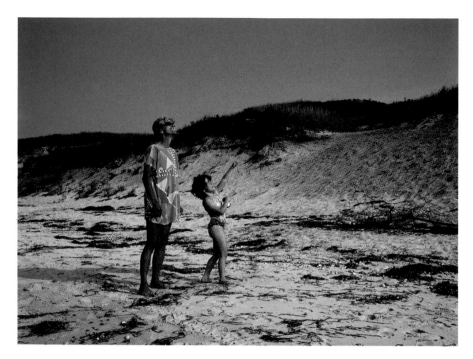

Kites and bikes at the shore. Kites have been flown for thousands of years, and the exhilarating tug on the end of a kite string is always a source of pleasure. In China and Korea, kites flown from houses at night are thought to ward off evil spirits. Kites are also hawk-like birds of prey known for their graceful, gliding flight. The name derives from *cyta*, the Old English name for owl. America's most famous kite flyer was Benjamin Franklin, who may have practiced here on the beach in the summer of 1750.

Opposite: Cisco Beach is reached by the Hummock Pond Road. John Cisco, an unsuccessful developer, is best remembered for this beach. Nana Huma was the name of one of the sachems, or Indian chieftains, who lived here, and the pond's name derives from the Nanahumacke Neck. The bike parked on the bluff overlooking the beach recalls the continuing popularity of one of America's first recreational fads. Cycling gained ground in the 1880s with the introduction of the Safety Bike, which replaced the intimidating high wheeler.

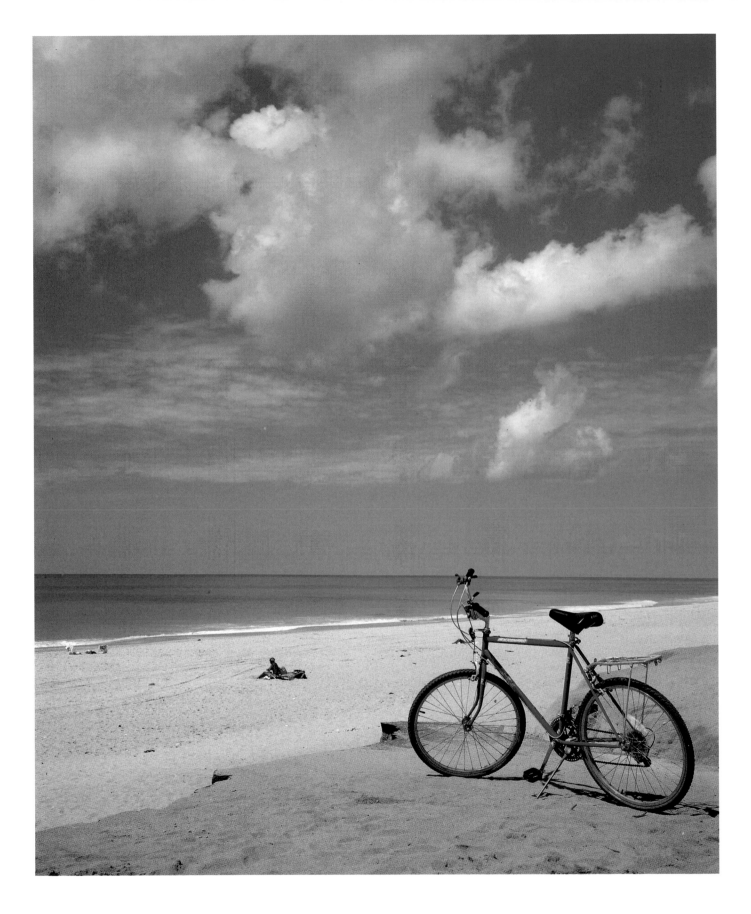

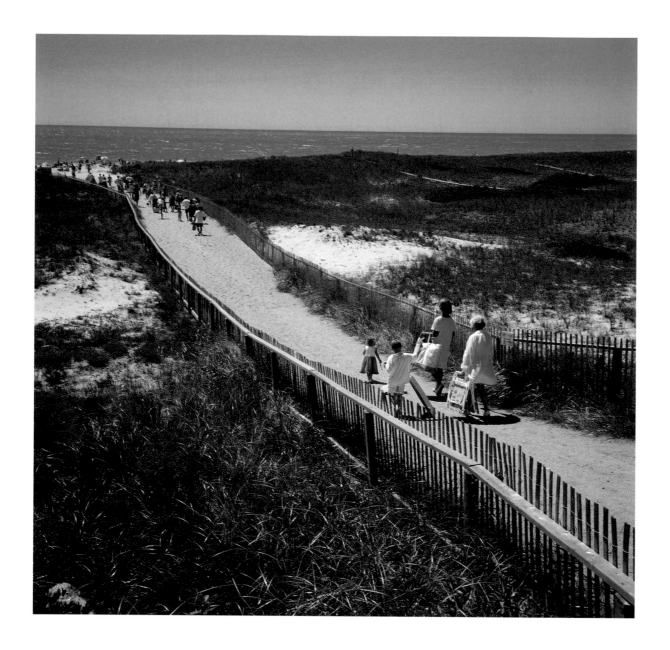

Nantucket is surrounded by almost sixty miles of clean, sandy beaches. The most popular one on the south shore is Surfside, as the numerous bicycles in the parking lot attest. Nantucketers come by jitney, bike, or automobile to enjoy the afternoon here.

Over a hundred years ago, beachgoers had the option of arriving by train. Peter Folger gave a boost to Surfside's popularity in 1879 when he began plans for a railroad. The original routing called for a run from Steamboat Wharf up along the Cliff, out to Long Pond, south to Surfside, and eventually on to 'Sconset. The plans were downscaled, and grading began in 1880 for a simple and direct run to Surfside. The train made its inaugural trip on July 4, 1881, with every piece of equipment

secondhand. The engine, named after Tristram Coffin's wife, Dionis, was purchased from the Danville, Olney & Ohio Railroad in Illinois, and the two open passenger cars (with glass windows installed at the ends, to keep cinders out of people's eyes) came from the Long Island Railroad.

The naming of the engine Dionis was not entirely altruistic. In 1881, the railroad promoters had learned that the Coffin family was planning a large reunion on the island later that summer which was sure to attract a lot of off-island attention. Travelers were treated to a festive program at the Surfside station, along with a series of dances, clambakes, and roller-skating events inside the Surfside depot. In August, over five hundred mem-

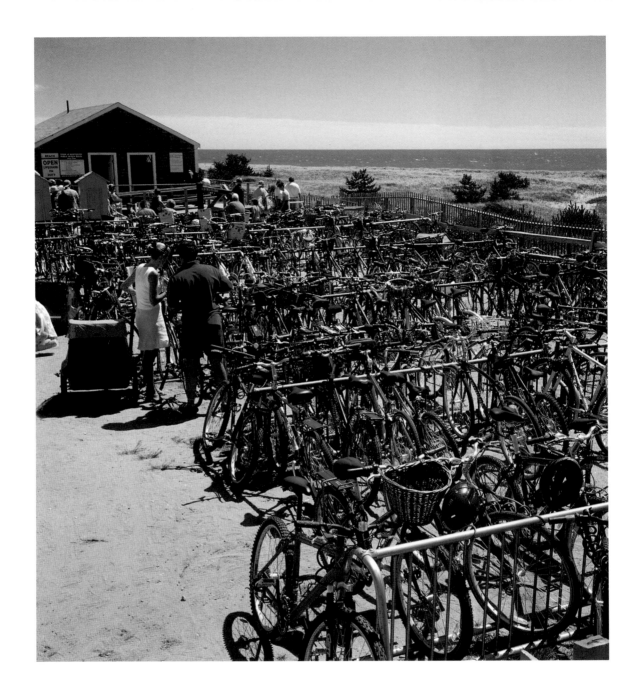

bers of the Coffin clan did indeed arrive and use the system. The plan was working quite well.

Henry and Charles Coffin were also eager to profit from the anticipated land boom. Instead of focusing on the ultimate destination, 'Sconset, the Surfside Land Company—together with the Nantucket Railroad—purchased a four-story hotel in Providence, dismantled it, and shipped it to Surfside. Reassembly of the old Riverside Hotel began in 1883, next to the depot. The July 4th activities that year were held at the hotel and included concerts, dances, rowing, and a swimming competition. Unfortunately for the promoters but fortunately for us, the expected land boom of the Surfside "Cottage City" never took off. Regardless of whether any lots were actually sold, no houses were ever built. The Surfside stop on the train was eliminated, and the line ran straight to 'Sconset. Business was never strong enough to offset the heavy maintenance of a roadbed built on sand. By 1887, the Coffin's one hundred lots were at auction for $2.80 each, and the hotel was boarded up. By 1917, with World War I sending up the prices of iron and steel, the cars and rails had been shipped off island; the sea reclaimed everything of this curious, short chapter. Only the bell of the Dionis (at the Nantucket Historical Association) and the Club Car restaurant remain of the railroad equipment. Some of the embankments are still hiding under reeds and brush, ready to be found by the inquisitive venturer.

Nantucket wildflowers. *Above*: Adjacent to Squam Pond, the Nantucket native rose mallow (*Hibiscus moscheutos*) thrives, blooming during August. It can be found growing all over the island, mostly on the margins of the brackish ponds and marshes (Capaum, Miacomet, Folger's Marsh), often with the plants' roots fully submerged during high tide.

Right: Quaise Pond, off Basset Road. Quaise means "at the place of growing reeds." Although this pond lies in the morainal portion of the island, it is too shallow to be a kettle-hole pond. In the foreground is slender-leafed goldenrod (*Euthamia tenuifolia*), a native wildflower that blooms from July to October.

Opposite: A path meandering through native scrub on Abram's Point. It is bordered on both sides by white oxeye daisies (*Chrysanthemum leucanthemum*), also called marguerites. The pink flowers on either side of the path are the native Virginia rose (*Rosa virginiana*), a scrubby, thorny, briar-like rose that grows wild in dunes, shrubland, and heathland and blooms from June to August. The flowers are deeply fragrant and produce bright red hips in the fall.

Mixed with the roses and daisies are vigorous native and introduced shrubs, indicating that this land was once clear, most of it probably former pastureland that has been filled in. Pictured here are Virginia creeper (*Parthenocissus quinquefolia*), a native climbing vine that turns scarlet and produces black berries in the fall; native beach plum (*Prunus maritima*), a low-growing, fairly unattractive shrub that flowers in early June and produces dark purple plums in September (it is the basis for Nantucket's delicious beach plum jelly); native black cherry (*Prunus serotina*), a fast-growing, spreading hardwood tree that flowers in June and turns lovely shades of yellow and orange in the fall; and Japanese honeysuckle (*Lonicera japonica*), an invasive, introduced shrub. In the background are evergreen Eastern red cedar trees (*Juniperus virginiana*), also introduced to Nantucket.

Inland Scenes

Above: Impatiens is a plant widely used on Nantucket now, having been introduced in the early 1960s. It originates from Zanzibar, and its Latin name comes from the habit its seed pod has of suddenly throwing its seeds out when touched, as the pod of the jewel weed does. This is a fun autumn event for children of all ages. Impatiens is wonderfully tolerant of sun and shade, blooming well up to the first frost. After that, however, it will bloom no more, and it does not like being brought into the house for the winter.

Opposite: Sweet autumn clematis (*Clematis paniculata*), also called Japanese virgin's bower. This vine was originally from Japan, but in some parts of the island, it has naturalized and grows entwined with old roses and day lilies on roadsides. This photograph illustrates the plant's growth habit as both a vine and a sprawling ground cover. It blooms in August and September, is beautifully fragrant, and is not attractive to deer or rabbits. After the flowers fade, the star-like seedheads remain on the plant well into the winter, resembling cut glass when coated with dew and frost in early morning. The flowers make fine additions to many arrangements.

Opposite, top: The beautiful native rose mallow. Rose mallow can be cultivated and grown in gardens either from seed or by digging and dividing established plants. While Nantucket's native mallow is clear pink, relatives in pure white, white with red eyes, burgundy, and other shades are now available commercially. The flowers have no fragrance and last but one day, on the plant or off; but the plant can produce so many buds that it will bloom for a month. While the blossoms on the native plant might reach four inches in diameter, the white cultivars can produce flowers the size of china plates.

Opposite, bottom: A Monarch butterfly on Nantucket's native boneset. Boneset (*Eupatorium perfoliatum*) got its common name from the way the stem is cradled by the leaves. The leaves were given to people with broken bones in the expectation that they would restore the bones to their original straight shape. Boneset blooms on Nantucket in August and is found across the island in sunny, damp areas. It is highly attractive to butterflies. Butterflies are Nature's gift of movement. And birds provide the music.

Above: Queen Anne's lace and spotted knapweed (*Centaurea maculosa*), another introduced (and invasive) common roadside weed. The birds enjoy its seeds.

The many maroon concrete posts decorated with the logo of the Nantucket Conservation Foundation attest to the island-wide influence of this organization. Presently it owns and manages more than 8,300 acres, or approximately 28 percent of the land in Nantucket. Its properties are open to all members of the public who are sensitive to natural resources. The head of the foundation and his dedicated staff know more about the island than just about anyone else, and they continue to provide the most valuable service to all of us—far beyond the transportation companies that get us here or the hotels and restaurants that keep us going. Without the Nantucket Conservation Foundation and its efforts over the years, this would be a vastly different island.

Spider webs, cosmos, and lilies are all part of the Nantucket scene. The cosmos shown here is interplanted with tickseed (*Coreopsis verticillata*), a non-native perennial flowering plant commonly available in the trades. Coreopsis blooms in July. Cosmos itself is an annual, grown widely on the island both in the garden and as a cut flower. It blooms all summer long and is native to the tropical Americas.

Opposite: An Oriental hybrid lily, Japanese Gold Band. All of the beauty of God is manifest in this gorgeous flower. Like Asiatic lilies, these are grown from bulbs and do very well in Nantucket's climate. Oriental lilies bloom later than do Asiatic lilies—in August and early September—and are highly fragrant. They are usually grown as garden plants. If a bulb is left in the ground and never cut, it will grow in size and begin producing more than one stalk. Those who want to grow Oriental lilies as cut flowers must buy one bulb per stalk and plant them fresh every fall.

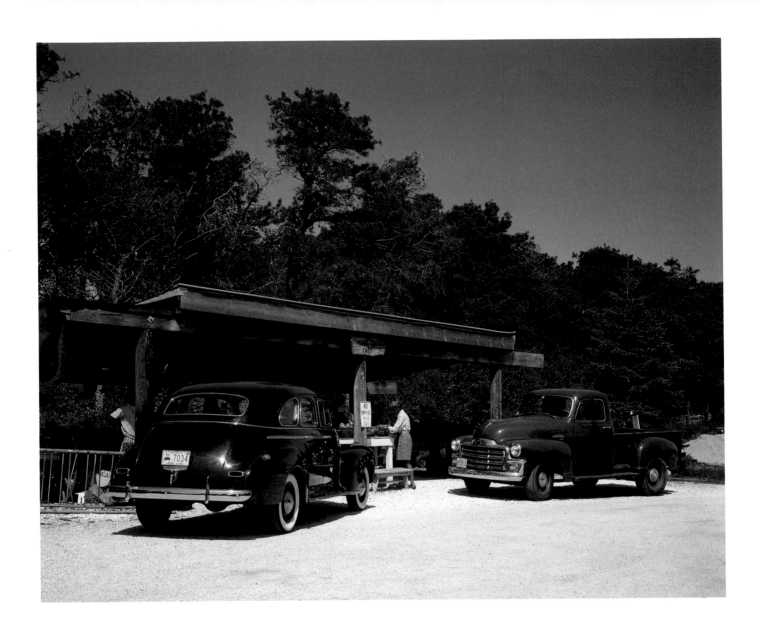

Farming on Nantucket. These are the farm stands of Moor's End (*above*) and Bartlett (*opposite*).

The Moor's End Farm has been in the Slosek family since 1957. Like the Bartlett Farm, it was primarily a dairy farm forty years ago. Parked at the stand are a 1941 Chevrolet Special Deluxe Sport Sedan and a 1953 GMC truck. The Chevrolet offered Aristo-Style design, Knee-Action suspension on all models, a special valve-in-head Victory engine, a vacuum-power gearshift, and Safe-T-Special hydraulic brakes, among other advertised features. In any case, it ran well.

The Bartlett Farm was started in 1822 by William Bartlett, who moved to the island from Marblehead. Today, five generations later, the family farms over two hundred acres east of Hummock Pond. Originally dairy farmers, the Bartletts later turned to raising sheep. But the sheep fell victim to disease, and the family began growing vegetables, which were (and still are) sold from the back of a truck at the corner of Main and Federal Streets. By 1961, the Black Angus cattle, which numbered over seventy head, had become a secondary commodity. Presently over one hundred acres are devoted to vegetables, herbs, and cut flowers.

During the summer months, there are over fifty people on staff. Three acres are covered with greenhouses that regulate temperature, fertilizing, and watering. John Bartlett studied farming at Cornell University, as did his father, and now all members of the family are engaged in the business. Summer production is substantial, with the farm selling over one thousand heads of lettuce and one thousand pounds each of tomatoes and potatoes on a typical August day. Five hundred dozen ears of corn per day is also average work. The family's dedication certainly shows, and now there is a seventh generation in the business, at Bartlett's Ocean View Farm.

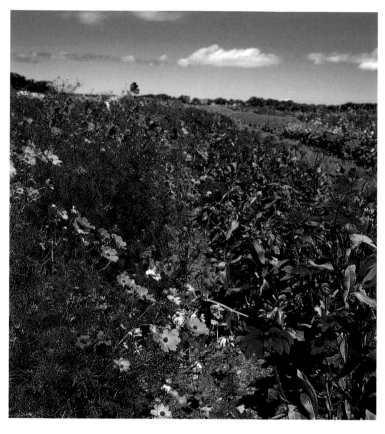

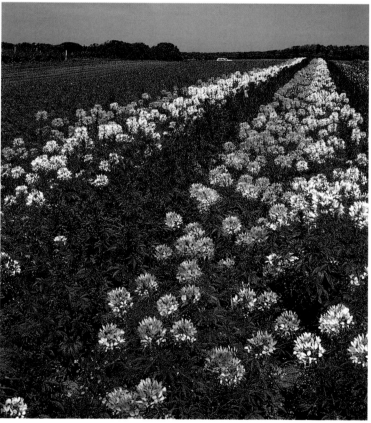

The Bartletts' Ocean View Farm grows flowers as well as vegetables. *Above, left*: Field-grown cosmos and a perennial variety of black-eyed Susan, called Indian Summer mixed with a few errant plants of anise hyssop. Black-eyed Susan (*Rudbeckia hirta*) is native to the U.S., but not to Nantucket. It is a common component in commercial wildflower meadow mixes and is considered a potentially invasive species. Some black-eyed Susan is biennial. It sets seeds in summer that germinate the following spring, grows into a small rosette of leaves, and overwinters to flower the following spring. It can get quite weedy. Nantucket is vulnerable to a number of invasive, non-native species that can, if aggressive, compete with and replace many native plants. Black-eyed Susan is a great cut flower and garden flower, but its seed is attractive to birds and easily spread, especially in open, sunny meadows.

Left: *Cleome spinosa,* an annual originally from the West Indies, is started from seed indoors in midwinter and set in the garden in late spring. This species is grown to be sold as cut flowers or as ornamental garden plants. The photograph shows a typical summer cut-flower field at Bartlett's Ocean View Farm. The farm obtains seed in huge batches from wholesale purveyors and starts all of these plants from seed in their capacious greenhouses in the middle of winter. In early May, trays are moved outdoors for a few hours at a time to "harden off" the young sprouts (accustom them to nature's realities of sun, wind and chills) before planting them directly in the ground. Later, when the soil warms up, the Bartletts will plant some seeds directly in the ground for a late summer and early fall harvest of flowers.

Opposite: Fields of zinnias in the foreground and cleome in the background. Zinnias are another popular, old-fashioned annual, native to Central and South America. They are great as cut flowers but can attract beetles and mildew in the garden, so not everyone grows them. The name comes from J. G. Zinn (1727–59), the German botanist who perfected this ancient Aztec flower.

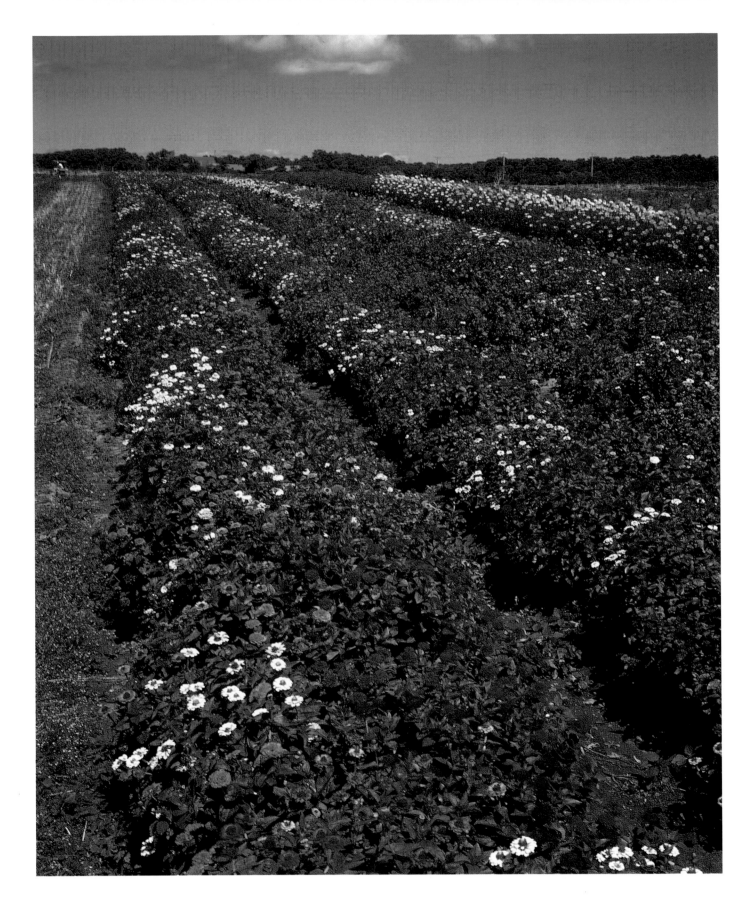

Along the Madaket Road. There are many "Stop," "Slow," and other signs along Nantucket's byways—including warnings for horses, deer and ducks—but there are no stoplights anywhere on the island.

Opposite: Crabbing for blue-claw crabs at Second Bridge. Crabs are attracted to bait (preferably chicken parts) hung on a hook at the end of a hand line. The crabs swim into Long Pond from Hither Creek at Madaket. The crabbing spot is so named because there used to be two wooden bridges over Long Pond, this one being the second one from town. The bridges have been replaced by large metal culverts, but that has not deterred the crabs or the crabbers. The only difficulty is that at the end of an unsuccessful outing, the latter can get crabby.

Opposite, top: The gravestones of Nantucket's whaling captains and sailors tilt in the wind, just as their ships used to list. Above left is Captain Benjamin Worth's plot in Old North Cemetery. He spent more years at sea than at home, and yet returned safely to retire on the island without losing a single member of his crew.

Opposite, bottom: The Quaker Cemetery on Saratoga Street contains over five thousand unmarked graves. The Quakers had little tolerance for earthly symbols. The simplicity that prevailed in the architecture and dress of early Nantucketers was attributable to their influence.

Above: Queen Anne's lace blankets Nantucket's roadsides and meadows during July and August. This remarkable flower is actually a form of carrot. It was named for the wife of James I of England who, during long afternoons in the garden at Somerset,

challenged her companions to produce a lace pattern as exquisite as the flower of the wild carrot. The flower is a compound umbel, made up of seventy-five smaller umbels, each of which contains a colony of smaller florets. Each floret is one-eighth of an inch in diameter and has five petals surrounding a tiny, royal-purple center. There are 2,500 delicate florets per umbel, giving the blossom its lacy appearance.

The root of Queen Anne's lace is tough and stringy. During World War I, however, studies aimed at improving the nutritional value of plants revealed that wild carrot leaves and roots are excellent sources of vitamin A. Scientific trials showed that carrots grown at temperatures above sixty degrees develop more succulent roots with increased levels of carotene, producing the bright-orange vegetable we are familiar with today.

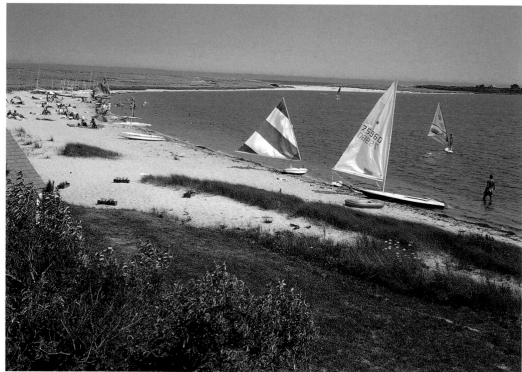

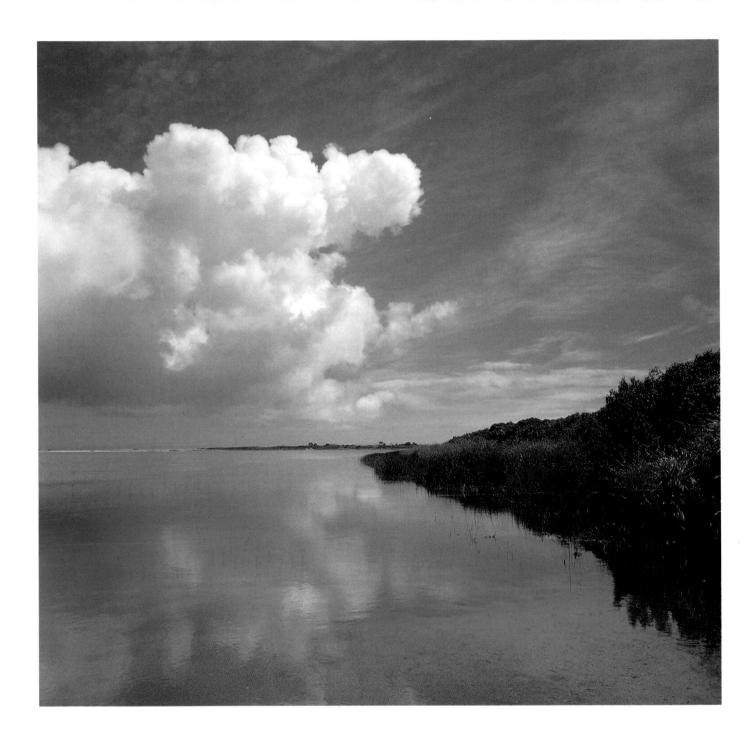

Sesachacha Pond. The northern side of Quidnet (which means "on the edge") on the pond's northern side was home to the last Indian settlement on Nantucket. These Native Americans, part of the Wampanoag of Rhode Island and Massachusetts, had chiefs who included Wauwinet and Nana Huma. One of the meanings of Sesachacha is "blackberry grove," and it may have been for this fruit, as well as its protected fishing grounds, that this area was popular.

This pond was once open to the sea and formed a protected harbor like Capaum. Many of the early fishing shacks of Siasconset were originally located here, but were gradually moved south as the pool closed up. The last building was transported from the pond in 1820. During the past century, the pond has been opened through human intervention at irregular intervals—most recently, only after a protracted committee review. The pond is now a favorite spot for fishing, sailing, and swimming on its Quidnet side.

Above: One of the two Wigwam Ponds near Altar Rock. This is a kettle hole—steep-sided with no inlet or outlet. Eventually it will become a bog. Nantucket's topography derives from a glacially deposited moraine of boulders and stones, forming kames (hills) and kettles (valleys) interspersed with occasional ponds. The kettles and ponds were actually once blocks of ice. As glaciers advanced, they brought gravel and rocks in their wake, depositing them along steadily melting edges. Large blocks of ice remained under the gravel, eventually melting and becoming kettles. The Ronkonkoma Moraine is a large deposit of this kind, which forms most of the edge of Long Island, as well as Martha's Vineyard and Nantucket.

There are ten thousand acres of heaths or "moors" on Nantucket, unique in this part of the world. The ground cover is dominated by members of the *Ericaceous* family: bearberry, low-bush blueberry, and huckleberry. Bayberry, heather broom crowberry and shadblow also flourish. Sun, fog, and the warmth of the Gulf Stream combine to give these plants all the nourishment they need.

Many of these plants spread out from their bases like grass when their tops are nipped off. Heaths dominated the landscape when sheep raising on a large scale prevailed on the island, and flocks fed freely. Since the early 1900s, however, scrub oak and other brush have reclaimed much of the land. Nevertheless, Nantucket has a greater variety of vegetation than any other spot of similar size in America. Many of these plants have been imported, including heath and broom from Scotland, ivy from England and even rugosa roses from Japan.

To stand on Altar Rock and look in any direction is to experience wonderful isolation in an endless landscape. There are no houses, trees, or other obstructions to obscure the carpet spread out as far as the eye can see.

Opposite, top: A ride through the moors in an open carriage. There are no stoplights on Nantucket and only a few stop signs. The countryside unfolds easily because most of the population is clustered in Nantucket town or at the extremities of the island. There are only three major paved roads: one to the west (Madaket), one to the east (Siasconset) and one to the northeast (Wauwinet and Quidnet). The rest is open space, broadly laced with unpaved tracks in sandy soil.

Opposite, bottom: Daisies form a showy blanket spread out at the water's edge, stretching as far as the eye can see in this extraordinary field on the property of the University of Massachusetts in Quaise (which means "at the place of growing reeds"). The flower's name derives from the Old English words for "day" and "eye." This variety is part of the chrysanthemum family, *chrysanthemum leucanthemum*. Often considered a herb, it is a hearty mainstay of New England's fields and gardens. The familiar American white daisy is often called the oxeye; its blossom actually consists of two groups of flowers—disk flowers in the center, surrounded by ray flowers.

The estate of Steven Peabody donated this parcel of 115 acres to the University of Massachusetts in 1964. A former dairy farm, the land has been converted into a year-round research station with accommodations for fourteen students. The property includes ponds, swamps, a salt marsh, harbor beachfront, and extensive open fields, providing a laboratory of almost every variety of flora and fauna on the island.

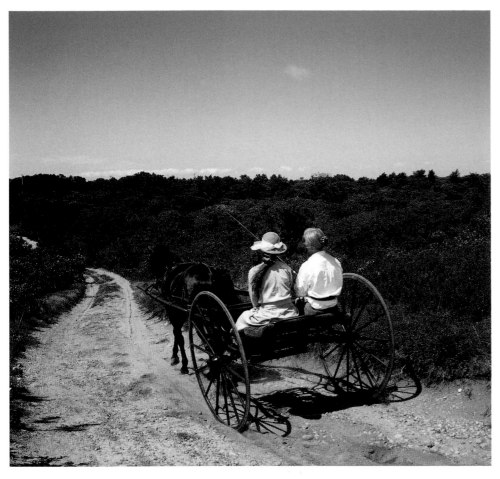

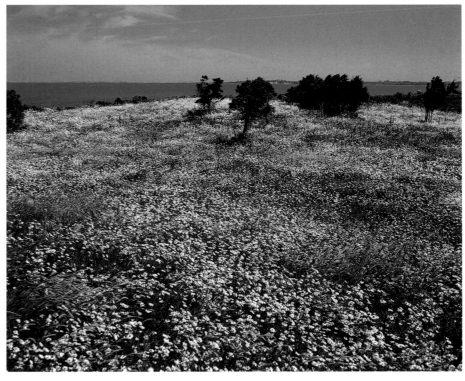

Opposite, top: Nantucket quarter horses. The name comes from the breed's superior speed (faster than a thoroughbred) at short—quarter-mile—distances. These horses were developed in the Colonial era from Arabian ancestry. They were favorites in the early West, renowned for their endurance under a saddle.

Opposite, bottom: The Franklin Memorial on the Madaket Road. Abiah, Ben Franklin's mother, was born near this spot in 1667. She was the youngest daughter of Peter Folger, an original settler who played a pivotal role in early Nantucket history because he was able to negotiate with the Indians here. The

Foulger Museum downtown is named in his honor. As for Folger's grandson, discussing his life might require another volume.

The 1949 Jeepster was made by Willis Overland Motors in Toledo. The name derives from the General Purpose Vehicle commissioned by the U.S. Army in 1939, nicknamed "G.P.," or Jeep.

Above: Reyes Pond is named after José Reyes, one of Nantucket's famous basketmakers, who lived at its edge in Polpis for many years. The pool is rimmed with arrowwood flowers, as well as tupelo trees and pitch pines.

Above: Altar Rock is one of the highest points on the island. On the horizon is the airport's white, navigational omni. This heath was once a major sheep-grazing area, covered with bearberry, huckleberry, and golden heather.

Opposite, top: Polpis Harbor, with its collection of dinghies, Hobie cats, Sunfish and other pleasure craft. Polpis means "divided harbor." It is the only harbor on the island where trees grow right down to the water's edge.

Opposite, bottom: The Nantucket Lifesaving Museum, seen from the Polpis Road in Quaise, is a replica of the original Surfside station (1874). Over five hundred shipwrecks have occurred on the notoriously treacherous Nantucket shoals, a large range of submerged sandbars east and south of the island, often covered with just three feet of water. Ships continued to run aground here despite careful charting of the waters and despite the light-houses built and supervised by the United States government from 1789 onward. In further efforts to minimize wrecks, the lightship *Nantucket* was stationed at the southern end of the shoals, and the Massachusetts Humane Society put up several refuge houses on the island in the late eighteenth century. The oldest surviving such structure is the boathouse on Muskegat, built in 1883. In 1915, the United States Lifesaving Service, established on the New Jersey coast in 1868, merged with the Revenue Cutter Service—founded by Alexander Hamilton when he was Secretary of the Treasury—to create the U.S. Coast Guard. In somewhat more recent history (1956), the SS *Andrea Doria's* captain attempted to steer the beautiful Italian liner over to the Nantucket shoals to keep her from sinking irrecoverably following a collision with the SS *Stockholm*; sadly, she was too crippled by the impact to make the trip, and now lies offshore.

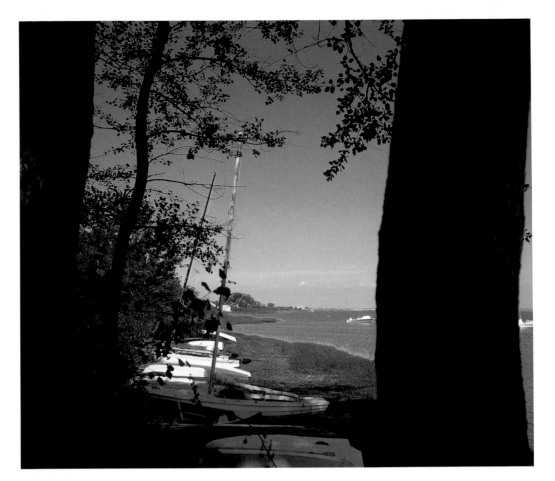

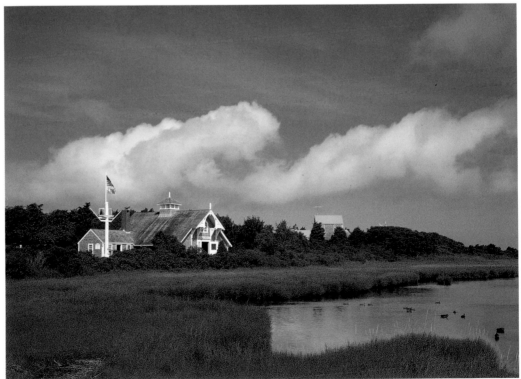

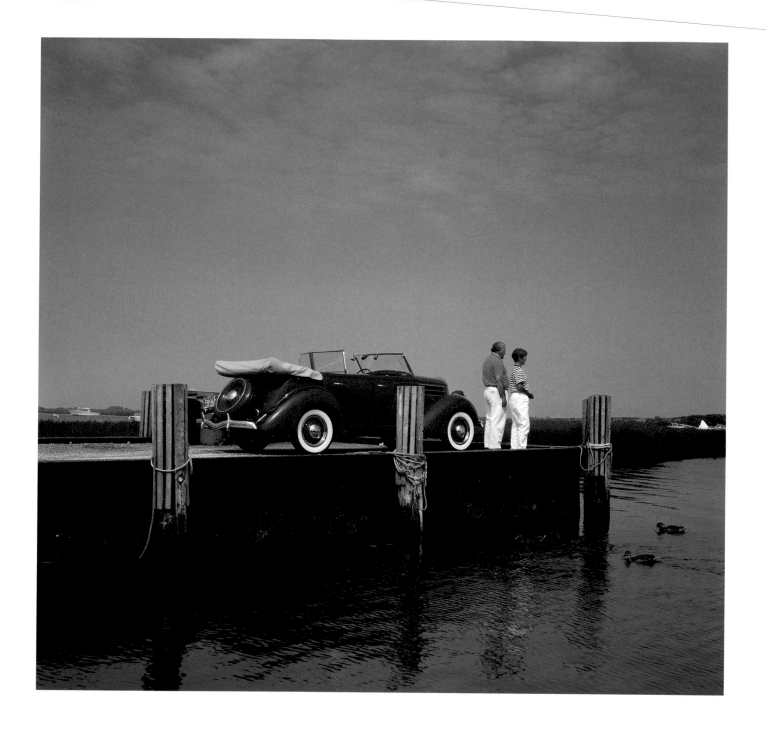

Above: Hither Creek in Madaket is where the first group of nine settlers arrived on the island in 1659. By the following year there were over sixty partners, and they relocated to more fertile sites near Capaum and Hummock Ponds. During World War II, "Madaket Millie" Jewett had her lookout station near here. For nearly fifty years, she was the guardian of the Nantucket's West End, flying storm warnings, locating lost vessels, and aiding fishermen. Today, Hither Creek is a perfect spot for islanders, including those here with their 1936 Ford phaeton, seeking refuge from activities in town.

Opposite: The island's two major cranberry bogs, initially built in 1865, are among the world's largest. In the fall they become lakes of wine-red fruit. The berries were known to the Indians and also to whaling captains, who kept a few barrels on board to help curb scurvy. Today the berries are harvested by flooding the bogs, submerging the vines, and paddling the berries loose. They float to the surface and are corralled by pontoons before being scooped out.

A collection of scallop, clam, and slipper shells at the harbor's edge. Nantucket always has a bounty of slipper shells. These are actually snails that resemble halves of bivalves. They are often found in stacks, with the older ones living at the bottom and the smaller, younger ones on top. They are prevalent on both coasts of the United States.

Until the early 1900s, scallops were called "clappers." They were used for bait, but not for food. Unlike other bivalves that generally live buried in the sand, scallops are mobile creatures that rest on the bottom of the harbor, in bays and in eelgrass beds. They can move swiftly, going as far as three feet with a quick clap of their valves. At the turn of the last century, it became fashionable in the large cities to actually eat scallops. Nantucket then began to harvest them in great quantities, raking them out of eelgrass at low tide and shoveling them into wagons or rowboats for opening at the shanties on the wharves. Larger scallops were dredged up with twine bags pulled behind rowing dories. Then came the catboats, often up to fifty at a time, dragging their dredges across the scallop beds. Not until 1909 were motorboats able to enter the game. Before that, they were not able to maintain the constant slow speed necessary for harvesting scallops. In 1935, when four-cylinder automobile engines were adopted for marine use, satisfactory control was finally achieved.

The scallop shell has been a spiritual symbol for over a thousand years. Recently my sister was installed as a trustee of her church. Just prior to the occasion, she and the other church officials were asked to gather and share with each other an object that brought them closer to God. Some brought Bibles and others showed wedding rings. My sister chose a scallop shell she had picked up in Nantucket. This reminds her of the summer time when the family comes together for fun and quiet relaxation. It also reminds her of God's help when there are perils at sea and other challenges. The scallop shell has been used extensively in religious art with its graceful fan shape and natural beauty. Many of the major European pilgrimages used scallop shells as emblems. When our son was baptized, the rector used a white scallop shell to scoop water to anoint him. The scallop shell: pure, simple and elegant.

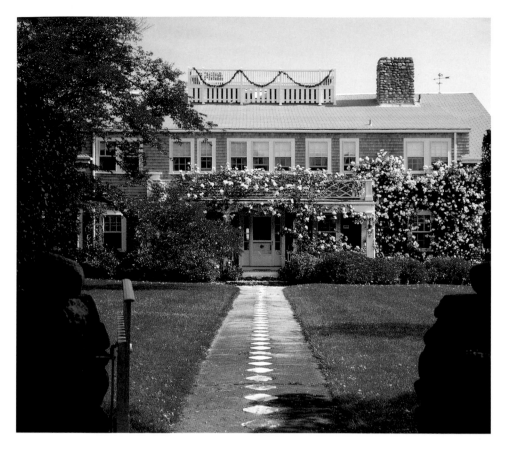

Siasconset, fondly nicknamed "'Sconset," was originally a little fishing village at Nantucket's eastern end. It overlooks a vast expanse of ocean that stretches uninterrupted to Portugal, the home of many of the Americas' original explorers. The name means "place of many whale bones." A settlement was established here at the same time that the town of Sherburne was relocated to the Great Harbor. During spring and fall cod-fishing seasons, fishermen traveled a rutted path to harvest these waters, building simple structures for shelter and storage.

Fishermen's families gradually discovered the recreational benefits of a retreat from town, and the shacks underwent a period of eclectic embellishment. Usually a "porch," or open-air kitchen, came first—followed by a "wart," a small addition at the opposite end of the house, just big enough to contain a bed and a dresser. Secondhand materials scavenged from town, as well as from shipwrecks on the shoals, were incorporated, with doors and windows of various sizes employed almost at random. Making the most of cramped quarters, some families installed hanging sleeping lofts with steep steps resembling those of a coastal schooner. In the 1830s and 1840s, whaling captains and their crews on brief rests from sea voyages would often retreat to 'Sconset, a welcome refuge from the unfamiliar noise and bustle of downtown Nantucket.

Above: The Sheiling (1830), whose Irish name refers to a restful haven for seafarers. *Right*: Tennis courts at the Casino, and a view of the 'Sconset rotary (*opposite*).

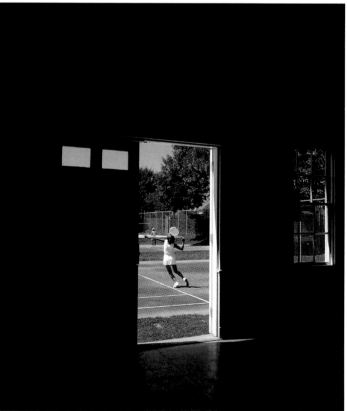

Siaconset

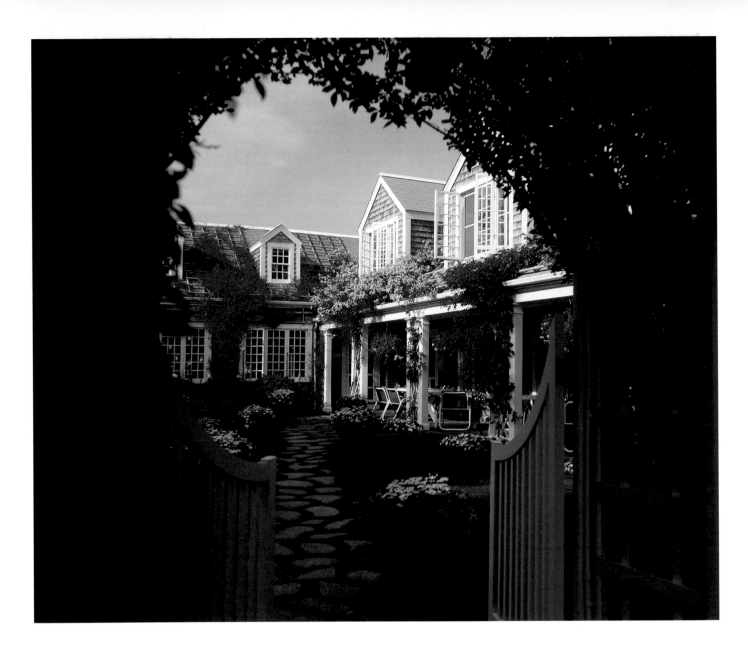

Opposite, top: Gone Crazy (1938) is the name of this little house in Codfish Park, a residential area and public beach tucked under 'Sconset bluff. The shoreline here is in constant flux at the whim of Neptune and nature. Until 1870, gales were strong enough to send surf right to the edge of the bank, even eliminating a street along the Bluff above. Then the currents changed, and the area below the bank actually began to widen. In 1886, Henry Coffin acquired a deed to the property. Originally, Codfish Park was used to store dories and fishing gear; but a flock of cottages have since been built. The village has paved the area and installed utilities, while attorneys continue to debate who owns the formerly submerged land.

Opposite, bottom: Two If By Sea is an archetypal rose-smothered 'Sconset cottage, owned by residents of Concord.

Above: Chanticleer, 9 New Street (*ca.* 1810), a favorite gathering spot for Nantucket gourmets. The carousel horse in the garden is the hero of a beloved children's book, *Escape from the Chanticleer*, illustrated by Barbara van Winkelen and written by Jared and Eva-Marie Tausig. The left portion of the building was once a fishing cottage that belonged to Charles Paddock and was originally located on the Bluff. Paddock was so concerned about the low, six-foot ceilings that he forbade men to dance the hornpipe unless they vowed to pay for any damage inflicted by their heads on the plaster above. Uriah Bunker moved the cottage in 1836 when New Street was laid out and additions were made to the eastern side.

The roses that envelop the Chanticleer are the essence of 'Sconset, which some consider the rose capital of the world. Many varieties flourish here on trellises, which encourage them to climb, keep them from sending shoots under shingles and gutters, and increase air circulation under the stems. The constant breeze and salt spray (salt is often referred to as nature's fungicide) keeps most common rose diseases in check.

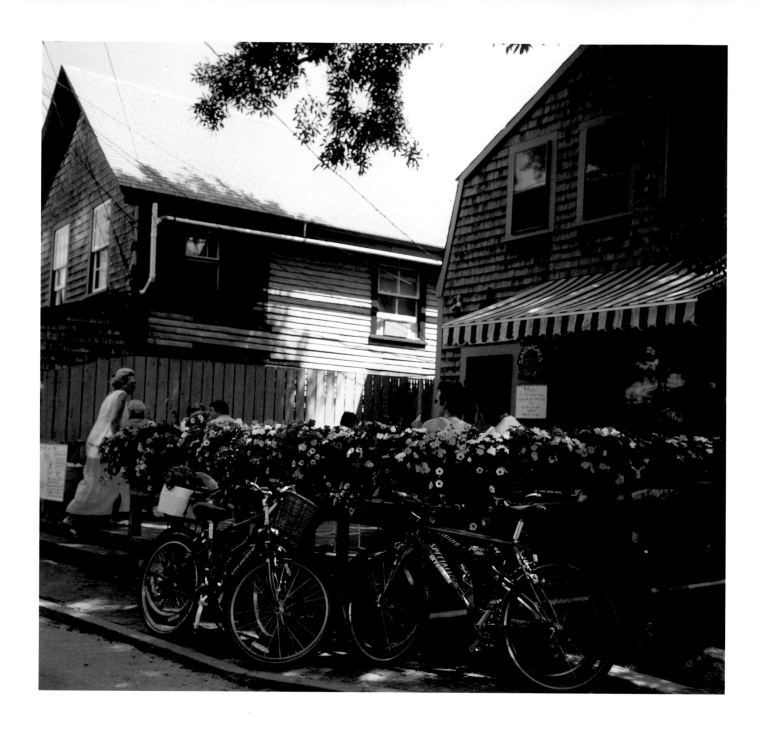

'Sconset Square. *Above*: Claudette's is a favorite gathering spot for "cyclists who lunch" after a seven-mile spin from town. This sandwich and box-lunch shop opened in 1968 and has changed little over the years.

Opposite: A view from the rotary. On the right is the 'Sconset Café, which is where Cliff Eddy's Book Store was once located, with his taxi stand outside. Not so long ago, 'Sconset had a library (housed in the George Gardner house) and an assemblage of small businesses catering to daily needs.

'Sconset's sleepy atmosphere was radically changed by the advent of railroad service in 1890. Suddenly the village was transformed into a sort of Nantucket Newport. Wealthy townspeople who wanted a change of scene built large, fashionable summer houses that dwarfed the old fishing shacks. In their wake came a sizable segment of New York's theatrical set, drawn by Edward Underhill's promotion of 'Sconset's summer rentals; the New Yorkers were charmed to discover the newly vacated "doll houses."

The bicycles so prevalent on Nantucket hark back to an earlier era. When automobiles became popular on the mainland,

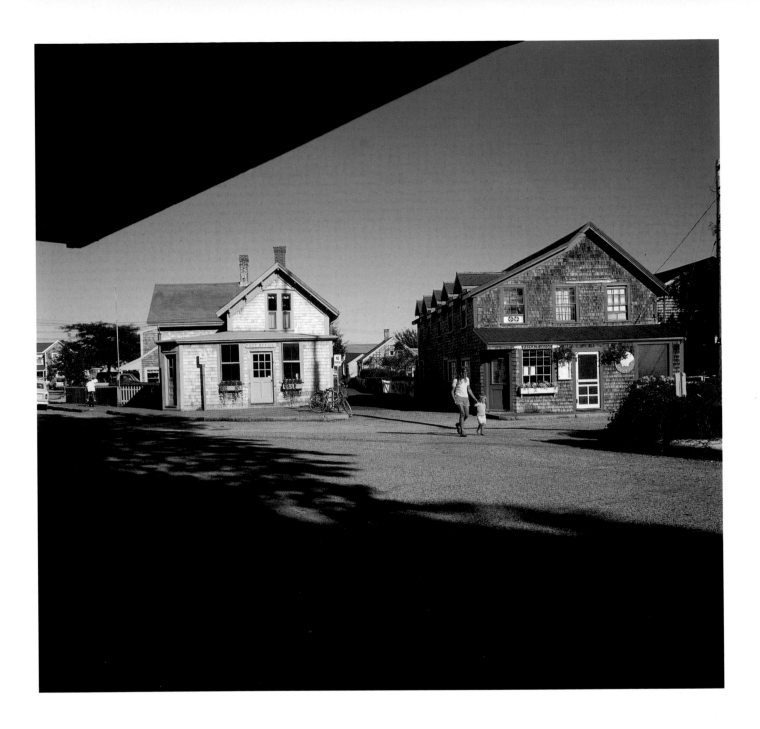

they remained banned on Nantucket. However, an enterprising mail carrier Clinton Folger, bearer of a distinguished island name, reasoned that motor traffic on Milestone Road was legitimate since it was a state road outside the town's jurisdiction. He proudly drove his car in from 'Sconset to the edge of downtown, then hitched a team of horses to the front end and let them tow the car while he made his rounds. The selectmen relented and allowed cars in 1918.

For a while, 'Sconset was a tiny, full-fledged town with a coin-operated laundromat, the Kozy Beauty Salon, a Chinese takeout restaurant, and local branches of Western Union and New England Telephone. More recently, it has regained its sense of simplicity and tranquility. Principal pastimes include morning gams at the post office, blueberry muffins and afternoon ice-cream cones from Claudette's for cyclists, and shopping for provisions in the little, well-stocked 'Sconset Market, all set to the pleasant pings and pongs echoing from the Casino's tennis courts. Once again, 'Sconset dozes in the warm, summer sunlight and sea air, pulling a blanket of roses over her gray cottages in July.

Opposite: The pool of the Summer House hotel and restaurant. Reached by a flight of steps leading down from the Bluff, the pool overlooks Codfish Park and the vast, uninterrupted expanse of the Atlantic Ocean. It is close to the original terminus of the Nantucket Railroad, which made its last run in 1917. After the Surfside spur was abandoned in 1887, 'Sconset became a newly popular out-of-town destination, especially given its recently opened tennis casino.

Above: The ninety-foot bridge over South Gully. This was built to facilitate access to the south bluff when it was divided into building lots by Charles Robinson and Franklin Ellis in 1872. They gave the area the evocative name of Sunset Heights, laying out Ocean Avenue and displaying their plans in Macy's dry goods store window downtown. Robinson also built the large Ocean View Hotel where the Summer House is today. But their grand plans never really came to fruition; until the advent of automobiles in Nantucket after World War I, 'Sconset was too remote for most visitors. After the war, the more affluent favored homes modeled after the opulent Newport "cottages," a style spreading across the mainland's resort communities.

Opposite, top: The Little House (1885). This is one of a number of cottages owned by Edward Underhill, a businessman with an office on Fulton Street in Manhattan, who was a regular summer visitor to the island. He began acquiring property in 'Sconset and by 1890 had three streets of charming, little houses, along with an extra room on wheels that could be dragged around to accommodate large families. He deliberately built the houses small as pastiches of early cottages, with low eaves and ladders leading up to children's sleeping lofts. Underhill so successfully marketed the rentals to the New York acting community (generally idle in the summer due to a lack of air conditioning in theatres) that 'Sconset became a type of Lambs' Club sleep-away camp.

The nearby Marconi wireless station was charged with the unofficial but vital responsibility of transmitting the outcome of New York Giants games to the summer community. The Lambs Club members would gather at the Ocean View House to "listen" to the game, as rendered by the urgent tapping of Morse code. A Giants win spurred much revelry, but defeats resulted in flags at half-mast and an aura of pervasive gloom in the holiday retreat.

Opposite, bottom and above: Eagle Cottage, 23 Broadway (1787), was built by Thomas Hiller, captain of the Coffins' barkentine *Lydia.* Numerous "warts" (additions) were added and gradually consolidated into more spacious rooms in the nineteenth century. The fireplace in the great room has an unusual but practical splayed configuration to maximize heat output; the front is four feet wide, but the back is only two feet wide, and the hearth projects three feet into the room. The mellow color of the original, wide floorboards adds visual warmth. Hiller sold the cottage to his son-in-law, Samuel Folger, a successful blacksmith and ship owner. His son James began his career as a successful gold rush prospector and eventually started the Folger Coffee Company. Captain William Baxter purchased Eagle Cottage in 1861 after he returned to the island to operate a 'Sconset stagecoach called the *Side-Wheeler Swiftshure,* which delivered mail and newspapers from town for a penny apiece. Henry Tucker and then Edward Lawrence were later owners of the house. Lawrence operated the Boston Dry Goods Co. at the corner of Main and Orange Streets, the former site of R. H. Macy & Co.

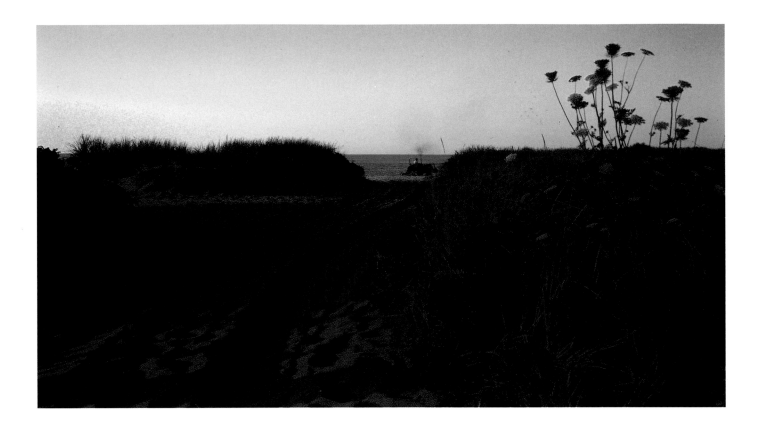

Above: Cleaning the beach at 'Sconset. *Opposite, top*: Petunias are a favorite of 'Sconseters' window boxes. Now available in almost every color except blue, these sturdy annuals have come a long way since they were discovered in South America in the early 1800s. The double blossoms date from 1855.

Opposite, bottom: A stroll along the Bluff at 'Sconset. For generations, residents of houses on 'Sconset's North Bluff have shared their splendid views, extending open invitations to walk across their lawns and between the hedges behind their houses, all the way from the gully to Sankaty Light. Erosion has taken its toll on parts of the path, and it is now closed.

The famous Marconi Wireless Station was built on nearby Bunker Hill in 1901. The owner and publisher of the *New York Herald*, Gordon Bennett, was an avid yachtsman who originally commissioned Guglielmo Marconi to put up two wireless stations on the shore, and two more on ships to cover the 1899 America's Cup races in the New York harbor. These installations resolved the longstanding problem of a news vacuum for transatlantic liner passengers in this area. With a wireless on the *Nantucket* lightship stationed on South Shoal and a relay at 'Sconset, news could be readily transmitted to and from passengers at sea. Today, we take wireless transmission for granted. It was such a significant development in its day, however, that Marconi not only won the Nobel Prize in 1909 for his invention of the wireless telegraph, but upon his death in 1937, he was honored by *two minutes* of radio silence around the world.

In 1908, a young immigrant from Minsk, who began as an office boy at the Marconi Company's New York office, became one of four operators at the 'Sconset station. It was a propitious career move. He was David Sarnoff, who later went on to become the founder of RCA. On the night of April 15, 1912, it was Sarnoff who first heard the startling SOS message of the SS *Titanic*. The entire Atlantic community was immediately alerted to the disaster, and through the miracle of the wireless, over seven hundred passengers were saved by the SS *Carpethia*. The next morning the story was on the front pages of the papers in New York, and the name of David Sarnoff came to world attention for the first time.

As a young man in 'Sconset, Sarnoff was fond of swimming. According to historian Robert Mooney, one afternoon in 1910 Sarnoff took a lone swim, unaware that a summer storm had left a dangerous undertow. Soon he was caught in a rip tide and dragged beyond the breakers. Fortunately, two young women who were familiar with the conditions at 'Sconset saw him, plunged in, and managed to rescue him as he was going down for the third time. They dragged him onto the beach, where he lay still. Others soon came to the scene and instinctively turned him upside down over a barrel, wrapped him in blankets, and gave him some whiskey. He recovered shortly and later proposed to one of the women who had rescued him. They were not married, however, according to Rosie Sarnoff, whom I met many years after. And neither did I propose to the young woman who came to my rescue in 1999 from a rip tide off Ladies' Beach. She saw me in a situation similar to Sarnoff's and summoned help because she was too ill to swim. One sixty-eight-year-old man swam out, along with his son. It was not until he was nearly upon me that he discovered I was his brother. We both survived to tell the tale and to warn everyone never to swim in an unguarded beach, especially after a hurricane, no matter how calm the waters may appear on the surface.

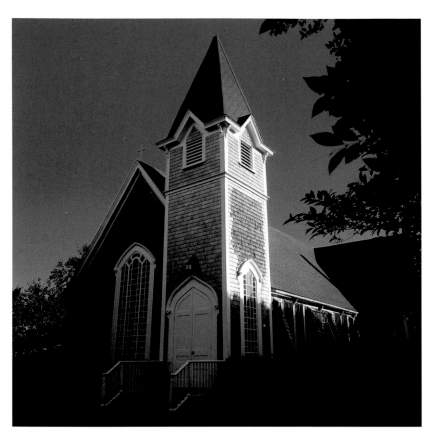

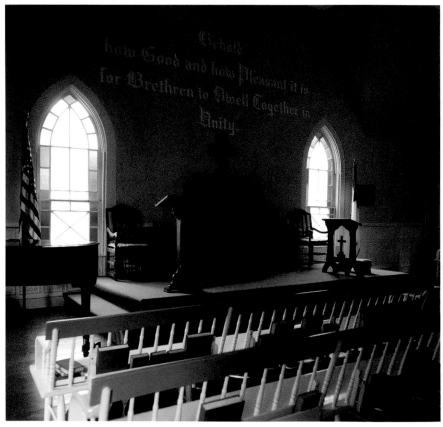

Opposite: Union Chapel is an interdenominational place of worship for the 'Sconset community. It was built by the developer Charles Robinson for $1,680 in 1883. Roman Catholic services were held in the 'Sconset schoolhouse as early as 1875. After Union Chapel was erected, Catholic mass was celebrated here on Sunday mornings, followed by an interdenominational Protestant service in the afternoons. Prior to the construction of the Siasconset Casino in 1900, the chapel also served as a concert hall.

Above: The Wade Cottages on Shell Street, originally built in 1929 by the prominent New Yorker Frank Edward Wade as a large family compound.

Be Thou my Vision, O Lord of my heart;
Naught be all else to me save that Thou art.
Thou my best thought by day or by night,
Waking or sleeping, thy presence my light.

—From Slane,
an old Irish folk melody.

Opposite, top: Auld Lang Syne, 6 Broadway, is believed to have been built by Mitchell Coffin around 1675. This is the oldest building still standing on Nantucket and picturesquely looks its age, having changed very little in the past three centuries. The simple interior comprises a large room for living, dining, and sleeping, a kitchen porch on the north side, and a small storage wart on the west side.

Shanunga and Nauticon Lodge are the names of other 'Sconset cottages dating back almost to the settlement's establishment in 1675. In 1758, the town of Sherburne laid out a grid plan for the village, with twenty-seven narrow lots (each three rods, or about forty-nine feet, wide) along Siasconset Bluff. When Center and Shell Streets were laid out in 1790, Shanunga, Rose Cottage, Nauticon Lodge, Martin Box, George Gardner, Dexioma, Snug Harbor, and Eagle Cottage were already clustered along the bank on their present sites. Below the Bluff stretched the vast beach, where grounded whales were sometimes discovered. This gave rise to Siasconset's name, which means "place of many whale bones" in the local Indian dialect.

Originally intended as simple fishing shacks for storage and occasional shelter, 'Sconset houses began with simple, almost identical, rectangular layouts. As the settlement became more established, warts were added to some of the old cottages in the late 1700s, and some had sheds tacked on at the opposite ends in the early 1800s (examples of that strategy include Auld Lang Syne, Shanunga, Heart's Ease, and Eagle Cottage). Dexioma added another wart, rather than a shed. The dwellings became increasingly idiosyncratic in the 1840s and 1850s as roofs were raised and gables extended (Nauticon Lodge, The Maples, The Corners). The front wall of Martin Box was moved forward as well.

Opposite, bottom and above: The Summer House, 17 Ocean Avenue. This appealing inn on the Bluff is an ensemble of old and new cottages, drowsing beneath roses or tucked behind lushly flowering plants. Most of the guest houses were built in 1941–42 around a restaurant called The Moby Dick. The simple beauty of 'Sconset has captivated visitors for over two hundred years.

Opposite, top: The Corners at Pump Square (*ca.* 1730) is sometimes referred to as Meeresheim, from the Dutch/German compound meaning "sea home." This cottage has changed even more over the years than 'Sconset's other old houses. Like Auld Lang Syne and Dexioma, it was first enlarged with a T-extension, followed by a kitchen porch, then by enlarged warts on the north and south, and finally concluding with a split gable "flounder wing."

Opposite, bottom: A 'Sconset trio: Dorothy Perkins roses, hollyhocks, and geraniums. "House of Lords" (1753), 15 Broadway, was built by Gershorn Drew. Its boastful name honors three fishermen with an elevated opinion of their own prowess.

Above: The Swain Cottage. Rambler roses blanket this house; the pink variety is Dorothy Perkins and the white is White Excelsa. The pink shrubs around the foundation are Anthony Waterer spiraea, and the roses on the fence are American Pillar. Nantucket has several native rose species that adorn its roadsides and bloom in June, but most island roses—including *Rosa rugosa*, the beach rose—come from elsewhere.

Rambler roses, like most cultivated roses today, are hybrids, the result of crosses between two species. While some species are native to the United States, many modern roses are crosses of roses originating in Japan and China. Roses have been crossbred for centuries, so it is often impossible to determine their origins. Rambling roses are considered old-fashioned because they predate most of the modern, disease-resistant hybrids. They were probably first brought to Nantucket in the early twentieth century. Ramblers differ from modern climbers, blooming late (in July) with little fragrance. The flowers appear in clusters on long, arching stems. Ramblers are prone to mildew and rampant, tangled growth, but they are extremely hardy with abundant, colorful blossoms. They flourish on Nantucket like nowhere else because the salty, circulating air keeps the diseases to which they are susceptible to a minimum.

American Pillar, another old-fashioned rose that is not disease-prone, is among the first varieties to bloom on Nantucket. It is called a "single rose" because it has a single row of dark-pink petals fading to white toward a bright yellow center. A pillar rose is halfway between a shrub and a climber. The stems are upright but not sprawling, and, unlike climbers or ramblers, American Pillar does not spread over trellises. It has no fragrance. No longer available commercially, the American Pillar is found only around old foundations or on abandoned sites.

Flowers and shrubs were generally not used ornamentally in the United States until the turn of the last century. Most early gardens were kitchen-utilitarian, and Nantucket was no exception. Any decorative plantings were quite formal and restricted to evergreen or deciduous shrubs arranged in geometric patterns.

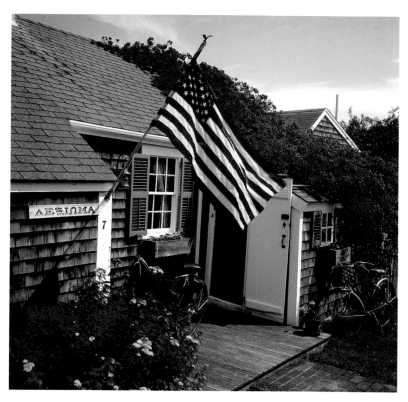

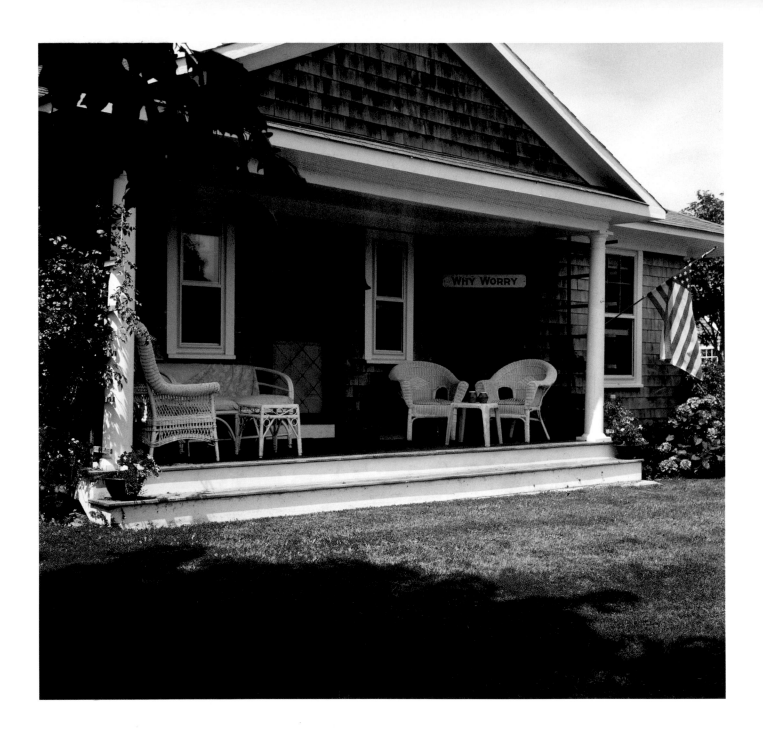

Opposite: Dexioma, 7 Broadway, also known as the Captain George Wilbur house. The name, transliterated from the Greek, means the clasp of right hands—hence a handshake or simply "welcome"—and was appropriately bestowed on the cottage by a Harvard classics professor in the 1880s. The great room and twin staterooms in the southern section constituted the original structure. The kitchen and adjacent warts were added around 1840. That kitchen has since been converted to a parlor, and the great room has become a dining room. A boathouse was added and adapted to be today's kitchen. It is connected to the main house by a pantry with a trap door opening to a sunken, circular storage room lined with cobblestones, an early refrigerator.

Dexioma's master bedroom has a cannonball bed (*ca.* 1825) brought over from Martha's Vineyard. On it rest soft pillows made from antique fabrics and laces. The straw hat is perched on a nineteenth-century quilt stand

Above: The name of this cottage says it all.

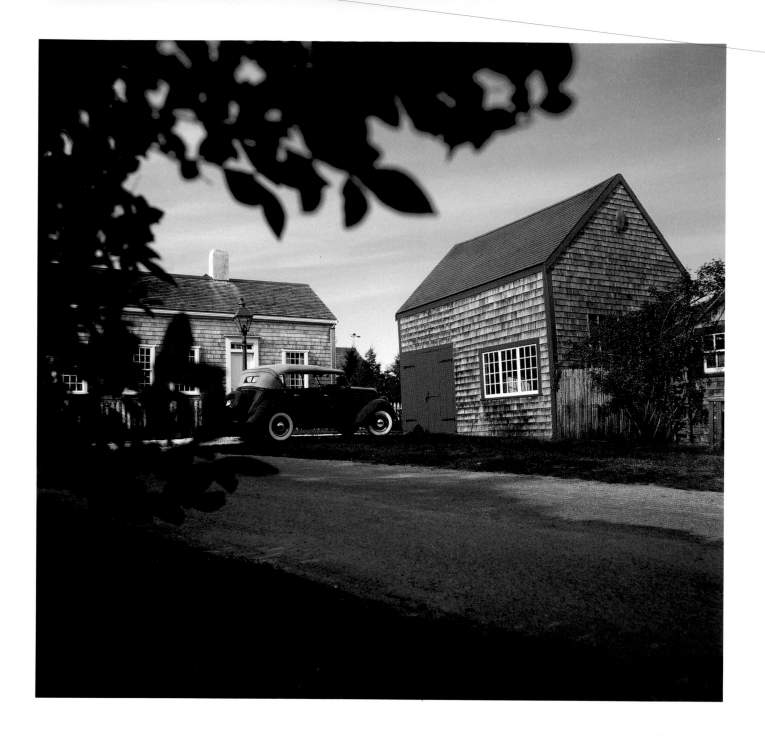

On the right of the photograph above is the stable of Nauma (*ca.* 1710), the Indian name for Sandy Point, now known as Great Point. Reuben Joy moved the house by raft to 'Sconset from Sesachacha as the pond there lost its sea access. Stone boulders, which have since settled unevenly, were used as the new foundation, so the parlor now has a picturesque list. Henry Chandlee Forman and his family lived in Nauma for 41 years in a very traditional fashion, sleeping on old rope-net beds and covering the windows with fine, cotton gauze in the summer to keep out the moths. Behind the 1936 Ford stands Sea Spray (1796), another peripatetic residence; it was moved from the section of town called New Guinea by Frederick Pitman around 1851. He enlarged the house, adding two stateroom warts and a kitchen.

Seldom Inn, 5 New Street (*ca.* 1830), is an appropriate name for a summer cottage. This house was moved in from the Bluff to New Street at the time of the 1841 gale. It is smothered with roses, which thrive in 'Sconset. The most popular are:

New Dawn, a shell-pink double hybrid (June-August) with six to eight blossoms per stem;

American Pillar, more than one hundred years old, a cross between a native prairie rose and a hybrid perpetual. A single rose, its flowers are deep-pink or red with only one row of petals. It is very resilient, capable of outdoing grass and weeds, and is 'Sconset's overall favorite.

Dorothy Perkins, an old rambling rose imported from England in the late 1800s, the last of the group to bloom with small, one-inch, bright-pink double flowers; and

Excelsa, a deep-red rose most often seen in 'Sconset and a near-twin of the Dorothy Perkins.

Right: Sankaty means "cool bluff," and the San-katy Head Lighthouse (1848) is at the island's highest point, 111 feet above sea level, outstripping Altar Rock (103 feet) and Folger Hill (109 feet). At the top of the lighthouse, the lamp is 158 feet above sea level and has a nominal range of twenty-nine miles, almost visible from the Cape itself. Four lamps within complete a full rotation every thirty seconds, so that a warning flash appears every seven-and-a-half seconds. Sankaty Light is at risk because of its proximity to the eroding bluff, and stronger beacons threaten to make it obsolete. Its future lies in the hands of the United States Coast Guard and Mother Nature. *Opposite*: Great Point Light was originally called Sandy Point Lighthouse. Its beams carry fourteen miles, and its location five miles north of Nantucket town makes it a familiar harbinger on the approach to the harbor.

This lighthouse had been planned even before the American Revolution because of the many wrecks on the surrounding shoals. In 1784, funds were finally appropriated for a wooden structure thirty-six feet high, which carried a spermaceti oil-fueled light visible up to twelve miles because of its prominent location. This lighthouse burned down in 1816 and was replaced two years later by a seventy-foot stone structure, the same height as Sankaty Head's. In 1857, more efficient Fresnel lenses replaced the old reflectors, and by 1882 the light was fired with kerosene instead of lard oil. A combination of erosion and gale winds destroyed this lighthouse in 1984. It was again rebuilt in 1986 on a site farther west, with funds from the United States government.

Nine

Lighthouses

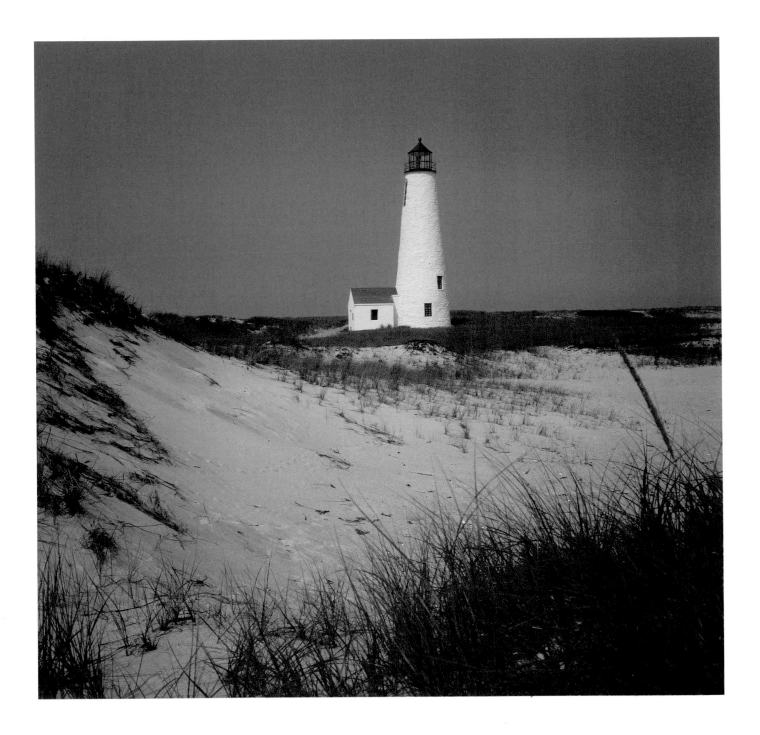

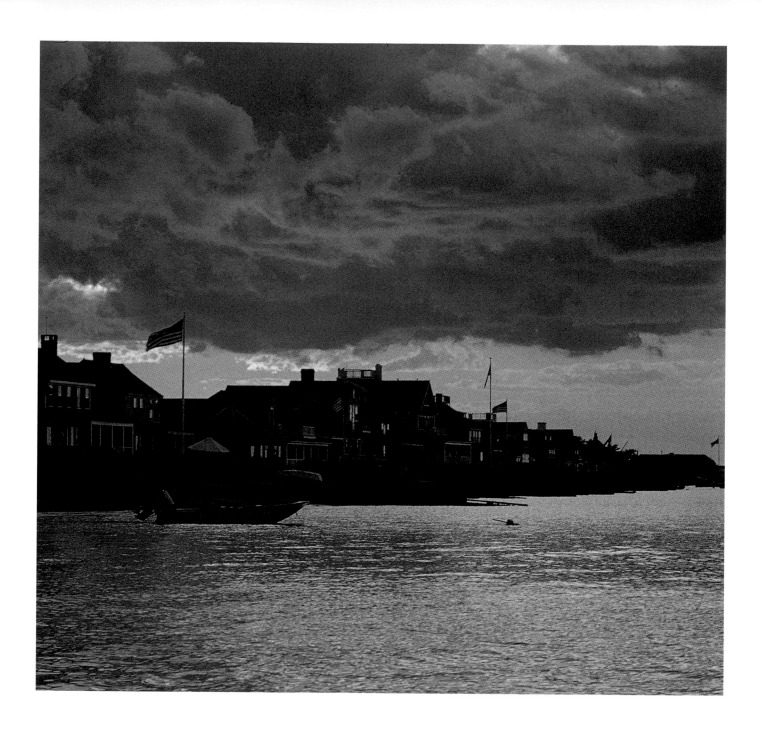

Above: Hulbert Avenue Beach at sunset.

Opposite: Brant Point Lighthouse (1746) was the second lighthouse built in America. The first was on Little Brewster Island off Boston (1716). Brant Point was first maintained by private interests but later taken over by the town. The first lighthouse at this location was destroyed by fire in 1759, and the second was blown down by a gale in 1774. A third burned in 1782, as did a fourth in 1783. The U.S. government took control in 1791, after the fifth lighthouse was wrecked in a storm. A brick lighthouse lasted until 1901, when it was replaced by today's wooden structure at the end of the point. The red occulating lamp (which means it is on more than off) has a ten-mile range; the cycle is four seconds—three on and one off. Red marks the starboard (right) side of the channel for ships entering from seaward.

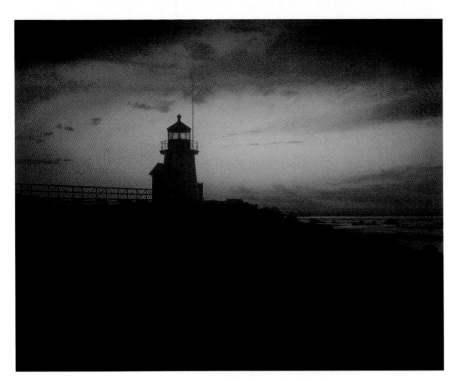

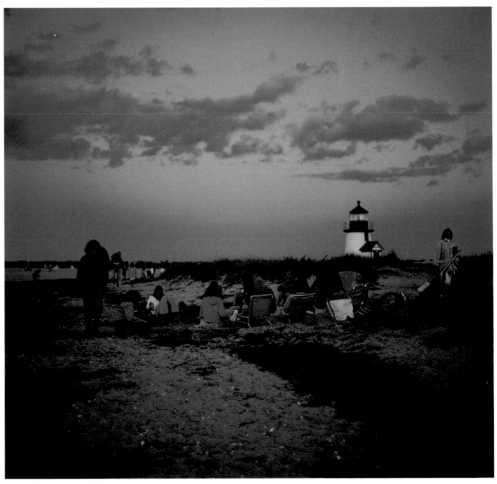

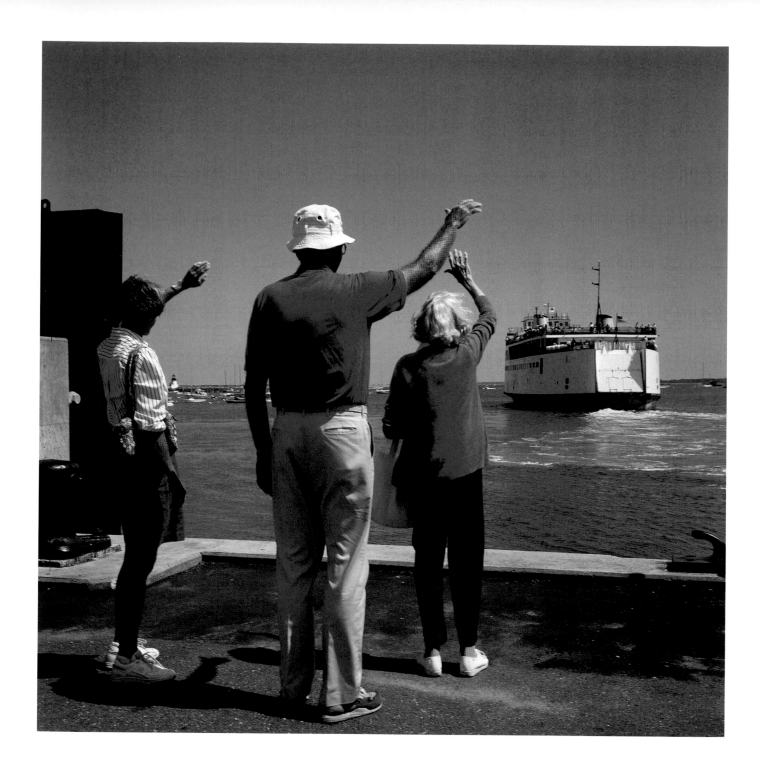

Two pennies overboard, and come again soon. Visitors follow a longstanding tradition that is supposed to ensure a return to Nantucket, tossing a penny or two overboard as the departing steamship rounds Brant Point and sets sail back to America. The irresistible appeal of throwing coins into fountains for luck is another manifestation of this pleasant superstition. The origins of this practice probably date back to the age of the Phoenicians, when voyagers made sacrifices to propitiate the sea gods and assure a safe return home. The offering was usually in the form of a coin or a jewel. This custom passed through generations of seafarers, including the whalers, surviving in Nantucket as a cheerful ritual of departure.

Index